WITHDRAWN
UTSA LIBRARIES

RENEWALS 458-4574

	DATE DUE		
MAR 28			
APR 18			
GAYLORD			PRINTED IN U.S.A.

Urban Verbs

Arts and Discourses of American Cities

URBAN VERBS

Arts and Discourses of American Cities

Kevin R. McNamara

STANFORD UNIVERSITY PRESS
Stanford, California 1996

Library
University of Texas
at San Antonio

Stanford University Press
Stanford, California

© 1996 by the Board of Trustees of the Leland Stanford
Junior University

Printed in the United States of America

CIP data are at the end of the book

Stanford University Press publications are distributed
exclusively by Stanford University Press within the United
States, Canada, Mexico, and Central America; they are
distributed exclusively by Cambridge University Press
throughout the rest of the world.

ACKNOWLEDGMENTS

For permission to reprint photographs and illustrations, I have many individuals and organizations to thank. Berenice Abbott's *City Arabesque* and photographs of the M. Orme Wilson House, the J. P. Morgan Library, Peacock Alley, and the Woolworth Building appear by arrangement with the Museum of the City of New York. Permission to reprint the photograph of the Chrysler Building that first appeared in the *Architectural Forum* (October 1930) was granted by the New York Public Library; I am especially indebted to Paula A. Baxter, Curator of the Art and Architecture Collection, who located it. Hugh Ferriss's illustrations for the 1916 New York Zoning Law are reproduced with the permission of the Cooper-Hewitt Museum. Other illustrations from *The Metropolis of Tomorrow* are made from photographs taken by me from the 1986 Princeton Architectural Press edition edited by Carol Willis; I thank the press and Jean Ferriss Leich for their permission. Illustrations and photographs of Robert Venturi and Denise Scott Brown's work appear courtesy of Venturi, Scott Brown Associates.

Chapter 1 appeared in slightly different form as "Building Culture: The Two New Yorks of Henry James's *The American Scene*" in *Prospects* 18 (1993): 121–51; copyright 1993 by Cambridge University Press. Reprinted with the permission of Cambridge University Press. Parts of Chapter 2 were first published as "The Ames of the Good Society: *Sister Carrie* and Social Engineering," in *Criticism* 34 (1992): 217–35; copyright 1992 by Wayne State University Press. Reprinted with the permission of Wayne State University Press.

To Grace George of Great Falls / s.u.m. National Historic District goes my gratitude for a wealth of material about historic and present-day Paterson, and to the Interlibrary Loan staff at the University of California, Irvine, my thanks for processing mounds of requests. Jennifer Calkins rescued some material I desperately needed. Alison Voight of Epson usa was an angel of mercy when my hard drive crashed. Helen Tartar, Lynn Stewart, Laura Bloch, and Barbara James at the Press have made the publication process easier than I feared it would be when I was in Olomouc.

What's good in this book owes a lot to colleagues and friends whose diverse perspectives have affected the course of my argument in ways not fully accountable in notes. Foremost among them is John Rowe. I have for years enjoyed the benefits of his friendship, advice, and instruction. *Urban Verbs* has its beginning in his graduate seminars, and all phases of the project have benefited from his criticism and suggestions. Stuart Culver and Brook Thomas were generous with their time and insights, particularly helpful in some of my cross-disciplinary work and studies of the history of other disciplines, as was Dennis Bryson, an historian with whom I shared an interest in early-century sociology, social control, and the novel. In the course of conversation others have influenced the book's direction, knowingly and unknowingly; among them are Theron Britt, Tom Cody, Michael Davidson, Wai Chee Dimock, and Kenneth Warren, as well as audiences at panels in Toronto and Santa Cruz and students in my classes at U.C. San Diego, where some of the arguments were tested. I am also grateful to my reader at Stanford for a sympathetic response and suggestions that brought it all together.

Closer to home, I owe unpayable debts to family and friends for emotional sustenance over the years of writing and rewriting. To my brother, Bob, my deep gratitude for many hours of face-to-face and electronic discussion about the issues of urbanity, and for the far less rewarding labor of looking up texts and quotations I would otherwise have done without. Thanks to Kathi and Dan for a place

to live and write a few summers back, and to Rev. Steve Garmey for fostering my interest in New York's architectural history. Most of all, my love to Lisa, who always kept her faith in this book and its author, especially when he didn't.

CONTENTS

FIGURES

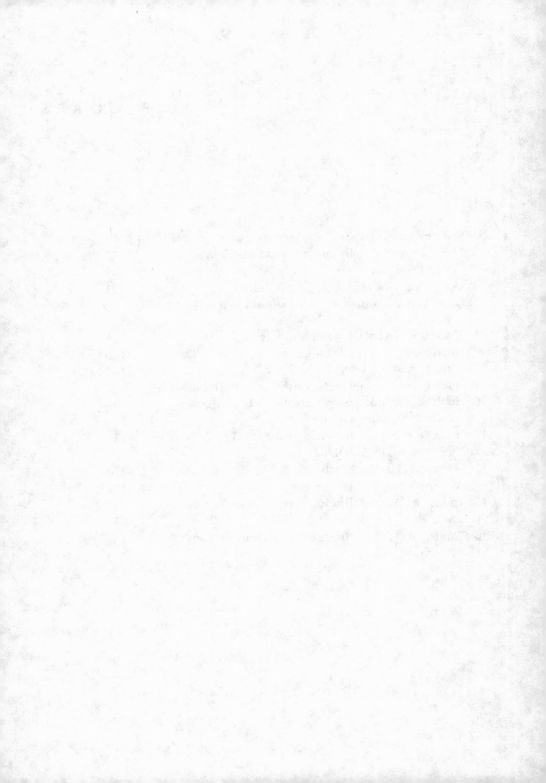

Urban Verbs

Arts and Discourses of American Cities

Introduction

In the city all the secret ambitions and all the suppressed desires find somewhere expression. The city magnifies, spreads out, and advertises human nature in all its various manifestations. It is this that makes the city interesting, even fascinating. It is this, however, that makes it of all places the one in which to discover the secrets of human hearts, and to study human nature and society.
> —Robert Park, "The City as Social Laboratory" (1929)

Until we learn to value the idea of the city, we can expect to see the streets paved with anger instead of gold.
> —Lewis Lapham, "City Lights" (1992)

My work on *Urban Verbs* was well underway a few summers ago when *Raritan* published the "New York Reflections" of urbanist and essayist Richard Sennett. In that essay, he makes the case that New York has failed to achieve its promise as a place where people's lives are turned outward and liberated from the psychological burdens of interiority. Equating difference and danger—not physical danger, but threats to the fragile order of a personal identity maintained at arm's length from the urban swarm—city residents by and large do not avail themselves of the wealth of experiences of otherness that would enrich their psychic lives, he argues.[1]

Earlier this century, such sociologists as Georg Simmel and the Chicago urbanists found signs of a new mode of social relations emerging from the diversity of cultures and the lightness of attachments among the people in the great industrial cities. Bonds of community nurtured over generations would not be recreated in

cities, they recognized; organicism was frustrated by the gulf sepa-
rating traditions and worldviews, as well as by the shifting rela-
tions among groups and their interests. At the same time that they
viewed these divisions of the urban polity, the Chicago urbanists
imagined that industrial cities were potentially the site of a broader
political culture composed of differences, not similarities: a cul-
ture of urbanity. "The criminal, the beggar, as well as the man of
genius" and everyone in between, might find companions with
whom to pursue her or his particular "vice or talent," Robert Park
suggested. Cities might thus thrive as communities proliferated,
created not only by shared ethnic and religious identity but also by
commonalities of interest.[2] The urbanists' hope was, Sennett ex-
plains, that in these fields of concentrated diversity the appreci-
ation of differences would be strengthened as people came to regard
them as the foundation of a vital collective life, not obstacles to
overcome. Making this leap, urbanites would extend rights across
the divides of class, race, ethnicity, religion, and gender.

The flourishing of communities among which one might move
would also change the individual's nature, these urbanists pro-
posed. Diversity in the great city presents urban-dwellers with
the liberty to remake themselves by pursuing desires that remain
suppressed in more homogeneous environments. The experience
of these options may be dizzying, even unimaginable, but Louis
Wirth, Park's student, believed that it was bringing about a new,
mobile subjectivity: "The heightened mobility of the individual . . .
[brings him or her] toward the acceptance of instability and inse-
curity in the world at large as a norm," Wirth proposed. He further
speculated that "this fact helps to account, too, for the sophistica-
tion and cosmopolitanism of the urbanite. . . . By virtue of his dif-
fering interests arising out of different aspects of social life, the in-
dividual acquires membership in widely divergent groups."[3]

It is difficult to imagine a city where more diversity is nour-
ished, more desires pursued, more individualities expressed than
New York. And yet, Sennett argues, instead of a celebration of dif-
ference and life made richer by encounters with others unlike our-
selves, New York is greatly a realm of defensive *indifference*; indi-

viduals and groups turn inward, glances are met with suspicion, if at all. Public life has been supplanted by "a complex and unhappy subjective life that is so much richer . . . , so much more compelling" than the metropolitan life portrayed by urbanists who share a faith in a dynamic pluralism.[4] Such a way of being leads to a submissive tolerance; I have remarked it in some of my students who were raised in homogeneous suburbs, for whom the mantra "Everybody's entitled to . . ." is not a celebration of the opportunities of a diverse culture, but rather a protective disengagement from a field of difference they fear poses only risks.

Two ideas remain radical in the Chicago urbanists: their suspicion of the ideal of self-identity, which follows from their recognition that the value of divided selves is found in their heightened responsiveness to the world of concentrated difference around them; and their insight that the ideal moral order of a city should be a suspension of moral judgment that will make nontraditional lives livable. By contrast, the *Gemeinschaft* world of rural villages, even the insular communities of the urban mosaic (Wirth's metaphor), indeed, any community formed by one "dominant" or defining characteristic, is impoverished.

Drawn to the thesis that a fluid urban social structure would allow the freedom to negotiate that field of differences and reconstruct one's self through changing networks of affiliations, and that from these activities a new form of collective life might arise, I began work on *Urban Verbs*. To explore what has come of these ideas, what forces and interests have altered them, I turned to representations of modern American cities in literary and visual texts, reading them alongside work in the social sciences. I examined in particular how urban society and culture are depicted. Let me define some terms: A New Yorker by birth and prejudice, I mean by "cities" primarily those large population centers shaped by industrialism that have long contained substantial ethnic and immigrant communities. By "modern" I mean the period from the postbellum rise of New York and Chicago as manufacturing centers until the demise of a set of modernist assumptions about urban space and urban planning and the regional shift of populations and

jobs to suburbs and "post-urban" sunbelt cities. I do not thereby endorse theories of the obsolescence of the cities, nor do I see a radical shift in the social and economic dilemmas facing the nation's older cities in the past 30 or so years, only an intensification of longer-standing problems. This limit is dictated by my sense that an adequate treatment of these regional shifts, the transition from industrial to information economies, the auto-determined geography of newer cities, and postmodern theories of urban form require more than a chapter appended to the present study. Thus, my final chapter, on Robert Venturi and Denise Scott Brown, is not about postmodern urbanism; it concerns their criticism of basic assumptions of modernist architecture and urbanism at a pivotal moment in the history of modernism. Finally, the representations I sought were of cities *as wholes*, not of city life, particular communities, or the city as a setting. I would argue that a city is the protagonist in all the texts on which I focus.

I have structured *Urban Verbs* into three pairs of texts that concern three moments in the history of American urbanism: realist narratives of the rise of industrial cities in Henry James's travel narrative, *The American Scene*, and Theodore Dreiser's novel, *Sister Carrie*; a stark contrast in modernist notions of the nature of a city in Hugh Ferriss's architectural fantasy, *The Metropolis of Tomorrow*, and William Carlos Williams's long poem, *Paterson*; and what we might call the climax stage of the modernist city in a film noir, *The Naked City*, and a set of architectural projects and essays by Venturi and Scott Brown.[5] That these texts will not represent the full complexity of a modern city is a given; as Derrida has taught us, the failure is in the nature of representation. I will, however, make the more modest claim that, taken together, these texts represent cross-currents of urbanist discourse during the period because the choices the authors and artists make about what to include in, and exclude from, the cities they create are not only aesthetic. Their aesthetic strategies are responsible to a theory of urbanism—of what cities are, can be, or must avoid becoming—that entails a politics of representation.

As they avail themselves of, and add to, a growing store of

knowledge about the life of the cities in order to influence readers' understandings of, and attitudes toward, the urban scene, these cities' creators also further urbanist discourse. The persistence of certain issues in, and concepts of, urbanism throughout the history of modern American cities forms the connections among the several chapters while marking as well advances and regressions of urbanist thought. To consider them fully, I move between the texts and contemporary developments in sociology, law, economics, political theory, historiography, architecture, planning, and art history, fields I am interested in as narrative (hence, form-producing) acts in their own right, not simply as "context." For even the most empirical social science assumes, if it does not defend, the significance of the data studied, a significance that can be justified only by appeal to a theory of urban form or function that asks our assent and commands our judgment.

This circumstance may seem to call for a thematic approach to a wide sampling of texts instead of a close reading of six, but any gain in breadth (most importantly, in the range of group representation) accruing from a thematic reading of the conflict between ideals of urban mobility and theories of urban stability would be offset by the loss of attention to the strategies of representation by which the texts' arguments are advanced. The surpassing advantage of a text-centered approach lies in its ability to reveal contradictions and lacunae in the discourses on which the authors, artists, and architects draw to represent the complexly woven texture of cities. Seeking a figure by which to convey the circulation of social energy in a city imagined as a whole, while to a greater or lesser degree recognizing that cities are open and aleatory systems, these texts project conflicts that careful discursive arguments conceal. The processes of selection and repression in the written or visual language that give form to events, govern circulation within a text's and a city's myriad symbolic economies, stabilize the flux, and rank differences provide my avenue into the ideological work performed by the mediation of aesthetic forms.

The overriding difference between the texts in each pairing is the perspective they privilege—within or at a remove from (often

above) the crowded activity—and the form it produces. In each case, the first text is less accepting of the seeming confusion of urban culture and institutes a formal control to stabilize social, economic, and cultural mobility, or the flux of a city's built landscape, into something ordered and legible. The second text begins (*Sister Carrie* and the Venturis' projects) or becomes (*Paterson*) more receptive to the disorder of urban experience, the instability of identity, the accrual of significance that makes urban landscapes the complex and overcoded products of relations among groups and individuals. Texts in this group move toward an understanding of the uses of apparent disorder and a recognition that the often unconscious negotiation of differences is what constitutes an urban polity; it is not a process to be resolved by external controls.

As I read, it became apparent that to pose a conflict between mobility and stasis is not only to simplify but to mislead. The ideal of unobstructed circulation is repeatedly invoked in representations of two different urban visions, which may be called pluralist and progressivist. The urbanism with which I began—Park, Wirth, and Sennett—is, of course, pluralist. The progressivist version of urban form has its origin at the turn of the century among those reformers collectively known as the Progressive movement. Opposing the increased power of wealth in American society, particularly as it undermined even the appearance of representative government from the national to the local levels, the Progressives turned their attention to most areas of American life, including the cities. They sought to reform the material conditions of factory labor and urban life, to foster democracy, to make cities more efficient centers of production and cultural reproduction.

Richard Hofstadter contends that the Progressive movement was necessarily plural because its interests reflected "the great heterogeneity of the country"; its supporters divided against themselves when reform programs clashed with personal interests.[6] Written in 1963, Hofstadter's observation suggests a shift in the meaning of pluralism that occurred by the 1950s, to which I must return. The Progressives' activities were a pluralizing force as they voiced the interests of the ill-housed and ill-fed, of children, women, African

Americans, immigrants living in crowded poverty, and organized labor, rather than of a generic (Anglo-American) "working man." Yet in describing a pluralism of competing interests that are only economic, Hofstadter overlooks a more important homogeneity among these reformers even as he incidentally suggests one problem with the pluralist's rhetoric of negotiation and exchange: as we are not all equally situated economically, so, too, there has always been a hierarchy of social value and an inequality of access to the social "marketplace."

What matters is not that the Progressives were predominantly white and male but something that perhaps follows from that fact. Theirs was the ideal of liberal individualism, reformulated to the exigencies of an interdependent society, perhaps, but very much in the Anglo-American grain. As they appealed to the moral responsibility of the polity in order to eradicate vice and corruption, many Progressives also sought to conform the ways of the immigrant poor to the forms of Anglo-ethnic culture. Fighting the power of urban machine politics in the name of representative government, municipal reformers displaced ethnic (usually Irish) organizations, but they left immigrant communities unrepresented. Ward bosses mediated between the ethnic world and the mysterious city, providing jobs, public works, assistance in dealing with the authorities, and other services in return for support. Municipal reform reconcentrated authority among native-born Protestants, many of whom feared the democratic "mob" even as they spoke up for democracy.

The technocrats who pursued the ideal of the efficient city formed another wing of Progressivism more important to the history retraced in *Urban Verbs*. While they, too, might avail themselves of the moral high ground, contrasting their goals with the greed of the plutocrats or the corruption of the ward bosses, their approach was more influenced by contemporary social science. These reformers' urban social models were taken from a sociology that approached human communities as organisms and studied social forces by analogy with physical forces. This knowledge was put to work developing technologies of social control, but

control was applied to a society necessarily in motion, because the social science ideology of the period was evolutionary. Sociologists may have disagreed about the efficacy of human intervention, but the voluntarists (descended from Comte) and the determinists (descended from Spencer, who was nevertheless a fierce defender of individual freedom) agreed that human society was moving toward a more perfect state. The pluralism with which I began is by contrast open-ended, focused on a process, not a result.

Progressive professionals ardently believed that "experts would always know more in their particular fields, and the public man would always see the whole more clearly." They viewed democratic consensus as an eventual product of their interventions, since they also assumed that "as all citizens became rational, they would naturally arrive at the same general answers."[7] In the meantime, many of them regarded the give-and-take of politics as an obstacle to meaningful reform. Appealing to the objectivity of social science, they never appreciated how their particular conception of interest was class- and culture-bound.

Economists shared the technocrats' optimism about mobility. Their answer to the instabilities of the market in the postbellum period of speculation was not stasis but a dynamic equilibrium—the steady, controlled growth of commerce and industrial production. Rather than resist the new forms of combination such as trusts and holding companies, many advanced thinkers accepted them as a necessary development toward a more complex and integrated market that ultimately would be more easily regulated in the public interest. Some even proclaimed the imminent end of the economics of scarcity and a dawning age of surplus.

In recent years, James has turned up among these Progressives because his writing is said to participate in technologies of social control. He has as well been considered a pluralist because of his appreciation for New York's ethnic communities. That fact is perhaps testimony to how these categories have come to define patterns of advanced social and cultural thought about the period, but as I explain at length in Chapter 1 it does little to illuminate the relation of *The American Scene* to the society and culture of turn-

of-the-century New York. James leads off *Urban Verbs* because his New York reflections are a threshold. He engages the built forms and cultural practices of the new rich and newly arrived ethnics from the perspective and within the value system of a culture that was already, he sensed, irrelevant to the great city. Unable, for once, to imagine the outcome of character development—what New York was making of itself—his travelogue is nevertheless rich with insights as well as blindnesses that make it a rewarding study of the emerging city.

If James falls into neither camp, Dreiser attempted to straddle them both. Concentrating on the use to which Dreiser's novel puts those sociological and economic theories just mentioned, I argue that he has the path of Carrie Meeber's progress describe the ideal structure of social and economic relations pursued by the Progressives, but that the novel's particular disciplining of desire to support social reproduction produces an urban world that is plural as well as integrated.

The possibility of such a balance was soon to disappear with the ascendancy of planning disciplines. The recurrent theme of projects for new cities designed in the 1920s was "a future into which the entire present is projected, of a 'rational' dominion of the future, of the elimination of the *risk* it brings with it."[8] As Chapter 3 shows, avant-garde planners responded to the "machine age" by conceiving the city as a vast mechanism whose principal features are media of circulation and communication among its parts; everything that posed an obstacle to efficient movement was to be removed or rebuilt. At the same time, pursuit of a built environment representative of "Modern Man's" powers of reason diminished the value of difference and discontinuity in the landscape. Set at naught were the claims of groups whose ways of life depended on the old, "inefficient" built spaces that had evolved over time, whose traditions and customs were reflected in what the planners could see only as forms of disorder. A language of liberation was used by Ferriss, Le Corbusier, the Constructivists, the Futurists, and other urban visionaries to herald a city purged of the diversity pluralists appreciate as supports of self- and society-making.

Sociology, too, underwent a paradigm shift at this time, although the result was clearest after World War II. Talcott Parsons proclaimed the death of Spencer (that is, of evolutionary social models) and the reign of a structural-functional approach to the study of societies. He emphasized social reproduction and the mechanisms by which social systems curtail or quarantine deviant forms of behavior. Parsons was insistent that the diversity of individuals and their interests is a defining character of a pluralistic American society, but his particular use of the term reveals the change I alluded to earlier. Allowing differences to propagate as long as they do not threaten social reproduction (redoubling them, he reduced the claims for class as a marker of fundamental social inequality), he and his colleagues devised a theory of pluralism whose key assumptions have been summarized as "the alleged equality of power among competing groups in America" and the ability of "technical experts to solve any problems that might crop up" in the reproduction of that balance.[9]

The Naked City offers a rich portrayal of this impoverished urbanity in the early years of the Cold War and postwar suburbanization. Proposing the police as agents of the urban social organism's natural self-immunization against the ills of unrestrained desire and immigrant populations that lurk in the city's dark corners, this film presents in detail an alarmed response to Dreiser's prospective optimism about the social benefits of desire and mobility (which was revised in William Wyler's nearly contemporary film version of *Sister Carrie*).

Parsons's deracinated pluralism has come for many to define the concept, supplanting William James's profound philosophical insight into the deceptive dream of unity, and the investigations of pluralistic urban societies by people like Park and Wirth. When I speak of and argue for pluralism I mean to extend their sense of its dynamic possibilities. The fact that this open-ended pluralism does not reduce well to the unity of a theory—it has been said to "depend on a lack of precision in social categories and a general acceptance of complexity and ambiguity"—is, I think, all the more reason for organizing *Urban Verbs* around literature and other arts.[10]

Paterson is in many ways my key text because during the poem's composition Williams changed his course as he recognized the inadequacy of his representational strategy—the trope of the city like a man—for the project he had undertaken. To represent the diversity and complex history of that city, he could not reduce Paterson or *Paterson* to an organic whole; he had to find another form and other metaphors. How he was led to the poem's final, open form and what it suggests about the nature of the city are my subjects in Chapter 4.

In Chapter 6, I examine Venturi and Scott Brown's powerful criticism of the authoritarian dimension of modernist progressivism and their proposals for a more pluralistic, pragmatic architectural and planning practice. My interests are the roots of their critique in a larger rethinking of modernist aesthetics, and the built forms to which it led. At the same time, I ask how their anti-ideological ideology can produce something "relevant" or "appropriate" (their terms), how architects can fulfill their ethical responsibilities if they do not think of their interventions as producing some degree of improvement in our actual cities, where economic, social, and cultural resources and opportunities are inequitably distributed. Is not some idea of progress requisite in devising "tactics for dealing with the present?"[11]

To propose a direction for that inquiry, let me return to Sennett's reflections, which move nimbly between abstract and personal, past and present, as he strolls from the Village to the East 40s. Reading them, my experience of recognition went beyond our shared interests and his traversing a turf (the East Side in the Teens and Twenties) that I still think of as home. We share as well, I think, a nostalgia for the prospective optimism of Park and Wirth. Sennett's narrative evoked my own memories (augmented by my parents' recollections, which span more than three-quarters of the century) of a city on which that optimism seemed to rest easier, even if, on reflection, any remembered sense of stronger common purpose probably owes more to the power of repression than to the power of recognition. Such a reaction is perhaps the special debility of modern culture; as Jean Baudrillard notes, while modernism may

seem "centered . . . on the future, . . . only modernity projects a past (time gone by) at the same time that it projects a future."[12] If that past is what the present triumphs over, it nevertheless measures the present and future that it shapes. What matters, what *Urban Verbs* looks closely at, is how we encounter the past and in the name of what future we reclaim it.

It is my hope that the acts of reading by which I reconstruct the historical moments of these texts and their critical engagement of contemporary urbanist discourse will also contribute to discussion about the urban present and future, because the current "crisis of the cities" is nothing new; the discussion of alternative urban futures based on differing versions of its past has a long, complex history. Moreover, I have tried to lace my discussion with caution about all talk of urban solutions, because American cities will be at the crossroads as long as they and their inhabitants remain self-transformative—and renouncing that capacity is by far the worse alternative.

Building Culture

The Two New Yorks of Henry James's 'The American Scene'

The adage says that New York will be great when they finish it. No, it won't; it will be an architectural exhibit in a museum, which is what . . . aesthetes try prematurely to make it by comparing it with dead, finished Venice. —Peter Conrad, *The Art of the City*

I

In *The American Scene*, Henry James's experiences of Harvard's College Yard and Philadelphia's Independence Hall offer paradigms of his relation to his natal land. I begin with these encounters with architecture to suggest how the New York City he recorded in this travel narrative is overdetermined by his manner of approaching it, as a landscape of forms that speak for themselves or as provocations of his own active consciousness. John Carlos Rowe is surely correct that James's reflection on the fencing of Harvard Yard contains the central meditation on the bestowal of "margins," James's own term for his principal aesthetic modus operandi: "The formal enclosing of Harvard Yard is comparable to his own activity of giving shape and dimension to the 'formless,' often chaotic world he encounters." This aesthetic closure protects the scene—of a cul-

tural repository—from corrupting exposure to the world of getting and spending, the ever-changing world beyond the gate. Relating the imposed order at Harvard to James's admonition at Independence Hall that one must "be ready, anywhere, everywhere, to read 'into' [the American scene] as much as he reads out," Rowe's elaboration on that counsel is crucial: "This interpenetration of man and his world transforms the social *product* into a cultural *expression*, the living record of a civilization."[1] The participant-observer creates an original, nonreproducible artifact through the critical consciousness he brings to bear on what are without this additional, but by no means superfluous, element merely the alienating products of alienated labor in industrialized America.

Where Rowe sees a single process at work in James's notes on Independence Hall and Harvard Yard, I find two distinct strategies of meaning production: one is dynamic and contingent, the other static and dehistoricizing. In the Philadelphia building whose very form has come to symbolize liberty, James moves freely; his narrative records what he "sees" of "architectural and scenic lines," what "facts struck [him]," what he "fancies" and "almost catches" (p. 291). Dependent upon the associations of a moment, the record opens the building. The fence at Harvard Yard, on the other hand, limits the possibility for other versions of sense-making by limiting the means of approach; it creates a "sovereign" place (p. 62). The fenced-off yard, often read as metaphorizing the artist's production of meaning, is, as a "drawing of the belt," equally a metaphor for the limitation of the field of meaning James achieved by deploying "establishe[d] values" (p. 62), both social and aesthetic, as a margin that mediated his experience of the United States. He used both modes of ordering the experience of space to shape his record of urban culture in *The American Scene*'s New York chapters.

James's often repeated desire was to see what America was making of itself, and he frequently looked to the forms, particularly the built forms, of Anglo-ethnic culture as an index of its achievement. James was not old enough to remember firsthand the old New York he described in *Washington Square* as "clustered about the Bat-

tery" with its upper boundary at Canal Street—that was 1820—or even the life of that square at the base of Fifth Avenue in 1835, which is described in that novel as "an ideal of quiet and genteel retirement."[2] Nevertheless, he knew the society of antebellum New York firsthand from that part of his youth spent in and around the square, where he was born in 1843 at 21 Washington Place.

The migration up Fifth Avenue was well underway by the time of James's 1883 visit to the United States, as some of the city's most socially prominent families commissioned new quarters. They and their architects were involved in a redefinition of American culture that, along with James's reaction to it, is my subject in Section II of this chapter. William B. Astor ("the landlord of New York") purchased the land for the Astor mansions on Fifth Avenue between 33rd and 34th Streets in 1827 and erected the first section of the Astor Library on its present site, Fifth Avenue and 42nd Street, in 1853. While Cornelius Vanderbilt may have lived contentedly at 10 Washington Square, his son William Henry arrived on 40th Street in 1867 on his way to a mansion on 51st Street designed and built between 1879 and 1882. Cornelius II took up residence in his George Post mansion (1879–82) between 57th and 58th Streets. William Kissam Vanderbilt was at home a few blocks away in his Richard Morris Hunt-designed chateau (1879–81) on 52nd Street; 25 years later, his son would move next door into a house done in McKim, Mead & White's most archaeologically correct François I style. With the opening of the Waldorf Hotel on the site of William Waldorf Astor's mansion in 1893, the Astors moved again. He relocated to a mansion on 56th Street designed by Clinton and Russell (1895), John Jacob IV to a Hunt creation (1891–95) on 66th Street.

As the elite moved northward, so did its cultural institutions. The Metropolitan Museum of Art was founded in 1869 and moved to its present site in 1880. The Metropolitan Opera, founded in 1854, moved from its 14th Street home at the old Academy of Music to a new building on Broadway near 40th Street in 1883. Columbia University abandoned its downtown campus for more spacious quarters at 49th Street between Madison and Park Avenues in 1857, but by the time of James's final return it was ensconced in

the McKim, Mead & White classicism of its Morningside Heights campus. Such, for the moment, was the built form of the city to which James returned.

Measuring America's cultural monuments against those of Europe, as James was wont to do, worked to the detriment of the United States when he treated American versions of European forms and institutions as derivative and unlikely to achieve distinction because of the rapidity of the changes in the nation's built landscape. To contrast American rawness with the landed stability of Europe, where culture was an inheritance, not something comparatively in the first stages of its production, he read into American architecture its political and economic contexts while allowing the patina of age to obscure the original ideological significance of Christopher Wren's majestic churches (to use one of his examples) in the context of monarchical and episcopal restoration after fundamentalist revolt.

Nevertheless, the result is often provocative, as when James read the skyscraper less as an emergent form of modern culture than as a metonymy for the extinction of aesthetic value in America's "vast crude democracy of trade" (p. 67), a loss he traced to the absence of the squire and the parson from the colonial past, where those preservers of "ancient graces" (p. 92) might have lent an element of difference to New England's "merely continuous and congruous" landscape (p. 24). Peter Buitenhuis suggests that we read the absence as *positive*, as enabling "American democracy" to have "chosen its own course with that freedom of action and movement that was one of the country's supreme characteristics," at least until the postbellum decades saw the end of provincial America and the rise of the businessman.[3] However, James's more condensed history of American social formlessness suggests that the successive versions, from Puritanism to transcendentalism to the more purely economic amorphousness of the trusts, need make no appeal to a "fall" or rupture. Each stage offered a vision of harmonious community brought about by aligning individual wills to the currents of a greater force, rather than what James valued—the creation of character by "friction and discipline on a large scale,"

the necessity of "having to reckon with a complexity of forces" (p. 427).

At other times, James turned his eye on the swarming diversity of city life. If he did not partake of the full experience of the Waldorf-Astoria's golden world, he found much he could appreciate. In his discussion of New York's immigrant population he was able to look beyond accomplished forms to observe the contending forces that were forming and re-forming the ghetto, Yiddish theaters, and Central Park, which become his complement to an Anglo-ethnic world of Fifth Avenue mansions, country clubs, and hotels. Among the immigrants, he saw a culture remaking itself by transforming the spaces it occupied and resisting the prods and lures toward homogenization. Forms and practices are, of course, never separable, as I may seem to suggest by this dichotomy: forms derive their meaning from historically specific practices, and changes in practice may transform those forms' established meanings, while the experiential becomes formal through representation. Still, these orientations toward the city offer us a point from which to begin our consideration of how James read and reconstructed New York as an urban text, and they will remain useful in subsequent chapters.

The implications of James's representational strategies are read differently in two important recent essays on *The American Scene*, and they result in vastly different interpretations of the constraints and freedoms of urban life. Mark Seltzer places James in a context of emergent professional discourses that formalized "a micropolitics of efficiency, normalization, and social engineering" intended to regulate all levels of society and to suppress individual deviations from prescribed behaviors. He concentrates on James's record of the disciplining of American society at three sites: the Waldorf-Astoria (two hotels designed by Henry Hardenbaugh and built in 1893 and 1897), which exists to "incite and even cultivate ideals and desires that, in a circular fashion, it is organized to gratify"; Philadelphia, where the boundary between prison and city, criminal and citizen, is always blurred; and Washington, D.C., "the City of Conversation" (p. 342) that seeks to talk itself into existence as a new social order. He contends that the Jamesian text does not

resist the logic of the new sciences of the social with its finely wrought, aestheticized response to American culture. Instead, *The American Scene* presents "an aesthetic duplication and formalizing of social practices of normalization" that directs its readers' desires toward the "something better" it produces (as many critics' responses testify).[4]

Ross Posnock opposes to Seltzer's James a James whose "sustained and sympathetic engagement . . . at once explores, accepts and critiques the 'ravage' of the American scene." While Posnock agrees that the self does not exist prior to socialization, he argues that self-making is more dialectical; he asks us to see it as an agon in which power acts as a provocation to the actions of free subjects. His James seems ready to grant the positive moment in consumption at the Waldorf because that activity "is inevitably entangled with human expressiveness, creativity, and happiness." Yet, rather than developing that potentially utopian moment in the Waldorf, as I shall, Posnock follows James to the ghetto (and, implicitly, to Central Park), where he found an alternative culture. Posnock finds James pursuing and even identifying with the examples of Otherness he discovers in the ghetto by renouncing his critical margin and celebrating the intensity and concentration of the individual Jew and the depth of Jewish community and culture as an antidote to Anglo-ethnic thinness.[5]

I find neither critic's argument wholly convincing or entirely off the mark. It is not just that each author concentrates on one-half of James's New York, the Anglo-ethnic or immigrant world. The claim that James was a tactician of discipline cannot be squared with his desire to preserve a realm of untrammeled privacy in an increasingly publicity-driven society. The social sciences, like the three previous guiding spirits of the American character I invoked earlier, create character without the sort of "friction and discipline" James valued. Their American would be another "human convenience," as James called the American woman, whose development had been stunted by her not having to face "a hundred of the 'European' complications and dangers" that develop character to fineness (pp. 347, 348). These disciplines cannot reproduce the

historic richness that James cherished in the Jewish ghetto and in the "old Germanic peace" (p. 204) of an immigrant-owned café he discovered in New York. That café's atmosphere offered James particular proof that the emerging social sciences will achieve nothing of lasting value because "it takes an endless amount of history to make even a little tradition, and an endless amount of tradition to make even a little taste, and an endless amount of taste . . . to make even a little tranquillity" (p. 169). On the other hand, while James welcomed many of the signs of difference he was able to discover in the urban landscape, he also wished to keep his distance, and to preserve margins among the immigrant groups and, especially, between them and the insatiable machinery of Americanization. He wanted to produce from the "aliens" an oppositional culture, but one with which he would not, finally, identify himself; rather, James would use the contrast between these two cultures to project a space for himself, the Europeanized American of an earlier time and a richer heritage.

The key to understanding the restless analyst's relation to New York, as to the nation generally, is an early observation about the built landscape of democratic America: "The open door . . . may make a magnificent place, but it makes poor places" (p. 62). This double-mindedness modulates every judgment in *The American Scene*. For, while it is true that James invoked " 'European' importances" (p. 136), "European discipline" (p. 97), and "English ancientries" (p. 24) as a measure of what the United States lacks, and that, as Jean-Christophe Agnew comments, he "was never loath to use the heritage of the Old World to touch the raw nerve of the New," James could be generous in his praise for such democratic institutions as libraries, museums, New York's City Hall, and even country clubs.[6] He confessed that he "distinctly 'liked' " such American monumental architecture as Grant's Tomb, John H. Duncan's homage to the tomb of Napoleon I along Riverside Drive at 122nd Street (1890–97), even while he mourned there "the absolute extinction of old sensibilities" (p. 146) and elsewhere bemoaned the lack of *"penetralia"* (p. 250) that a democratic program in architecture required.

To understand James's approach to, and evaluation of, New York, I want to read the two cities he constructed, the Anglo-ethnic and immigrant domains, as his representation of them engages a set of issues central to urbanist discourse at the turn of the century, issues that often overlap those Seltzer and Posnock explore. In the next section, I consider how the social construction of urban space represents and reinforces class, cultural, and gender hierarchies modeled on European norms while at the same time revising the significance of the European tradition for the present, but also how the activity within newer spaces like hotels and country clubs (particularly hotels, because they most fully broke away from such privileged values as the family, the family name, and the ethic of productive labor) facilitated a restructuring of those hierarchies at a time when the boundaries that separated "Society" from the rest of the citizenry were in flux. In the third section, I turn to James's treatment of immigrant groups and how they adapted to their needs the built forms amidst which they lived, in the course of which examination James tacitly engaged questions of ethnic pluralism, tenement reform, and the democratic aim of the parks movement. Here, we see him reject the idea that the darker-complected new immigrants would be unassimilable, and the logic of most antiethnic attitudes, particularly anti-Semitism, which countered evidence of the immigrants' economic success with an enumeration of differences between immigrant manners and Anglo-ethnic norms in order to "prove" the new arrivals' inherent inferiority.[7]

My argument will not make James an assimilationist, however. If in much of the United States he was caught between a desire to credit the democratic place and a dissatisfaction with the undistinguished forms the culture produced, when treating the immigrants in the Jewish ghetto, that German's café, and Central Park, his apparent pluralism supports an ultimately genteel critique of market-mad America, not a social and political alternative to assimilation and exploitation. American culture in *The American Scene* is tripartite, not binary: the still-embryonic but now-endangered genteel culture of James's youth, the market-centered world of the businessman-American, and the older, exotic heritage of the

immigrant. A paradoxical antiassimilationist, James insisted on the power of the margin—the homogeneous, genteel Boston and New York of his youth as well as the immigrants' cultural consciousnesses—as alternatives to America's "great grey wash." Yet, as we will see, his reasons for urging resistance to the "Bribe to Submission" (p. 237) that lured immigrants to assimilation, although aesthetic and cultural, not economic or racist, recontained the immigrants nevertheless. James's immigration policy ensured their continued social and economic disenfranchisement while creating for himself a provisional space in a new-made world.

II

The other dimension of the new city was vertical. James had left a city of low buildings to return with the skyscraper age well underway. The steam elevator was succeeded by the hydraulic elevator in 1878 and the electric elevator in 1899, and Bessemer steel-frame construction commenced in the United States with William Le Baron Jenney's Home Insurance Building of 1884. If in 1870 Post's Equitable Building (equipped with a steam-driven elevator) had been tall at 130 feet, five years later his Western Union Building rose to 230 feet, the same height as Hunt's Tribune Building, completed the same year. Post's Pulitzer Building of 1890 stood 26 stories high; within twenty years, Ernest Flagg had achieved 42 stories in his Singer Building and Napoleon Le Brun and Son brought their Metropolitan Life Insurance tower at Madison Square to 52 stories.

More problematic than height was the increased concentration of tall office buildings. From a city of spaced towers, New York was evolving into a city of infill skyscrapers that cast their shadows across the downtown streets. In the redundant stacking of floor upon floor in skyscrapers and the succession of buildings occupying a lot over a brief period, James read the moral that "one story is good only till another is told, and sky-scrapers are the last word of economic ingenuity only till another word be written. This shall be possibly a word of still uglier meaning, but the vocabulary of thrift at any price shows boundless resources" (p. 77). Nor was he

alone. The pace of development that Stern, Gilmartin, and Massengale label "frenetic" had led the *Real Estate Record and Guide* to warn of an "Invasion of New York City by Darkness," while Montgomery Schuyler, a leading architectural critic, warned of the detrimental aesthetic and public health effects of buildings that are no longer "head and shoulders above their fellows, but stand waist deep, knee deep, ankle deep" among them.[8] Nor did Schuyler want the buildings standing shoulder to shoulder.

The respites from development along New York's repetitive gridiron for which James pleaded, those "fortunate nook[s] and casual corner[s]" (p. 101) like Washington Square or Gramercy Park, were components of the City Beautiful plans offered near the time of his visit. Inspired by the success of the "White City" (the ensemble of classical architecture on the Court of Honor at Chicago's 1893 Columbian Exposition), and prompted at least in part by a sense that too much of the city was being privatized, these plans—one was being produced by the New York City Improvement Commission during his stay—would have created open space protected from commercial development, a firmer image of the physical city through the creation of districts, landmarks, and major arteries, and a sense of civic identity that could foster the notion of the city as a common possession. Given the failure of the City to execute a coherent development plan, it is tempting to follow James in taking the testimony of individual buildings and the city itself—the only direct speech recorded in *The American Scene*—at facade value. But the plans' defeat was a matter of more than money. In 1904, architecture and culture critic Herbert Croly contended that "the ugly actual cities of today make a livelier appeal to the imagination than does an ideal city, which in sacrificing its ugliness on the altar of civic art, sacrifices also its proper character and vitality."[9] For all its flaws, he suggested, the existing city, overcoded by history and contending programs, offers the inhabitant a superior symbolic richness and diversity of activity.

Despite the optimistic civicism that since the 1890s had found in New York's "diversities of race, of religion, of social, political, and personal ideals . . . a unity which the country has as yet failed to recognize, a genius which belongs to the future," James doubted

that the city or the nation could realize this promise.[10] He imag-
ined New York as an interminable series of unconnected construc-
tion projects that precluded the accretion of history. His descrip-
tions of buildings and the speeches he assigned them exploit the
surface confusion of their styles and formal allusions. The struggle
among the author, the buildings, and the aliens for the right to ar-
ticulate the "*il*legible" word (p. 121) of the American future and to
determine its accent is central to the New York chapters. The sky-
scrapers' (ar)rhythmic impact on the cityscape echoes the rhythm
of New York speech. They are "*the* feature that speaks loudest for
the economic idea. . . . If quiet interspaces, always half the archi-
tectural battle, exist no more in such a structural scheme than
quiet tones, blest breathing-spaces, occur, for the most part, in
New York conversation, so the reason is, demonstrably, that the
buildings can't afford them" (p. 95). At such points, the elements
of the cityscape threaten to become, as Wallace Stevens might
have said, "things exteriorized / Out of rigid realists."[11] There is a
danger that these singular performances will obscure the social
and political programs and resistances that will permit us a fuller
reading of James's New York. We must repopulate the buildings
he found "a record, in the last analysis, of individual loneliness"
(p. 159) and see them instead, as he also did, in the context of the
practices for which they provided a stage.

For many people of established wealth who shared James's anxiety
over the social flux, the architecture of their mansions served in
their attempt to steady the course of a culture they thought too
unstable. This sentiment influenced post-1890 New York architec-
ture, as the "eclectic freedom" of the "Cosmopolitan Era" gave way
to the "architectural rigor" of the "Composite Era." The postbel-
lum era of urban expansion had been marked architecturally by in-
dividual, monumental structures that borrowed from, and freely
interpreted, a wide range of historical styles. The Composite Era's
return to classicism reflected both an aesthetic revulsion at the
clash of styles resulting from individualistic monuments being
built closer together, and a social and political concern that New
York had lost its identity as a culturally homogenous city. While

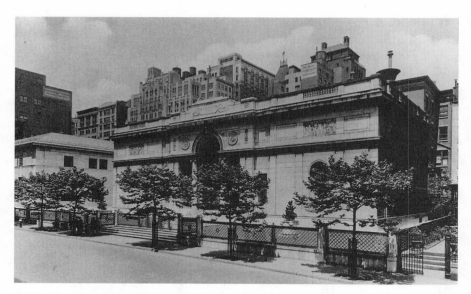

Figure 1. Scientific eclecticism: *J. P. Morgan Library* (1902–7).
McKim, Mead & White, architects. Photograph by H. L. Witteman.
Museum of the City of New York. Gift of Leonard Hassam Bogart.

James was, then, greatly correct in thinking the architecture he
viewed "reduced . . . for 'importance' . . . [to] the present" (p. 161),
its ideological burden reveals that architecture's "American Re-
naissance" did not utterly lack past and future. Architects reread
styles from the cultural past so that they might better construct a
future based on the "growing conception that America was the heir
to Western civilization." The Composite Era proclaimed this mes-
sage in two principal styles. "Scientific Eclecticism" aimed for
"more or less archaeologically correct reproductions of elements
and even entire compositions from the past, particularly from the
classical tradition" of imperial Rome (see Figure 1). The "Modern
French," a dialectic of classical elements and contemporary tech-
nology and taste (see Figure 2), originated during the French Second
Empire; the Paris Opera House (1862–74) is an influential exam-
ple. A more dynamic and decorative vocabulary, it was to its de-
tractors "something inflated and unrestrained," "the negation of

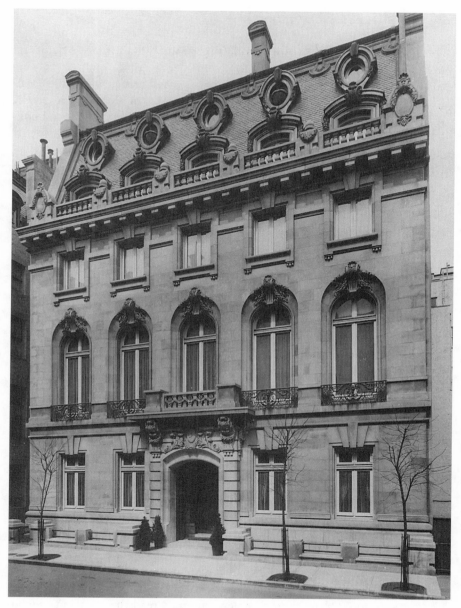

Figure 2. Modern French style: *Orme Wilson Residence* (1903–4).
Warren & Wetmore, architects. The Wurts Collection,
Museum of the City of New York.

repose"—that is, not a style that promoted an image of cultural stability.[12]

Each style was endorsed by patrons and critics who were as interested in the politics as in the aesthetics of architecture. In the May 1902 *Architectural Record*, Croly projected the cultural politics of aesthetic preferences:

> The millionaire is as little of a revolutionist in social as in political matters. . . . In intellectual, artistic and moral affairs he lives by tradition alone. . . . He does not try to cover up his sense of his own newness merely by vulgar ostentation. . . . But he does wish to emancipate his children and his fellow countrymen from the reproach of being raw and new; and consequently he tries in every way to bring to bear upon them historical and traditional influences.[13]

This passage reads better as instruction than as a description of common Gilded Age attitudes, for the nation had thrown off the yoke of European tradition early in its history, with the result that "cultured" Americans now found themselves without any past except what they could appropriate. But instead of aesthetic competition with Europe, appropriation of other architectural pasts signaled an Americanization of Europe, the Caribbean, and the Pacific (economically *and* militarily in the latter two regions) that repeated the process of plunder that accompanied Europe's earlier colonialism. Indeed, it may be argued of both European and American eclecticisms that the collection of signs of authority concealed a lack of authenticity at the culture's center.

The ideological messages carried by the mansions' facades were but one way those structures disseminated the Anglo-ethnic elite's cultural politics. Interiors aided in preserving the family as the basic social and moral fact in late-Victorian America. The interior-exterior dichotomy schematized the predominant sex-role distinctions: a male face to the world in which one reads a history of conquests and an expansionist future, and an interior where women oversaw the reproduction of moral values in the next generation. Or, following Veblen, one may read the mansions' elaborate exteriors as expressing the dynamic of vicarious consumption—the woman's economic role—while the interior was given

over to the performance of her domestic function, which, to James's dismay, was becoming increasingly public.[14]

Such institutions of the feminine in *The American Scene* supplement the American culture of commerce. Women are complexly necessary to, and separated from, that male world, as James observed in a telling image of American "men supplying, as it were, all the canvas, and the women all the embroidery" (p. 66). He designated the woman's realm "society," naming thereby "all the *other* so numerous relations with the world [besides business relations] . . . imputable to the civilized being" (p. 345). Chief among them is the "constitutive, creative talk" (p. 344) that embellishes the otherwise dull social canvas with the richer colorings and more intricate patterns of events that define cultured life. A rarefying response to reification, conversation turns physical possessions into aesthetic and spiritual ones, as it did for Emerson, who believed conversation the highest among "the fine arts— . . . the arts of women." He praised it as "the last flower of civilization and the best result which life has to offer us. . . . All we have, all we can, all we know, is brought into play, and as the reproduction, in finer form, of all our havings."[15] As a scene of instruction, conversation conveys rules of conduct through example (of which conversation is itself paramount), approval, and censure; as a collective endeavor it aims for consensus on the conventions governing correct interpretation of the perceptual and empirical world.

The sound of speech was for James an index of broader culture, since attention to tonic distinctions "implies . . . vigilance and . . . is the result of a very highly 'evolved' discipline." Writing on "The Speech and Manners of American Women" in 1906, he declared that "the interest of tone is the interest of manners, and the interest of manners is the interest of morals, and the interest of morals is the interest of civilization." Conversation thus becomes a force for preserving the entire structure of American culture from an onslaught of ignorant foreigners. Emerson had justified women's suffrage just over 50 years earlier by arguing that

if in your city the uneducated emigrant vote numbers thousands, . . . it is to be corrected by an educated and religious vote. . . . If the wants, the

passions, the vices, are allowed a full vote through the hands of a half-brutal intemperate population, I think it but fair that the virtues, the aspirations should be allowed a full vote, as an offset, through the purest part of the people [that is, women].

James, too, was uneasy with the threat the Southern and Eastern European immigrants posed to the predominantly Northern European America he remembered, and he believed that the woman's two-thirds of life—"all of the social" (p. 346)—contributed to the preservation of existing political, economic, and social arrangements. Although he came to see the necessity, even the desirability, of concessions to the aliens, he was not willing simply to abandon the field. In his commencement address to the all-female graduating class at Bryn Mawr, he exhorted them to become "models and missionaries, perhaps a little even martyrs of the good cause" of protecting the tone of American speech from the destructive forces of those "innumerable aliens [who] are sitting up (*they* don't sleep!) to work their will on their new [linguistic] inheritance and prove to us that they are without any finer feeling or more conservative instinct of consideration for it, . . . than they may have on the subject of so many yards of freely figured oilcloth . . . that they are preparing to lay down, for convenience, on the kitchen floor."[16]

Yet the defense of American values had effects on architecture that James strongly censured. Protesting the publication of privacy, he decried the de-sexing of the house by the suppression of those interior spaces he often called "penetralia." He emphasized the mansions' suitability for a panoptic function and assumed their unsuitability for women's arts because in their plan "we have the law fulfilled that every part of every house shall be, as nearly as may be, visible, visitable, penetrable, not only from every other part, but from as many parts of as many other houses as possible" (p. 167). Edith Wharton's Ellen Olenska feels the oppression of a house in which "one can't be alone for a minute" when she wishes a private interview with Newland Archer. "Is there nowhere in an American house where one may be by one's self?" she laments; "I always feel as if I were in the convent again—or on the stage."[17] James, too, felt thrust onstage as the nation's domestic "open door" policy under-

mined "the essence of the room-character . . . so indispensable . . . to the play of the social relation at any other pitch than the pitch of a shriek or a shout" (p. 167). James did not consider what is apparent in *The Age of Innocence*: how an architecture of openness might assist women in their social guardianship by providing a theater in which to stage the accepted familial and social roles of Victorian America. Omnipresent parents, to whom one must explain oneself, and children, before whom one must be careful what one does, curbed antisocial activity. Before this corps of voluntary spies, one was "serv[ed] . . . up, for convenient inspection, under a clear glass cover" (p. 167), even as the disoriented and paralyzed performer was unwillingly thrust among "apertures, corridors, staircases, yawning, expanding, ascending, descending" (p. 168) in all directions at once.

This publicizing of privacy somewhat paradoxically helped define a new exclusivity. The post–Civil War industrial boom had disqualified wealth as sufficient warrant for good breeding. Coupled with waves of immigrants bringing their own sets of cultural practices, the rapid creation of new fortunes produced as a backlash a desire to delineate an American character lacking the pioneer's mobility. The social evening at home, a quasi-public civilizing performance, celebrated both the acceptable models of American success and the proper code of social conduct. Adherence to the code allowed participants to display their cultivation and to distinguish themselves from the less-well-bred rich. These gatherings were also the occasion for the indoctrination of the next generation into the forms of good breeding.[18] An architecture of publicity enabled viewing of the spectacle and attempted to ensure against passionate or otherwise improper behavior that would jeopardize the striving for social stability and the respectability that James's novels remind us was more of a concern in the United States than in Europe.

If every word in the mansions was "said for the house" (p. 168), a day at the country club offered a larger audience, not a respite from social surveillance, because the programs were similar. James remarked that the "diffused vagueness of separation . . . between

hall and room, between one room and another, between the one you are in and the one you are not in, between place of passage and place of privacy," is a feature that the club "shares impartially with the luxurious 'home'" (p. 166). As the construction of the private home provided easy visual and aural access to others' actions, so, too, the spatial construction of the country club made it likely that one, or one's family, was at all times performing for others. Another institution of the family ideology in America, the country club moved the family more squarely into the public realm. Its center was a large "house of hospitality" (p. 328) among whose "great ver-andahs and conversation-rooms, . . . halls of refreshment, repose and exercise, . . . kitchens and . . . courts," one wandered as part of an "active Family" (p. 327) among others like one's own.

What James feared as the final result of an architecture of open doors was not so much a shift in morality as a loss of social distinc-tions along with the regularizing of behavior; indeed, he thought the Waldorf-Astoria lacked the "adventure in the florid sense" (p. 103) of its namesake, the frontier Astor. Ultimately, however, James balanced despair over the clubs' work as agents of publicity and leveling against a recognition that they were, *for the time*, comparatively collective institutions. The American country club reversed the British tradition of London clubs for countrymen in town on business, and it expanded membership to entire families.[19] Through much of his description, James pronounced the institu-tion a successful indigenous social form. He imagined it as a shin-ing suburb on a hill where the social differences that preoccupy the European mind were displaced by a democracy of manners and the commercial spirit was refined by the softening influence of femi-nine and finer distinctions the London clubs lacked. At such times, the club performed its ideological function as a quintessentially American institution: it read the family as a network of relations, not the history of a name, and it acknowledged the accomplish-ments of families that were alike in their "sublime and successful consistency" (p. 325). By this orientation it announced the end of European history, testifying that "the people [have] 'arrived' . . . *en masse*" (p. 327).

The country club was indeed American, although its democratic image was fraught with contradiction. Frederic Curtiss and John Heard explained in their inside history of the first country club, *The Country Club, 1882–1932,* that

the club . . . is the product of democracy, and at the same time it is a revolt against and a negation of democracy. It is a banding together for the purpose of making available to the group facilities which previously had been the privilege of the wealthy aristocrat. And, at almost the same hour, it is a denial of the spirit of democracy, since a small group sets itself apart from the majority, . . . making admission . . . more or less difficult according to the temper and social requirements of its members.

The authors remark that the proliferation of clubs was part of the dispersal of Society as it stood at midcentury into numerous soci-*eties* that "depend not on ancestry and the bond of 'belonging,' but on the congeniality of tastes, of personalities, and, above all, of occupations."[20] Yet, if clubs proclaimed the equality of "societies," James found that differences were reproduced by "nature and industry . . . as fast as constitutions keep proclaiming equality" (p. 326). *Industry* here signifies both the means of achieving social distinction by the father's diligence, a perpetuation of the work ethic that defined and separated the male sphere of action from the woman's domain of home and society, and the manufactories that produce markers of distinction. Thus, the spectacle of "the sovereign People . . . 'doing' themselves" (p. 327) existed to be consumed, and it could act as a spur to consumption despite the leveling of differences among members; it served a disciplinary function while it transgressed the old social margins.

If skyscrapers, mansions, and country clubs formed a stage on which the American "real" was acted as a cycle of work, home life, and mock-pastoral repose, the Waldorf-Astoria's architecture of consumption challenged that conventional representation of family life. It provided the image of a world of freedom-as-recreation in which individuals dallied amidst a seemingly endless store of exotic delights. It may seem traditional now, but in its time, the old Waldorf was at the center of a realignment in New York's social

life. The newly wealthy flocking to New York desired their own society and entertainments. Excluded from New York's older social circles and desirous of validation of their status, they turned to more public venues. At the same time, younger members of "the four hundred" (New York "Society" as it was defined by the capacity of Mrs. Astor's ballroom) broke with the restrictive form of the social evening in favor of the variety of entertainment available in larger, more public spaces. The new, highly conspicuous consumption conflicted with the dominant ethic of industriousness and the private entertainments of the previous generation, and it led to two modes of blurring class distinctions: a shift in the moral standard of conduct and an emulation of the public life of the wealthy by the middle class. Dinners out, theater evenings, and other nighttime entertainments split the family unit into parents and children, or husbands alone. To some blue bloods, such a life was too entirely public. Marianna Griswold van Rensselaer warned that "the easy-going pseudo-social life" and "profusion of public pleasures" conspired "in keeping many people contentedly adrift after they might have homes and begin to form genuine social ties." But others found welcome freedom in the new spots. In 1899, Robert Stewart marveled that young women at the Waldorf "wear a more or less conscious attitude of expecting you to ask them to dance. At home it would be shocking, but in frivolous New York they are here for a good time and mean to have it." [21]

This deformation of the old order was not fully discerned by James, and it is ignored by Seltzer, who subordinates James's diverse perceptions of the Waldorf to his final simile: "the likeness of an army of puppets" controlled by the Waldorf's presiding genius (p. 107). James's figure does resonate with Foucault's description of "a police that would manage to penetrate, to stimulate, to regulate, and to render almost automatic all the mechanisms of society," but it is not adequate to the multileveled relationship of patrons and management in the hotel. The model of panoptic surveillance Foucault described in *Discipline and Punish* is more coercive than any power deployed in the hotel. The panopticon "could be used as a machine to carry out experiments, to alter behaviour, to train or

correct individuals"; generalized to the economic sphere, it could intervene on the individual "to strengthen social forces—to increase production, to develop the economy, spread education, raise the level of morality." This deployment of power more closely approximates the dynamic of the social evening, or even the country club, both of which were more closely aligned with the older family-centered morality. What relation there was between the hotel and the expansion of economic and diplomatic power escaped James's view, although any description of that actually existing function would prominently include the adventures of J. P. Morgan, who, when he was not dining publicly "with a lot of gayish women," dined, gambled, and built trusts with Andrew Carnegie, Henry Clay Frick, Elbert H. Gary, John W. Gates, William Henry Moore, and Charles Schwab in the privacy of the Waldorf's Men's Cafe, which Gates is said to have rented for more than $20,000 a year. Other notables in such a story might include Philippe Bunau-Varilla, the French Panama Canal Company's chief engineer, who worked out of the hotel when he sold the American Congress on the Panamanian route on which his company had abandoned work, and Jutaro Komura, the chief Japanese negotiator of the Portsmouth, New Hampshire, Treaty that ended the Russo-Japanese War; Komura stopped at the hotel for the summer of 1905, when his government was formalizing its position.[22] Such florid offstage adventure doubtlessly supported the hotel's public activity, but at the hotel, as in *The American Scene* generally, James was more interested to see what America was making out of such raw materials. In the Waldorf, it was making a place for patrons to escape the demands of economic production and conventional social reproduction.

Following James's emphasis, the more interesting inquiry is the extent to which the hotel experience "not . . . merely gratifies [patrons' desires] . . . but . . . anticipates and plucks them forth" (p. 440). Seltzer moves toward this question in the final pages of his chapter on *The American Scene*, where he introduces the concept of the "*deployment of . . . desire.*" One might even speak of *incitements to desire* in order to explain how Peacock Alley quickly be-

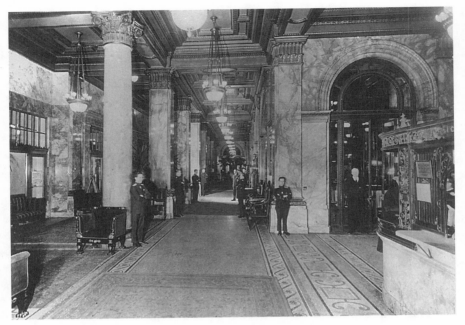

Figure 3. *Waldorf-Astoria Hotel, "Peacock Alley"* (1893–97). Henry Hardenbaugh, architect. Photograph by Wide World Photos, Inc. Museum of the City of New York.

came the spot to view the emerging society as seated onlookers consumed the spectacle of the finely dressed on their way to the Empire Room or one of the hotel's other ornate dining rooms or cafés (see Figure 3). And we should recall that if patrons were aided by innovations dreamt up by the "master-spirits of management" (p. 106), the ideal of leading a lavish and gregarious life was a blueprint drawn by consumers. For the newly wealthy, subjecting themselves to the scrutiny of onlookers was the means of affirming their newfound prominence, and one was nowhere more on display than on the "new Main Street in America." Diversely appointed rooms provided instant atmosphere for all sorts of events, including that most basic of Waldorf pastimes, lounging in an air of pub-

licity, but so central to the Waldorf experience was this corridor that "its floating population on an ordinary day might be twenty-five thousand" and increase to 36,000 when a famous person was in town, even in the Depression.[23]

This revision of the hotel experience in *The American Scene* is not an imposition on the text. Unlike Maxim Gorky, who visited New York ("the City of the Yellow Devil") a year after James and found only unrelieved suffering—even at Coney Island!—James himself seemed to be of at least two minds about what he saw. When focusing on the *expressions* to which the forms lend themselves, James confessed to experiencing "a single irresistible obsession":

the ache of envy of the spirit of a society which had found there, in its prodigious public setting, so exactly what it wanted. One was in presence, as never before, of a realized ideal and of that childlike rush of surrender to it and clutch at it which one was so repeatedly to recognize, in America, as the note of the supremely gregarious state. It made the whole vision unforgettable, and I am now carried back to it, I confess, in musing hours, as to one of my few glimpses of perfect human felicity. It had the admirable sign that it was, precisely, so comprehensively collective—that it made so vividly, in the old phrase, for the greatest happiness of the greatest number. (p. 104)

This confession undermines James's and Seltzer's attempts to resolve the ambiguities of the Waldorf's "gorgeous golden blur" (p. 105) by insisting on remembered visions of "master-spirits of management" pulling the strings of "an army of puppets." The hotel may not have offered the world of finely articulated differences and the European discipline in which he had long thrived, but he could not deny the happiness produced in this realm where difference is often no more than the play of styles and surfaces.

James's impressions of the moment suggest Rem Koolhaas's description of the Waldorf's aleatory, fantasy world. What he says of its second incarnation applies also to the original:

A Hotel *is* a plot—a cybernetic universe with its own laws generating random but fortuitous collisions between human beings who would never have met elsewhere. It offers a fertile cross-section through the population,

a richly textured interface between social castes, a field for the comedy of clashing manners, and a neutral background of routine operations to give every incident dramatic relief.

With the Waldorf the Hotel itself becomes such a movie, featuring the guests as stars and the personnel as a discrete coat-tailed chorus of extras.

By taking a room in the hotel, a guest buys his way into an ever-expanding script, acquiring the right to use all the decors and to exploit the prefabricated opportunities to interact with all the other "stars."

As Koolhaas suggests, one must know the hotel's interior to understand its attraction. James assessed it as a pastiche of, among other things, the "richest rococo," "Oriental opulence" (p. 106), and "pretended majesties" (p. 103) like the "recaptured actuality of an easy Versailles or an intimate Trianon" where one might "commun[e] . . . with the shade of Marie Antoinette" (p. 105) in a drawing-room Edward Hungerford described as "reproduced almost to the last detail from the apartments of the poor French queen at Versailles." The pervasive sense of empire tells us much about the final ideological charge of the Waldorf-world and its relation to the worldview conveyed by the mansions' exteriors; it, too, was a gathering of copies of cultural treasures and a celebration of America's imperial intentions. Decor was a major factor in this dynamic. To create a world in miniature, each public room was designed in a different period style and furnished with imported objects. "The cafe on Thirty-fourth Street was 'finished with English oak in the style of the German Renaissance, with Flemish decoration,' while the style of the dining room along Fifth Avenue was 'Italian Renaissance. The magnificent pilasters and columns are carved from marble from northern Russia.'" James Remington McCarthy noted that the Waldorf Gallery was "an exact replica of the Soubise ballroom in Paris, in the style of Louis XV." The 95-foot long, three-story high, 1,500-person-capacity ballroom "could be transformed almost instantly from a huge *place-de-danse* into a most comfortable and practicable theater, with more than eleven-hundred neat little gilt chairs." Moses King praised the Empire dining room, "modeled after the grand *salon* in King Ludwig's Palace at Munich, with frescoes, satin hangings, upholstery and marble pillars, all of pale green."[24] What better testi-

mony to the American's ability to remake a world for his better entertainment?

The Waldorf was thus in many ways the Disneyland of its day, a fantasy by which one marked the rest of the world as real, where a guest (even an onlooker) partook of, and participated in, a vision of what America could become. Indeed, the two venues are so similar ideologically that Louis Marin's catalogue of the fantasy-park's promise applies equally to the hotel: one might go to either for an experience of America as "comfort, power, welfare, consumption, scientific and technologic progress, superpower and morality." The list needs modification only to note that the Waldorf's "morality" was at a midpoint between the standards of New York's ancien régime, some of whom disdained the publicity of the Waldorf, and the even flashier, more indulgent life of Broadway's lobster palaces, which were a more celebrity-conscious version of the Waldorf-world. But, like Disneyland in Marin's analysis, the hotel was a "degenerate utopia": it resolved the conflicts and contradictions of American society "in the form of . . . a collective fantasy" of America as Prospero's island, a land of riches proffered by willing servants whose invisibility let one overlook the class stratification on which it was built.[25] Indeed, the hotel was an exemplary site of negotiations that were shaping American culture; the dissonance between the democratic performance and its aristocratic setting suggests the contest of American myths between the older republican ethos and postbellum imperial designs manifest in the nation's creation of foreign territories and economic spheres of influence, a policy crafted by John Hay and articulated in Theodore Roosevelt's Corollary to the Monroe Doctrine. The pastiche of styles itself suggests the negotiation of cultural differences underway at the time in the American "melting pot," a complement to the Americanization of Europe, to which I turn in the next section.

The Waldorf was no "social order in positively stable equilibrium" (p. 105). The collective fantasy of an unstable society, its balance, like Central Park's, is an effect of James's representational strategies. If the complex system of gazes constituting the spectacle reproduced the existing class structure, the fissuring of Soci-

ety and the greater democracy of access revised those demarcations. In the blurring of class boundaries and the multivectored desires to transcend the restrictions of the social hierarchy, one might even discern the outlines of what Fredric Jameson calls "the *figures* for the ultimate concrete collective life."[26] James hyperbolically rendered them in his notice that "in the United States every one is . . . practically in everything, whereas in Europe, mostly, it is only certain people who are in anything" (p. 103). Given the scene's contradictory dynamics, any choice between management and enjoyment, between insidious imperatives to adapt one's patterns of consumption to a new norm and the possibility of an ingenuous joy in picking one's way through social products that promise plenitude is fraught with uncertainty. We might instead, as Posnock suggests James did, recognize the positive (even utopian) moment in the intertwined activities of consumption and self-production.

III

Whatever James found likable at the hotel, he did critique the Waldorf for presenting a world of simulation rather than culture's real thing. He lamented that in its "halls and saloons . . . art and history, in masquerading dress, muffled almost to suffocation as in the gold brocade of their pretended majesties and their conciliatory graces, stood smirking . . . with the last cynicism of hypocrisy" (p. 103). This ersatz world is implicitly contrasted with the *echt* culture he discovered at the Metropolitan Museum of Art, the Library of Congress, and Harvard, three "thick-walled convents and quiet cloisters" (p. 353), dignified repositories of cultural productions, not *re*productions, that perpetuated an older truth and mode of production—in short, an alternative cultural power. To praise the cultural effort, James had to excuse what was pretended majesty on buildings of lesser cultural significance. Thus, at the Library of Congress he winked at Smithmeyer and Pelz's "riot of rare material and rich ornament" (p. 353), conceding to American cultural institutions the power, through "money alone," to "gather in

on such a scale the treasures of knowledge" and let them, the "books and documents, themselves organize and furnish their world" (p. 354). Yet James suggested that world was under siege from its inception, since he left ambiguous the form of "interest" produced by the "violent waving of the pecuniary wand" (p. 354).

Even if in its raw state the artworks on the walls of the Metropolitan Museum betrayed culture's dirty secret, James assured us that Richard Morris Hunt's classical temple of Art "was going to be great" (p. 193) when the works' aesthetic value was freed from the value determined by the less creditable arts of collection and they gained the aura of disinterested respectability enjoyed by European collections. Founded in 1869, the Metropolitan had become the common property of all New Yorkers only in 1891 when it was opened on Sundays, the only day that the working classes were able to go, and 12,000 people turned out on that first Sunday.[27] Yet it was common property of a curious sort. One finds in the museum's curatorial practice, which over the past few decades has provoked lawsuits from governments trying to reclaim their national treasures, the reproduction in the cultural sphere of the economic exploitation of foreign lands and immigrant laborers born in countries where the museum was actively collecting. That same exploited labor helped produce the surplus wealth that underwrote collection development. For the museum to become theirs as well, newly enfranchised aliens had to consume the old world in a new context, as part of an acculturation process in which they renounced their cultural heritage as they were reintroduced to it in an American cultural institution. Thus, even culture's real thing, against which James found the American reproductions wanting, was read out of its original context to signal the Americanization of Europe, not the Europeanizing of Americans.

The palace of Art is no less troubling than the palace of consumption. The museum is neither a foil to the Waldorf—the displacements of the "real" disallow that—nor simply a parable about the intertwining of various strands of cultural power. Its logic is reproduced, as I will show, in James's own curatorial view of immigrants. No xenophobe, he desired to preserve aliens, in all their

visually pleasing difference, from "ingurgitation" (p. 84) by the machinery of Americanization. But he was put off balance by the mobility of the aliens, who seemed out of context and troubled his view as they would not were they still European peasants with whom the American on tour delights to chat. James often treated them as objects of unadulterated, unchanging culture, his seeming pluralism at such points relaxing into a "soft focus" appreciation of exotic poverty. The evolution of his attitude toward aliens—from resentment to the mode of acceptance that is my subject—is traced by Buitenhuis, who locates a turning point in James's thinking after his tour of Ellis Island (pp. 84–86), where James saw first-hand the welcome awaiting the newly arrived labor force.[28] While this episode precedes generally sympathetic accounts of the Jewish ghetto and Central Park, I find in *The American Scene* no linear development in James's sympathies. His principal enlightenment did occur when he acknowledged the "truth" that "it is his American fate to share the sanctity of his American consciousness . . . with the inconceivable alien" (p. 85). Yet, the passage reads like an account of demonology: to face the alien presence is to see "a ghost in [one's] supposedly safe old house" and feel "a chill in [one's] heart" that "grow[s] and grow[s]" (p. 85).

Still, to be possessed by aliens is a better fate than awaits the American "haunt[ed]" by a "sense of dispossession"; for, unlike the friendly spirits of Mount Auburn, the "monstrous" aliens who are moving in insist loudly on pulling up the flooring and rearranging the furniture (p. 86). The dynamic of invasion and possession is staged in a "small crammed convivial [Yiddish] theater" (p. 205) in the Bowery. This encounter, James's closest brush with otherness in New York, raises questions about whether his concern over assimilation qualified him as one who unproblematically "valued non-identity, difference, and heterogeneity." When the margin between analyst and exotic disappeared, James found not the intrigue of the Other, but a "scent . . . not further to be followed" (p. 205). He fled. James's olfactory conceit is more than mere metaphor; it exposes his fear of being possessed by aliens. His reaction loosens the "intertwining of self and other" that Posnock detects in the

text, and it gives an unexpected twist to his alignment of James with Adorno, for whom "the organ of smell is crucial" because "When we see we remain what we are; but when we smell we are taken over by otherness."[29] Here, the analyst who cherished any faint traces of the alien found a figure too bold. However, the alien insinuated himself into James's consciousness nevertheless as James, among "foreigners, physiognomically branded as such" (p. 198), became preoccupied with protecting his own oversensitive nose.

This encounter in the theater is a paradigmatic dramatization of James's ambivalence toward the alien. Any positive reading of his protests against the fading of ethnic minorities in the American bleaching vat (which certainly deserve credit) will have to be balanced against his vigorous maintenance of margins both between himself and the "others" and among the various national groups, even in his comments on the strength of the Jewish community and his record of his "utopian" moment in Central Park. The final cost of cultural integrity in James's accounting is the preservation of that picturesque poverty on which he could look down from the tenement window.

To construct his parallel to the Anglo-ethnic grouping of mansions, country clubs and museums, and the Waldorf-Astoria, James outlined an alternative cultural economy of tenements, cafés and theaters, and Central Park, while suppressing the grittier side of downtown life. Bowery theater offered a range of relationships to the uptown stage. The Windsor's thin American melodramas provoked James's question of whether immigrants would fall to the local level of picturing reality, but Yiddish theater was a different matter. Performers often crossed between the latter stage and Broadway. On one level they traveled the path of "ingurgitation," but they also returned. The Broadway stage thereby undercut its Americanizing force by indirectly funding the alternative spaces in which the Jewish community saw its own culture presented—both onstage and in the audience. One must, then, question if the name "Windsor" for the theater full of immigrants "had the cosmopolite lack of point" James claimed for it. It may be, as a desire for return

required James to repress, that the "strange outland form[s]" (p. 196) occupying this Windsor castle had remade it to their own needs, enacting the dynamic of possession and dispossession that had overtaken the America of James's youth.

On Rutgers Street, James carefully sidestepped the tenement debate and tiptoed over the material conditions of tenement life by describing a single building "of conditions so little sordid, so highly 'evolved.'" Rather than darkness, stifling air, and the stench of waste found in many old-law tenements whose owners invested nothing in them, James remarked "the evolved fire-proof staircase" of one of the new tenements as "a thing of scientific surfaces, impenetrable to the microbe, and above all plated, against side friction, with white marble of a goodly grain" (p. 135). Indeed, there had been halting advances in tenement reform in New York. The "dumbbell tenements" that were built according to the winning design of an 1879 competition placed on each floor two apartments on either side of a central stairway and community toilets, like their predecessor, the "railroad tenement." Their principal improvement over the earlier tenement was a 28-inch indentation running the length of the three bedrooms, in theory bringing light and air to those rooms on each of the building's five or six stories; railroad tenements ran parallel for the length of the building. Three years later, the legislature passed a Tenement House Law that mandated certain health standards and prohibited certain activities (principally the manufacture of goods like cigars) in the apartments. But the building James visited had not become the norm after passage of the law or in the fifteen years since Jacob Riis's photojournalism had shown Americans *How the Other Half Lives*. The New York Supreme Court's ruling in *Jacobs* (1885) had nullified the Tenement House Law, finding the new regulations that had been written to promote public health in violation of the takings clauses of the Fifth and Fourteenth Amendments. A second law was not passed in New York until three years before James's visit, not nearly time enough to have redeemed the slums. For a sensitive emissary from the upper classes to find satisfactory "the simulta-

neous enjoyment [of the tenement] by five-and-twenty families" (p. 135), while similarly housed others scaled fire escapes as happily as "squirrels and monkeys" (p. 134) might be to pronounce the "disinfect[ion]" (p. 134) of the ghetto that was only beginning an instant success.

On other levels, however, James's record of his visit to Rutgers Street serves poorly as propaganda for the effort's corollary goals. It suggests that the material improvement of tenement conditions need not undermine the life of the community, even though, as Gwendolyn Wright shows, many tenement-rehabilitation organizations sought to replace the community as the primary social unit with the individual and the family by introducing into the ghetto some of the architecture of privacy that was disappearing uptown. Charles R. Henderson, a sociologist, had warned that "a communistic habitation forces the members of a family to conform insensibly to communistic modes of thought," while Commissioner of Labor Charles P. Neill declared that "home, above all things means privacy. . . . There must be . . . separate rooms, so that at an early period of life the idea of rights to property . . . may be instilled."[30] Thus boarders (often an economic necessity) were evicted from family dwellings and street life was curtailed by moving families into apartments exhibiting "room-character."

What James's description of the Lower East Side shows at its best is the necessity of reading residents' practices against the ideology that produced changes in the built environment. His record of a community's successful resistance to the reformers' ideology exemplifies Foucault's caution that, since "liberty is a *practice*," one should look to the *use* of the structures, rather than saying "that one thing is of the order of 'liberation' and another is of the order of 'oppression.'"[31] To portray monolithic power or practice beyond its reach may be useful polemically, but it can be misleading historically. As offensive as James's apparent bestialization of tenement dwellers is, the picture of a bustling and even recreational life on fire escapes that it attempts to convey is no fiction. The fire escape, like the stoop and the window ledge, is a margin between apart-

ment life and street life, an urban porch whose activities a new generation of inner-city artists like Martin Wong paint as celebrations of vital culture.

James indeed echoed common stereotypes when he referred to "the Hebrew conquest of New York" (p. 132), when he discussed the Jew's inscrutable motives (p. 135), and—worst—when he reduced Jews to slithering worms and snakes that, "cut into pieces, wriggle away contentedly" (p. 132). And yet, these figures lay the groundwork for a nonpejorative "New Jerusalem on earth" (p. 133) as they are remade into praise for the Jewish community. "Pushiness" becomes the "jostling" of one's "fellow pedestrians," who in the larger view of Rutgers Street are "individual throbs in the larger harmony" (p. 136). *Harmony* captures James's sense of the Jewish community working for general, not individual, gain while preserving its cultural heritage. In that quality he saw the particular strength of Rutgers Street: a firm sense of tradition protects the neighborhood against the encroachment of "sordid" elements more efficiently than would any police force. Reading tolerantly James's comments on the Jew as "savingly possessed"—as I believe they deserve to be read—one understands that the *non*economic possession of the individual Jew and the "unsurpassed strength of the race," which is the meaning James reads out of his serpentine comparison, are precisely what he counterposes to the past- and futureless America so evident to him in New York's skyscrapers and the immersion of cultural difference in the great gray wash. It is the American, *not the Jew*, who has a " 'businessman face' " (p. 64) and a head for figures. Yiddish culture survives, James implied, because each individual embodies a long and living tradition.

What James was approving ("embracing" transgresses a margin) was a culture that remained centered over time and in different places. Repeatedly in *The American Scene*, the image of hope is the person who is nonidentical with the American middle *and* solidly centered in another tradition he or she will not relinquish. Any disintegration of cultural margins disturbed James, not just its final step, as we see in his reaction to local color—laid on "with malice prepense" (p. 206)—at a Slavic restaurant whose owner cultivated

it to lure a Fifth Avenue crowd that sought something exotic yet safe. In part, James was reacting against the bad postmodernism (before its time) of this restaurant, which reduced ethnicity to a consumable signifier. But he was again unnerved by the mating of "American" and "European" identities that spawned "the fluent East-Side New Yorkese" in which the boss articulated his philosophy and future plans to become an ethnic master spirit of management (p. 207).

The implications of his attitude in this passage are indeed more disciplinary than liberatory. They defend not the right but the *necessity* to maintain cultural separation. The gain, for James, of pockets of pleasing "modesty" in a city of ethnically pure neighborhoods (to recall one of Jimmy Carter's less fortunate ideas) is offset by the exclusion of immigrant entrepreneurs from these hybrid enterprises and from the American business community generally. James did not predict the outcome of the clash of cultures. He did, however, leave massed around Rutgers Street the forces that he believed would determine it. Two are rendered metonymically through their built forms: the "'district' public garden" (p. 134) was well integrated into the community, which it served as a refuge where people met in a more relaxing environment. The "great overtowering [Seward Park High] School" (p. 134) is a more ambiguous presence. Education offered the mechanic bribe of "Yankee machinery" that would bring economic well-being along with cultural literacy—the gospel of Americanization that would threaten the community's cohesiveness by deflecting interest from collective life to the privacy of the family and individual life, unless it were to produce in reaction some "intellectual resistance, a vague stir . . . of some unwitting heritage" that might withstand "the effort to corrupt" these youth (p. 199). The third force is the most interesting and uncharacteristic for James. The "icy breath of Trusts and the weight of the new remorseless monopolies" (p. 136) sounds the economic note that he earlier disqualified himself from recording. The effects of the trusts are considered in the next chapter; James limited his consideration to only one dimension of their effects: the overwhelming of individual industry and the consign-

ment of "the small fry of future generations" to poverty (p. 137). Still, it is a remarkable move that implies much more than it states. James here subverted the anti-Semite's contention that a conspiracy of Jews dominates finance by pointing his finger at a homegrown economic institution. The trust is described as an almost transcendent economic and cultural force, beyond any "madnesses of ancient personal power," that threatens "the living unit's property in himself" (p. 137). In this capacity the trust threatens Jews far more than Anglo-ethnic Americans, for Jews are more possessed of themselves. Indeed, the "personality" of the trust, in which the individual is a mere cipher, not even an agent, may, as I have suggested, be read as a logical stage in the development of an American self that is, as James saw it, increasingly a formless market function.

James found evidence of the authentic cultural alternative he sought in that café owned by a German who maintained an interior distance from the surrounding society by refusing "to learn the current American" (p. 204). The German is an ethnic middle ground, a Northern European, likely a Protestant, and part of a group established in America for decades. His establishment opposed everything the Waldorf cultivated; the atmosphere was "particularly pure and particularly simple" (p. 203), created by "unbuyable instinct" (p. 204), not, as at the Waldorf, the Library of Congress, or the Metropolitan Museum of Art, by the American shortcut of lavish expense. *Instinct*, out of the racial and genetic heritage, is by James's logic precisely what Americans can never have, for the American is either no race or all races; to him, the two are the same. This café both subverted the proliferation of *re*productions in the architecture and design of the city's mansions and pleasure sites through a "felicity of suppression and omission" (p. 204) and deconstructed—as James realized—the opposition of European privacy and American publicity by "making publicity itself delicate" and reconstructing Europe in America (p. 203). The quiet café succeeded by being so exactly what it was, and so adequate a representation of its owner's *person*, not his aspirations. James's response is

our best authority for revising Posnock's notion of James's decentered stance. While preserving his analysis of James's insight into the social production of the self, we must add that only a preference for a self that knows itself and wishes to maintain its integrity can explain James's admiration for the Jew and this German café owner.

The principal marginal-culture response to the Waldorf-Astoria is not, however, the privacy of the café or the image of one of those restaurants that "flash back the likeness of Venetian palaces flaring with the old carnival" (p. 208). *The American Scene*'s utopian vision of New York is set within the stone and arbor boundary of Olmsted and Vaux's Central Park. An extremely complex space, the park stands in contradiction to the rest of Manhattan, at once central to and beyond the grid. A belated response to the privatization of land, speculative development, overcrowding, and repeated cholera outbreaks, Central Park was a concession to reformers who believed that open space was essential to the physical and psychological health of those citizens who could not afford to leave the city.

The park is feminine, according to the logic of gender in *The American Scene*. It brings relief from the unrelenting sameness of city blocks whose regular intersections weave the canvas of the male realm, to return to James's metaphor; the winding paths and greens that bring soothing respites and communal spaces are the embroidery of the urban grid. A public space, Central Park nevertheless permits familial privacy, and it "offers its guests," as Lynn Wardley notes, "a theater of interiority." James further insisted on the park's femininity by comparing it, burdened by so many demands, to an actress forced to play a wide range of parts on successive nights—and he praised the performance, despite Leon Edel's assertion to the contrary.[32] The park even upsets the dominant sexual economy because it makes the female central; the city that grew around Central Park frames *it*. Neither geographically peripheral, as the countryside was, nor a supplement functioning legally or by custom as an amenity for a particular class, as earlier

parks had been, Central Park became, as Olmsted intended, a center stage on which to enact a transclass, multicultural urban democracy.

Discovering the value James found in Central Park has been complicated by recent readings of the park's ideological genealogy and function. Ross L. Miller reads the parks movement as an off-shoot of transcendentalism; his focus on abstract utopianism and political quietism threatens to reduce Olmsted's parks to imaginary gardens with real sheep in them. M. Christine Boyer and Alan Trachtenberg interpret the park as a disciplinary mechanism "designed," Boyer writes, "to impose civilized values and order onto the American city. The realities of urban life . . . were displaced through images of a rural order infused across the fabric of the city, the fears of social unrest dispelled by the calming presence of open vistas and pastoral promenades." Such readings reduce the park's complex function to a single intention instead of considering the amazing diversity of practices the park has supported and continues to support. The disciplinary argument is trivially true, for to say that administration involves the exercise of power is to say that it is involved in a system of social relations. If, as Foucault reminds us, power "is a mode of action which . . . acts upon [the] actions" of free subjects, power relations are integral to social life; they "are rooted deep in the social nexus. . . . [T]o live in society is to live in such a way that action upon other actions is possible—and in fact ongoing." The question is not if the park has a discernible disciplinary aspect; the attempt to deny one would be the utopian folly. Instead of fixating on regulation, one should follow Foucault's instruction to understand power as a provocation that opens up "a whole field of responses, reactions, results, and possible inventions" and consider what the pressures and counterpressures of restraint and freedom produced.[33]

Undeniably, Olmsted hoped the park would promote a sense of community embracing a diverse people living in both crowded poverty and the city's exclusive neighborhoods. His intention was to further the democratization of public space. His writings make clear that he did not wish visitors to feel superintended in their

conduct; nor is it clear that he wanted to replace foreign manners with the gentility of tea tables, as Trachtenberg insists. When Olmsted juxtaposed the life of curbstones and dramshops to tea-table society in a now-infamous passage, it was not simply to draw an invidious contrast showing why working-class culture had to be eradicated. Olmsted's comparison is not free of judgments that reflect his class and background, but he saw beyond them to argue that both groups manifest "the influence of the *same* impulse" to fraternal intercourse, and he made the not surprising connection between urban poverty and alienation.[34] In the 1850s, some, notably the *New York Herald*'s editors, thought it foolish and even dangerous to suggest that ethnics and the immigrant lower classes could use the park before they had been socialized. Had Olmsted capitulated, he would have accepted the declarations of democracy's limited field and the lack of communal feelings among the urban poor and temporarily arrested parks' evolution from royal enclosures to public spaces. Fortunately for all New Yorkers, he rejected the arguments of the sterner disciplinarians and went ahead with a plan that saved a large urban space from privatization.

James's record of Central Park at least partly attests to the viability of Olmsted's plan. It repeatedly returns to the diverse population as a particular attraction as it notes the "polyglot" voices, the "number of languages" and "variety of accents" spoken, and the ability to make a tour of the globe (p. 177) within the park's brief compass. The implicit contrast is with the Waldorf-Astoria, where cultural diversity was an *effect* of representation. James's Central Park presents, as Olmsted hoped it would, a more broadly democratic spectacle of "common" people "enjoying . . . their rise in the social scale, with . . . that serenity of assurance, which marks . . . the school-boy or the school-girl who is accustomed, and who always quite expects, to 'move up'" (p. 179). The scene depicts *activity*, not tranquilization: a swell of divers voices and "children . . . frisking about over the greenswards, grouping together in the vistas" (p. 179). In that picture one comprehends the "disciplinary" logic behind limiting sports to certain areas of the park: it created a large common safe for such frolics. These people

on the grass may be read as participating in what Trachtenberg calls "a noncoercive means of control," but the term need not describe a technique of discipline that imposes the mores of genteel culture. *Noncoercive control* describes as well a collective sentiment that the park is worth preserving, as Francesco Dal Co suggests by noting that parks function as "a means of social levelling and of educating the populace in their collective responsibility for well-being."[35] To be sure, collective responsibility imposes a discipline (except in utopian imaginings), but this sort of discipline recovers for the term some of the positive connotations it used to have. Olmsted reiterated throughout his writings his desire for such a response, and as Dal Co's observation suggests, fostering that consciousness is essential to the survival of urbanity. Whether the park would help to revive an egalitarian ideology or end up as a placating gesture on the part of those in power was out of Olmsted's hands. The reformer's choice is to risk failure in the attempt to improve the material condition of urban life or to refrain from acting. New York (or any city) without parks is a grim prospect; whom that situation would benefit I cannot conceive.

An elaboration of the alternative I am offering to Trachtenberg's reading of Olmsted's "Benthamite" mechanism is found in James's description of the park as a theater in which James is the principal spectator, but others are "practically . . . spectators" (p. 177). The interpellative force that the scene constructs for those viewers bears no charge upon them to shift their patterns of consumption or realign their desires to an "American" norm. Rather, in the diversity of language and activity the participant-observers take their places in a nonidentical, heterogeneous, multicultural whole. Confronting this polyglot scene James was able, for the moment, to put his anxieties about "the 'social question'" behind him (p. 177). His reasons, left unstated, seem to revolve around the rich diversity of scenery, activity, accents, costumes, and practices that attested to the preservation of alternative cultures despite educational and economic bribes to Americanization. They rest in part on his acceptance here of the spectacle of "remarkably clad and shod" children (p. 179) without questioning how indicative the lack of "sor-

didness" (p. 178) was for the city as a whole, and in part on his not considering too closely the economic relation of the people in the park to the mansions east of it, which stood empty for the summer, their owners having retreated to the country. Thus, the utopian quality of the park—*James's* fiction, not Olmsted's—depends for its full effect on the spectator making absolute the stone and arbor boundary that sets the park apart from the city. If one accepts the bounding of the park more willingly than the fencing of Harvard Yard, it is because the park is a functional democratic space, a space of activity that images a better future.

The more important framing of the scene from the standpoint of James's narrative is a conceptual frame he imposed that rein-scribes Central Park's urban pastoral in an essentially aristocratic, European context. To discover how it works, one need only con-trast James's regard for the aliens at play with the distress produced by his encounter with the Italian trench diggers of Deal. In New Jersey,

What lapsed, on the spot, was the element of communication with the workers, . . . that element which, in a European country, would have oper-ated, from side to side, as the play of mutual recognition, founded on old familiarities and heredities. . . . [Here, i]t was as if contact were out of the question. . . . This impression was for one of the party a shock. . . . Had [the exchange with any encountered type] not ever been, exactly, a part of the vague warmth, the intrinsic color, of any honest man's rural walk in his England or his Italy, his Germany or his France? (pp. 118–19)

As James walked through the park, the summer warmth and col-orful costumes were supplemented by a transferred warmth and color that transformed New York into a *European* space. Here, as in that German's café, the best American place is the least Ameri-can place. James's ability in Central Park to imagine that he was looking out upon the once stable world of European manners and classes answered his social question in two ways: his waving of the authorial wand created a world that contested the dominance of money as manners, and, adding a final twist to the dizzying play of aliens and alienation, effected his repatriation by producing an im-age of a foreign culture in which he felt at home. The display of

European peasants in their purity was transformed by his gaze into, if not exactly a Central Park zoo, a safari park in which the peripatetic analyst observed a variety of human "species" at play. Only this double preservation of Anglo-ethnic culture and its Other from each other captures James's sentiments toward, and use of, the aliens. What seemed an active engagement is another margin like the ones that prevented him from fully partaking of the Waldorf and raised him above the Rutgers Street "flood." In the park, the analyst finally interacts with a fiction of his own creation; he turns practice into form, categorizing and reconstructing the scene as a closed system viewed from outside.

James's desire for a recaptured European past stands in for any last answer about the future of American culture. His commentary on the pervasiveness of the economic motive is often insightful, even as it conceals his implication in economic dealings: his ability as a literary stud to earn his keep by performing his "horrid act" for " 'private' 'literary' or Ladies' Clubs," and his desire to produce for Harper and Brothers "the Best" piece of travel writing "ever devoted to any country at all."[36] There is thus more than a little of Spencer Brydon (the protagonist of "The Jolly Corner") in our restless analyst, although he did not have to confront the specter of the man of affairs he might have become had he, like Brydon, not had the means to pursue his predestined career; nor would he consider how that freedom shaped his cultural criticism.

James was at his best as an analyst when he could take the long view of American culture, rather than limit himself to the effect of local social and economic forces on the built landscape. Indeed, what James said of the American scene is equally true of himself as a tourist: both are "at [their] best . . . when most open to . . . friendly penetration" (p. 291). At Independence Hall the distinguished building fully engaged his "historical imagination" (p. 291). At Mount Auburn Cemetery he conversed with the "ghosts" of Boston's literary past (p. 68), while Concord became a textually mediated, synchronous landscape in which the Concord fight and

"the 'transcendental' company" (p. 258) vied for attention and "not a russet leaf fell . . . , but fell with an Emersonian drop" (p. 265).

The New York chapters react to the pace of urbanization and industrialization, and to the work of advertising and the social sciences in producing the real—in sum, to the dislocations of modernity. James experienced them most personally as the loss of the houses where he was born and experienced his "earliest fond confidence in a 'literary career'" (p. 229), and the threat to his patrimony—the house of American fiction and its linguistic foundation. He had noted its frailty in his *Hawthorne* and literalized the metaphor in remarks on the House of the Seven Gables, which suffered the neglect of Salem's "flagrant foreigner[s]" (p. 265); he inveighed against the deformation of the language of his literary fathers in the ghetto's "torture-rooms of the living idiom" (p. 139) in both *The American Scene* and his address at Bryn Mawr. Yet his perspective is suspect. His preference for Europe's longer tradition required the very forgetting of history that he rightly did not allow himself when regarding the American scene. Or, if it is the vicissitudes of history that effaced the mechanisms of domination and allowed James to see the majesty of Christopher Wren's churches outside their historical context, he denied the possibility of a similar historical development to the States. Thus it was an axiom for James no less than for American magazines that "when you haven't what you like, you must perforce like, and above all misrepresent, what you have" (p. 457). What he had was a cultural archive that, to make his point, he reduced to a world in stable equilibrium, a set of touchstones against which to measure America. His "misrepresentation" was that the forms were only aesthetic, a condition the products of American culture were too new to claim.

Reading the dialectic of culture and domination as it played across the Manhattan skyline, James produced a useful caution against the reduction of all value to cash value and the transmutation of aesthetic power into imperial power. But as a defense of European cultural self-possession, *The American Scene* was not prescient. The First World War was less than a decade away when he

returned to Lamb House; James died fearing its effects on English culture. Ten years after his return, another American expatriate would settle in England, but in *The Waste Land* T. S. Eliot criticized England for the very failings James found in America, including the historical amnesia in which James's text is complicit.

Anxious at his encounter with the future of the West, James let his thoughts run simultaneously toward aesthetics and extinction. That combination is most apparent in his speculations on language, particularly his assertion that "the accent of the very ultimate future, in the States, may be destined to become the most beautiful on the globe . . . ; but whatever we shall know it for, certainly, we shall not know it for English—in any sense for which there is an existing literary measure" (p. 139). This moment is a confession of imagination's failure. (What would he make of the wonderful, multicultural, multilingual experience of London's Hyde Park or Regent's Park today?) James's admission should provoke the reader to an ironic understanding of his final response to the Pullman that invited him to see what America was making. James saw only what it was "*not* making," not because it was creating "arrears" (p. 463), but because the new word, the new language, remained "*il*legible" to him. It had to, because "America" threatened the structures of difference through which he produced, and in *The American Scene* preserved, himself: the clarity of aesthetic meaning was undermined by pastiche and displacement, while the stability of racial and social classifications was undermined by the logic of assimilation and the lack of ancient institutions. In response to the polyphony of accents on the East Side and the degraded commercial language—"the still uglier word[s]" of the skyscrapers—James produced a narrative in the familiar accents of his idiosyncratic late style, embellished with personal memories, to supply the margin that would preserve his finely formed consciousness from "ingurgitation."

As for the social changes underway, James could not finally reconcile himself to the manifest fact that the people "*liked* the crowding, the hubbub, the noise, the rush, the money, the glitter. . . . James, emotionally identifying himself with the aristoc-

racy of the past with all its traditions and disciplines, felt bewildered and left out."[37] In those words, Louis Auchincloss sums up the failure of *The American Scene*. Unlike the churches of Wren and the art of Venice, this text was never new. James's record is traversed by nostalgia, literally, the pain of a return home. His criticism of American provisionality is often on the mark, but by imagining culture as something already constructed, he missed the activities of its remaking that were spread across the American scene. That task fell to Theodore Dreiser, an author a generation younger, who lacked James's heightened sensibility. Drawn to Chicago's and New York's bright lights and the diversity of its life, he offered in his novel *Sister Carrie* a more sympathetic view of urban institutions and entertainments, and expressed optimism about the ability of the emerging urban discourses to produce improvements in the often miserable conditions of urban existence that were also his subject.

"Markets of Delight"

'Sister Carrie' and the
Romance of Metropolitan Life

> [Commerce] must be allowed to flow in its accustomed channels, wholly unvexed and unobstructed by anything that would restrain its ordinary movement. —John Marshall Harlan, dissent in
> *Standard Oil Co. et al. v. U.S.* (1911)

> Women . . . represent a natural value and a social value. Their "development" lies in the passage from one to the other. But this passage never takes place simply.
> —Luce Irigaray, "Women on the Market"

I

Of all the Americans he saw on his journey, Henry James was most preoccupied with the American woman because of her social function, which he discussed in *The American Scene* and several lectures and essays given and published during his American sojourn. She was less the preserver of social distinctions than she was to be their producer. Exactly how James understood the process of manufacturing the American "woman-appliance" is uncertain, but the matter had been addressed four years prior to his visit from quite a different perspective by Theodore Dreiser.[1] His novel *Sister Carrie* tells what happens when a girl with vague dreams of success comes to a city that thrives on new arrivals.

The very surfaces of urban life whose transience James lamented were Dreiser's raw material. He recorded names, dates, and places

as a mark of his novel's authenticity. Chicago's and New York's nightlife are described sympathetically and in detail, with the result that one can chart the characters' fortunes by the locations of their residences and the restaurants they frequent. As if anticipating James's reservations about the Waldorf-Astoria, Dreiser commented on the new sites of public recreation that were revising the moral standard of the age: "To one not inclined to drink, and gifted with a more serious turn of mind," he wrote, "such a bubbling, chattering, glittering chamber [as a posh "resort"] must seem an anomaly, a strange commentary on nature and life" (p. 38). However, he distanced himself from the conclusions of that consciousness and speculated that "one might take it, after all, as an augur of the better social order" (p. 38). If that assessment is not an unequivocal endorsement of self-production through public acts of consumption, his observation, "That such a scene might stir the less expensively dressed to emulate the more expensively dressed could scarcely be laid at the door of anything save the false ambition of the minds of those so affected" (p. 38), suggests the extent to which he viewed such behaviors as a benign undoing of the old moral order and its class distinctions in the new metropolis.

The combination of desire and the better life that the resort represents, the promise of the Waldorf-Astoria but in a still more democratic space, is Dreiser's subject in *Sister Carrie*, a novel that uses the atmospherics of realism and the rhetoric of contemporary social and economic theory to represent the utopian possibilities of turn-of-the-century urban life. My interest in this chapter is to show how Dreiser fashioned his novel as a seductive advertisement for these emergent economic and social relationships by using discourses of a seeming realism to construct for the reader a vision of a "better order," one in which the heroine's desires are effortlessly fulfilled as she rises with the tide of economic and social development.

My reading of how Broadway personality Carrie Madenda is produced from the young, innocent Carrie Meeber who left Columbia City for Chicago on an August day in 1889 (p. 1) begins with these theories of economic and social conditions and their relation to the

structure of the novel. It therefore owes a debt to recent historicist readings of *Sister Carrie* that challenge earlier readings of Dreiser's realism as constituting a strongly critical response to what Walter Benn Michaels calls the "economy of excess" that structured both the sentimental novels contemporary with it and the financial speculation that drove the American economy in the decades after the Civil War.[2]

The pace of that urban and industrial development was most vivid in the Chicago to which Carrie comes. *The Real Estate Record and Guide* for April 9, 1898, may have found it "doubtful" that the pace of "change has been quite so rapid in any other of the major centers of population as in New York City," but New York had experienced nothing like the rebirth of Chicago after the fire of October 8–10, 1871. The roughly 18,000 buildings destroyed within a 3.5-square-mile area of Chicago represented more than one-third of the city's assessed value—$192 million out of a total valuation of $575 million; their ruin left 100,000 Chicagoans homeless.[3] Throughout the rest of the decade, the city was a vast construction project; an average of 1,275 buildings were put up each year, with 1882 setting a record of 3,113.

The fire gave Chicago an unprecedented, if unwanted, opportunity to apply new construction techniques to its central business district. Chicago was in these years the home of some of the greatest of the first-generation skyscraper architects. Members of the Chicago school developed a distinctive style for the tall building: minimally ornamented, steel-frame constructions that made ample use of the large plate-glass windows that in Chicago's great department stores would become Carrie Meeber's gateway to a world of undreamed riches. In the final two decades of the century, Chicago's four principal architectural firms (Adler and Sullivan, before Sullivan struck out on his own in 1893; Burnham and Root, which became D. H. Burnham & Co. after John Root's death in 1891; Holabird & Roche; and William Le Baron Jenney) would design and construct more than 30 office and retail structures at least ten stories tall, and several more apartment and hotel blocks. In those decades Chicago grew outward as well as upward. From a population

just under 300,000 in 1870, the city grew to over a million in 1890 and added another 700,000 by the turn of the century. Land values within the Loop increased sevenfold, from $130,000 an acre in 1870 to $900,000 in 1890. The total area within the city limits increased fivefold in those twenty years, from just over 35 square miles to 178 square miles. Much of that growth occurred in just one day, June 30, 1889, when Chicago absorbed its suburbs of Hyde Park, Lake View, and Jefferson, as well as part of Cicero, instantly adding 250,000 citizens and 130 square miles of land.

Within that area, men were busy surfacing 600 miles of streets and 2,200 miles of sidewalks, installing gas lighting, and laying hundreds of miles of sewer and water mains. Meanwhile, the streetcar lines, electrified in 1889, were extended farther out of the city to serve a growing population for whom fear of congestion and another fire, and the offer of low-priced commuter tickets, made the outlying areas a desirable and affordable alternative to the city.[4] Chicago, as much as New York, was on the leading edge of a rapidly expanding urban industrial society in the United States, one characterized by the speculative activity that led to the creation of great personal fortunes as well as to great suffering as a result of the periodic collapses of an unstable, often overheated economy.

Dreiser vividly captured the age of the speculator in *The Financier*, the first book of his trilogy based on the life of Charles T. Yerkes, who by 1893 owned most of the 500 miles of streetcar tracks in and around Chicago, and had sold the land along the routes he planned to build. The logic of speculation has been read into *Sister Carrie* by Michaels and two other recent critics, Philip Fisher and Amy Kaplan. Each believes Carrie's rise to metropolitan success is attributable to her ability to speculate with her self. As part of a sweeping rereading of what he denominates "the logic of naturalism," Michaels discovers a principle of internal difference that destabilizes a self constructed on desire, speculative capitalism, the representation of value, and representation generally. He argues that Carrie engages in a form of self-speculation that deconstructs the myth of the bourgeois self's inherent character, which older realists like William Dean Howells had offered as the unvary-

ing measure of one's value. Fisher and Kaplan both concur with key points of Michaels's argument. Fisher describes Carrie's "anticipatory self," in whose inner world "the psychological notion of down payments, installment credit and commodity speculations is . . . entirely in place." Kaplan finds Carrie "sell[ing] her self in a repetitive gesture that constructs the self."[5] Interestingly, all three readings of Carrie thus seek to preserve some version of autonomy as they deconstruct her.

My understanding of what Dreiser's particular construction of economics on a principle of diffuse, undifferentiated desire entails for *Sister Carrie*'s relation to the capitalism of the time differs markedly from these conclusions. Despite the power and allure of Michaels's presentation of the heretofore undiscovered cultural logic of the period, I find myself wanting to demur. For one thing, his logic of internal difference threatens to become an ontological principle rather than an effect of specific historical forces. On the other hand, his historical focus is not as sharp as it at first seems. In his pursuit of an all-informing logic of capitalism he fails to heed other social and economic discourses that, I believe, give a better picture of the forces shaping the industrial economy and urban society of the years *Sister Carrie* spans. Instead of attending to discourses that were newly underway, he reads forward the logic of speculation to a period in which, economic historians have argued, it was losing force.

One of those newer forces that I want to consider, Progressive social science, sought to rationalize economic and social relations, to create a more equitable prosperity, and to contain the power of men like Yerkes; indeed, he was forced to relinquish his control over the streetcar system by the turn of the century. Reading Dreiser's descriptions of self- and society-making alongside contemporary work in the social sciences, I will concentrate on the considerable common ground in their rhetorics and their conceptualizations of urban industrial society. For motivating Dreiser's art and the discourse of Progressive social science was the question of how to conceive of the individual in a society whose units already were increasingly being recognized as interdependent, as

well as the challenge of Herbert Spencer's pathbreaking application of Darwinian principles to the study of social relations. Remarking in *Sister Carrie* the engagement of these concerns and the emplotment of social models elaborated by contemporary sociologists, one comes to see that Dreiser's Chicago and New York are very different from the cities he has been credited with creating.

My attention to this crucial yet neglected dimension of Dreiser's novel is what prompts my divergence from Michaels's reading. While I agree that Carrie is a representative self and that the path of her success represents the forces of the market in the production of wealth, I reject the contention that Carrie is a speculator. I propose to read her as a speculum—a mirror reflecting desires (ultimately, male desire) and social ideals, which makes her an instrument of *re*production, and an instrument through which a series of handlers make their entry into the market and improve their (and, incidentally, her) situations in Chicago and New York. "Carrie [is] capital" (p. 353), a producer observes. Others create her value, though none of them demonstrates anything near the speculative prowess of Frank Cowperwood, Dreiser's fictionalized Yerkes. Although in my reading Carrie continues to have no stable identity and still undermines the ideology of self-possessing individualism on which laissez-faire capitalism supposedly rests, it is not because she is constantly producing herself. Rather, what Michaels himself notes in one instance I elevate to a general pattern: others help Carrie to want. As she is made and made over by those characters who focus her vague desire, she becomes an example of how wealth and a self are produced through the social and economic institutions of an interdependent society.

To prove this claim, I must also respond to the bad press that Bob Ames has gotten recently. The electrical engineer—who was for an earlier generation of critics like Ellen Moers an "intellectual midwesterner brought on near the novel's end to express Dreiser's own opinions," particularly opinions that suggest the "shallow-[ness]" of the other characters' levels of "metropolitan success"—is now dismissed as something of a prude, while Carrie is said to embody the truth about the market.[6] I do not propose to rehabili-

tate Ames as Moers's moralist (although he does moralize), or even
to make him a mouthpiece for Dreiser's own judgments, but I do
plan to see him for what he is—the novel's representative of the
Progressive movement's faith that professionals like himself pos-
sess the expertise and vision to stabilize and more fully democra-
tize American society and culture—and to scrutinize the rhetoric
of individualism he puts in play as a figure for the emergent *mana-
gerial* economy and its promise of a prosperity that would be more
equitably distributed than it was during the period of speculation
portrayed in *The Financier.*

Michaels has been most responsible for the recent reversal in
Ames's fortunes with his dissection of Ames's position in an essay
whose multileveled argument has three closely related targets.
Against Leo Bersani, Michaels argues that literary excesses of de-
sire like Carrie's "are not subversive of the capitalist economy
but constitutive of its power." They aren't subversive—this is his
larger point—because the essential, autonomous self described in
theories of laissez-faire capitalism was a mystification. In reality,
he writes, "the capitalism of the late nineteenth and early twenti-
eth centuries acted more to subvert the ideology of the autono-
mous self than to enforce it," since the economy of speculation
that for him is the economy of the United States in that period
"runs on desire, which is to say . . . the impossibility of ever hav-
ing enough money," that causes the speculator incessantly to risk
what he or she has (that is, what he or she *is*). In *Sister Carrie*, the
representative self, Carrie Meeber-Drouet-Madenda-Hurstwood-
Murdock-Wheeler-Madenda, is defined not by properties she natu-
rally possesses (the theory of possessive individualism), but by
what she lacks yet desires. At the heart of the self, then, is "a noth-
ing of desire" that makes the self "speculative" because "in *Sister
Carrie*, satisfaction itself is never desirable; it is instead the sign of
incipient failure, decay, and finally death."[7]

In a local but important argument in American literary history,
Michaels opposes this speculative self to a self built on what How-
ells called "character" and Michaels, quoting *The Rise of Silas Lap-
ham*, defines for us as something that "resists fluctuation; [it is]

'never the prey of mere accident and appearance.'" While crediting Howells's "commitment to social justice," Michaels produces his reading of Howells's moralizing response to capitalist excess in order to place him at the head of a tradition that includes Bersani, but, more importantly, "a certain strain of American criticism, a strain that has by no means died out today," whose "gentility consist[s] not in being insufficiently critical of [its] society but in being scandalized by it." The literary history becomes important for my reevaluation of Ames's function in the novel because according to Michaels, "the closest anyone comes in *Sister Carrie* to articulating this Howellsian morality is . . . the midwesterner Ames."[8] Ames is, we are told, contemptuous of the sentimental tradition's emotional excesses, respectful of serious art (as Lapham never is; his understanding of paint is wholly instrumental), and a believer that a person can occupy only one place at a time and should find happiness in it.

At the risk of placing myself among the scandalized, I want to contest Ames's supposedly anachronistic gentility as well as Carrie's speculative posture. Ames's judgments are certainly harsher and more "cultured" than Dreiser's pronouncement on the new resorts, but Michaels's issue is the genteel tradition and the investment in individualism that he hears in Ames, not gentility per se. Superficially, Ames does recall another Chicagoan lauded by that genteel tradition of cultural criticism, architect Louis Sullivan. In some of Chicago's most critically acclaimed buildings, Sullivan visually engaged the fate of individualism in the industrial age, although with a nostalgia that is absent from the novel. In his writings and talks, Sullivan mythologized himself as a prophet of democratic individualism, an inheritor of Emerson and Whitman. His image of an ideal skyscraper adopts their ethos: the building stands "*solus*, . . . [and] the lofty steel frame makes a powerful appeal to the architectural imagination." His autobiography (given the rather Emersonian title *The Autobiography of an Idea*) also stresses the importance of the moment in Chicago when he was introduced to the researches of Darwin, Huxley, and Tyndall in the natural sciences, and especially the profound effect on his sense of

vocation caused by reading Spencer's definition of evolution as a universal process "implying a progression from an unorganized simple, through stages of growth to a highly organized complex." Sullivan then understood that his task was to resolve the tension of architecture as an expression of humanity's creative nature in remaking the world, the Emersonian inheritance, and the wholly impersonal, physical laws of evolution that, he read in Spencer, were the true source of human activity. His solution lay in part in a symbolic ornamentation that combined geometric and organic motifs. In the margin of one of his studies of ornament, Sullivan called the result a "mobile equilibrium" of elements that he believed to represent a dialectic of form and growth, intellect and emotion, borrowing a crucial term in the economic and sociological discourse of the time. The way the ornament emerged from, indeed overtook, a building was intended, William H. Jordy argues, as a figure of the transcendence of art and expression over the technology and commerce that support them and, in the case of architecture, call it into being.[9] Still faithful to his transcendentalist roots, Sullivan was seeking visually to represent the dialectic of art and technology that had been given poetic form in Whitman's "A Passage to India."

Dreiser's undertaking diverges from Sullivan's in significant ways. Neither the novel nor Ames participates in Sullivan's celebration of individualism or the sustaining powers of nature. Nature is a theme that runs throughout the *Autobiography* from Sullivan's early memories of the Massachusetts countryside to his later retreat in Ocean Springs, Mississippi, where he "did his finest, purest thinking, . . . [and] saw the flow of life, that all life became a flowing for him."[10] Urban interdependence has the status of an accomplished fact in Dreiser's world. The country is what is left behind on the novel's first page; individuality exists as it is created from the options the city offers. What matters to Dreiser is not nature, but divining the "natural" development of a society that is now urbanized and industrial, a society in which the old laws of proprietary capitalism no longer apply.

My contention is that Dreiser defused this conflict between the

older ethos of innate character and the new options for self-making in urban America at the turn of the century by having Ames's words defend neither a static self nor an economy of unrestrained excess, but an ethic of cooperation and controlled-growth economies of commerce and desire whose natural movements would be subject to the benign control of professional social scientists. Like most of his contemporaries in the social sciences and economics, Dreiser applied the adjective *natural* to social forces with more than the force of metaphor. The same physical forces that animate nature were assumed to structure and propel the society and the market, a condition that makes the electrical engineer an ideal figure for the undertaking. Furthermore, Dreiser could not be content with employing symbols to express a resolution achieved. Working in a narrative form, he had to represent the effects of these new forces and how they might reshape urban society.

Before we can fully comprehend the sort of self this society produces, we need to understand the social science ideology that informed this social vision and Ames's role as its spokesman within the novel. We may begin with his explanation of how Carrie can become, in his words, a figure for "all desire" (p. 385). These words seem at once to advertise and to contain an excess of desire. Yet, the excess in Ames's words is one that Michaels fails to contain. For, if Ames's advice to Carrie not to "wring [her] hands over the far-off things" (p. 384) is advice born of "an economy of scarcity, in which power, happiness, and moral virtue are seen to depend finally on minimizing desire," then, as Michaels also notes, when Ames advises her, "If I were you . . . I'd change" (p. 386), he comes to "represent to Carrie . . . an ideal of . . . perpetual desire" and thus becomes desirable to her.[11] Carrie, clearly, is not speculating in this passage; however, Ames may well be speculating with himself by speculating on the possibility of speculation with Carrie. To say that Ames is having it both ways within the short compass of two pages may be to underestimate the potential of these lines.

As such, one would be wise to suspect the lack of reserve with which Michaels offers, and Rachel Bowlby warrants, the notion that Ames opposes to nineteenth-century capitalism's Desire, Ltd.,

an economy of strict limits on desire. Bowlby has what would seem to be the last word on Ames according to the new reading when she asserts that Michaels "is surely right to protest against critics who have seen a conscious authorial projection in . . . Ames, who impresses Carrie on one or two occasions [two-for-two is a good average!] and persuades her to read Balzac. The solid literary values represented by the midwesterner are simply an anachronism."[12] Solid values drawn from an earlier generation of literary realists like Howells may be anachronistic, as is his critique of "showy . . . gastronomy" (p. 254). But there is a more fundamental anachronism in the now-dominant reading of *Sister Carrie* that needs to be corrected. Simply put (although I shall spend some time substantiating it), by 1889, the year Carrie Meeber boarded that southbound train for Chicago, the proprietary-competitive, or laissez-faire, market was fast becoming an anachronism. While it had defenders, these "old conservatives," as legal historian Morton J. Horwitz names them, were a minority—albeit at times an influential one—fighting against the shift to a corporate-managed economy, in which monopoly was replacing speculation as the major economic problem. Given these conditions, the Sherman Antitrust Act of 1890 was, in Horwitz's analysis, "a last desperate and largely ineffectual effort to preserve an older America of small competitive businesses."[13] Moreover, the age of incorporation, combination, and trust formation, the period that social scientists from the turn of the century onward have identified as marking a shift in American social relations from autonomous individualism to social interdependence, produced new models of the self and a new class of professional men like Ames, who were called upon to transform and channel the desires produced by capitalism into forms that would serve the public interest as they defined it. Recent criticism of *Sister Carrie* has failed to take the significance of these developments sufficiently into account.

Ames is no prematurely obsolete engineer. The young electrical wizard is becoming a *social* engineer and theorist of the self when he takes the final role in the creation of Carrie Madenda as representative of her society, a representation that justifies the econo-

my's and Carrie's own evolution by reorienting her desire from economic to social production. In that crucial scene (p. 385), he preaches not the minimizing of desire, but the careful channeling of desire and capital in directions likely to benefit both the individual self and the larger social "organism." His authority derives from his professional position as a businessman and engineer in a world where combination has rendered the circulation of capital as carefully plotted as the circulation of electricity among the streetcar lines that await the planned and channeled growth of Chicago. "Connected with an electrical company" when we first meet him (p. 252), Ames disconnects himself after his "little success" and opens a laboratory in New York's SoHo district (p. 382). His career move suggests a rise from a level of practical action that facilitates the unobstructed flow of electric power to a self-directed inquiry into the mechanics of social power; in effect, he moves from being a technician to becoming a theorist of what we may follow Michel Foucault in calling "pastoral power."[14] Like Dreiser, the onetime journalistic depicter of social conditions who in *Sister Carrie* mapped the circuitry that channels the flow of social and economic energy, Ames negotiates his way from pragmatic, local activity to the study of the structure of nature's forces, which the novel and much social theory contemporary with it repeatedly assert are the same forces that support economic and artistic endeavor.

II

Pursuing this line of argument necessarily takes me back to the origins of American sociology and the early history of antitrust law. I will begin by recalling the work of Spencer, the English Social Darwinist whose influence on Dreiser was remarked by an earlier generation of critics but has recently been ignored. In this, Dreiser criticism is consistent with recent work in the history of the social sciences. Whereas in the 1940s Richard Hofstadter wrote of a late-nineteenth-century "Vogue of Spencer," in the late 1970s Thomas L. Haskell argued that Spencer's importance to the period's social thought has been overestimated. Focusing on the

American Social Science Association in his study of *The Emergence of Professional Social Science*, Haskell contends that biological determinism was not "its mainstream. Most serious social thinkers in England and America read Spencer with mingled fascination and horror, clinging hopefully to a far more voluntaristic and spiritual view of human affairs." An overemphasis on Social Darwinism's determinist dimension may well be the reason that Spencerian thought can, as David Hollinger wryly notes, "now claim a dubious honor: that it has been shown *not* to have existed in more places than any other movement in social theory."[15] But Spencerian thought has more dimensions—and contradictions— than is often allowed, and those contradictions extended its reach.

From *Social Statics* onward, Spencer defended individual liberty against all forms of state compulsion in the name of achieving "the greatest happiness." Unless one's pursuit of a desired goal infringes on the freedom of others, he argued, the state should not seek to curtail such activity or otherwise to affect the conditions of life beyond ensuring to all citizens an "equal freedom." Spencer's defense of laissez-faire still had enough currency at the turn of the century for Oliver Wendell Holmes to object in his dissent to *Lochner v. New York* (1905) that "the Fourteenth Amendment does not enact Mr. Herbert Spencer's Social Statics. . . . A constitution is not intended to embody a particular economic theory, whether of paternalism and the organic relation of the citizen to the state or of *laissez faire*."[16] At issue in the case was whether a statute fixing the maximum work week for bakers at 60 hours was a protection of their labor power from exploitation or an infringement of their right to enter into contracts. That Holmes wrote for the minority suggests that Spencer's idea of liberty had indeed insinuated itself into the language of the Fourteenth Amendment, which had been extended to protect corporate persons.

Thus, we find in Spencer a conflict between diachronic determinism and synchronic freedom, both of which are justified by their accordance with natural law. The world of organic individuals, of free agents constantly negotiating to balance their own desires with a respect for the rights of other equally free agents, fully

supported a laissez-faire ideology whose utility had not been exhausted; however, the inexorable evolution of natural and social organisms to larger, more fully differentiated states equally entailed that a corporate economy was the natural economic form for a society that is itself a corporate body. There is also in the ethical implications of Spencer's evolutionary model what Donald Pizer has correctly noted as a "built-in paradox" that adapts social evolution to both "a struggle-for-existence ethic" and "the realization of Christian idealism in man's personal and social life as evidence of the true direction of evolutionary progress," the position I argue Ames champions in its secular form. Such are the paradoxes that Spencer bequeathed to the next generation of sociologists: equal freedom must be preserved at all costs while social evolution toward a communal, cooperative state is natural and inevitable; yet, poor laws, protections of the right to labor and other Progressive interventions to further this evolution are all only testimony "to the futility of . . . empirical attempts at the acquisition of happiness," because "men who seem the prime movers are merely the tools with which [evolutionary change] works; and were they absent, it would quickly find others."[17]

When *Sister Carrie* was published in 1900, many Americans feared what Henry James called "the icy breath of Trusts," but another large segment of opinion in the United States believed that by effective regulation these forms of cooperative combination would be made less chilling. This group hoped that combination might bring the economy to "a comparatively constant state" of growth that would be, in Spencer's words, "conducive to a better equilibrium of industrial functions"—a mobile equilibrium. Under this regime, unbridled (and often unprincipled) competition would give way to the steady growth of a well-managed economy. Among an older generation of social critics, the trust was a harbinger of Christian socialism, while many Progressives and unionists found in the new arrangements a possible means to rationalize industrial production. They read the promise of the emerging corporate capitalism as "greater stability of employment and better wages with higher productivity, as well as pensions, profit-

sharing, recreational facilities, and even advancement from blue collar to white and prospective advancement up the corporate ladder," all of which would benefit men and women with the least economic power. *Sister Carrie* narrativizes such market self-regulation, whose result was postulated as a dynamic balance between demand and supply in a "dependent moving equilibrium" like that maintained among the functions of a single organism. As a paradigm of this process, the novel's representative fortune, Fitzgerald and Moy's, grows under the stewardship of managers like Hurstwood as the city grows. Its growth is synecdochic for the symbiosis of social and business interests that Dreiser, following Spencer, imagined as the inevitable outcome of individual fortunes being "conserved by the growth of a community or of a state" (p. 260). Rooted in classical market theory, dynamic equilibrium had been codified in Say's Law, which holds that "production and demand must generally balance each other at relatively full employment, with imbalances occurring only episodically and serving as corrective signals restorative of equilibrium."[18] The novel allegorizes Say's Law by the balance between Carrie's desire and the opportunities at hand for its satisfaction—not by an imbalance, as Michaels contends—and by the ease of her movement along the circuit of her success. Thus the novel is, I cannot resist suggesting, a "Spencerian romance" in which motive powers are natural, not supernatural, and the heroine, a "half-equipped little knight . . . dreaming wild dreams of some vague, far-off supremacy" (p. 2), succeeds in a quest that proves the virtue of the market and through it her own virtue as she rewrites the canons of moral behavior.

The near-invisibility of the managerial apparatus furthers Dreiser's romance plot by mystifying the powers at work in *Sister Carrie* and thereby rendering them benevolent. Just how inevitable this economic development was, or how much it stood in need of active direction, was a matter of contention between the evolutionists and the new bureaucrats. They agreed on one thing; by 1900 "no significant segment of organized opinion advocated a return to the old competitive market or the preservation of laissez-faire prohibitions on regulatory intervention by the federal government," ac-

cording to Martin J. Sklar. Yet the courts had lagged public opinion in this matter until the "Rule of Reason" cases codified the distinction between reasonable and unreasonable restraints of trade that Theodore Roosevelt had proposed in his first Presidential address to Congress. In one of those cases, *Standard Oil*, John Marshall Harlan agreed with the Court's breakup of the oil giant, but he dissented from its definition of reasonable restraint with the argument for laissez-faire quoted as an epigraph to this chapter. Harlan wanted to maintain the Court's earlier position, in *Trans-Missouri*, that if Congress meant to prohibit only unreasonable restraints it would have to stipulate that reservation in an amendment to the Sherman Act, which as passed declared illegal "every contract, combination in the form of trust or otherwise, or conspiracy in restraint of trade." Harlan's reading of the Court's opinion was sound, but his appeal to the organic market was also being used to naturalize the new economic forms he would forbid. His unrecognized dilemma was that if trusts and other industrial combinations were a new evolutionary stage of capitalism, then antitrust activity was a vexation and obstruction of the motion of the market. Roosevelt struck a middle course, finding trusts and other combinations "natural" but nevertheless subject to the rule of law and custom to make them function in the public interest.[19]

Years earlier, Spencer had maintained that social progress is "part of nature; it is all of a piece with the development of an embryo or the unfolding of a flower. The modifications mankind have undergone, and are still undergoing, result from a law underlying the whole organic creation; and provided the human race continues, and the constitution of things remains the same, those modifications must end in completeness" and more complex social organisms. Evolutionary progress is, we are asked to believe, what best describes Carrie Meeber (amoeba?) as she evolves from that flat-footed girl whose "hands were almost ineffectual" for any kind of work (p. 2) into the ultimate celebrity. For, following Spencer, Dreiser used the rhetoric of the natural sciences to describe the processes of social and economic exchange. Spencer's and Dreiser's vocabularies are both filled with terms borrowed from biology, but

as Franklin H. Giddings, Columbia University's first professor of sociology, noted almost a century ago, "the basal theories of [Spencer's] sociological thought" in *First Principles* rest on "the persistence of force, the direction and rhythm of motion, the integration of matter and the differentiation of form." It is "at bottom . . . a physical philosophy of society, notwithstanding its liberal use of biological and psychological data." While organic metaphors are equally important to the construction of *Sister Carrie*'s world, that world is held together by electromagnetism: Chicago is "a giant magnet" that draws capital and people like Carrie to it; electric streetcar lines extend its field (p. 12). The assembly line on which Carrie works is a self-regulated circuit that keeps shoes marching along the path of least resistance, the path Spencer said the "complicated motions" of capital naturally follow.[20] Characters are likewise charged fields. Drouet has a "daring and magnetism" that attracts Carrie (p. 2), while his "electrical, nervous condition" transforms her as "Laura" (p. 143). When Carrie and Drouet dine together, an "interchanging current of feeling" "connect[s]" their eyes (p. 49). Hurstwood "fixes" Carrie with his eyes' "magnetism" (p. 94). Drouet bestows on Carrie her own magnetism: viewing herself in the stylish clothes he has bought for her, she feels "her first thrill" of the attractive power (p. 63) that will draw male theatergoers to her in New York. Clothing has its own magnetic power over Carrie; at the Fair department store, "each separate counter was a show place of dazzling interest and attraction" (p. 18). Conspicuous by his immunity from these nodes of power is Ames, the electrical engineer who has mastered their circuitry.

Yet, as we know, economic and social change for the better at the turn of the century did not occur spontaneously. For one thing, Say's Law of dynamic equilibrium does not hold true in an industrial economy. As economist and monetary authority Charles A. Conant explained at the time, the need to tie up capital in fixed plant creates a pattern of cyclical fluctuation as healthy profits and low rates of interest invite an expansion of fixed plant that eventually leads to an oversupply of goods, then to declining prices and profits, higher interest rates, economic slowdowns, and, finally, de-

pressions because fixed-plant investment is an immobile form of capital. The dystopic effect of cyclical slowdowns and the increasing concentration of wealth in fewer hands had been explored in Brooks Adams's *The Law of Civilization and Decay*, another "scientific" study of economic and social structures; it was published four years before *Sister Carrie*. Adams shared with Spencer and Dreiser a sense that conscious human action played but a small role in shaping history; all three men thought that the major forces governing men were instinctual—that is, natural. But unlike Spencer, who thought larger economic "organisms" a sign of evolution toward better social and economic relations, Adams appealed to history in order to argue that centralization creates "two extreme economic types,—the usurer in his most formidable aspect, and the peasant whose nervous system is best adapted to thrive on scanty nutriment."[21] While Spencer was writing against state paternalism, Adams's immediate context was the Panic of 1893 and the debate between advocates of the gold standard and bimetallism. Published as William Jennings Bryan and the "Silver Democrats" campaigned against William McKinley, the candidate of the banking interests, Adams's book was attacked in some quarters as a political pamphlet writ large, even though it never mentions American finance. It did not have to, because Adams's final focus on the bankers of Lombard Street—who, any populist could tell you, controlled banking in the United States—made clear the nation's implication in the history he was recounting.

Had Dreiser followed Adams's "inevitable" cycle, *Sister Carrie* would have focused on the defeat of the Brooklyn Trolley workers by their bosses and the banks. But Dreiser let go of the strike when it had shown Hurstwood's fate: his inability to keep the streetcar circulating smoothly along its determined path signifies the loss of his former managerial ability as much as the success of the strikers. The strike does suggest that the "new socialism," which Dreiser at one point informs readers produced "pleasant working conditions" in factories (p. 31), was widely resisted, even if he omitted such monumental events as the Haymarket Riot (1886) and the Pullman Strike (1894), which are directly pertinent to

a novel partly set in Chicago. While the headlines proclaiming "80,000 people out of employment" (p. 267) place Hurstwood in a larger context of economic crisis, they are counterbalanced by Carrie's thought after her quick success as a job-seeker that "no man could go seven months without finding something if he tried" (p. 312). The competing theories of dynamic equilibrium and business cycles come into their most direct opposition in these contrasting observations, but the case for disequilibrium is undercut by the particular circumstances in which Hurstwood finds himself as an aging felon. They make the problem he represents seem less systematic than individual, as the voodoo economists would later say of the S&L and junk bond crises. By tying the workers' struggle against banks and corporations to Hurstwood's struggle against age and the inevitable "turning in the tide of [his] abilities" (p. 260)—a different tide from "the tide of change" (p. 244) carrying Carrie—Dreiser subverted the concrete reality of the strike. When the violence breaks Hurstwood, he leaves the conflict with a sense that the job is not for him, not that the strikers are right or wrong. We leave the strike without mention of its outcome, only the surmise of an already defeated Hurstwood that "those fellows can't win" because the corporations own the police (p. 322). What might have been a critique of the use of police power by the corporations and the way social crises are misrepresented in newspapers thus dissolves into ambiguities that reflect Hurstwood's private confusion as he looks out on a world in which he has relinquished his place by diverting the circulation of capital from Fitzgerald and Moy's customers to their safe, from which it is reinvested in Chicago's growing economy to maintain the dynamic equilibrium.

If the mitigating circumstances of Hurstwood's fall, together with the ease of Carrie's rise, deflect our attention from the central issues of the trolley strike, the immediate effect is to draw readers into the sort of passivity in the face of social crises that Spencer counseled. Readers of *Social Statics* are urged to "look upon social convulsions as upon other natural phenomena, which work themselves out in a certain inevitable, unalterable way." Spencer al-

lowed that "we may lament the bloodshed," but he warned that "it is folly to suppose that . . . things could have been worked out differently" because, in the final analysis, change is "brought about by a power far above individual wills. Men who seem the prime movers are merely the tools with which it works." For proof, he turned to poor laws and laws protecting the right to labor, which he thought testament "to the futility of . . . empirical attempts at the acquisition of happiness."[22]

However, other rhetorical and theoretical forces at work in American social science may explain Dreiser's decision not to place greater emphasis on the strike and other forms of open conflict. By the mid-1880s, Spencerian social evolution was being supplemented by, though not replaced with, a faith in human volition as an effective force for social change by such first-generation American sociologists as Giddings and Lester Ward, whose two-volume *Dynamic Sociology* (1893) was the first American sociology text. Ward's sociology employed the vocabularies of Darwinism and physics, but he took issue with many of Spencer's arguments about individualism and the social order. He rejected laissez-faire by arguing that such abstract concepts as the law of equal freedom mystified the actual relations of power that determine the extent of individual rights and the direction of history.

The notion of "interdependence" was fundamental for these sociologists. Used to describe postbellum social, industrial, and economic relations, it, too, was couched in a language of forces and vectors. As Thomas Haskell has recently defined it, *interdependence* describes an objective "tendency of social integration and consolidation whereby action in one part of society is transmitted in the form of direct or indirect consequences to other parts of society with accelerating rapidity, widening scope, and increasing intensity." While conceding that the history of meliorist intervention to date had been largely negative, Ward found cause for optimism in the fact that such activity had some measurable effects and that they might be positive if properly aimed. Using an analogy with technological research and development, Ward ar-

gued that legislation must be invention, and legislatures research laboratories, for the ordering of society. Giddings likewise believed in the need for "scientifically-trained statesmen" if social evolution was to progress as a dynamic or "moving equilibrium." The goal of these scientific studies of society was explained as "bring-[ing] the social units into proper relation to one another, and to the society as a whole" by George G. Wilson, a professor of social science at Brown University who later expanded his scope as a Harvard professor, author, and agent of the U.S. government in the field of international law. While they defined the subject of this new social science as "the development of mind as a product of social activity and as an evolution of social nature," these sociologists departed from Spencer's conclusions.[23] They maintained that mental phenomena can also be causes, and that the reciprocity of internal and external causes must be understood as part of an ongoing, mutual process of adjustment and adaptation of humans and the social world.

Rhetoric borrowed from evolutionary biology and physics to explain patterns of individual and social behavior was no doubt instrumental in the legitimation of sociology as a social *science*, although it created another internal contradiction in the discourse—between inevitability and intervention. The technocratic rhetoric of sociology not surprisingly attracted the attention of engineers, who were busy organizing their profession as a science, rather than a craft (although civil engineering had been a recognized profession before the Civil War). Certainly, engineers were at home with concepts of transmission, acceleration, and intensity; they also thought of actions as produced in increasingly complex and efficient circuitry. In his history of American engineering during the Progressive Era, Edwin T. Layton, Jr., explains that the influence of Spencerian thought on engineers is in large part traceable to the fact that "Spencer himself was an engineer. Engineers regarded him not only as a colleague but as an example of a new professional role: that of lawgiver and philosopher." Robert Thurston, the first president of the American Society of Mechanical Engineers, noted

in his 1880 presidential address that Spencer "vastly widened the legitimate concerns of the engineering profession to include general questions of politics and economics." If many, even the majority, of engineers did not share the Progressives' faith in the utility of government-sponsored reform, many engineers and laymen did share a faith in the applicability of engineering solutions to the problem of producing and distributing goods at reasonable prices. Thus, in his 1895 presidential address to the American Society of Civil Engineers, George S. Morison declared that "accurate engineering knowledge must succeed commercial guesses," and that "corporations, both public and private, must be handled as if they were machines." This same sentiment informed the vision of Progressive reformers and Franklin Roosevelt's creation of a "brain trust"; it perhaps reached its apotheosis in Thorstein Veblen's post–World War I call to replace present industrial managers and syndicates of investment bankers with a "soviet of technicians" whose concern would be the efficient production and distribution of goods, not profit margins.[24]

It is in such a context that we must see Bob Ames, *Sister Carrie*'s engineer and sometime cultural critic, and its protagonist's final director. A representative of the social theorist as practical man, Ames uses his mastery of technical knowledge to improve his economic situation while (more stridently than Dreiser) criticizing the "wasteful" excesses of city life (p. 254). He directs his criticism of literature and theater toward the social uses of fiction. Ames fits University of Chicago sociologist Charles R. Henderson's description of the social theorist as someone whose "associations are with the refined, and [whose] ideals of life are formed in the best company. But his professional pursuits compel him to weigh the claims of the entire community."[25] One note of caution about this reading: having alluded to the brain trust and suggested Ames's suitability as an agent of a pastoral power that Foucault identifies with the interests of the state, we must remember that the Progressives began as critics of government and many of them remained so. Further, when they wielded government power, as in FDR's adminis-

tration, their programs were often blocked by a hostile legislature or voided by the courts. Pastoral power is not necessarily state power.

III

When Ames and Carrie meet for the second time, she, too, is moving in the "best" company. Having begun her career as "a half-equipped little knight . . . venturing to reconnoiter the mysterious city and dreaming wild dreams of some vague, far-off supremacy which should make it prey and subject" (p. 2), Carrie is less an immigrant to a thriving industrial city than a character out of a quest romance. She comes to Chicago with her dreams of the prince, the palace, and the gold because her desire is fueled by a popular romance, *Dora Thorne*. The narrative of Carrie's triumph shares with the romance the strategy of naturalizing social forces, which in the novel's case entails mystifying the process of capital formation and the conditions of labor in order to make the achievement of success appear frictionless. Dreiser manages it in part by keeping Ames at a distance from the economic sphere in which he nevertheless succeeds and keeping Carrie an "innocent" despite what happens to and around her. Her theatrical conquests come not from hard work, but from her "naturally imitative" behavior (p. 84) and "natural look" (p. 384) that, with chance events, propel her "evolution" (p. 305) toward representative celebrity: She *happens* to meet Drouet on the train; he *happens* to see her on the street when it seems she must return to Wisconsin; her first role results from a constellation of events beyond her control; her first spoken line comes when she *happens* to be in front of an ad-libbing star; her winning frown is not part of her act but a lapse out of character into unfeigned emotion.

Taken together, these events make her career appear directed by some unseen hand—whether God's or the market's does not matter, since the two were not wholly distinct for Spencerians or for Dreiser. In magazine articles about the music industry written at the same time as the novel, Dreiser described a world in which a

person desirous of fame gets a lucky break and rides the promotion and distribution machinery to stardom, just as a theater critic notes that "pretty, good-natured, and lucky" Carrie did (p. 362). Omitting what he knew of the hard-nosed business from his brother, songwriter Paul Dresser, Dreiser has a "clever Broadway wit" in "Birth and Growth of a Popular Song" dismiss the utility of study, insisting that once one has memorized the tricks of song-writing, "why, you *can't* write the song." In "Whence the Song," a woman takes Pittsburgh and makes the rounds of fashionable New York after deciding "she will [sing]. The world shall not keep her down."[26] Luck is not "the residue of design," as Branch Rickey said; it is the consort of desire.

Similarly, the theater becomes for Carrie "a secret passage" to a "chamber of diamonds and delights" that she thinks is "no illusion" (p. 138), a world not unlike the one she imagined awaited her behind the department stores' plate glass windows when she first arrived in Chicago. The Casino Theater, where she rejoins the working world as she and Hurstwood near bankruptcy, is not a stage facing seats filled each night at a certain price, or the site of a job that will help her stave off economic defeat; it is a world "redolent of the perfumes and blazonry of the night, and notable for its rich, oriental appearance" (p. 303), qualities that always enchant Carrie. A similar patina of romance had obscured from her the social significance of Chicago's millionaires' row. Mrs. Hale tries to teach Carrie "to distinguish between degrees of wealth," but while she succeeds in making Carrie see the discrepancy between the "three small rooms" she shares with Drouet on Ogden Place and the mansions along "what is now known as the North Shore Drive," the language of that distinction derives entirely from romance: "Such childish fancies as she had of fairy palaces and kingly quarters . . . came back" to her when she saw the lamp-lit mansions (pp. 92–93). For Carrie, even money itself "assumes the character of an independent and definitive basis of esteem," as Veblen observed about Americans generally in a time when fortunes were becoming removed from the context of production and exchange.[27] Carrie, who does not understand any form of economy beyond in-

dividual use, believes money to be "power in itself" (p. 51). Even Ames participates in this mystification when he tells Carrie the talent that is the source of her income is a "gift" of "no credit" to her because she "paid nothing for it" (p. 385). More accurately, her ability as an actress is no credit to her because she never draws on it. Indeed, the novel ends with Ames rekindling Carrie's attraction to theater as a mysterious world of truth.

This is not to say that production and exchange are not central to the novel. They are, but they are displaced because Dreiser's metaphoric uses of electricity and magnetism to describe the city and the characters extends as well to money and material production. When the narrator refers to money as "honestly stored energy" (p. 51), echoing Mill, we may reflexively complete the definition with the words "of labor," but Dreiser does not. His electromagnetic metaphors that describe Chicago and the characters suggest the presence of an unseen animating force that does the work and drives progress in the novel's world. In conventional romance, nature is animated by an unseen God; in *Sister Carrie*'s materialist romance, the source of the energy that makes the increase and circulation of wealth possible is, I propose, the dynamo. Although never mentioned, the dynamo is strongly implied by the novel's time and setting. It was featured in the Electricity Building on the Court of Honor at Chicago's World's Columbian Exposition, held four years after Carrie's arrival in the city and seven years before *Sister Carrie* was published. Dreiser covered the festivities for the St. Louis *Republic*. Henry Adams also attended what he called an "industrial, speculative growth . . . induced to pass the summer on Lake Michigan." Both men thought the new technology that was changing the fairgoers' lives had been "made to seem at home" there; the dynamo, Adams wrote, seemed to most fairgoers "as natural as the sun," even if (or was it precisely because?) they "underst[oo]d one as little as the other." Adams took the dynamo for the sign of a new phase of history and transcoded it into the rhetoric of romance, calling it "a symbol of infinity" that "he began to feel . . . as a moral force, much as the early Christians felt the Cross."[28] General Electric, meanwhile, brought its first dynamos on line at Niagara Falls, New York, in 1895.

If the world of the high romance was nature still, but nature moralized, its Spencerian version (which here accords with Michaels's reading) reads morality out of a nature animated by desire. Desire, Spencer wrote, "is the incentive to action where motives are readily analyzable, . . . probably the universal incentive; . . . the conduct we call moral is determined by it."[29] As Dreiser extended this dictum, Carrie's virtue is affirmed by the success she achieves despite her violation of the moral economy of the Howellsian realism Michaels describes. That moral economy is invoked at the outset when we read that Carrie's trip to Chicago opens her to two possible fates: "Either she falls into saving hands and becomes better, or she rapidly assumes the cosmopolitan standard of virtue and becomes worse. Of an intermediate balance, . . . there is no possibility" (p. 1). But Carrie's adventure combines these options in a type of *felix culpa*; her fortunes rise as she falls out of Sven's "saving" hands and circulates through Chicago and New York.

This activity does not, I will say again, make her a speculator. Already taking at his word the producer who calls Carrie "capital," I want now to follow the advice Hurstwood gives Carrie as he begins to win her in the euchre game with Drouet: "Don't you moralize . . . until you see what becomes of the money" (p. 80); the money is, of course, Carrie. Money is, Brooks Adams noted, different from other forms of capital in that it is easily transmuted into many forms of activity.[30] By the time Ames tells Carrie that in order to be herself she must be other than who she is, she has accumulated quite a history of names and roles outside the theater. Under the name "Madenda," which names only namelessness, she lacks "the pride and daring of place" (p. 356), but that lack is a key to her success because it affords her no attachment to what she is at any one time. The only constant in her life is an unfocused desire for something better. Michaels is correct that such a lack of attachment defines the speculator, as Howells shows us with different moral weighting in his portraits of Milton Rogers and Silas Lapham. But reasoning from Carrie's lack of attachment to her position as a speculator, Michaels constructs a faulty syllogism. Carrie's "high-flown speculations" are only "calculat[ions] upon that vague basis which allows one the subtraction of one sum from an-

other without any perceptible diminution" (p. 23), and "thoughts of a thousand dollars" exercised on a base of 50 cents (p. 126). Even when Lola prompts her to demand $40 a month upon her promotion to her first speaking part, Carrie asks only, "How much do I get?" (p. 342) and settles for five dollars less.

So, when Michaels writes that "Carrie's insatiability suggests that for Dreiser capitalism was just the economic transcription of feminine biology," we may wonder whether that economy is speculative or if women's position within the social organism implies another economic model. Bowlby suggests that Carrie "makes it, but only to the extent that 'it' makes her," and I concur—although I am interested in a wider reading of the dialectic of consuming and being consumed than she considers.[31] Carrie's performance extends beyond the stage to the theater of everyday life, where her success becomes an image of the potential her audience can imagine to inhabit their own social and economic situations. As audiences recognize in her the reflection of their own desire (what Ames means by Carrie's ability to express the world's mute longings [p. 385]) and see in her fame the promise that a system of managed production will satisfy the desires of people who start with nothing, they, too, may turn from hopes for more radical social transformation toward a faith in incremental change.

Carrie performs her socially integrative functions well, but incidentally. As an expression of the collective longing for fulfillment, of what Eric Sundquist calls "the age's own dream of success, its special romance," she reflects, but is unable to reflect upon, the relation between the production of goods, the production of desire, and the production of "individuals."[32] She is not a theorist like Ames, who follows Henderson's prescription to "weigh the claims of the entire community." He tells her that she can make private and public interest coincide (a goal he sets for her) only if she achieves her great personal success while renouncing her interest and agency in favor of becoming the transparent conductor of the world's unvoiced desires (p. 385). Ames's comments and his practice recall Emersonian aphorisms when he counsels Carrie to use her "genius" to become "representative" (p. 385) and to live for

more than herself. When he reminds her that she can "occupy but one [situation] at a time" (p. 384), the implication of his advice is that she can comprehend the world from her position, as he can. At the same time, his advice to her, "If I were you . . . I'd change," names a logical contradiction ("If I were you, I wouldn't be you") through which he makes himself desirable to her and installs himself as her last director. What distinguishes his philosophy from her "high-flown speculations" is that he measures possibilities near at hand, while she passively dreams of what is far off. Yet the advice he gives is appropriate for Carrie, an actress who must produce "selves" that are not her own and remain alienated from those "selves."

Ames's proposal occurs at a critical point in the novel, when it appears that Carrie's wanderings have been in vain because objects, having become accessible, are losing their power to command her attention. Her desire is reanimated by his espousal of an essentially Spencerian altruism whose Emersonian resonances are again discernible. What he urges may be glossed by a passage in *Social Statics* that describes the "ultimate man" as one "whose private requirements coincide with public ones. . . . In spontaneously fulfilling his own nature, [he] incidentally performs the functions of a social unit."[33] The means of ensuring this interdependence of self and society, achieved without the quest romance's moral requirement of a willing self-sacrifice, is precisely what the Progressive sociologists sought. Exploiting the paradox Pizer has noted in Spencer's rhetoric, Ames makes Carrie a figure for everything as she becomes nothing herself—although as a product of the entertainment apparatus she, more than the Emersonian hero or the trust, is nothing but a point at which forces concentrate.

When Ames proposes this future for Carrie, he in effect divests himself of the "trusteeship" he has gained over her. As he tells her of the gift that is no credit to her, he invests her with an agency that she never knew she possessed and must now relinquish. Recent objections to Ames center on this sort of rhetoric, with its echoes of Wordsworth's charge to poets in his Preface to the second edition of *Lyrical Ballads* and its affiliation with transcendental-

ism. In fact, Howard Horwitz has detailed a pervasive and deliberate overlap in the rhetoric used to describe the Emersonian self and "the dream of the trust, . . . to become a powerful person by not being an agent, or rather by being merely the agent or instrument of transcendental forces." The trusts' proponents in fact decontextualized and recycled Emerson on agency and harmony to cast as a benevolent "conver[sion of] the self to a transparent trustee of the energy of production, seeing all, concentrating all, seen by none, doing nothing," what detractors saw as activity in restraint of trade. Thus, an Emersonian ethos was summoned on both sides of the argument about emerging socioeconomic relations. But Carrie does more than allegorize economic activity. By the way she provokes desire or identification, she *performs* what Ward wrote is "the practical work which sociology demands . . . , *the organization of feeling*" into a well-managed economy of desire.[34]

Carrie has in this respect a specifically gendered role to play, one that Ames's sublimations of sexual desire shroud. Her circulation from one man to another (Sven, Drouet, Hurstwood, the producers and gay young men, and, finally, Ames) describes the hierarchy of the new urban society of Chicago and New York, but the relations she creates are only among these men. She and other women are absent from those relations except as they marry, and it has been said before that women do not marry men: they marry the fortunes of two families. Carrie is, indeed, always and only a cipher, multiply named and nameless. Representative of all "women on the market," a market whose players are all men, her value is constituted by the process of refinement that creates from the " 'natural' body" of Carrie Meeber the desirable commodity, Carrie Madenda, whose "socially-valued, exchangeable body . . . is a particularly mimetic expression of masculine values."[35] She rises not simply as she desires, but as she becomes increasingly an object of masculine desire. Brother-in-law Sven, at the base of the urban hierarchy, does not comprehend this motive force, which guarantees for him a life of perpetual toil. He fails to realize the full truth of his words when he tells Carrie on her arrival in Chicago, "It's not very hard to get work . . . if you look right" (p. 24); he is commenting on Chicago's

demand for unskilled labor and does not think of increasing her value to him by making her "look right." Drouet and Hurstwood do invest money and clothing in Carrie to improve their positions. Being made more desirable to others, she becomes more valuable to them. The drummer shows her off to impress his circle of friends, while Hurstwood sees her as proof of his recovering virility.

Drouet begins the transmutation of Carrie Meeber by using his "habit" of noticing all the good-looking women on the street and remarking their assets to awaken in her "little suggestion[s] of possible defect[s] in herself" (p. 82) that lead her to practice in front of a mirror until she can reflect what he desires to see. She is not thereby becoming the master of her own desire or indulging in self-speculation; her better looks are less resources that she deploys than the means by which her exchange value is increased. As "a girl of considerable taste" (p. 84), she is complimented by Drouet on her appearance and manner. Clearly, it is a self-reflexive compliment that notes how good he has made her look, and the immediate profit from her modish ways is his. Only once does Carrie recognize her commodity status: when Drouet tries to "hoard" her by keeping her at home and out of play. They fight, and she accuses him of trying to "make a toy of [her]—a plaything" (p. 178). The rest of the scene undercuts her asserted independence by reminding us of how completely her "self" is at that time the incarnation of his desire. She removes a pin he had given her, throws it to the floor and says, "You can take your old things and keep them" (p. 178). Her exit is described with a telling irony: she leaves after "she had secured *her* hat and jacket and slipped the latter on over *her* little evening dress" (p. 179; emphasis added). If these are her clothes, she possesses them only because Drouet bought them to make Carrie fit his image of the stylish woman, and thus to show himself to advantage. As she leaves, her clothes and mannerisms, traces of Drouet's desire grafted onto her, are all the identity she has.

Thus clothing, according to Dreiser the feminine discourse *par excellence*, is structured by the syntax of masculine desire. Veblen had situated clothing within the larger context of vicarious con-

sumption, that is, of men adorning women to produce signs of their wealth. Women's clothes, he wrote, demonstrate the survival of "the patriarchal past . . . [by] put[ting] in evidence her household's ability to pay" large sums of money for objects that declare their impracticality. In her own way, Carrie uses clothing to mark social distinctions, as when she compares Hurstwood's shoes of "soft, black calf" to Drouet's patent leathers and finds the drummer wanting (p. 78), or senses her inadequacy vis-à-vis the stylish "shop girls" (p. 18) without considering the debt they often accrue to meet their employers' expectations of proper attire.[36] Dreiser supplemented Veblen's emphasis on the pecuniary standard with attention to the sexual desire that drives the men in the audience to consume Carrie as a "delicious little morsel" (p. 353), and hotel managers to associate their establishments with Carrie's appeal (p. 357). Veblen's theory of the leisure class was built on the logic of accumulation under an assumed condition of scarcity. For all his mystifications of relations of production, Dreiser's economic scenario, in which the production of Carrie Madenda attests to the ability to manufacture both desire and the objects that offer its provisional satisfaction, gives a more complete picture of emerging consumer capitalism as it reflects the belief among at least some of his contemporaries in the dawning Pleasure Economy.

Carrie's rise describes the stages of the individual's relation to commodities as it traces her reification. When she first peers in the department store display windows of Chicago, she must see among the objects for sale her own image reflected in the glass, as she would have imagined her own face on the stylish young women depicted by the popular magazine illustrators of the period. Desiring and longing, the specular Carrie takes an anticipatory value from her relationship to commodities, so that, upon "seeing a thing, she would promptly set to inquiring how she would look, properly related to it" (p. 81). By the novel's end, she has come full circle. Her image or her name is placed in relation to objects to accredit *them* as having value. But in neither case is Carrie "properly related," for there is never any Carrie proper if she is infinitely transmutable, exchangeable, and consumable. Of course, it is

equally true that the desires of her audience are not entirely their own either; for, as she is interpellated by Drouet, Hurstwood, and Ames, so they are interpellated by her expression of their heretofore mute desire.

Ames, then, cannot be dismissed as simply as recent critics would have him be. As a scientist, incipient social scientist, and amateur art critic, he is the ideal figure of pastoral power in the novel. As Dreiser's figure of the Progressive, he represents the new technologies of social power that were reshaping American society as forces for personal and cultural improvement, thereby making cooperation itself desirable. He is perhaps less a high priest of culture, as Michaels suggests, than he is a representative of a form of impersonal agency the turn-of-the-century sociologists were attempting to imagine. As Foucault explained this new pastoral power, it supports the state's "very sophisticated structure, in which individuals can be integrated under one condition: that [their] individuality would be shaped in a new form and submitted to a set of very specific patterns" that determine not just behavior within the law, but also normative behavior.[37] There is, as I have said, no necessary reason to identify all such interpellative authority with the state, though the effect of Ames's call is that Carrie will become an agent of social integration as she pursues her new desires. Because this pastoral power is dispersed through social networks, and because its use requires the preservation of the subject's freedom to act—power is an action upon the subject's action, Foucault told us—Dreiser and several generations of Progressives have been able to dress their power in the language of freedom. In fact, Ames's advice to Carrie is something we, too, are asked to follow because the desire that lures us to change is offered as the fundamental mechanism of the economy and of our personal satisfaction if, as Carrie, Ames, and Drouet appear to do, we align our desires with the flow of socioeconomic forces.

The individual in *Sister Carrie* is thus neither a molecular self nor a pure speculative desire. It is a culturally produced effect—an effect of the agon of power—whose being foregrounds the paradox implicit in Spencer's theory that individuality is the product of

social evolution and Dreiser's representation of the relations of managerial capitalism as potentially conducive to this individuality: The ideal form of individuality is not the speculator's radical individualism, which threatens the equilibrium of the socioeconomic organism, or even the molecular self of laissez-faire; it is a subject constituted by the structural forms and discursive practices of the society it freely serves (a process described forthrightly by Talcott Parsons, whose sociology I discuss in Chapter 5). Spencer left the mechanism obscure when he envisioned as the subject's final stage, the "ultimate man," one who a priori conducts himself so as to serve society. This subject's motivation is no longer divine example, as it was in the Christian ethic that is so clearly Spencer's model, but a principle of moralized Darwinism by which ontogeny recapitulates social dynamics: "As surely as the tree becomes bulky when it stands alone, and slender if one of a group; . . . so surely must the human faculties be moulded into complete fitness for the social state; so surely must the things we call immorality disappear; so surely must man become perfect."[38] As I noted earlier, the evolutionist faith had not completely died out among the voluntarists.

It is a telling irony of the period that at the same time the individual was being reinterpreted as a socially constituted entity rather than a natural one, and Reconstruction was giving way to the doctrine of separate but equal, courts and legislatures were rethinking the legal status of corporations and declaring them natural, not artificial, persons subject to Constitutional protections, including those contained in the Civil War Amendments.[39] Carrie Madenda serves to obscure these changes in the concept of personhood by creating the illusion that individual success is propelled by a superior "emotional nature" (p. 398), that certain unrepresentable something of self. She thus appears to rescue the notion of individual character from the cult of personality fostered by the very constellation of consumer capitalism, advertising, and the entertainment business that produced her. When Carrie left Columbia City, she dreamed of making the city her "subject." The world does not disabuse her of her dream, since New York, Chicago, and

their theaters are not revealed as sites of illusion. The narrative's illusion is that Carrie succeeds when the "mysterious powers" have made her their subject. Her final role is as a name and a face invoked to demonstrate that "natural" powers benevolently guided do important social work.

In *Sister Carrie*, Dreiser produced a novel whose art—both the art of the novel and the art within the novel—supports his optimism. Its fiction of production suggests that the real production, even in the early stages of consumer society, is of representations. Through an artful use of the discourses of social science and transcendentalism to represent the new economic and social relations, Dreiser performed Ames's task: he elided the boundary between art and the market and made the prospect of serving the industrial apparatus self-actualizing by showing that desire, sublimated by imagination, is productive, and that its products are the things we should desire to possess. And he did so without making the distinctions among modes of consumption and expression that Ames makes. Art in *Sister Carrie* is, then, neither a critique of economics nor the transcendence of the economic and the completion of the social realm, even though at different times in the novel it appears to be offered as one or the other.

In this respect, the architecture of the novel resembles the structure of ornament on Sullivan's buildings, as I described it earlier. A still better comparison may be made to the architecture of another city, the 1893 Columbian Exposition, which Sullivan was to look back on as the point where the tide turned against democracy in architecture. The truth is more interesting. To many visitors the White City had the same compelling power Carrie found in the theaters of Chicago and New York. Even Howells, by that time a socialist, was deeply affected by its vision of the arts reunited for the first time since the Renaissance on a site cultivated with respect for the claims of nature. His unease was not with the architecture, but with the insistence of his Altrurian Traveller's Bostonian guide that the spectacle before them was the final fruit of competitive capitalism. The Altrurian answers with a reminder

that the American market was by then monopolistic and that so-cialism—the one great monopoly administered in the public inter-est—was capitalism's next logical development. Montgomery Schuyler's comments were more perceptive. He praised the White City as an architecture "festal and temporary"; it was not a new urban order but "a triumph of occasional architecture." Invoking throughout his "Last Words about the World's Fair" comparisons with the masque in *The Tempest*, and especially echoing Prospe-ro's warning against mistaking the golden world for everyday re-ality, he cautioned that this "most admired group of buildings" posed a danger to our actual cities if architects merely copied them instead of inquiring into the reasons for their success. The White City's purpose was utopian, Schuyler intimated. It was an image of a civic order restrained and enduring, unlike the city beyond the gates that was gripped by the panic of 1893 and soon to be torn apart by the violence of the Pullman strikebreakers. The City Beau-tiful movement that developed from the White City's success pro-moted a civic sense, but its aesthetic program had no effect on de-velopment or on a grossly inadequate housing stock. The often bombastic assertions of civic unity stood in need of Schuyler's cau-tion and even more of Herbert Croly's telling criticism that these plans sacrificed "on the altar of civic art . . . [the] proper character and vitality" of the nations' diverse cities.[40] Still, for its insistence on the importance of public space (a value missing from much modernist planning), the City Beautiful deserves respect.

Nevertheless, the White City was only half the Fair. If it pre-sented the associations of the refined and the ideals of the best kind of people—the values of the Progressive social theorist as Hender-son described them—there was on the Midway a representation (somewhat sanitized) of the diversity of life. The Midway's initial purpose had been edification; Harvard University professor F. W. Putnam, director of the Fair's Department of Ethnology, planned "to demonstrate an evolutionary movement of cultures and civili-zations toward the ideals of Western (and American) society." Mer-cifully, this racist display was never mounted as he planned. Al-though such messages remained present on the Midway (in part

through absences; except for the "Dahomean Savage" there was no black participation in the Fair), the focus of the Midway shifted. The atmosphere became more carnivalesque under the supervision of Sol Bloom, an entrepreneur who insisted that "a tall skinny chap from Arabia with a talent for swallowing swords expresse[s] a culture . . . on a higher plane than the one demonstrated by a group of earnest Swiss peasants who passed their day making cheese." Potentially postmodern in its "pastiche, collage, juxtaposition," as well as "the breakdown of distinctions between elite and popular culture," the Midway stood to the White City as the Waldorf-Astoria to the Metropolitan Museum of Art: as an expression of popular culture and its more sensuous enjoyments. Its world in miniature combined the Waldorf's celebration of consuming the world's many delights with Central Park's inclusivism, and it was not governed by a didactic ethnocentrism. Although he expressed reservations about the risqué *danse du ventre* at the Persian Palace, Schuyler himself praised the Midway as the Fair's true "cosmopolis."[41]

The space of the Fair thus inscribed but did not resolve competing codes of classes and cultures. Spatially, it maintained a hierarchy of tastes. The White City extended from just before the temporary railroad terminal to the ceremonial harbor entrance. The Midway extended west from the boundary of the main fairground, which was on a north-south orientation along the shore of Lake Michigan; most of it lay across the Illinois Central tracks. Still, if a map of the grounds asserted the centrality of the Court of Honor, the flow of patrons attested to the primacy of the Midway, a fact that has led critics to see two fairs in 1893.

Dreiser's novel, too, never resolves that conflict, which it represents as between Ames's vision and criticisms of conspicuous consumption, which the Vances conspicuously ignore, and the narrator's far more tolerant view of the social life of Chicago's and New York's resorts.[42] Ames speaks with cultural authority, but only for one point of view. What the novel and the Fair share, then, is a hope that the cultural and economic dislocations of the late nineteenth century would be subject to amelioration if the market and the city

could be preserved as a realm of self-creation while functioning efficiently for the general good.

This claim is different from, and more modest than, Michaels's claim to have uncovered in Dreiser's novel the secret "logic" of capitalism denied by the genteel tradition of oppositional criticism, a tradition that we have seen can also include James's *The American Scene*. Instead, I would say that Dreiser was responding to, and even reproducing the contradictions of, one historic phase of American capitalism. His response remains useful because the Progressive heritage is still with us and *Sister Carrie* allows us to explore the power and limits of the Progressive vision as it is offered by Ames.

Over the next decades the trend toward scientific planning would escalate. The aesthetic solutions of the City Beautiful—from the White City to Burnham's subsequent plans for Chicago, Washington, D.C., San Francisco, and Cleveland—gave way by 1912 to the technological program of the "City Functional" or "City Efficient." In the next chapter I turn to this modernist urban planning, much of which responded to the expansion and congestion of cities, their increasing economic instability and decreasing quality of life, with a discourse whose "dominant theme [was] that of a future into which the entire present is projected, of a 'rational' dominion of the future, of the elimination of the *risk* it brings with it."[43] In this way, as we shall see, it too often also eliminated the values of individuality and diversity, values to which Dreiser clung in their metropolitan, market-mediated forms. In the aftermath of such grand-scale attempts at urban restructuring, of which Hugh Ferriss's Imaginary Metropolis is representative and, in its intention, surprisingly humanizing, we may want to say of Dreiser's more modest proposal that despite the later evidence that his faith was misplaced—the natural equilibrium on which his market rested was a property of a preindustrial market; the evolutionary dynamic does not adequately represent human society—the novel's picture of the benefits of a corporate society was far from unusual and certainly more benign than many visions of reform in its use of that optimism.

Recentering the City

Hugh Ferriss and Urban Form

Use either no ornament or good ornament.
—Ezra Pound, "A Few Don'ts" (1913)

I

The Progressives had hoped to rationalize economic and political systems that resulted from unplanned development in the nation's industrial cities, while the City Beautiful planners endeavored to reassert civic values in public structures. The project on which this chapter will focus, Hugh Ferriss's Imaginary Metropolis, a rationally ordered skyscraper city constructed *ex novo*, sought not merely the reorganization of urban space, but its transformation—aesthetically, socially, and cognitively. Ferriss hoped to integrate art with science and business, but beyond that to see planners call on the resources of the human sciences to help the architect actualize "man's potentialities of emotional and mental well-being."[1] He carried forward the City Beautiful program of aesthetic intervention (while dissenting from its reflexive classi-

cism) to the extreme of what has come to be called total planning, while supplementing total-planners' technological, systems-oriented approach with attention to the city as a human environment. The result is, I argue, an instructive example of the limits of city planning.

The concern for rationalizing development and various modes of circulation within industrialized cities was, of course, a transatlantic problem. While Daniel Burnham was busy designing his City Beautiful downtowns, cityscapes learned from the nineteenth-century Paris of Baron Haussmann, French planner Tony Garnier was already engaged in a more scientific and broad-scope mode of planning; he first exhibited his plans for a *Cité industrielle* in 1904. Europe's great cities, even more than cities in the United States, had to undergo significant redesign in order to meet the opportunities and demands of new production, construction, and transportation technologies. World War I provided an unwanted occasion for the rebuilding of Europe, but on both continents migration to the cities and the rapid increase in the volume and types of traffic (private autos, commercial trucks, buses, streetcars, and subways) all traveling at different speeds had already demonstrated the inefficiency of street patterns determined decades or even centuries earlier and designed for pedestrians and animals.

With the professionalization of urban planning as a field of scientific analysis and its institution as an arm of municipal and regional government, the post–World War I generation of architects and planners undertook the rationalization of the cities. From Bauhaus functionalism to Le Corbusier's 1929 declaration that the straight line is man's way and must supersede the terrain-determined paths of preindustrial cities, and even to American poet Ezra Pound's 1928 declaration that cities must "follow the stream line" and support "the natural flow of the traffic," those who imagined the ideal form of the modern city saw something entirely different from existing cityscapes.[2] The more radical plans would erase a city's signs of history and ongoing life in order to begin over again with an ideal urban form. Le Corbusier's prototypical city of widely spaced cruciform towers was designed to pro-

duce a reasonable standard of housing in buildings whose height would give more of the ground back to nature, which led to its nickname, the "city in a park." The buildings' shapes and orientation were intended to maximize all units' exposure to natural light; their precise, ordered forms embodied the aesthetic of Purism he developed in collaboration with Amédée Ozenfant to express the values of machine civilization. In Germany, the Bauhaus designed worker neighborhoods throughout the 1920s. In 1928 it added a Department of City Planning directed by Ludwig Hilbersheimer, who had recently published a monograph, *Großstadtarchitektur*, that made the great city the focus of national planning because population and production concentrate there. In interwar Czechoslovakia, structures by Josef Gočar defined the new city portion of Hradec Kralove, completing work begun by his teacher, Jan Kotěra. No industrialized nation was without its plans.

Many of these planners preferred horizontal urbanism to the city of towers whose height was a sign of their modernity. Among the skyscraper-city planners, Le Corbusier was certainly the best-known polemicist for the extreme urban redesign predicated on a Progressivist faith in the application of technological solutions to the problems of improving public health and maximizing the economic efficiency of the industrial city. Aware of fears about the spread of political revolutions whose underlying causes he traced to the conditions of daily life among the working classes, Le Corbusier solicited the attention of financial and political leaders by advertising his "machines for living in" with the slogan "Architecture or Revolution"; that is, the architectural revolution of his *Ville contemporaine* (1922) or socialist revolt. His writing celebrates the authority of the engineer and the unsentimental forms of machinery. His particular contribution to the rationalization of urban life was his work "delimiting, classifying and standardizing" structures and their uses in order to arrive at "the absolute of the planned unit."[3] The virtue of such units and the city composed of them would be their infinite and inexpensive reproducibility.

At the Bauhaus, meanwhile, Walter Gropius and Bruno Taut had sought an architecture adequate to the new spirit of socialism

they hoped for. Briefly they turned toward glass, whose materiality and seeming immateriality they used as a symbol for the transparency of the subject with relation to the collective. By 1922, however, the Bauhaus program had abandoned romantic symbolism for the scientific objectivity predominant among the urbanist avant-gardes of the age. Constructivism was promoted as "a metaphor for the technological organization of society," not a critique of techno-bureaucratic instrumentalism. Hungarian Ernst Kallaí wrote without nostalgia that human unity with nature and the transcendent was irrevocably lost; "our paths," he declared, "run according to energies dominated by science and technology, organized by reason." The manifesto of the International Union of Neoplastic Constructivists likewise abandoned all responsibility to the claims of humanism or politics for the superior insights of technological reason. Expressing a sentiment not at all atypical of the time, Ilya Ehrenburg asked, "Can a cubist who constructs his paintings according to a rigorous equilibrium of forms and an impeccable interdependence of weight among the various colors breathe freely in a state founded on chance, the arbitrary, and anarchic confusion?"[4]

The Italian Futurists advanced similar arguments but celebrated the violence of modern life along with the virtues of machinery and speed. Antonio Sant' Elia's manifesto offers a reader the choice, "circulate or perish," as Reyner Banham has observed. Futurist rhetoric was designed to shock, nowhere more than in Sant' Elia's call to action, "Let us call a halt to monumental, funereal, commemorative architecture. Let us blow up monuments, pavements, porticoes, stairways, and sink the streets and piazzas." He could imagine a city only as a mechanism for supporting circulation in great volumes and at high speeds. His city would have streets that "plunge many levels underground and consolidate metropolitan traffic with interconnecting links to metallic cat-walks and high speed conveyor belts." The Futurists may have been the only avant-garde celebrating violent destruction, and they inevitably chose Venice as their example of a city that did not work and must be destroyed, but Le Corbusier's *Plan Voisin* would have leveled the historic core of Paris to replace it with a Radiant City, and the

Architectural Studio of the Construction Section of the Mossoviet proposed the simultaneous rationalization of the capital and eradication of the Czarist past by restructuring the center of Moscow and decongesting the city through a series of satellites.[5]

England had no equivalent urbanist avant-garde, though it was home to the Vorticists. Two of them, Wyndham Lewis and Ezra Pound, commented regularly on the direction of modern architecture and urban design. Lewis may have been seen to exempt architecture from the modernist fascination with movement when he wrote in *Blast* that "a machine is . . . a living thing. Its lines and masses imply force and action, while those of a dwelling do not"; four years later, however, he brought architecture within the Vorticist field of energized form. Demanding of architects, "Where is your Vortex?", he denigrated the "static cell-structures in which we live our lives" and called for artists to become active in the design of new building forms. Pound, to whose aesthetic I will return in order better to place Ferriss's own aesthetic within the field of modernism, wrote on New York's architecture as early as 1913, when he made the claim, surprising in light of his later politics, that "the beautiful leaf" of the city's architectural achievements has been fostered—not hindered—by the interests of commerce. That essay's criticism is impressionistic. Fifteen years later Pound placed himself in the main currents of modernist planning; he entered as his solution to a "perfectly clear engineering problem" a configuration of towers of "great Ls grouped at the apex of the city," rising 30 or 40 stories in the business district. They would house 2,000 offices and have below-ground parking for 20,000 autos. Pedestrians would avoid being run over by using the footbridges provided on every tenth or fifteenth floor. In the residential quarter, buildings would rise only ten or twelve floors; he imagined them making liberal use of loggias and with tennis courts beside each building "in the concave side of the L."[6]

What Britain had instead of an urban avant-garde was a New Towns program under the direction of Raymond Unwin, Chief Architect for Building and Town Planning in the British Ministry of Health. First proposed by Ebenezer Howard at the turn of the

century, the new towns, or garden cities, were conceived as self-contained centers of population large enough to support industry but small enough to avoid the problems of congestion and alienation for which cities were attacked. Surrounded by "greenbelts" of undeveloped land and farms, they would be incapable of expanding outward to house populations larger than 30,000 people. (Some theorists proposed grouping them around a larger city—though nothing as large as New York, London, or Chicago—to take advantage of the greater diversity of life and interests to be found there.) The Regional Planning Association of America was instrumental in introducing the garden-city concept to the United States; its most important members included architects Clarence Stein and Henry Wright, and essayist/cultural critic Lewis Mumford. Mumford in particular polemicized in favor of the garden city as an organic form of planning, deploying metaphors learned not from Howard but from the Scots botanist turned garden-city advocate, Patrick Geddes. Opposing biological metaphors to the technological rhetoric of the age, Mumford's defenses of the garden city and attacks on the great city were an integral part of his antimodernist cultural history of cities, in which urban development since the Middle Ages is a falling off from a time when "the city was the center of organized intelligence."[7] I will return to Mumford's arguments against cities in general and Ferriss in particular throughout the chapter.

Thus the international scene. Ferriss was not alone in the United States, of course. Raymond Hood, probably the best of the 1920s American skyscraper architects despite the brevity of his career, and Harvey Wiley Corbett, perhaps better known as a polemicist for skyscrapers than as an architect, were only two of the designers with whom Ferriss often worked. Henry-Russell Hitchcock and Philip Johnson were instrumental in introducing the new architecture to an American audience through their International Exhibition of Modern Architecture at New York's Museum of Modern Art (1932) and their accompanying text, *The International Style*. However, they dissented from the strict technological program followed

by many of the Europeans; Hitchcock and Johnson asserted in their primer that the "new conception, that building is science and not art, developed as an exaggeration of functionalism" and is not entailed by any of functionalism's premises.[8] Ferriss, too, we shall see, distrusted the functionalist ideology.

Well respected in his time as a skyscraper-city theorist, Ferriss published his comparatively gentle manifesto for a new urbanism, *The Metropolis of Tomorrow* (1929), at the height of his influence. His text opens in the "Cities of Today," with a portfolio of sketches of recent American buildings accompanied by commentary that explains their significance for the future of architecture and planning. These drawings preface his discussion of projected trends in architecture, which includes his major contribution to interwar urban design, a set of drawings executed in collaboration with Corbett to interpret the practical maximum volumes allowable under New York's 1916 zoning law. The book concludes with studies for "An Imaginary Metropolis," in which trends Ferriss earlier discerned are applied to the work of producing a livable skyscraper city.[9] In devising his Imaginary Metropolis, Ferriss went beyond practical design considerations and the technologic order embraced by the avant-gardists who, like Kallaí, believed in nothing beyond scientific reason. Ferriss also went backward, because he sought not only a modern architecture responsive to new construction technologies but the recovery of an organic unity he postulated as once having existed among signs, men, and societies.

Ferriss has since fallen into obscurity, in large part because *The Metropolis of Tomorrow* had the misfortune of being published shortly after the stock market crash—and just over two years before the International Style's American debut at the Museum of Modern Art. However, an exhibition of his work at New York's Whitney Museum, the publication of a selection of his works, and the reissue of *The Metropolis of Tomorrow*, all during the Reagan years and the brief ascendancy of "postmodernist" architecture, revived his oeuvre—if not his reputation—in a climate in many ways reminiscent of the 1920s.

A native of St. Louis, Ferriss studied architecture at Washington

University and came to New York after earning a B.S. in 1911. He worked for Cass Gilbert from 1912, when the Woolworth Building (1910–13) was under construction, until 1915. Despite his training, Ferriss became an architectural renderer, or delineator, whose job was to make presentation sketches of buildings. Although Gilbert's great skyscraper was "the first building [Ferriss] ever had occasion to draw from blueprints" (see Figure 4), this good fortune became the catalyst for his disenchantment with contemporary design practice. Initially fascinated by the New York skyline, he would later recall that

> In time . . . doubts arose. The Woolworth Building inevitably caught the eye; it was fascinating, at the time, to see and to draw. But is there anything really Gothic about an American office building? Wasn't the paradox as obvious as the nickname "Cathedral of Commerce"? The notion of a truer union between purpose and appearance refused to be laid aside, and one day I said to my boss that maybe I could do better in some small studio all by my self.

Like Henry James, Ferriss did not fully consider the broader cultural implications of this American absorption of Europe's architectural past, which I argued in Chapter 1 was part of the larger significance of turn-of-the-century architecture. The tower that Montgomery Schuyler enrolled among "the rarest achievements of modern architecture" was to Ferriss but more evidence that his contemporaries shrank from the specifically aesthetic problems posed by the tall building.[10] The use of decorative allusions to campaniles and cathedrals was, he thought, an attempt to invest commercial property with an undeserved aura when architects ought to inquire into what the spiritual content of a modern office building might be.

After setting up on his own, Ferriss got another break when he collaborated with Corbett on the zoning law portfolio. The law had been written to ensure the presence of light on, and open space above, streets in business districts; the 40-story wall of E. R. Graham's Equitable Building (1912–15) unintentionally became convincing evidence of the need for zoning restrictions. Ferriss greeted the law as an opportunity for architecture to exist again in three

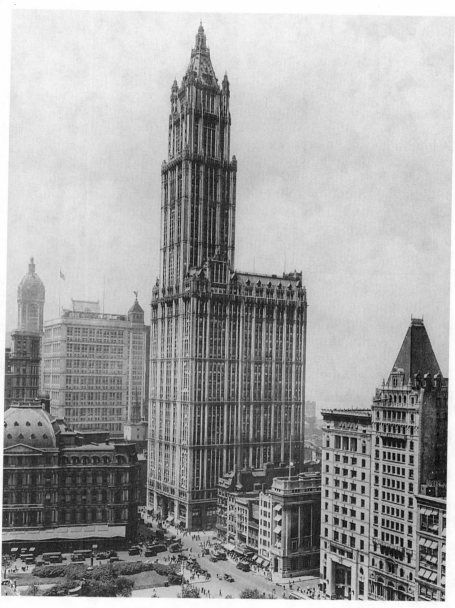

Figure 4. Skyscraper Gothic: *Woolworth Building* (1910–13). Cass
Gilbert, architect. Museum of the City of New York.
Gift of Leonard Hassam Bogart.

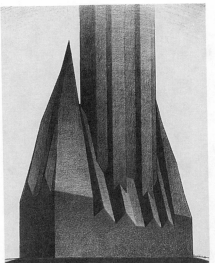

Stage 1 (DP 1969-137-1).

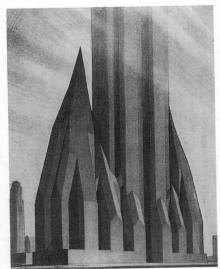

Stage 2 (DP 1969-137-2).

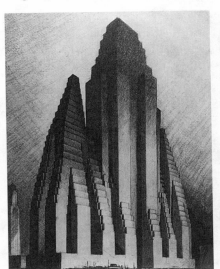

Stage 3 (DP 1969-137-3).

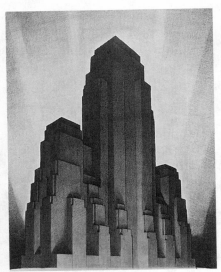

Stage 4 (DP 1969-137-4).

Figure 5. Hugh Ferriss, *Study for the Maximum Mass Permitted by the 1916 New York Zoning Law*. About 1925. Carbon pencil, brush, and black ink, stumped and varnished. 67 × 51 cm. Gift of Mrs. Hugh Ferriss. Photo: Scott Hyde. Courtesy of Cooper-Hewitt, National Design Museum, Smithsonian Institution / Art Resource, N.Y.

dimensions, because its "set-back" formula determined a building's maximum height as a percentage of the width of the street in front of it, extending that maximum at a ratio of from one-half foot to five feet, depending on zone, for each foot the building or a portion thereof was moved back from street line. Ferriss and Corbett's four sketches trace the process of making the legal envelope into a usable space (see Figure 5). By demonstrating how a functional office building could be formed within the envelope, the designs transformed the statute from a restriction into a new set of architectural possibilities—with a new set of historical precedents—for the years before Mies van der Rohe and Philip Johnson's Seagram Building (1956–58) ushered in the postwar rage for the autotelic glass-and-steel slab Gordon Bunshaft once described approvingly as "a building that stands in the center of space with space all around it."[11]

Ferriss read the 1916 law as a demand that architecture respond to social needs. He hoped that the "absence of ornament" from the sketches' "buildings in the rough" would support the reemergence of architecture's progressive potentialities by serving as "a recommendation" for the reunion of exterior forms with structural programs (p. 80). He believed that once architects became sculptors rather than scene painters and applied decoration gave way to a new organicism of the sort he had learned from Sullivan's theory of the tall office building, the buildings would become organic expressions of the culture in which they were produced. Toward this end, he devoted his practice to depicting what he called the "Truth" of buildings. Opposed to the "snail's eye view" that moves brick by brick, ornament by ornament, over a surface, Ferriss drew to capture the image (in Pound's sense of an intellectual-emotional complex) that a "building itself produce[s] in the mind" of a "thinking, two-eyed man."[12] His renderings therefore concentrate on aspects of architecture that are, in his words, "powerful agencies in determining the nature of [people's] thoughts, their emotions and their actions" (p. 16).

If Ferriss was keenly interested in the spiritual presence and moral agency of architecture, his skills were in demand because

developers recognized his drawings' value in the marketing of their plans. Some of his champions—and detractors—went so far as to claim that his drawings became models for architectural design. Claude Bragdon wrote that Ferriss "has served his masters so well as to himself enslave them, in that they manifest an increasing tendency to make their buildings look as much as possible like his imaginative drawings."[13] However, these occasional aesthetic agreements never mitigated Ferriss's dismay over the results of speculative development. While he never produced a sustained analysis of the failings of 1910s and 1920s architecture, from comments he made throughout his career it is clear that Ferriss found the decorative reuse of period styles unmoored from the cultural milieu they once expressed (were he writing today, he might have called them "floating architectural signifiers") and the deployment of conventional shells to conceal structural innovations convincing evidence of architecture's failure to represent the spiritual and material realities of the day. In a wry moment, however, he revised that criticism by conceding that perhaps "Architecture inevitably expresses its Age correctly," showing "both the characteristic structural skill and the characteristic urge—for money" (p. 16) that defined the period.

His claim is worth pursuing, given the activity, even hyperactivity, of the real-estate market that produced New York's skyline. In 1929, Hood explained that a "vicious circle" at work throughout the decade assured that transportation improvements in the city would only further congestion because "as soon as real estate operators learned there was to be a subway along Eighth Avenue land values in the vicinity leaped skyward. While subway engineers were digging under the street, other engineers were sinking building foundations alongside. . . . The subway is still a long way from completion but rows of tall buildings have grown up along the route, many of them already occupied."[14] If the construction boom had commenced in response to a real need, a vacancy rate below 6 percent for office space in the early 1920s, the 92 percent increase in space by 1929, supplemented by another 56 percent increase from buildings completed after the crash, was out of proportion to immediate need.

Even the Waldorf-Astoria quickly became outmoded. Refurbishment in 1924 had not been enough; making the Waldorf truly modern again meant starting from scratch, building it bigger, and moving it uptown. An advertisement announcing the next occupant of the old hotel's site neatly encapsulates the history of urban development in New York to 1931. It begins with the sale of twenty acres to John Thompson in 1799 for $2,500. The land was next held by a Charles Lawton, who bought it in 1825 for four times that amount and resold it in less than two years to William B. Astor, John Jacob's son, for $25,000. The Astor mansions subsequently built there gave way to the Waldorf and Astoria Hotels in 1893 and 1897, respectively. Finally, in 1931, "the EMPIRE STATE, an office building, [would take] its logical position on this site. A building designed to be a worthy follower of its historic predecessors—in dignity, in size, in beauty of architecture and in efficiency of service to the great business population that will occupy it." For four decades it would be the world's tallest building.[15]

This advertisement suggests that the land speculation of the 1920s (nearly seven million dollars' worth of construction bonds were sold during 1925 alone) was not exactly a new phenomenon, and it indicates the extent to which developers in New York, as elsewhere, cultivated individual sites with little regard for the relation of new buildings to their surroundings. A highly successful contractor, Colonel William A. Starrett, explained that in such an overheated market one need not even build in order to profit: If a developer purchased a lot and commissioned an architect "to draw him an imposing picture of a skyscraper," rumor of the project would have "fifty brokers . . . waiting in the promoter's office [the next morning] to ask him if he wants to sell. They have no purchasers in view, but are confident of finding such."[16] The key element in such ventures is the sketch of an "imposing building." While applied decoration was often used to signal a developer's willingness to spend lavishly to attract tenants desirous of a distinctive address, a Hugh Ferriss rendering had no less cachet.

The result of this confluence of interests was an architecture with little sense of urban form. When architects did consider their work in relation to other buildings, their concern was often to over-

top rivals; thus, Irwin Chanin built his 56-story Chanin Building (1926–29) on 42nd Street and Lexington Avenue to overshadow his rival Fred French's French Building (1927), which briefly dominated the midtown skyline from Fifth Avenue and 45th Street. (Although shorter than the Woolworth Building, at the time New York's tallest building, the Chanin squeezed more floors into its frame.) In 1930, William Van Alen's Chrysler Building rose across the street from the Chanin. The Chrysler easily dwarfs its neighbor and the Woolworth, but it found its rival downtown in the Bank of Manhattan Building (1930) designed by Van Alen's former partner, H. Craig Severance. Severance sought to top Van Alen by placing a lantern and 50-foot flagpole atop his 71-story structure. Van Alen resorted to stealth, erecting the Chrysler's 185-foot spire in the building's fire shaft and raising it only after construction had ceased at the Bank of Manhattan. But Van Alen's reign lasted less than a year; Shreve, Lamb and Harmon's Empire State Building was completed in the spring of 1931, topped by a mooring mast for dirigibles. The mast, used only twice, was defended from functionalist critics by Hood, who noted that "it pays its own way" by bringing a million dollars a year in tourist revenue to the building. Rem Koolhaas, without equal as an interpreter of New York's architectural (il)logic, suggests that the Empire State's port-in-air "resolves Manhattan's paradoxical status as a city of landlocked lighthouses" like the Bank of Manhattan, Ernest Flagg's Singer Building (1905–08), Napoleon Le Brun and Son's Metropolitan Life Tower (1909), and Warren and Wetmore's Consolidated Gas Building (1926), all of which are topped with beacons.[17]

Such was the architectural milieu in which *The Metropolis of Tomorrow* appeared in 1929. Its first section closes with the Chanin, Chrysler, and Bank of Manhattan Buildings (pp. 50–55), and a call for architects to expand the scope of their practice and create a visual and functional unity out of the chaos into which the fetishizing of individual structures had thrown the city. Ferriss returned to this theme in the 1950s, when he recalled how, in the skyline of the 1920s, "the uprearing shafts of the Wall Street skyscrapers, each oblivious, so to speak, of its neighbors, each seeking the ascendancy, seemed monuments to the 'rugged individual-

ism,' the *laissez faire*, the unbridled competition of a period. Their gilded spires and topmost, unoccupied floors seemed an architectural record of rampant advertising and conspicuous waste. . . . Of a relationship between individual building and the community, there was hardly a trace." This indictment of architectural fashion, buildings as commodities, speculation, uneven development, and individual will exercised at the expense of collective needs might seem to be Ferriss's palinode for his optimism in *The Metropolis of Tomorrow*. Indeed, he sounds like his frequent antagonist, Mumford, who dismissed the Imaginary Metropolis as "painfully childish romanticism," as he had earlier called the "Titan City" a plan to sacrifice lives to commerce "on a scale that would make Moloch seem an agent of charity."[18] Yet, Ferriss had been sounding these themes since well before he published his utopian vision.

II

To this point, I have treated Ferriss's argument that architectural design in the period was almost entirely an aesthetic effect of underlying economic causes. Placing Ferriss's program within modernist aesthetics requires that I look at his aesthetic as a mode of cultural criticism contesting the legitimacy of existing economic and social relations and attempting to reconstitute society on a basis more secure than historical accident. For most American architects of the 1920s, the best means of resisting the compartmentalization of individual life and the loss of cultural memory lay in a mode of individualistic expression that architect and educator Lewis Pilcher heralded as "distinctively American . . . [and] *nonstylistic* because each architect is individual and progressive in his designing and it constitutes a *type* that satisfies the aesthetic, social and economic demands of the time."[19]

As an example of the new designs, consider the Chrysler Building, Gothic in its spire and gargoyles, contemporary in its corner windows, and blatantly commercial in the use of automotive—specifically Chrysler—symbolism as a design element (see Figure 6). Tellingly, Ferriss's sketch in *The Metropolis of Tomorrow* censors the pastiche of ornamental innovations that makes the

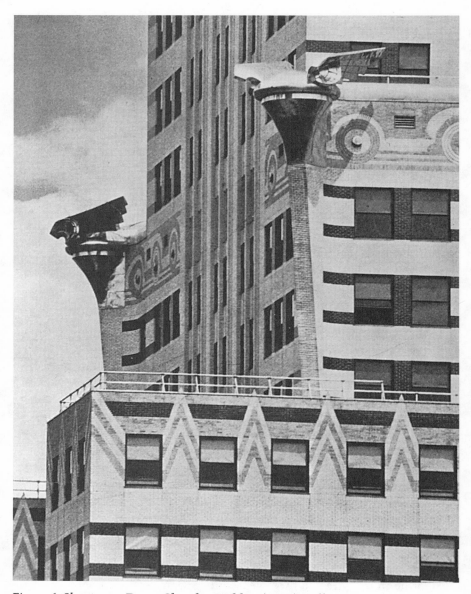

Figure 6. Skyscraper Deco: *Chrysler Building* (1930). William Van
Alen, architect. Photograph by Sigurd Fischer. Art and Architecture
Collection, Miriam and Ira D. Wallach Division of Art, Prints,
and Photographs. The New York Public Library.
Astor, Lenox, and Tilden Foundations.

Chrysler Building a unique expression of its time (see Figure 7). He rendered only its "extreme" height, while the accompanying text alludes cryptically to "many novel effects" other than "the fenestration and brickwork" that "the architect has ingeniously produced" (pp. 52, 53) and the artist suppressed.

Ferriss had a different, though no less canonically modernist, understanding of the artist as an instance and agent of spiritual and cultural reintegration. He expressed that unity through a gendered allegory of artistic creation in which a dialectic of "feminine" receptivity and nurturance with a "masculine" conceptualizing power enables the artist to express the spirit of his age rather than his own personality. The feminine is iconographically present in what Koolhaas calls the "Ferrissian womb," the chiaroscuro background of the drawings. This womb, he argues, functions to "blur the issue of paternity" by "absorb[ing] . . . any number of . . . influences" that are "effortlessly accommodated" because, as the Chrysler sketch shows, Ferriss's carbon pencil could not reproduce the surface details that "preoccup[ied] Manhattan's architects."[20] Only by effacing these individualistic signatures could Ferriss address what he considered architecture's paramount task for the coming decades, reforming the city of private towers into a "strong and unified" space (p. 22).

The second plate in "Cities of Today," a view of the St. Louis Plaza (p. 23), is *The Metropolis of Tomorrow*'s first practical statement of this theme (see Figure 8). A late City Beautiful plan for a municipal center consisting of a city hall, a library, and a courthouse disposed around a central plaza, it is the only collaborative effort discussed in the text. Ferriss's comments address not the architecture of the individual structures, but two lifelong preoccupations that were indeed hallmarks of the City Beautiful: collaborative design and the effort to create "a plainly apparent nucleus" for cities (p. 22). Concentrating on the ensemble rather than the individual components, he turned his description of the Plaza into a promotion of his craft without mentioning renderers or delineators. Instead, he explained the job of the "visualist, whose commission is to analyze, assemble and depict, as one project, all the contributory ideas of a large commission of architects." No matter

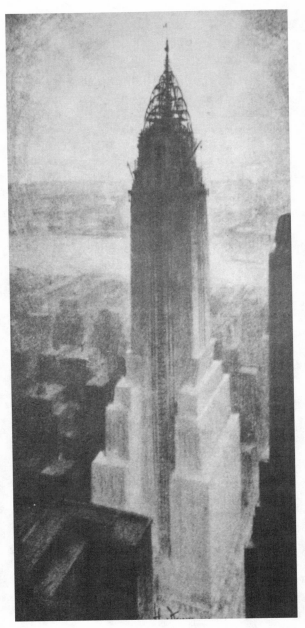

Figure 7. Hugh Ferriss, "The Chrysler Building." *The Metropolis of Tomorrow* (1986 edition, Princeton Architectural Press).

Figure 8. Hugh Ferriss, "St. Louis Plaza." *The Metropolis of Tomorrow* (1986 edition, Princeton Architectural Press).

how distinguished the architects, it is left to the "visualist" to draw from them the sort of "startling satisfactory results . . . occasionally produced by the individual mind working alone" (p. 22). The "Ferrissian womb" is thus a mental space in which the renderer absorbs the seminal ideas of the individual architects in order to be both mother and midwife of a form he alone begets. Other womb figures occur at strategic points in the text as provocations to creation; they are filled by skyscrapers that display the phallic strength and unity of, for example, Corbett, Harrison and McMurray's Master Building (New York, 1929), whose exterior color grading "suggests a kind of growth" (p. 34), or Hood's Radiator Building (New York, 1924), whose shaft and bold gold crown Ferriss considered "distinctly virile" (p. 28).

Two textual wombs in *The Metropolis of Tomorrow* dramatize most effectively the architect's heroic capacity to impose order on chaos. The first is the Biblical womb in which the text begins: "an early fog" in which, "literally, there is nothing to be seen but mist; . . . there is not a suggestion of either locality or solidity." As the mist lifts in the text's final section, the "cloud-capped towers"

Figure 9. Hugh Ferriss, "Lobby of the Daily News Building."
Raymond Hood, architect (1929). *The Metropolis of Tomorrow*
(1986 edition, Princeton Architectural Press).

(p. 15) that emerge—Ferriss quotes Shakespeare's great visualist—
orient the scene along the coordinates of a Cartesian grid. The
most striking womb focuses Ferriss's treatment of Hood's Daily
News Building (New York, 1929), which repeats the Biblical womb
even more theatrically (see Figure 9). What interests Ferriss about
this building is not the massing or the exterior striping that most
critics discuss, but the lobby's centerpiece:

A CIRCULAR SPACE 150 feet in circumference,—to be enclosed by a wall
of black glass which rises, unbroken by any windows, to a black glass ceil-
ing; in the center of a brass-inlaid floor, a cup-shaped well from which
light—the sole illumination of the room—is to stream. Bathed in this
light, a ten-foot terrestrial globe is to revolve—its even revolution reflected
darkly in the night-like ceiling above,

inviting us to experience for ourselves the "sense of large actuali-
ties" (p. 38) the scene represents. The scene is a myth of origins
familiarly gendered: the earth as an egg in the black womb of space
raised to life by a luminous stream of sperm. In the words of the
text and the iconography of the drawings the womb signifies primal
chaos, a potential world awaiting the form-bringer's intercession.
The artist is thus hermaphroditic. The womb from which creation
springs is within him, but it is also around him.

Intentionally or not, this introjected womb also mythologizes
the exclusion of women from the sphere of cultural production by
representing architecture (always, for Ferriss, a synecdoche for cul-
ture) as a discourse made and remade by men alone. When, after
World War II, Ferriss figured architecture as a feminizing response
to a too-thoroughly masculine discourse of science, he recuperated
the feminine as a necessary property of the complete man. This
gendering of creativity is by no means unique to Ferriss among
male modernists. Pound argued that mind fertilizes mind directly;
he speculated in his postscript to Remy de Gourmont's *Physique
de l'Amour* that the brain is "a great clot of genital fluid held in . . .
reserve." William Carlos Williams, among the many writers of his
generation (not all of them male) influenced by Otto Weininger's
tract, *Sex and Character*, defined male and female as "an engender-
ing force and a definite point of action." These models are more

than metaphors; each of these artists used the biophysics of pro-
creation in his effort to define an artistic practice that in its very
forms would be a criticism of the artificiality of the consumer cul-
ture that was regarded as women's domain. Thus, the typical Fer-
riss sketch, which recalls Pound's description of "the symbolism of
phallic religions, man really the phallus . . . charging, head-on,
[into] the female chaos," is also an heraldic device for the modern
architect confronting the city of his time.[21]

So much for the banner under which Ferriss marched. I turn now
from his self-construction as an artist to his depiction of his cul-
tural mission. In most familiar images of the artist as agent of cul-
tural reunification, he (our canonical high-modernist is all but in-
evitably male) wills a coherence out of the fragments that are all
that remains of an earlier, healthier culture; think of Pound gath-
ering the limbs of Osiris in 1912, or T. S. Eliot shoring fragments
against his ruin a decade later. Rather than becoming a manipula-
tor of luminous details and radiant gists, Ferriss pursued a new
wholeness in urban design, a response certainly influenced by the
fact that, as we have seen here and in earlier chapters, fragments
were already being shored in the dominant commercial practice of
recirculating floating architectural signifiers—without the poets'
regard for the historical rootedness of their aesthetic value, and
thus with ruinous consequences, Ferriss maintained.

This denunciation implicitly genders ornament. If in Ferriss's
estimation the Master Building and other skyscrapers whose ap-
pearance is the result of design choices are virile males, then in the
logic of modern asceticism from Veblen's critique of the deliberate
uselessness of women's attire forward, decoration is feminine.[22] Be-
hind this gendering is a moral critique that assumes an excess of
ornament conceals a flawed character, as well as (especially in
Pound's case) a need to assert art as a masculine pursuit in a culture
that did not value it as such. Like Veblen, Pound and Ferriss also
used this gendering as a reason to ignore ornament and used art to
intervene in the "male" world of economics.

While I doubt that Ferriss was deeply familiar with Pound, and
his comments are wholly without the poet's frequent paranoia and

anti-Semitic venom, their common economic-aesthetic conver-
gence, their promises of aesthetic solutions to social crises, is rea-
son enough to read Ferriss alongside Pound for the purpose of defin-
ing his position within modernist aesthetics. Pound had equated
false metaphor and ornamental metaphor as early as 1915. When
he later declared in favor of the monogamy of the signifier in "Na-
tional Culture: A Manifesto 1938"—"It is a time for clear defini-
tion of terms. . . . It is not a revolution of the word but a castiga-
tion of the word"—the context was his decades-long polemic that
blamed the financial and *rhetorical* practices of the "usurocracy"
for, among other things, the degeneration of art into marketable
kitsch in which an overlay of ornateness covered for a lack of sub-
stance. Nearly two decades earlier, he had lamented the loss of the
"profound psychological knowledge in medieval Provence" that
was once "carried into early Italian poetry," but had "faded from it
when metaphors became decorative instead of interpretative."[23] In
later years, Pound needed only to juxtapose the loss of cognitive
content in metaphor with the simultaneous rise of the Italian com-
mercial city-states to make his economic argument.

The conflation of finance and signification enabled both Pound
and Ferriss to ascribe to the market the blame for the demise of
art and to claim for modernist aesthetic speculations the power
to redeem art and the social order. Coincidentally, Pound began
Canto XLV, the famous Usura Canto, decrying usury's effects on
architecture, which he used as a synecdoche for all social and cul-
tural construction:

> With usura hath no man a house of good stone
> each block cut smooth and well fitting
> that design may cover their face,
> with usura
> hath no man a painted paradise on his church wall,

and he went on to reiterate his theory of the visual arts' degenera-
tion: "with usura the line grows thick."[24] Ferriss, the delineator,
was as concerned with the purity of the architectural line as Pound
was with poetic, painterly, and musical lines. As we have already
seen in his drawings, Ferriss sought to restore the line to its clarity

by omitting the ornament that distorted the meaning of the past through repetition of its forms emptied of their original significance and hid the truths of modern construction beneath nostalgic facades. The rehabilitation of the line promised the restoration of a lineage for both Pound and Ferriss. If the articulation of capitalism and the arts were redefined, architecture would be made new as period styles became expressions of the best qualities of their times, and architectural historians would be left to read cultural evolution as it is embodied in architectural forms.

For both men, the cure for ornamental obfuscation was right naming in a pictorial language that would reunite signifier with signified. Ferriss's building-as-hieroglyph, like Pound's ideogrammatic poem, was to be the image of an idea. Ferriss traced to his youth his preference for this sort of symbolic architecture; he relates having been entranced by a picture of the Parthenon because even its ruins immediately reveal the structure's religious function. Later, he found in Gothic cathedrals, by some standards highly ornamented structures, a form that beautifully fulfills a spiritual function—"not so much to house a particular historic church as to exert, in terms of form and space . . . , an influence for the betterment of mankind" (p. 61). (Lest an emphasis on spirituality seem premodernist, recall that theosophy and the teachings of Gurdjieff, whose colony the Ferrisses visited, had a profound effect on a number of modernists, including H.D., Jean Toomer, W. B. Yeats, and the Suprematist and de Stijl painters.)

III

Ferriss's way beyond the ransacking of the past was to imitate an earlier American architectural practice, rather than to copy its forms. He noted that "our forefathers had erected, in New England and elsewhere in the colonies, buildings that plainly showed the stuff of which they were made, how they were put together, and what purpose—farmhouse, town house or meetinghouse— they were to serve." His counterexample from early New England is motivated by desire for an "honest" American architecture.[25]

Like the Parthenon and Gothic cathedrals, the early–New England vernacular presented to him a unity of form and meaning from which the institutionally accepted and commercially successful architecture of the 1920s was a falling off: They declare the materials of which they are made without concealment or ornamental overlay; their forms reveal structural functions; designed from the inside out, they denote the need they were built to satisfy—to provide a structure for the religious, civic, or familial spirit to dwell in.

His chosen example of honest architecture is an index of his moral economy of representation. Choosing to ignore the use of historical styles to celebrate America's rise to preeminence among western nations, he wondered instead "how many idle Corinthian columns—'engaged columns' supporting nothing—artists were called upon to delineate between 1920 and 1929," and why "banks pretending to be temples, skyscrapers pretending to be cathedrals, Madison Square office buildings pretending to be Venetian campaniles all were getting gold medals" for their attempts to bestow unearned dignity on the new structures and their occupants. He stated the ultimate stake of his preference for a functional aesthetic most succinctly in "Technology and Vision," a 1952 article that declares, "What makes great buildings great is not their appearance, attractive as it may be, but the fact that their appearance is the outward and visible sign of an inward and architectural reality."[26] This statement encapsulates Ferriss's metaphysics of the sign. For, by privileging reality over appearance (which deceives when false cathedrals and campaniles claim a dignity and authority the occupants cannot command, or when steel-framed buildings pander to outmoded ideas of solid construction by deploying idle columns or forgoing the option of corner windows), Ferriss took the side of ontology and theology, Being and presence, over the play of representation; the side of the signified and referent as the content and origin of the signifier in his understanding of the sign, which he gave human form in the relation of body (outward form) to soul (contained reality); and even the side of the particularity of use value, what an object is and exists for (as, indeed, what an architect, what Man, is and exists for), over the commensurability of

exchange value favored by developers and commercial architects. His distinction between sculpting and scene-painting (that is, between buildings that show their inward, structural qualities and those whose two-dimensional facades are false fronts), and his use of "deception" and "decadence" to condemn applied decoration make his neo-Keatsian credo, "structural beauty [cannot] exist without truth" (p. 60), a moral mandate for subordinating form to function.

Recourse of this sort to a metaphysical base for functionalism, like all forms of foundationalism, has been rigorously critiqued in the wake of modernism. Semiotic theories like Ferriss's, and their articulation with economics, have been deconstructed. The universalism his appeal to Truth entails has been challenged by critics ranging from the early urban sociologists to postmodernists, all of whom rightly contend that the particular (if unrealized) virtue of cities is their concentration of differences, the diversity of communities with which one may simultaneously be affiliated. For these strong pluralists, losing one's center, not gaining it, is the greatest virtue of urban life because it allows one's self (or "spirit" in Ferriss's terms) to develop through the negotiation of complex experiences not imaginable in a landscape of sameness.

A particularly disabling critique of functionalism engages its practitioners' attempts to link it with spirituality; it argues that functionalism has "nothing to do with pleasure, with beauty (or horror), whose nature is conversely to rescue us from the demands of rationality." Modernist functionalism is, as the Constructivists maintained, an architecture of Enlightenment, which seeks "the disenchantment of the world; the dissolution of myths and the substitution of knowledge for fancy."[27] One of its effects would be a reduction in the range of beliefs and cultural practices a city so designed supports.

Functionalism was not always so strictly defined as to eliminate concern for the power of buildings to affect the viewer or occupant. As I noted earlier, Hitchcock and Johnson argued in *The International Style* that the idea of architecture as science, not art, "developed as an exaggeration of the idea of functionalism." Responding

to "stringent" functionalists who dismissed aesthetic concerns as a remnant of a nineteenth-century ideology of the beautiful, and who thought the real issue in judging a building was whether or not it fulfills its practical purpose, Hitchcock and Johnson, like Ferriss, proposed a more "elastic"—more humanist—definition of functionalism that preserved architecture as a subject for aesthetic study by distinguishing between ornament applied after the fact from the aesthetics of the design process. In their formulation, *ornament* designates any merely decorative commodity; *design*, on the other hand, names the organic result of an architect's free choices in the course of articulating a plan that embodies a conceptual beauty. *Ornament* is secondary, a supplement that distorts a building's true being; *design* comprehends those unadorned forms whose denotative contents are the actual construction techniques and intended use of a building. In its "elastic" definition, functionalism embraces any style in which "aesthetic expression is based on structure and function," as it arguably is in Gothic cathedrals as well as classical temples.[28] Still, any discussion of use, certainly in non-industrial buildings, inevitably confronts the beliefs and hopes of occupants unless those matters, too, are judged unscientific.

Ferriss remained adamant about the necessity of accounting for psychological needs throughout his career, which required him to add to Louis Sullivan's dictum, "Form follows Function," a moral charge not obvious in the original. But as we see in the Imaginary Metropolis, the spirit is weak though the materials are virile: the spirit Ferriss would defend is itself the product of a rationalization. For his dressing-down of the architectural signifier (like Pound's castigation of the word) to curtail its circulation, it has to be possible to strip the connotative excess that cloaks the naked truth of denotation and to show that any functions served by the "merely" connotative are unnecessary, later additions to the originary linkage of the sign to the physical or psychological reality it signifies. Ferriss upset these oppositions when he expanded the scope of "functionalism" to comprehend spiritual needs in addition to the "stringent functionalist" minimum of physical requirements.

While there may be determinable minimum daily requirements for the body, the assumption of a universal knowledge of the soul capable of discriminating true needs from mere desires would eventually be modernism's greatest liability.

Jean Baudrillard critiques such appeals to function at a more fundamental level. Working analogically from Roland Barthes's definition of denotation as "the *last* of the connotations . . . , the superior myth by which the text pretends to return to the nature of language, to language as nature," Baudrillard defines use value as the last of an object's potential uses, the one that completes the economic system by returning it to the nature of things. He locates the origin of "human needs" not in use but in the system of exchange itself, by means of which an individual produces himself or herself. Needs are not defined once and for all time by the nature of Man; for, as an individual's need to speak assumes the existence of language as a medium of verbal exchange, so too, "consumption does not arise from an objective need of the consumer." It begins with "social production, in a system of exchange, of a material of differences, a code of significations and invidious . . . values." Rather than an unmediated need determining the utility of an object, "the functionality of goods and individual needs only follows on this [system of distinctions produced by the possibility of exchange], adjusting itself to, rationalizing, and in the same stroke repressing these fundamental structural mechanisms." If needs are something induced in the subject by the logic of exchange rather than some preexisting biological minimum, then the explanation of need comes to look strikingly like the explanation of desire offered by Theodore Dreiser in *Sister Carrie*, in which Carrie's needs are all produced by the economy and are necessary to its continued functioning; they answer to no moral law at the heart of the human. In this "productivist definition" of needs, minimum need is "what is necessary to maintain the rate of growth and surplus value" and thus the prosperity of the group as a whole.[29]

This postmodern interpretation of needs answers Ferriss's ontological account with an alternative, perpetually decentered ontology with parallels in Michaels's logic of naturalism. Limiting

this speculation, it is worth recalling that even within Ferriss's program one encounters the contingency of the form in which Spirit expresses itself. The Gothic cathedrals that he praises represent a certain topography of man's relation to a God separate from his creation that would not be recognizable to a pantheist; their cruciform plan arises from the historical accident of the Roman apparatus of capital punishment. Even more to the point, the early–New England vernacular whose spareness Ferriss also praises is opposed to both the Gothic and the magnificent cathedrals of Christopher Wren, with which they are contemporary. All house the same God. The marked difference between the contemporary styles reflects a *politics* of religion; both forms are "authorized" by the Bible but their bases are in fact fully historical. Representing the "spirit of the age," they remind us that the spirit is not singular.

So, despite the strength of Ferriss's criticisms as an indictment of the speculative excesses that were soon to end in the Great Depression and the construction of buildings that could not exist *solus* on a crowded island, as ontology and psychology his critique rests on an insufficiently dialectical understanding of self- and social-production. It assumes as the ground of meaning what we may call the last of the meaning-effects. While the functional building was defined as one that fulfilled its program most efficiently, "efficiency" being determined by construction costs and the rate of production the building supports, the meaning of functionalism in architecture was subject to change. The functional structure began as a sign (assuming that all of a building's features are in fact functional), but it soon became a signifier of ideas that have less to do with industry than with image production. That is, the "functional-effect" became desirable as a way of claiming for one's corporation an aesthetic or technological vanguard position that could in turn be marketed to consumers who poorly understood the actualities of economic or architectural production. Functionalism in this way eventually became a potent signifier and an option for self-expression like all the other decorative innovations of the 1920s.

The use-value and exchange-value economies, the latter at least

as functional as the former, thus meet in a clash of utopian equilibria: the functionalist's stasis of unitary signs opposes the dynamic equilibrium of signifiers in circulation. Neither model may claim priority if, as I argued in my reading of *Sister Carrie*'s economy, the connotative level of signs or objects—fashion, style, status—is not a corruption of economics, but the economy itself, fueled by desire and maintained by the reproduction and circulation of signs. If there is a problem with the connotative, it is not a lack of function. Rather, it functions too well. Functionalists may reject the circulation of "free" signifiers as kitsch, but they risk finding themselves unable to distinguish their own aesthetic, shorn of gaps, ambiguities, and defamiliarizations, from an ascetic rationalism satisfying only to those of sufficient means to indulge themselves with the sophistry of spareness, as did the self-proclaimed "aristocratic" defenders of the International Style, or those who, like Ferriss, mistake the seriousness of art for the seriousness of philosophy and would deny artists their play with the multiplicity of signifiers.[30] They foreclosed the option of the frankly communicative public architecture that will be my subject in Chapter 6.

IV

In Ferriss's extended critique of architecture's corruption by economics and the possibility of its regeneration, as well as his arguments for a discipline of planning in which architects would call on artists, scientists, and psychologists to help make the city livable (p. 142), we should hear distinct echoes of Dreiser's Progressive engineer, Bob Ames. There is a definite continuity between Ferriss's aesthetic and urban program to liberate the urban masses from the conditions of life in the "stupid and miscellaneous" American cities (p. 16) and Ames's plan to free Carrie from herself and to make her a figure for all human desire as interpreted and represented by him. But what seemed as far off in *Sister Carrie* as the ultimate man and social stasis are in Herbert Spencer's social philosophy arrives full-blown in Ferriss's Imaginary Metropolis, a city designed like Le Corbusier's *Ville contemporaine* to house "an

even greater center of population than anything we had hitherto known" in apartment towers sited "in no case . . . less than half-a-mile apart" (p. 109). In many of Ferriss's drawings the towers extend beyond the space of representation (see Figure 10).

Ferriss attempted a cross-disciplinary, multiperspective urbanism in which buildings were to be comprehended from "the argus-eyed viewpoint of the city itself." This stipulation suggests a greater awareness of the life within cities than was shown by the architects and planners who approached the city from without as a machine, while his call to "raze the congested areas of large cities within a generation" and institute a housing form in which "tenements will present a new facade—not a wall facing another wall but a slope facing space [and] present cubages will be so massed as to leave ground spaces to which Nature will return," represents a welcome change from the crowded tenements of Manhattan. Like Le Corbusier, Ferriss sought in his building to overcome natural obstacles by means of technology but also to recreate nature in parks on land opened up by the city's vertical orientation and to bring it into the man-made realm as rooftop gardens. The extent of Le Corbusier's influence on Ferriss has been a subject of debate. While some architectural historians insist on the connection, Ferriss scholar Carol Willis argues that Ferriss's exposure to Le Corbusier and other continental skyscraper theorists occurred only after his own ideas had been formed. She also notes the existence of a fundamental difference in material and meaning between the two plans: "Le Corbusier proposed a business center of cruciform glass towers, regularly disposed on a Cartesian grid, with zones of low-rise apartment blocks right-angling through a continuous *tapis vert* of park [while] Ferriss's mountainous masonry pyramids and symbolic plan [are] focused on the civic circle."[31]

Structured on theosophical numerology, the Imaginary Metropolis indeed seems a City of God at the end of a textual journey that commences with our transport to a kaleidoscopic, cacophonous City at Night, which the author allowed "must seem . . . a little like Dante's descent into Hades" (p. 18). The inferno is apt for the circles of hell it suggests: ornament circulating in the function-

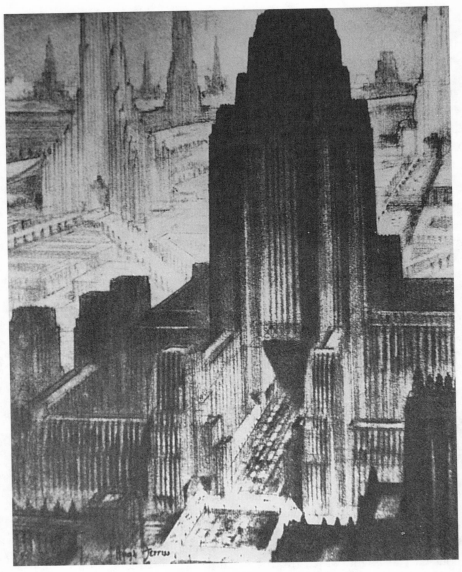

Figure 10. Hugh Ferriss, "An Imaginary Metropolis, Looking West from the Business Center." *The Metropolis of Tomorrow* (1986 edition, Princeton Architectural Press).

alist's "hell of *connotation*,"[32] but also people creeping slowly in circles as an image of the urban circulatory problem that Hood described and for which Ferriss, like nearly everyone else, proposed the cure of a multilevel traffic system (p. 66). Such was the imbalance of the physical components of the 1920s city; at least in *Sister Carrie*'s Chicago the transportation infrastructure awaited the city's expansion.

The theosophical symbolism Ferriss encoded in his groundplan (see Figure 11) determines his city's meaning in the way machine forms reveal the larger cultural significance of the *Ville contemporaine*. In the civic center around which the Metropolis is oriented, two overlapping triangles are inscribed to form a six-pointed star that signifies a union of spirit and matter. An epilogue explains his reason for placing the Imaginary Metropolis's three principal centers at the vertices of one triangle through the device of a plate from a "manuscript" that "may have been of quite ancient origin." It declares that "the City—its sciences, its arts, its business— could be made in the image of Man—his thoughts, his feelings, his senses—who is made in the image of"—and there the page appears torn, inviting us to imagine our city's (and our own) potential conformity to a divine model (pp. 142–43).

If Ferriss's triad of human faculties brings no surprise, his choice of institutions corresponding to them does; for in the seat of practical reason, civil government is subordinated to commerce (p. 112). This substitution was not to have been predicted from his critique of the real estate market's effect on architecture and urbanism; the next year he asserted that "capitalism opposes and obstructs the city planner; the aims of the two are hostile." However, he had no more confidence in "a proletarian government" as an agent of urban change. Like Le Corbusier and many other urbanists of the period, Ferriss believed appeals to the business community had become inevitable after the City Beautiful movement's demise early in the century, when as Stern, Gilmartin, and Mellins observe, "the corporate-owned skyscraper replac[ed] the lower public building as the preeminent symbol of . . . civic pride."[33] What needs to be explained, however, is what will turn the capitalists of the 1920s whom Ferriss criticized into the citizens whose interests are

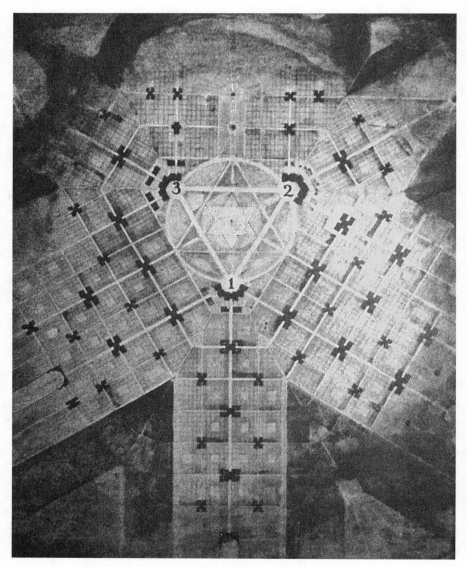

Figure 11. Hugh Ferriss, "Plan of an Imaginary Metropolis."
The Metropolis of Tomorrow (1986 edition,
Princeton Architectural Press).

also the interests of science, art, and the diversity of the Argus-eyed city. Foregoing consideration of alternatives to capitalist development, even as he recorded its overwhelmingly negative effects on urban space, Ferriss shrugged off the question of how to move beyond this impasse when in his last words on his Metropolis he offered it as "a potentiality which the citizens, whenever so moved, could fully actualize" (p. 140) as the representation of their collective desire.

There were a few projects on which he could pin his hopes for a more responsive corporate sector. Rockefeller Center was the first, and is probably the best, example of such civic-minded development. Although privately owned, it was intended to "serve the needs of the general public and constitute a permanent gift to the city." Its continued year-round recreational use testifies to its success on that score. Mumford reflexively condemned it as "a planned chaos" that "under artificial lighting, in a slight haze, . . . looks like one of Hugh Ferriss's visions of the City of the Future," but later critics have found much more to praise. Stern, Gilmartin, and Mellins contend that "it transcended the conventions of dollars-and-cents realism to offer a brilliant application of the idealistic principles of the City Beautiful movement to the problems of densely concentrated office space." The *AIA Guide to New York City* lauds it as "the greatest urban complex of the twentieth century." The Center never fulfilled its entire cultural mission; it never housed the Metropolitan Opera (though it is home to the mass-cultural mecca, Radio City), and it was never extended to a cultural plaza planned to terminate at the Museum of Modern Art. That expansion could have "offered a precise indication of [the Center's] possible developments in space and time," Manfredo Tafuri notes, even as it would have demonstrated "the absolute autonomy of the great corporations in determining the use of urban land."[34] Thus, although the Center cannot completely justify Ferriss's hope for the commercial sector's support of responsible development, it remains a textbook example of the complexly interwoven ideological, utopian, and speculative impulses inherent in large-scale capitalist urban planning.

To explore further how Ferriss's new urban order would over-come these conflicts of interest, I first have to confront a problem of interpretation: Does it make sense to criticize the practical fail-ings of a figural realm like the Imaginary Metropolis? Ferriss's ideal city is, finally, more figural than actual. It lacks the level of practi-cal detail Le Corbusier designed into his planned units, while its meaning is overdetermined by its theosophical allegory, which is nowhere more apparent than in the mystic program of the Philoso-phy Tower's "threefold plan and . . . sevenfold ascension" (p. 136). Any utopia is an essay in ontology under the sign of urban plan-ning, and the Imaginary Metropolis does more than propose an al-ternative space in the manner of Le Corbusier; or Hood, whose ver-tical city was zoned by commercial interests into towers that had shops and theaters on the first ten floors, then fifteen stories of of-fices, ten stories of hotels and restaurants for visitors, then the apartments; or the Regional Plan of New York (1929), the primary goals of which were: to recentralize industry and decongest the urban core, to distribute residences into neighborhoods spread throughout the region, and to subcentralize the business sector ac-cording to an arrangement that would make it convenient to area residents.[35] Ferriss's plan goes beyond these practical considera-tions by inscribing them in a map of human knowledge that is drawn after the image of a divine model. Since this logic and the logic of planning are said to coincide, I will use a practical critique of the urban space as a means of disclosing the underlying contra-dictions of that allegory.

The groundplan is a cognitive map that represents the final con-figuration of human endeavor—for, it is obviously impractical to move buildings in order to reflect a changing balance among disci-plines such as, say, architecture's relation to art, technology, in-dustrial arts, and business at different points in its history. Until that impossible, impassible moment when the multitude of disci-plines forms a coherent whole, this arrangement would create dis-ciplinary ghettos interpolated along the axes formed by his new trivium. Ferriss resisted this interpretation throughout the final section of *The Metropolis of Tomorrow*. He insisted that the sepa-

rations in his ideal city's plan are only apparent because the system of roads facilitates communication (see especially pp. 138–40); yet they equally suggest constraints on interdisciplinarity that protect against any radical innovation capable of undermining the psychic and social space the city maps. Much of this failing may be attributable to the philosophy of science Ferriss would have known, one in which knowledge was regarded as cumulative rather than subject to the seismic upheaval of paradigm shifts described by Kuhn, or the far less stable ground of postmodern science described by Lyotard. In any case, the result is that citizens become conformed to the logic the city represents as they master its knowledge or, more likely, as they perform their limited function within the urban hive. Indeed, some such division of roles among the citizens seems a more probable manifestation of diversity than any range of idiosyncratic visions brought about by the flourishing of art in its zone.

James's and Dreiser's cities are rich with possibilities: a wealth of domestic arrangements, social practices, and entertainments spanning most cultural tastes. In the Imaginary Metropolis there is no such vitality; it is, as Willis notes, "surprisingly silent and static."[36] Domestic life, for example, is almost entirely neglected, being reduced to the comment that residential districts "may expand indefinitely away from the Civic Circle" (p. 138). The words assert the continued fruitfulness of the female principle, but they do so within a "masculine" discourse of measured productivity. Space for unproductive public activity is neglected. There is, further, no space in the Imaginary Metropolis in which to enact that utopian moment witnessed by Henry James in Central Park; there will be no celebration of cultural differences held in common in a city so monocultural, as there is in Ferriss's text no imagining of recreative activity. Returning after this brief tour to a renewed scrutiny of Ferriss's "Argus-eye" metaphor, one sees how it suggested all along that the new urban vision is still to be referred to an ideal perceiver, not dispersed among the diverse populations of actual cities. As the many-eyed Argus is still an individual, so, here, the urban "perceptual apparatus" is referred to "the city it-

self"—that is, to one capable of comprehending the complex structure of a city. Like the "two-eyed man" of Ferriss's early article, "Truth in Architectural Rendering," Argus and the city are, finally, avatars of the author. What Robert Venturi and Denise Scott Brown repeatedly note as a failing of so many modernist planners, that their designs were intended to house their ideal of Man, not the diverse men and women of actual cities, is no less true for Ferriss because of the limits of his humanism. Confident of the uplifting effect of his vision, he saw no need to provide room for alternative cultural practices, for other ways of living in—not for—the city.

V

Ferriss's Imaginary Metropolis is thus a far cry from the modern metropolis foreseen by early-twentieth-century sociologists like Georg Simmel, for whom the particular significance of the city was its provision of "the arena for [the] struggle" of two not wholly reconcilable projects: liberation of " 'the general human being,' " which Ferriss passionately desired, but also the expression of each citizen's "qualitative uniqueness."[37] Uniqueness opposes generality in a tension that admits no dialectical resolution, only the continued experience of both. In their zeal to apply new technologies to the liberation of the urban masses by an intervention into the production of urban form, Ferriss's generation of planners overlooked the possibility that the building of cities, no less than the production of truth, is an ongoing and revisionary process of forming and reforming a fragile consensus.

This oversight might have been Mumford's subject when he spoke of the Imaginary Metropolis's "painfully childish romanticism," except that the high premium on unity was no less common in the garden city he championed. As I suggested at the beginning of this chapter, both forms of planning have their origins in the social and economic crises of industrialization, which they sought to overcome through the provision of stable environments. (The concern for, and theorization of, stability rather than dynamic

equilibrium increased in the ensuing years, as we see in Chapter 5.) That Mumford's garden-city vision would be affected by a romanticism of its own is predictable from his nostalgia for the village-like New York neighborhood of his youth, his idealization of the medieval city as a "center of organized intelligence," and his eulogy for its brief American incarnation among the Transcendentalists in Concord, when "the inherited medieval civilization had become a shell; but, drying up it left behind it a sweet, acrid aroma, and for a brief day it ha[d] a more intense existence in the spirit." The burden of these ideals led him to embrace the value of what Clarence Stein called the "visually homogenous neighborhood" over the accretion of history and the diversity of cultures found in a typical New York neighborhood when he took issue with Jane Jacobs's celebration of the messy vitality of her New York block; her book, *The Death and Life of Great American Cities*, was a key text in the revival of urban pluralism. Mumford's arguments are often blindly antitechnological, his rhetoric naively organicist. His urban ideal was of a city large enough to reproduce itself, but no larger.[38] Citing Howard and Michelangelo, he arrived at an ideal population of 30,000.

Mumford's preferred alternative to urban complexity was attempted by his colleagues in the Regional Planning Association of America. They designed and partially constructed a garden city in the New York suburbs at Radburn, New Jersey. This city of 30,000 was to be subdivided among three neighborhoods. The plan was arrived at by determining a population large enough to support a high school, but small enough not to reproduce an urban sense of alienation; the neighborhood populations were based on the needs of elementary schools. A "town for the motor age," as its slogan said, Radburn employed the superblock concept; that is, the entire city was treated as a single block and not penetrated by through roads. Within its boundaries ran a system of connector roads, service roads, and cul-de-sacs that were kept apart from the network of footpaths. The housing stock was to consist of 430 Georgian-style single-family houses, 60 townhouses, 54 duplexes, and 92 apartment units located toward the planned commercial sector.

As the careful separation of traffic and the zoning of commercial property to the margin suggests, a sense of safety was a key element of the Radburn plan. Recalling it later, Stein wrote that an environment for children had been his primary concern.[39] Toward that end, he oriented the houses not toward the street, but toward the common play-space in the midst of each group of houses.

The intention was to create an orderly, convenient, and peaceful alternative to the city that would be affordable for a large cross-section of the urban population. The reality was quite different. Some of Radburn's problems are attributable to the Depression, which caused construction to be suspended and the town's population to hover at 1,500 through the 1930s. (It did not grow past 3,000 residents.) Other problems stem from the RPAA members' tepid political engagement; as Daniel Schaffer notes, they were "long on principle and short on strategy. . . . Preferring not to engage in formal political organizations, they rarely presented a precise political strategy for achieving [their] goal." Thus, business never came to Radburn, nor did a cross-section of the region. One clear reason for the latter failure was the cost of housing and monthly maintenance fees, which were high enough to exclude the vast majority of families in the New York metropolitan region. Added to the financial barrier were restrictive covenants that excluded Jews and African Americans. Radburn quickly became a commuter suburb that was visually homogenous in ways Mumford did not wish: 77 percent of the population were Protestants; over 80 percent had attended college; 70 percent of its employed residents worked in New York; 88 percent of them were professionals or business owners, and there were no blue-collar workers among them.[40] Many of the same difficulties plagued Radburn's English precursors, Letchworth and Welwyn, neither of which attracted a significant cross-section of the population or a strong industrial base—which was limited to light industry at Radburn.

The city's failings were not only economic, in which they bear no comparison with the Imaginary Metropolis. Stein wrote that he tried to plan for what people wanted, but in the attempt to create a stable community from the town's inception, the plan preempted

one from arising out of the lives the residents made together. Writing of urban and suburban planned communities, Richard Sennett has reduced the planner's dilemma to the axiom, "you cannot begin something significant by creating immediate fullness." In this respect among others, Radburn does parallel the Imaginary Metropolis, even though the causes of the failures stem from underplanning in Ferriss's city. For all the dramatic visual differences between the Imaginary Metropolis and the organic autopia, out of context it is well-nigh impossible to guess if Ferriss or Mumford said of his urban ideal that it "represents the fuller development of the more humane arts and sciences—biology and medicine and psychiatry and education and architecture."[41] The separation of functions and the emphasis on reducing ambiguity to homogeneity finally eliminates the urbanity of both cities.

Lacking things unanticipated or unknown, which are inevitable in the time-filled pluralist city, both ideal cities lack the means of provoking the citizen out of himself or herself. Neither one of them challenges the imagination. Studying the imagination at play in an urban environment (an underinvestigated subject) the authors of *City Play* concluded what any city kid already knows: the city is transformed by tactics of the imagination into a space of adventure, fantasy, and freedom. What to the planner may seem inhospitable—streets, buildings, loading docks, for example—are for urban youth the equipment of their recreation as form *leads to* new functions and the significance of objects becomes overcoded. Designing the townscape for predictability and substituting supervised recreation for invention may increase safety, but it is also deadening. It allows no room for creating and recreating oneself through the trials of complex and disparate experiences. *The Naked City* pays homage to this knowledge when the main character will not discipline his young son for crossing the street alone because he admires the boy's "spunk"—even though the film is structured on the difference between the safe world of a visually homogenous Queens and a Manhattan whose dark secrets it is the job of that man, a police detective, to expose.[42] Produced during the Cold War xenophobia, *The Naked City* reminds us that one prop-

erty of organisms unaccounted for in Mumford's polemics is that they reject foreign bodies.

Invested with the rhetoric of safety and predictability, the skyscraper- and garden-city utopias were easily co-opted as ideological showpieces at the 1939 New York World's Fair, to which Ferriss and Mumford contributed. Representing technology, Norman Bel Geddes's Futurama promised a sleek skyscraper city for 1960, while the Fair's centerpiece was the 11,000 square-mile "Democracity" comprising a "Centerton" (the business, social, and cultural hub) surrounded by 40 "Pleasantvilles" (residential towns of 10,000 people) and 30 "Millvilles" (industrial cities with housing for 25,000 workers and their families). The Futurama was not truly an urban vision. Constructed inside the General Motors pavilion, it was a future designed for speed on open roads. The futuristic look and new modes of transportation lured 28,000 visitors a day to an exhibition that nevertheless reserved its highest praise for farm villages and one-factory towns.

Democracity, ensconced in the Theme Center, was condemned by Mumford for not going far enough in abandoning the economic and cultural dependence on large cities. He had his platform in the Science and Education Building where, under the auspices of the American Institute of Planners, was shown a film, *The City*. Scripted by Mumford, the film attacked the evils of the industrial city, portraying a dirty, smoky New York full of people who are alienated, drunk, despondent, and physically ill from environmental causes. Opposing to it a garden city secured by science, the narrator promises that in the garden city "safe streets and quiet neighborhoods are not just matters of good luck, they're built into the plan . . . [and] meant for everyone, not just for a few who get the breaks." Acclaimed critically by many reviewers, the film was watched carefully enough by the editors of the *Architectural Review* that they found, "although the desirability of such charm is obvious, [the garden city] appears surprisingly flat and lifeless in comparison with the teeming energy of the city." The problem is, in short, that what the ideal garden city, the Imaginary Metropolis, and other forms of total planning protect us from—chance, the ar-

bitrary, and confusion, as Ilya Ehrenburg enumerated it in a comment quoted at the beginning of this chapter; the meeting and clashing of cultures, I would add—is nothing less than our life in a world that remains contingent.[43]

Regardless, in the throes of the Depression, the model cities seduced viewers with their promises of prosperity, security, and freedom while they deferred the crucial question of how to support an industrial base and the cultural diversity typical of an American metropolis. Only through the reintroduction of those elements of human life—desire, difference, the aleatory—that many planners strove to contain in order to protect us from risk and uncertainty can we hope to create cities where it is possible to experience and to express our unique subjectivities, or, better, to *construct* them from our various affiliations. It was from the standpoint of such strong pluralism that architectural and cultural critic Herbert Croly observed in 1904 how "the ugly actual cities of today make a livelier appeal to the imagination than does an ideal city, which in sacrificing its ugliness on the altar of civic art, sacrifices also its proper character and vitality." It was not Croly's intent thereby to endorse the de facto and de jure segregation of different communities, but his comment does have a certain prescience as an assessment of the postwar, middle-class garden suburbs whose economic and cultural homogeneity is expressed visually in the lack of variety in the housing and its surroundings. This respect for the ordinary in fact returns at the other end of modernism, as I will show in Chapter 6, in a discussion of work by Venturi and Scott Brown. Rightly or wrongly, their approach to cities has been identified as one of the sources of architectural postmodernism. Leaving that discussion mostly to the side, my interest will be the contribution of their works, which Venturi describes as "trying to deal with the mess, the richness of our real situation," to the questioning of the idealist, formalist impulse in modernism that occurred across the arts (including the arts of urbanism) in the 1960s.[44]

For now, it will be enough to recognize that if Ferriss's Imaginary Metropolis must fail as a practical solution to an ongoing urban crisis, it does retain a poetic, that is to say critical, power. It speaks

to desires that, however ultimately unrealizable, are undoubtedly compelling for most of us: safety, comfort, opportunity, equitable prosperity. Despite itself, the Imaginary Metropolis winds up as a caution against valuing these ends over the means of their achievement, a way to teach us the undesirability of our unreflective longings. Having taught the limits of a world of use and denotation, *The Metropolis of Tomorrow* returns us to our actual cities with a renewed sense of the liberatory potential of a city we make together. It should thus lead us back to the lessons of that first generation of urban sociologists: that the particular (if unrealized) virtue of cities is their concentration of differences in a realm that allows for a wide and unpredictable range of behaviors. In that field of difference, whose built representation would be the city "as a multi-coded or overcoded totality"—an open totality, rights and recognitions would become more significant as we find ground for a common life with others unlike ourselves.[45]

It teaches as well the need for all of us, as cultural critics inside and outside the academy, to value history and diversity—and their signs—in the full connotative richness of those terms. Such was the intention, if not entirely the achievement, of William Carlos Williams in the text to which I now turn, his long poem *Paterson*. Set between Ferriss's city that defines a single nature for modern man and *The Naked City*'s regime of social hygiene that purges the urban organism of its dysfunctional members, this poem presents a compelling contrast. In it, Williams pursues a more historically engaged and particularist dimension of modernism that survived as a countercurrent in the period. We will also see that over the course of writing *Paterson* Williams significantly rethought his own convictions about the shape of urban experience and the ability of the artist to represent the worlds of his fellow citizens in a coherent form. He began the poem with the hope of expressing a total culture, but he came up against the hard facts of his materials: a city that he wanted to represent, not to transform. In the failure of his initial project was his ultimate success.

Expanding the City's Limits

The Opened Form of
William Carlos Williams's 'Paterson'

The essence of Paterson is probably beyond description. It may be the absurd castle or the doomed majesty of the Falls. It is partly an unwritten communal history formed by millions of hours of sweat in red-bricked mills. It is partly the tenements and partly the elaborate Victorian mansions . . . carved into tenements themselves.
> —Christopher Norwood, *About Paterson*

Doctor, do you believe in
"the people," the Democracy? Do
you still believe—in this
swill-hole of corrupt cities?
> —William Carlos Williams, *Paterson*

How did they get
cut off this way from representation . . . ?
> —Williams, "The Forgotten City"

I

The concrete historical situation that motivated Hugh Ferriss in his intervention in the development of urban form did not drive him to consider in depth the social forces of which the cityscape of the 1920s was only a recent expression. His Imaginary Metropolis exemplifies instead the flight from history to mythic structures and "timeless" values that is often remarked as the failure of modernist aesthetics. As we have just seen, for designers and redesigners of modern industrial cities, history was an impediment. Denial of the city's temporal extension and its social and cultural diversity was common among planners faced, as they were on the

continent, with "rebuild[ing] a war-ravaged Europe in the image of the new," or, as they were there and in the United States, with adapting to the demands of new technologies cities whose development followed patterns initiated before the machine age.[1]

A more historical-minded modernism is evident in varying degrees in works about civic culture by several American modernist poets. William Carlos Williams's *Paterson*, the subject of this chapter, T. S. Eliot's *The Waste Land*, Ezra Pound's *The Cantos*, and Hart Crane's *The Bridge*, for example, sift the cultural archive to reclaim the vitality of a culture fragmented by wars, instrumental rationalism, and the displacement of social relations with economic relations. In Margaret Dickie's subperiodization of modernist poetry, these long poems represent the movement's second phase; after the imagist purification of the received language, the poets moved beyond their concern with language in itself to a recovery of its social utility in the public performance of the poem-including-history. Dickie labels this phase "conservative or conserving," an assessment I second to the extent it is limited to indicating the poets' recognition of a need for engaging the past in a project intended to "express, address, and refer to an objective world."[2] While the city as a chief expression of Euro-American culture was a recurrent topos among these poets, its centrality to the individual poems varies. Early drafts show that Eliot conceived *The Waste Land* as a London poem. Substituting a mythic frame for urban satire, he increased the importance of the theme of the legitimation of authority, but contemporary London remains the instantiation of the conditions against which he wrote; contrasting London's present with its former stature is one way Eliot revealed decay at the metropolitan center.

Pound addressed the problem of the modern city directly in his 1928 essay, "The City," which I discussed in the previous chapter. *The Cantos* focus on men who build; the city—Ecbetan, Dioce, Wagadu—is an ideal of place "in the mind indestructible." It has no physical location, unless it be in the postwar Detention Training Center where, Kathleen Woodward argues, Pound descended from his interior Taishan to form "a close social bond" with his fellow inmates.[3]

Crane, Dickie notes, desired "to locate what he call[ed] . . . variously 'spiritual events,' 'resurrection,' a 'new stage' in some relation to the new forms of the modern city." New York is the principal site of a hoped-for redemptive future in *The Bridge*, one to be achieved by the reintegration of spiritual and economic values, as imaged in Crane's invocations of Columbus, supported by the Spanish royal treasurer and the Queen's confessor; the Wright brothers, preacher's sons who pioneered aviation; and Walt Whitman, a poet who "Surviv[ed] in a world of stocks" to celebrate American expansionism as an unfolding of Spirit in "A Passage to India."[4] But the dissonance of prophecy and profit is resolved more by the poem's rhetorical performance than a critical engagement of the history the poem recovers.

My criticism of Crane is nothing new. The reduction of history to rhetoric in order to create a "redeeming language" internal to the poem has been remarked of all four poets, for years as a positive judgment. When Joel Conarroe states that Williams's "triumph" in *Paterson* is to have discovered "a language commensurate with the present world," he heralds a new measure for all values. Yet, when he proclaims that "only the poet holds the key to the rescue" of inarticulate Patersonians, he concurrently dismisses Williams's economic motif as "peculiarly unsuited to poetry." This conventional reading of the modernist long poem, in which language is the realm of freedom and the poet is the culture's redeemer, has justly been critiqued for turning the techniques of collage and montage on the telling of history in order to escape the determinations of the historical past, rather than to recover and build on a recovered alternative social and cultural tradition. John Carlos Rowe's description of a modernist textual practice that, "by taking cultural expressions out of their material, historical contexts, . . . transform[ed] such narratives into abstract, ahistorical 'verbal assemblages,' which could be used to create a poetic space, a 'world elsewhere,' for poetic authority with no necessary obligation to the historical networks from which these 'stories' had been stolen" captures well the evasions of the material world produced first by the New Critical focus on spatiality, on a utopian space where the interest is in the play of words and images amongst themselves,

and more recently by newer modes of rhetorical criticism. The yield of this critical tradition has been a portrait of the modernist as a man seeking in the languages of art reassurances the world denies him. Yet Williams found in the annals of Paterson history a human "curiosity" whose condition illustrates the dangers of just such a practice: Peter the Dwarf, a Paterson citizen of the Revolutionary era, was a hydrocephalic who could not take "an *active* part" in politics, although he happily discoursed with clergymen.[5] Peter's final rest, head and body in two same-sized caskets (p. 193), emblematizes the result of such a poetic, and it prophesies the fate of a civic body composed of a coterie of "knowledgeable idiots" (p. 34) who direct the lives of the rest of us "automatons" (p. 6). More importantly, this portrait of the modernist is subjected to an extended critique as Williams distances himself from the poet-within-the-poem, his alter ego, Dr. Paterson.

As I read *Paterson*, Williams's particular contribution to the problematic of representing the modern city is his ability to reveal the limits of the modernist ideal of representation described by Rowe (who has in mind Pound) while at the same time offering a focused critique of the politics of representation in American urban culture by availing himself of the history of economic and social relations in a single locality with which he was intimate. His hope, once expressed to Henry Wells, was that the poem—all of his poetry—would be read as an "experiment, toward assertion . . . of a new and *total* culture," but he conceded in the same letter that the experiment must fail.[6] It must fail because culture is not an achievement or possession, as Eliot's and Pound's models of erudition suggested it could be, but a conversation—or contestation—of material-social practices expressing the histories, traditions, and interests of different constituencies, even though, as we shall see, Williams seems to have arrived at this conclusion only slowly in the course of writing *Paterson*. I am particularly interested in how Williams's path to that realization is revealed in his changing understanding of the structure of *Paterson*, a poem in which political and aesthetic representation are deeply entwined.

To appreciate this movement toward open-ended community,

we need to know something of how Williams understood the goals of, and obstacles to, representation in a democracy, as well as in poetry. At the nation's founding, a period Williams studied and wrote about frequently throughout his lifetime, the question of just political representation had been addressed in terms that are useful for a reading of *Paterson*. Among the framers of the new national system there were two principal theories of representation. The proponents of "virtual" representation were believers in an abstract estate of "the people"; predominantly Federalists, they assumed that all citizens, "despite great degrees of rank and property, . . . were essentially a unitary homogeneous order with a fundamental common interest." The other major faction endorsed the ideal of "actual" representation, the attempt to create " 'in miniature an exact portrait' of the people" and their interests, which would reflect local and regional differences.[7] Proponents of actual representation ran the gamut from the radicals who proposed universal suffrage and in the 1780s begged Thoreau's question in "Civil Disobedience"—Is a citizen bound by legislative acts he or she does not expressly approve?—to moderate republicans who held that the success of local representation depended upon the emergence of a class of natural aristocrats, respected for their accomplishments and abilities, who would govern in the name and interest of the local unit.

Williams was a strong localist, and thus predisposed toward the representation of diversity. His politics and his poetics were shaped by the Progressive historians' narrative of American history as the triumph of democracy and individual rights, and by philosophical pluralism—William James's belief that "the world's history . . . [is] a rope of which each fibre tells a separate tale," all of which "run parallel to each other, beginning and ending at odd times," and John Dewey's declaration that writers must seek their subjects in the heterogeneous thickness of their corners of the world instead of in a vague nationalism—much less universalism.[8] This outlook did not mean that he abandoned the day's "big" issues; it required that his ideas must be discoverable in, and his argument worked up from, the life around him.

His method would have to be partially documentary, and the years in which he was making plans for the poem were a rich time for such endeavors. Using the evidence of history, personal letters, and political and economic pamphlets that he told Edith Heal were, along with his personal witness, the poem's raw material, Williams attempted to make the poem an example of democratic representation. Embracing the diversity of local speech and writing, recording alongside the prose of journalists and historians broken English and the slang that Kenneth Burke suggests we understand as a collective linguistic response to changing conditions of life, he sought as well to let his townspeople represent themselves in the accents of an American English that they made together.[9]

The partisan uses of documentary are given some attention in the next chapter; here I am interested in a less goal-directed practice. Of particular relevance is Berenice Abbott's use of the camera across the Hudson River from Paterson in her photodocumentary, *Changing New York* (1939). Abbott explored what she called the "civic use of the camera," by which she meant its use "to improve the education of the public to an understanding of its civic responsibilities." To achieve this end is not to prescribe those responsibilities, but to allow the citizen-viewers to arrive at their own conceptions of where they stand and how they should act. Photography is an especially good medium for this activity. The public perception of the photograph's factual status gives the scenes authority, while the lack of narrative determinants leaves their significance open to viewers' interpretations. What Alan Trachtenberg fears as "the dangerous indeterminacy of unanchored images" is released in *Changing New York* as a strategy for representing, in Abbott's words, "this great uncrystallized city, the truest phenomenon of the twentieth century which, in its present form, combines so dramatically the old with the evolving new."[10] The photographs supply only the elements; viewers must imagine the structure of political, economic, and social forces whose effects are manifest in the built landscape she recorded.

Abbott's book is resolutely of its time, but it does not take the Depression and its effects as the only, or even the prime, cultural

fact of the day. One sees a city of ethnics: Jews, Lebanese, Irish, Italians, blacks, the work of a Swiss immigrant; a modern transportation nexus: streets crowded with pedestrians, autos, buses, and trucks, as well as bridges, trains, ships, airplanes, the elevated, and their terminals; everywhere signs of diverse cultures sharing the same space. Historical development is recorded in the juxtaposition of architectural styles, as in one photograph's combination of the Washington Arch, antebellum residences around Washington Square, the residential skyscraper at One Fifth Avenue, and, in the distance, the Empire State Building (number 40). Others record a brownstone redone in glass-bricks by William Lescaze (the first of its kind) in the row of brownstones it inhabits (number 66), Rockefeller Center rising behind the Church of Saint Nicholas (number 67), and a tall ship against a backdrop of tall buildings (number 5). The theme of architectural change even contains an homage to architect Raymond Hood, whose work represented here includes his redesign of the Mori Restaurant, above which he lived (number 38), Rockefeller Center (numbers 67 and 68), the Daily News Building (number 65), and the McGraw-Hill Building (number 60).

True, the images are anchored on the page by Elizabeth McCausland's text, but the function of the captions varies. Her report of oil-company revenues bears an implicit critique of big business, especially beneath a photograph of a small filling station (number 84), and her dollar figure on the value of real estate in midtown Manhattan must have shocked many viewers (numbers 64 and 69). Her comments on the corralling of street vendors into markets protest the drying up of street-life (numbers 7, 24, and 91), while her caption to photograph 89, of a black mother and two children against a backdrop of boarded-up houses, adds a text on the greed of landlords to the visual presentation of the landscape of racism.

At other times, the text is strictly historical. At still others, it complicates the picture. Photograph 15 shows a group of men lying or sleeping alongside a shack on a pier, but the text hails the heroism of the dock watchmen and tells us the building is no shanty. Who, then, are these men? Many of the men and women in the photographs are workers, and even when they are absent their labor

is praised—on tugboats (number 13) or in constructing something as wonderful as the Brooklyn Bridge (number 17). Another photograph, of New York's Municipal Building looming over Henry Street settlement houses (number 18) seems foreboding, an image of two worlds, one about to crush the other; however, McCausland tells us that New York Governor Al Smith rose from these same streets to the halls of power. The text, then, presents the contesting forces that shape the urban scene and provokes viewers to an examination of its meaning and their responsibilities in the process.

That Williams was thinking about these issues we know from his review of a similar project, Walker Evans's *American Photographs*. Although Evans took the nation for his subject, he avoided abstraction because, Williams explained, his photographs "particularize" the United States as a series of localities bound by some beliefs and experiences, separated by others. What he did, Williams continued, was to embody it by lifting "ourselves . . . from a parochial setting" and making us "worthy in our anonymity." Praising Evans in the same words he would later use for himself as one who made "the life around him . . . eloquent," he went on to caution that the result was "no photographic picnic" but a record of "social upheaval." Williams was, after all, a progressive Democrat whose sympathies ran to the poor as he knew them through a lifetime of medical practice among them. He was supportive of the New Deal; what he resisted, and praised Evans for avoiding, was the style of the "long nose poking into dirty corners for propaganda and for scandal," an intrusion into others' lives that supported a politics and an art with which he was not in sympathy.[11] Like Evans and Abbott, Williams would call on the documentary record and not censor it.

Paterson, too, is a record of social upheaval, exploitation, and the destruction of nature, as well as a celebration of human survival and triumph. Williams needed to devise a poetic form adequate to the task, one that would itself be local (that is, unique) and capable of encompassing a diversity of voices, perspectives, and materials; also one that would present material for interpre-

tation—in an order, to be sure, as Evans's photographs had an order, but nothing obviously imposed.

Seeking unity in the existing diversity, Williams eventually ran up against the limits of form. As ever, he was preoccupied with language. But the experimentalist who had praised himself as much as Marianne Moore in 1931 for "wiping soiled words or cutting them clean out, removing the aureoles that have been pasted about them or taking them bodily away from greasy contexts," shared his mind with the cultural critic who was a keen student of the social history of language and the eloquence of impure, everyday speech.[12] This is not to say that there is no lexical purification at work in the poem, for in *Paterson* as everywhere in Williams's writing are reminders of the oppressive weight of accrued meaning on attempts at expression. Williams's quest for the purified word seems to me of a piece with his faith in the existence of a presocial self that needed to be liberated from the deadening effects of social conventions. Both that word and that self were realms of ideal freedom; the recurrent problem in Williams's texts is attaining them. The fire that destroys the Library is one way to liberate language from its thrall to the past and

> Texts [that] mount and complicate them-
> selves, lead to further texts and those
> to synopses, digests and emendations. . . .
> Until the words break loose— (p. 130)

but in *Paterson* Williams enacts a more productive response to the language of "objective" scholarship.

Williams knew that narratives record and disseminate ideology in their *form* as well as content, and that an uncritical stance toward the syntax of history assured its perpetuation. He imagined his poetic interventions into historiography as challenges to that ideology, particularly to the moralism and economism of his day. Thus, *Paterson* contains history, but it is not narrative. The poem is a field of quotation, thematic repetition and variation, juxtaposition, collage, and definition by "ideogram" (an accretion of examples in order to present the living gist of an idea); it is a col-

lection of notes and fragments interwoven with, and sometimes rendered as, poetry. History is not represented as an unfolding chronology, but the matter of events is arranged to suggest evidence of an unseen energy or force that animates history, a notion that also underlies the historiography of *In the American Grain*. While the field of the poem influences readers' attempts to generate its meaning(s), the structure leaves one freedom to read resistively, as Williams read history.

Containment would continue to be a problem for the poet. Even if history starts and stops, and runs along different tracks simultaneously, as William James said, Williams undertook the project thinking that *Paterson* could be a whole poem, as a culture could be "total." For years, he assembled the poem following a four-book plan predicated on the idea that a man is "like a city" (p. 7), even more, that a human life, or nature's cycles, or the course of a river could adequately represent the development of a complex, man-built city, and that a poem could "embody [one's] whole knowable world" (p. vii). Yet, this plan was always at best a stretch; the poem follows the course of the Passaic River only approximately, and the life of the poem's eponymous protagonist, Dr. Paterson, even less. Dr. Paterson begins as a natural aristocrat who imagines that the truth of his townspeople's lives is in his mind: they are "his thoughts" (p. 9). He recalls Williams's self-portrayal as a doctor-poet who used poetry as Evans used a camera to lift the lives of his inarticulate patients to expression: "The underlying meaning of all that they want to tell us and have always failed to communicate is the poem," Williams declared in his *Autobiography*, "the poem which their lives are being lived to realize," and of which he would be the midwife.[13] However, in the course of writing the poem Williams took increasing distance from his doctor, whose pretensions are ironized and whose understanding is contested by Williams and others within the poem—most notably in several letters by "Cress," one by "E.D." (pp. 28–29), and one by "Henry," whose dog Dr. Paterson ordered killed for biting him (p. 131)—because he does not adequately comprehend the diversity of meanings in the world around him.

Try though Williams did to find a means or metaphor for unifying the diversity around him, he was not stubborn in the face of the poem's testimony. Unlike Pound's "Ego, scriptor cantilenae," who remains convinced that "it coheres all right / even if my notes do not cohere," the poet of *Paterson* was awakened from "this dream of / the whole poem" (p. 200) by the human voices he recorded.[14] By this rhetorical gesture, Williams conceded that it would not be possible to represent the "whole" of Patersonian culture (itself synecdochic for American culture) except by that central oxymoron of pluralism: the open totality. This concession pushed Williams further toward the radical extreme of actual representation—and thus away from the Cold War ideological consensus that, we see in the next chapter, recognized variant political interests, but contained them with invocations of the nation's destiny and a threatened national interest. By his shifting relation to Dr. Paterson and his willingness at least to allow other voices their say, Williams moved *Paterson* toward a representation of a city as an open nexus of overlapping communities with different histories, interests, and even languages. I will show further that the critique of representation the poem presents was not one Williams could fully control; the fictional doctor and his creator were so closely identified (the damning letters were actually written to Williams; the fictional doctor and his creator share regressive notions of the meaning of race and gender difference) that the poet's privilege as centering consciousness is also effectively challenged.

II

Rather than get too far ahead of the poem, I turn now to a group of found materials (pp. 12–17) about the ecology of early Paterson society. Each of them addresses a dialectic of nature and culture in early Paterson—how the land was transformed to exemplify a social order, but also how different understandings of nature produced different forms of community and relations of people to the land. The function of these narratives, as I read them, is to begin a critique of Paterson's history as a manufacturing city and to recover

a democratic alternative to the instrumental relations that struc-
ture industrial society—an alternative the poem failed to achieve,
thereby opening it up to a more radical mode of representation.

One of *Paterson's* richest tales concerns the events of September 30,
1827, when Tim Crane opened his Forest Garden on the north side
of the Passaic River's Great Falls. To create this rural pleasure
ground, a place for food, drink, and occasional popular entertain-
ments, it had been necessary for Crane to uproot the wilderness
and wind a network of gravel paths through the ornamental land-
scaping he introduced. He also had to provide Patersonians with
convenient access to the far bank of the Falls. The solution to that
problem was the crowning accomplishment of Crane's entrepre-
neurship; he designed a covered bridge that was put in place on this
festive Saturday. Like many of Paterson's most careful plans, the
deployment of the Clinton Bridge did not proceed as expected.
Instead,

> When the word was given to haul the bridge across the chasm, . . . they
> had only pulled it half way over when one of the rolling pins slid from the
> ropes into the water below.
> While all were expecting to see the big, clumsy bridge topple over and
> land in the chasm, as quick as a flash a form leaped out from the highest
> point and struck with a splash in the dark water below, swam to the
> wooden pin and brought it ashore. (p. 16)

This vignette might begin a tale of cooperation in which two men
triumph over the Falls on one afternoon. However, Williams's
source for this account, Charles P. Longwell, was concerned to re-
late a tale of animosity between "Timothy B. Crane," a "hotel
keeper" (p. 16), architect, builder, sawmill owner, and speculator,
and Sam—not Samuel—Patch, a millworker, miscreant, and alco-
holic, whom the narrator knew well: "He was my boss, and many
a time he gave me a cuff over the ears" (p. 16).

As Longwell tells the story, it rests on a moral distinction be-
tween a gruff layabout and a "man of much energy and no little
ability" (p. 16), whom the locals were wont to call Uncle Tim. The
rivalry had far deeper resonances. To comprehend what was at

stake besides personal pride, we must recall the role the "natural" world of Crane's retreat played in defining an economic, social, and cultural hierarchy in Paterson. For the antagonism that existed between Patch and Crane was greatly class-based; informing it were conflicts over the right to claim for oneself possession of an art and the definition of masculinity. The Forest Garden's cultural mission was to allow patrons to contemplate the ways of nature in a setting enhanced by an artistic cultivation of indigenous and imported flora. One friendly reviewer declared that Crane had "so far domesticated the wilderness . . . and blended it with the improvements of art, that Passaic Falls is no longer a place for the melancholy retirement of the horror stricken wanderer." If by harnessing the Great Falls to a millrace, the Society for the Establishment of Useful Manufactures (s.u.m.) had created an icon of the young nation's economic and technological potential, by harnessing it to a discourse of the beautiful, Crane created an emblem of its cultural progress. His artistry did not end with designing a retreat that appealed to the aesthetic sensibility of the emerging bourgeoisie; in fact, Paul Johnson notes, the Forest Garden was "filled with silliness and bad taste." Crane's greater claim to "art" lay in the social and entrepreneurial vision his Forest Garden represented: the practical skills of orchestrating the purchase of the land, construction materials, and labor, and convincing people that the project embodied not his own aspirations, but what he called "the hand of ART" guiding the progress of the Republic.[15]

The promotional rhetoric for Crane's resort distinguished two classes of men by their modes of leisure. Passive contemplation was construed as a mark of refinement, while physical activity like Patch's falls-jumping became evidence of rawness. Indeed, it was in Crane's interest to omit reference to falls-jumping and other forms of active recreation altogether, since he built his pleasure ground on what had been by customary usage public land. That publicist may have limited the area's former visitors to "horror stricken wanderers," but the millworkers of Paterson, Patch's peers, knew better; they considered themselves in possession of a right to use this land. They also had their own ideas of "art." Locating them-

selves in an artisan tradition, they equated crafts and arts; if they were spinning-machine operators, acquiring full knowledge of the machine's operation amounted to possessing an art. So, too, as Crane claimed Forest Garden was a work of art, Patch claimed the status of art for his own mode of performance. He told the newspapers that falls-jumping was an "art that [he had] practiced from [his] youth." Like landscape improvement, leaping the Falls demands a physical overcoming—in a sense a transformation—of nature. It is the leisure-time art of a mechanic, someone who did the physical work that allowed the new class of entrepreneurs and improvers to "render the natural elements . . . subservient to the comfort and prosperity of the town." Patch's leap "to prove his / thesis: Some things can be done as well as others" (p. 15) did not merely upstage Crane; it reasserted the ideal of a democracy of labor in which the men who do the physical work of production are the equals of manufacturers. While Longwell's jealous Patch says, as he leaps, "Tim Crane thinks he has done something great; but I can beat him" (p. 17), an alternative version of the event has Patch announce that "Crane had done a great thing, and he meant to do another."[16] The second version redefines the nature of the contest. It asserts an *equivalence* between Crane's triumph over the Falls with Clinton Bridge and Patch's mastery of them by his own physical skills.

Notwithstanding the democratic—if class-specific—rhetoric of social uplift in which Crane couched his intentions, he intended for the Forest Garden to turn a profit, and he made arrangements to assure the patronage of a clientele likely to support it. He charged a penny toll at the bridge, which brought complaints from Patersonians incensed at having to purchase access to what they regarded as public land. Crane justified his economic barrier in a local newspaper by claiming that, "1st. If the bridge were thrown open, the Gardens would be occupied by a set of lazy, idle, rascally, drunken vagabonds, 2d. This would drive away all decent people," causing the enterprise to fail.[17] Crane here assumed a correlation between economic standing and taste that was not necessarily the case, since locals resentful of encroachments on their recreational

space drove him to bankruptcy by vandalizing his Garden. Some likely paid the toll. Forest Garden was thus no Central Park, which preserved for public use an area within congested New York that otherwise would have been developed. While both Crane and the leaders of the parks movement privileged passive recreation in their green retreats, by the admission fee and prescriptive regulations he extended the domain of the urban economic and social structure and sought to exclude from his resort the very classes by whose inclusion Frederick Law Olmsted hoped to reaffirm the experience of democratic community across an increasingly diverse populace.

Patch's thesis struck a chord with Williams's own democratic ethos. Williams's attempts to think through the economic crisis of the 1930s as a symptom of a greater cultural meltdown had led him to common cause with American Marxists about the conditions of the poor, with whom he had daily professional contact, but not about the inevitability or desirability of class warfare, which helps explain why the silk-workers' strike of 1913, probably the city's most famous event, is scanted in *Paterson*. (Billy Sunday is roundly criticized as a shill for the United Factory Owners Association [pp. 172–73], but the unions are damned for becoming part of the institutional structure of industrial capitalism rather than securing "the economic freedom of the *individual*" [p. 99; emphasis added]—as Williams reinterpreted the goal of labor militancy in conformity with his faith in autonomous individualism.) The force oppressing labor is displaced in the story of an unnamed man found "near the wheel house of the water works" wedged "in the 'crotch' of [two] logs" by "Mr. Leonard Sandford, of the firm of Post and Sandford" (p. 36), although here again, names are an index of social standing. The worker is reduced to "a mass of clothing, . . . the legs of a man, . . . [a] body," and the ensuing description of the pollution of the Passaic takes on an added degree of terror, because we cannot be sure if industrial dye or human blood spews "Half . . . red, half steaming purple / from the factory vents" (p. 36). This striking image does critique the destruction of both nature and workers, as well as the reproduction of that logic in the journalistic report to

demonstrate the pervasiveness of the problem. However, it does so in the mode of Williams's poem "The Yachts," which renders an America's Cup race a metaphor for industrial relations as "skillful yachts" sail over "an entanglement of watery bodies / lost to the world bearing what they cannot hold."[18] In both cases, the poor are done in by industry's products, not its captains.

The underpinnings of Williams's liberal compassion often prevented him from recognizing the poor as members of a class with a history and, perhaps, a destiny—especially one whose interests might conflict with his own. He placed his hope for society more on the progress of liberalism and change that would emerge from a broad-based coalition like the one William Jennings Bryan had asserted against the self-designated business interests who were crucifying mankind on a cross of gold, as Bryan said in 1896.[19] Bryan is memorialized in Williams's parodic anthem, "America the golden" (p. 68), along with John P. Altgeld; if Bryan's bimetallism reflects Williams's economics, the Illinois Governor who pardoned the Haymarket Anarchists with a stinging denunciation of the state's case and challenged President Cleveland's authority to order federal troops into Illinois during the Pullman Strike could have been of more immediate relevance for a poem about the nation's first company town.

After a brief flirtation with Marxism, Williams followed Pound to C. H. Douglas's Social Credit theory, which picked up the campaign against idle holders of idle wealth. Douglas located the cause of economic disenfranchisement not in the rate of surplus value but in the cost of credit controlled by a small "credit monopoly" that raises the prices of goods above their "just price." Pound had explained that credit—"the future tense of money"—rests on "the abundance of nature and the responsibility of the whole people," not the will of the bankers. As "A Poet-Physician [writing] on the Money-Cancer," Williams once offered a "Social Diagnosis for Surgery" to be performed on the banking industry.[20] He recalled the figure in *Paterson* when he implored the bankers to "release the Gamma rays that cure the cancer /. the cancer, usury. Let credit / out" (pp. 182–83). In *Paterson*, greed-produced disease is presented

as a *literal* fact. The poet protests the excess profits generated by hospital pricing systems that result in substandard care for the indigent (p. 182) and quotes a *Journal of the American Medical Association* article that argues that paid sick leave will curtail the spread of disease carried by infected hospital personnel (p. 177).

Even so, Williams would not find it easy to endorse structural or institutional change that might alleviate these burdens. Recognizing the necessity of a New Deal, he also believed that the paramount issue of the time was preserving individual freedom from totalitarianisms of the right and left. He never confronted how the ideology of individualism could be—and, we saw in Chapter 2, was—reconstructed to serve the interests of capitalism. The social struggle was, in Williams's paraphrase of Bryan, between "the good guys and the bastards," not workers and owners, and Social Credit addressed that conflict. After all, he could reason, did not Douglas acknowledge workers' "spirit of revolt against a life spent in the performance of one mechanical operation devoid of interest, requiring little skill, and having few prospects for advancement other than by the problematical acquisition of sufficient money to escape from it," while subsuming economic debate into a larger cultural framework?[21] Douglas's ability to relate economic and imaginative values (especially as Pound read him) was particularly important to Williams, who also knew, again via Pound, Brooks Adams's historical account of how mercantile societies neglect the imaginative arts for the arts of trade and war. Williams reduced the dependence of culture on credit—not money—to a "Poundian" formula:

What is credit? The Parthenon.
What is money? The gold entrusted to Phideas for the
statue of Pallas Athena, that he "put aside"
for private purposes

—the gold, in short that Phideas stole
You can't steal credit : the Parthenon.

(p. 184)

The tone is at least partly parodic, since we are asked to "skip any reference, at this time, to the Elgin marbles," treasures sculpted under Phideas's direction and stolen two millennia later by Lord

Elgin, but the marbles help Williams make his point by suggesting that European imperialism had produced a rootless culture and was doing so again at Forest Garden. (The accusation extends to what he saw as Eliot's raid on the Loeb Classical Library in *The Waste Land*, a subject never far from his angry gaze.)

Patch's democracy of acts was one way of remaking a social structure that was producing invidious distinctions among men and reasserting the dignity of all labor, even if it did not address the production of economic disparity. However, to revive it as the alternative to the hierarchical, increasingly cosmopolitan societies of the industrialized world would be to ignore the effects of industrialization on laborers as well as the repressed matter of gender that complicates that ideal union of equally situated individuals proclaimed by Patch at Clinton Bridge. Forest Garden is indicative of what has been called a feminizing of American culture, a process of settlement and domestication well documented at the time by Cooper; the association is particularly apt here since Crane had moved easily in the rough company of men before his marriage to Maria Ryerson, the daughter of an established Dutch family. Patch's oppositional space, in which differences between *men* have ceased to matter and gender is effaced by an immediate relation of men to a supplying female that is nature "herself," has in practice been the leading edge of the society it sought to escape. We therefore reach a moment of crisis in Williams's pursuit of the democratic ideal: How does one turn that ultimately sterile world elsewhere of men in nature to contemporary use in a world riven by class, gender, and racial conflict?

III

Given his long-standing interest in American history, it is not surprising that Williams began his search for alternative social orders in the Revolutionary period. Alexander Hamilton (the architect of the Bank of the United States and the s.u.m.) was an easy choice as the archetypical bastard, while in the name of democracy Williams had already traced the intellectual lineage of some contemporary leftists to colonial radicals. Favorably reviewing an

American Communist poet, H. H. Lewis, Williams compared him to "the American patriot of our revolutionary tradition," while in "The Attack on the Credit Monopoly" he asserted that "the objective of those advocating a classless society today" is close to "the original conception of a revolutionary America in the minds of such agitators as Samuel Adams, Freneau and some others."[22]

Significantly, Williams did not invoke the American Indian past as an alternative culture, as he had in *In the American Grain*. He could have done so with confidence, because the historical records he used for *Paterson* were rich with information on the area's early inhabitants. Nelson's *History of the City of Paterson* devotes considerable space to local Indian groups, portraying them as noble, generous and peaceful unless provoked by white settlers, and living in strong, "democratic" communities. They could even have served Williams's search for a "redeeming language" to contest the discourse of the academy, which has fallen "SILENT BY DEFECT OF VIRTUE IN THAT IT / CONTAINS NOTHING" of its authors or audience (p. 122). Lacking a written language, the Lenape used wampum belts not just for money, but as "jewelry, ornaments, annals, and for registers; . . . the bond of nations and individuals; an inviolable and sacred pledge which guarantees messages, promises, and treaties." Wampum was for them a medium at once natural, pictorial, symbolic, and narrative. Seductive as such recourse might have been, Williams knew that the city of Paterson and the nation were built on the erasure of Native American culture; he chose not to participate again in its reinscription. His use of the Kinte Kaye, a ritual dance, better indicates the place of Native Americans in *Paterson*. Nelson had cited two accounts of its use, both in celebrations: " 'Feast days are concluded . . . by the young with a *kintecaw*, singing and dancing.' . . . In 1675 the Indians [*sic*] sachems of New Jersey were highly pleased with the promises and presents of Gov. Andros, and 'they return thanks and fall a *kintacoying* with expressions of thanksgiving.' "[23] In the poem, the dance is associated instead with the death of Native culture: it is performed by a brave slaughtered by the Dutch for a crime some of them knew he had not committed (p. 102) and to honor the warrior chieftain Pogatticut at his burial (p. 132). By pairing a festival of fire

and light (p. 114) with the fire of 1902 that burned the library
(p. 115), Williams again acknowledged that the Native past was for
his purposes an unusable past. All that remains of "the Indian" in
the 1940s and 1950s are the Long Island guide who speaks French
(p. 168), the ironic issue of Père Rasles's encounter with the New
World, and the Hollywood Injuns who "come out whooping be-
tween the log / house and the men working in the field, cut them /
off . . . / . . . and . . . carry them away," a script mercifully broken off
by an authorial "for God's sake, Cut / out that stuff" (p. 52).

That the "contact" with redeeming nature pursued by the he-
roes of *In the American Grain* is beyond the realm of possibility is
the message implicit in the newspaper account of Sarah Cum-
ming, who came to the Falls fifteen years before Patch. We are
asked to imagine that her descent (a fall or a leap) may be an escape
from imprisonment in the conceptual world of her husband, the
Rev. Hopper Cumming. His conventionality is conveyed in the re-
peated pieties of the newspaper article in which Williams found
the account and in an aesthetic discourse that denatures the land
around him by remaking it as a "wonderful prospect" of "romantic
scenery" (p. 14). Sarah is mourned for her "usefulness" (p. 14) and
reduced to a chaste ideal of the feminine—"an amiable disposition,
a well-cultivated mind, distinguished intelligence, and most ex-
emplary piety."[24] She frees herself of her husband and his language
by playing on his instruction to "set [her] face homeward" (p. 14)
and setting it toward a home he could not fathom because in his
account of the world (inherited no less from the Enlightenment
than from the Puritans) no one is ever at home *in* nature. However,
readers have all the information we need to understand why the
Falls spoke (punningly) "A false language" (p. 15) to Sarah Cum-
ming. Like the aesthetic discourse in the newspaper, their wild
roar conceals the Falls' ownership by the s.u.m., which had di-
verted Passaic River water to the mills (pp. 73–74). By 1812, the
Falls were fast becoming as remarkable for their output of energy
as for any "stupendous works of nature" still surviving around
them (p. 14). Once we know whose Falls Mrs. Cumming swooned
or leaped into, her act of defiance reads instead as a prophecy of the

fate of the individual, the community, and nature in Paterson's mills.

In these passages, Williams demonstrated a strongly dialectical understanding of nature's relation to and shaping by social forces that directs his handling of a contrastive pair of societies that "grew up together" near Paterson: the "cultured" life at "Ringwood—where the old Ryerson farm had been—among its velvet lawns, . . . ringed with forest trees" (p. 12), and the formation of the "wild" Jackson White enclave by "Tuscaroras, forced to leave their country, . . . [who] took to the [Ramapo] mountains . . . where they were joined by Hessian deserters from the British Army, a number of albinos among them, escaped negro slaves and a lot of women and their brats released in New York after the British had been forced to leave" (p. 12). The descriptions of Ringwood and the Jackson Whites seem archetypical, complementary stories of local "origins": the transplanting of European forms to the New World, and the making of the American masses from the scraps of other societies.

Williams's pairing of social form and landscape in these descriptions is unmistakable; yet, his point is more nuanced than it had often been in *In the American Grain*. At first blush, the Jackson Whites appear to be an alternative to a society stratified by wealth, race, and gender. Their racial and ethnic mixture had a particular resonance for Williams, who once confessed to Horace Gregory that, "of mixed ancestry, I felt from earliest childhood that America was the only home I could possibly call my own. I felt that it was expressly founded for me, personally."[25] The Whites' bonds, formed by descent (five Dutch names and their variants predominate), suggest a melding of natural and social orders, as does that "*Geographic* picture" of

> the 9 women
> of some African chief semi-naked
> astraddle a log, an official log.
> (p. 13)

In a utopian fiction, these early American outcasts who took to the Ramapos would be progenitors of a green society, but in *Paterson*

they represent a society that failed to develop and remind us of the fragility of that democratic dream. Their name was no act of self-representation. It may derive from the name of General Clinton's procurer, a Mr. Jackson, whose "Whites" were white prostitutes, or a General Jackson who was a benefactor of poor whites, or a corruption of "Jacks and Whites," "Jacks" being a derogatory term for freed slaves. In any case, the name appears to have been forced on them. The Whites' "wildness" may be explained by the fact that they were unwilling emigrants. They were the effluvia of early American society, produced by forces of oppression and marginalization active in Euro-American culture from its start.

Once settled, the Whites reproduced the sexism, racism (toward blacks), indeed, the violence to which they owed their creation. A dearth of traditions of their own left them frozen in the moment of their founding, adding resonance to Williams's dictum, "Without invention nothing is well spaced" (p. 50). They could not resist being turned to the mines and mills around Ringwood, where they held onto nothing that might preserve the vitality of their life as they moved between two societies. Future generations, "the pure products of America" Williams had called them, were

> young slatterns, bathed
> in filth
> from Monday to Saturday
>
> to be tricked out that night
> with gauds
> from imaginations which have no
>
> peasant traditions to give them
> character.[26]

Williams never noted that the Whites outlasted the manufacturing operation, which shut down in 1931. Perhaps it was because the victory was slight: they went on public assistance, lived in shacks or company houses without plumbing, and shopped in a store run by the Ringwood Company's real estate office.

Ringwood Manor was, however, much more than a commercial operation in the Revolutionary era. The society centered on the

manor was once a conscious attempt to institute an American cul-
ture by marrying European traditions with the "raw new," much as
"Monticello, with its originality, good taste, with its distinctive lo-
cal quality, [had been] one of the few places where the two cultural
strains . . . in [American] history . . . consciously dr[e]w together."
At Ringwood, the issue of this marriage was a house measuring a
scant 30 feet by 62 feet in the Dutch-colonial style that, Williams
likely knew, "resembled nothing but [itself], and [was] even more
radically different from the work of the Dutch in Holland than [it
was] from the work of the other colonists."[27] It was once occupied
by Robert Erskine, F.R.S., a Scot sent to New Jersey in 1771 to look
after the American Iron Company, the British-owned works that
comprised the economic life around Ringwood. When revolution
was imminent, Erskine took up the colonists' cause, purchased the
operation with local capital, and remained as its manager. In 1775
he mustered his workers under his captaincy; in 1777 he was com-
missioned Surveyor General of the Continental Army. He died in
1780 of an illness contracted on a surveying expedition.

In his multiple roles of captain, surveyor, manufacturer, and
magistrate, Erskine stood for a republican ideal dying even then,
and against the specialization of economic and social roles that was
already being forecast as the necessary correlative of the increased
wealth and comfort enabled by the rise of industry. His biographer
writes that a sense of duty kept Erskine "intensely alive to the so-
cial and domestic needs of his neighborhood and the welfare of his
people."[28] This paternal concern for his workers made social bonds
familial, and a preference for reasoned discussion over litigiousness
casts Erskine as a benevolent father raising his townspeople toward
responsible citizenship. Thus, in the interplay of the photograph,
the story of the Cummings, and the story of the "two phases" of
life, we can see Williams laying the groundwork for a critique of
the economic imperatives that shaped Paterson by developing an
alternative set of social relations.

Nor did Williams have far to search for the cause of the republi-
can promise's collapse. In the Revolutionary period he could op-
pose to Erskine, *Paterson*'s would-be hero, its undisputed villain,

Hamilton. Conveniently for Williams, Erskine's years in New Jersey were the revolutionary decade of the 1770s, so his passing and the advent of the s.u.m., intended as the centerpiece of "Hamilton's . . . drive for an industrial aristocracy and consequent economic centralization under narrow control," enact locally the Federalist triumph over democratic localism in the 1780s.[29] Williams held Hamilton responsible not only for the future of industrial depredation in the area but also for the failure of democratic culture in this city founded as a company town. (Hamilton proposed that the power to appoint the city's municipal officers be exclusively in the hands of the s.u.m.) Pierre L'Enfant was Hamilton's choice to lay out the city, perhaps to place the commercial capital on a par with the political center; his baroque design based on a network of radial boulevards echoed the District of Columbia plan. It promised to be a perfect spatial representation of the order Hamilton desired—a well-defined, well-defended center for a commercial aristocracy—but the plan proved "more magnificent than practical" (p. 74). Peter Colt succeeded L'Enfant and built expediently.

If urban form was not cultivated in any manner, other aspects of Hamilton's plan for the land around the Falls were realized; over time, they turned the Passaic River into what Williams once called "the vilest swillhole in christendom." The process of subjugation began with Hamilton's visit to the Great Falls during the Revolutionary War, when it was a sparsely populated Dutch farming settlement (see pp. 193–95). He saw not the sublime, but "waterpower to turn the mill wheels" of "a great manufacturing center, a great Federal City" (p. 69), and he grew more expansive as he composed his "Report on the Subject of Manufactures." In addition to vesting civic power in the s.u.m., the "Report" proposed granting it liberal powers of eminent domain for opening canals and diverting the Passaic, over which it would hold exclusive water rights. The earth itself was depicted as a vast storehouse whose "bowels as well as the surface" will be "ransacked for articles which were before neglected."[30] By *Paterson*'s associational logic, Hamilton's ravaging vision is the precursor of such other economically motivated assaults on the environment as the destruction of *unios* oys-

ters in the search for pearls after David Hower found one (pp. 8–9) and the frenzy of the slaughter of fish and eels in the drained lake (p. 35).

Hamilton did not settle for maximizing the exploitation of natural resources; he turned his attention to laborers—not as citizens but as tools. He argued for deskilling workers—stripping them of their arts—by limiting them to one task, where repetition might foster time-saving innovation while decreasing the "distractions, hesitations and reluctances, which attend the passage from one kind of business to another." Considering segments of the population previously neglected, he envisioned entire families in the mills because "women and children are rendered more useful and the latter more early useful" by mechanized production. The ultimate horizon of Hamilton's plan was not the transformation of men into machinery but the obsolescence of the laborers. Replaced by machines that bring "an increase of hands; an accession of labor, *unincumbered too by the expense of maintaining the laborer*," workers were to be retired without a share of the wealth they produced to live in a town planned with little regard for the nonlaboring dimensions of their lives.[31]

It would be foolish to deny Hamilton's foresight in trying to establish a manufacturing base for the nation. V. L. Parrington, for whom Hamilton is the source of much of the evil in American history, conceded that "no other man in America saw so clearly the significance of the change that was taking place in English industrialism[:] . . . the productive possibilities that lay in the division of labor, factory organization, the substitution of the machine for the tool." Even Williams conceded that Hamilton "led the country . . . to financial stability," although "at the cost of much that had been envisioned during the early years of the Revolution." However, the perpetuation of Hamilton's focus on the means of maximizing productivity and profit goes far toward explaining how Paterson got its reputation as "a nationally known proving ground in the struggle between employers and workers."[32] Besides the sheer amount of turmoil, Paterson was famous for its labor firsts, including the first lockout, in 1794, and the first strike and sympathy strike, in 1828. So, if "among/the working classes SOME sort of breakdown/has

occurred" (p. 51), and by Williams's day it had, typography points us to its primary cause: management strategies from the founding of the S.U.M. onward that have "beaten thin" (p. 51) the minds and the wills of Paterson's workers.

The early promise of Paterson was thus short-lived. Ringwood Manor did not long endure as the seat of a natural aristocrat who, on the basis of his accomplishments and abilities, would be fit to govern in the name of the people and the interest of the locality. In the mansion and gardens Williams knew, one read the effect of pecuniary culture's triumph over local cultivation. While they dated to the early 1800s, additions later undertaken by the family of industrialist and onetime New York Mayor Abram S. Hewitt "so changed and enlarged [the Manor] that all traces of the original [were] removed." Mrs. Hewitt refinished it "like English country places," by "covering the original bare clapboards with a coat of white stucco, and trimming the structure with pseudo-Gothic bargeboards, bay windows, and Tudor cornices." Her hope was to create a house answering her husband's desire for the "sort of rallying place for future generations" held by the hereditary British aristocracy. Ringwood thus became another object like millowner Catholina Lambert's Belle Vista Castle, which the Federal Writers' Project *New Jersey Guide* describes as a "ponderous castellated structure of rough-surfaced red and gray stone, generously fenestrated, balconied and terraced."[33] "Balmoral on the alluvial silt" (p. 99), Williams called it. They are opulent piles

<div style="text-align:right">divorced</div>

<div style="text-align:center">

from the insistence of place—

. . .

—the terms
foreign, conveying no immediacy,
(p. 83)

</div>

I have already argued that much of this architecture expressed the postbellum industrialists' belief that America was the destiny to which European history had been building; it is of a piece with the American plundering of Europe by newly wealthy collectors. But the new rich did not copy European forms, they imitated the pro-

cess by which Europeans appropriated the works of older cultures as symbols of their newfound preeminence. The Hewitts turned Ringwood into the site of an eclectic collection of artworks and artifacts of the iron trade that included Civil War artillery, gateposts and stone columns from New York, a lead fountain from Versailles, yew trees grown from a seed picked in Constantinople (compare the Ryersons' use of indigenous trees), a Venetian well curb, and French statuary. Ringwood (and Belle Vista to a lesser extent) thus represented what Williams thought worst about America: owners' instrumental relationships to land and workers, the failed possibility of a natural aristocracy and an aristocracy of taste, and the abandonment of American art by collectors who might have used their wealth to foster it.

Nor did Sam Patch's nascent populism develop into anything redeeming. He became a showman and made a living off leaps that in his later days he had to preface with speeches to give them the meaning his first public leap derived from its context. The words had less and less to do with the action, except for making it more "desperate" (p. 17). Finally, frozen in river-ice after failing to conquer the Genessee Falls, Patch becomes an emblem of the "blockage" or "divorce" between word and deed that has corrupted all public discourse in *Paterson*—Hamilton's plans, which carried forward what Gordon Wood calls a "decidedly disingenuous . . . appropriat[ion] and exploit[ation] by the Federalists of] the language that more rightfully belonged to their opponents," Billy Sunday's union-busting sermon "at the *Hamilton*" Hotel (p. 173), Klaus Ehrens's rambling homily (pp. 64–73), and August Walters's social credit broadside (p. 181), to name only a few examples.[34]

IV

Achieving an immediacy that was lacking in a culture well represented by Belle Vista and the later Ringwood was Williams's central problem in *Paterson*. The predominant metaphor for that unity throughout *Paterson*—indeed, throughout Williams's writing—is *marriage*. Architecturally, it is expressed, as we have seen, by the fusion of the two cultural strains at Monticello, the original Ring-

wood, and the Ryerson estate there. We read in *In the American Grain* that Père Rasles sustained for his lifetime in the new world a close embrace of Native American culture, while Daniel Boone sensed that "there must be a new wedding"—not by his going native, but by being *"himself* in a new world, Indianlike." Similarly, "the graduate of / the old university" in Williams's poem "A Morning Imagination of Russia" awakens to find after a Revolution within as well as without that there is no longer any separation between him and the peasants.[35] Native Americans and Russian peasants both exist in a close relation to nature, which Williams always represented as feminine. Their societies echo the vision of men in nature implicit in Patch's democracy of acts outside Paterson, on the "wild side" of the Passaic, and the clan-based society of the Jackson Whites and Mangebetou chieftain and his wives.

Dr. Paterson faces a stiffer challenge in a twentieth-century city. He finds his immediate relation to a supplying female nature in Paterson has been blocked, concretely. Garret Mountain Park may lie "female to the city" (p. 43), as a critique of privatized, commercially determined urban space, but this "man—like a city" will have trouble finding his "woman like a flower" (p. 7) in a "ravished park, torn by / the wild workers' children" (p. 37). True marriage is offered as immediacy in the blending of cultures to produce new values and the practices and objects that embody them; it is thus the fundamental social bond. The most striking example of this immediacy in *Paterson* is the story of Jane and Merselis Van Giesen, who achieve "marital felicity! dreaming as one" and vanquishing their quite-literal demon together—the black cat haunting her that he shoots with a silver sleeve button (p. 134). Yet, the poem suggests, the currents of enlightenment that freed us from our devils and our hells also stripped us of our heavens. The Doctor searches for beauty in a town where it is too expensive (p. 44). He gropes for words but settles for borrowed erudition. Most importantly, he searches for the woman who would draw him into the scene with which he has no contact, with whom he could dream the redeemed city.

Behind the poetics of marriage, authorizing the use of the *National Geographic* photograph and the description of an Ibibio

burial rite in which women "cut young branches from a sacred tree and wave the bough over the genital organs of the warrior to extract the spirit of fertility into the leaves" (p. 143)—a ritual that preserves the phallic power that creates and protects cultures—is Williams's 1917 call to overcome the sterility of philosophy by marrying "a male and a female element: an engendering force and a definite point of action," a masculine conceptual apparatus to bestow meaning and a feminine ground.[36] Williams never abandoned this commonplace, or his belief that men are alienated from the material world and must rely on women for their vital connection to it. Their compensation for this condition is (as we saw in the previous chapter) their potency as form-givers and city-builders. That log Williams added to the *Geographic* photograph is the phallus that reorders the world in the image of his desire, while Marie Curie's heroic labor is slighted as she is reduced to a "baby-nurse" pregnant with the radium (p. 172). She becomes the midwife in the poet's discovery of a metaphor: radium as "radiant gist" (p. 109) and as credit (p. 182), specifically a depreciating stamp scrip. The reductive gender stereotyping that points the way to the marriage of man and world, language and matter, simultaneously reveals its unsatisfactoriness in any world beyond the poem—an unsatisfying poem. Fortunately for *Paterson*, although Williams never abandoned the trope, at least he allowed a critique of it to develop within the poem's dialogic field.

Much of the responsibility for this failed quest is first assigned to the middle-aged Doctor who, like the young Williams, has a head too full of Keats to appreciate the vitality that surrounds him. Dr. Paterson is affronted by the "frank vulgarity" of a sunbather whose two-piece suit covers "only the breasts / and the pudenda" (p. 51), and he concludes that the city's

> women are not
> beautiful and reflect
> no beauty but gross . . .
> Unless it is beauty
>
> to be anywhere,
> so flagrant in desire.
> (p. 71)

It is beauty, and one difficult to maintain, as Williams reminds us through a series of anecdotes of the moral police that would have us deny our nature: the forces of law and order who chase a wild mink through town with their clubs drawn and guns blazing (pp. 49–50), the correspondent who fears that "B" will never speak to her again because "B" 's dog, Musty, became pregnant while in her care, even though she "took sticks and stones after" the intruder (p. 54), and, of course, the sign that is

> a clarion
> for belief, to be good dogs :
> NO DOGS ALLOWED AT LARGE IN THIS PARK.
> (p. 61)

Dr. Paterson may imagine himself "just another dog / among a lot of dogs" (p. 3), but he has already had Henry's dog put to death for biting him.

Like James's restless analyst in Central Park, Dr. Paterson is a cultured Anglo-ethnic surrounded by a polyglot symphony of "Voices! / assaulting the air gaily from all sides" (p. 54), and the spectacle of a multiethnic populace making the park its own through a variety of recreative activities. Also like James's analyst, he can appreciate what he sees only by mediating actual events with his aestheticizing impulse. If there is hope in the park, Williams told John Thirlwall, it is in "the impassioned simplicity of young lovers."[37] However, it is only grudgingly, the double negative tells us, that Dr. Paterson comes to respect them as "Not undignified" and to make of "churring" crickets a pastoral wish for "Gay wings / to bear them (in sleep)" from the harsh present (p. 52)—a flowery conceit in which we should not miss a note of irony at Dr. Paterson's expense.

The same sort of rhetorical filter between himself and the dirty world creates the Doctor's only solace on that day, the two lyrics he composes and the dancing of Italian Mary, drunk with the memory of "the old cultures" (p. 57). She is a "reply to Greek and Latin" from the bare ground, but he must reimagine her as "the satyr— / (Priapus!)" and cast her as "the peon in the lost / Eisenstein film" (p. 58) in order to appreciate her passion. In the lyrics

burial rite in which women "cut young branches from a sacred tree and wave the bough over the genital organs of the warrior to extract the spirit of fertility into the leaves" (p. 143)—a ritual that preserves the phallic power that creates and protects cultures—is Williams's 1917 call to overcome the sterility of philosophy by marrying "a male and a female element: an engendering force and a definite point of action," a masculine conceptual apparatus to bestow meaning and a feminine ground.[36] Williams never abandoned this commonplace, or his belief that men are alienated from the material world and must rely on women for their vital connection to it. Their compensation for this condition is (as we saw in the previous chapter) their potency as form-givers and city-builders. That log Williams added to the *Geographic* photograph is the phallus that reorders the world in the image of his desire, while Marie Curie's heroic labor is slighted as she is reduced to a "baby-nurse" pregnant with the radium (p. 172). She becomes the midwife in the poet's discovery of a metaphor: radium as "radiant gist" (p. 109) and as credit (p. 182), specifically a depreciating stamp scrip. The reductive gender stereotyping that points the way to the marriage of man and world, language and matter, simultaneously reveals its unsatisfactoriness in any world beyond the poem—an unsatisfying poem. Fortunately for *Paterson*, although Williams never abandoned the trope, at least he allowed a critique of it to develop within the poem's dialogic field.

Much of the responsibility for this failed quest is first assigned to the middle-aged Doctor who, like the young Williams, has a head too full of Keats to appreciate the vitality that surrounds him. Dr. Paterson is affronted by the "frank vulgarity" of a sunbather whose two-piece suit covers "only the breasts / and the pudenda" (p. 51), and he concludes that the city's

> women are not
> beautiful and reflect
> no beauty but gross . . .
> Unless it is beauty
>
> to be anywhere,
> so flagrant in desire.
> (p. 71)

It is beauty, and one difficult to maintain, as Williams reminds us through a series of anecdotes of the moral police that would have us deny our nature: the forces of law and order who chase a wild mink through town with their clubs drawn and guns blazing (pp. 49–50), the correspondent who fears that "B" will never speak to her again because "B"'s dog, Musty, became pregnant while in her care, even though she "took sticks and stones after" the intruder (p. 54), and, of course, the sign that is

> a clarion
> for belief, to be good dogs :
> NO DOGS ALLOWED AT LARGE IN THIS PARK.
> (p. 61)

Dr. Paterson may imagine himself "just another dog / among a lot of dogs" (p. 3), but he has already had Henry's dog put to death for biting him.

Like James's restless analyst in Central Park, Dr. Paterson is a cultured Anglo-ethnic surrounded by a polyglot symphony of "Voices! / assaulting the air gaily from all sides" (p. 54), and the spectacle of a multiethnic populace making the park its own through a variety of recreative activities. Also like James's analyst, he can appreciate what he sees only by mediating actual events with his aestheticizing impulse. If there is hope in the park, Williams told John Thirlwall, it is in "the impassioned simplicity of young lovers."[37] However, it is only grudgingly, the double negative tells us, that Dr. Paterson comes to respect them as "Not undignified" and to make of "churring" crickets a pastoral wish for "Gay wings / to bear them (in sleep)" from the harsh present (p. 52)—a flowery conceit in which we should not miss a note of irony at Dr. Paterson's expense.

The same sort of rhetorical filter between himself and the dirty world creates the Doctor's only solace on that day, the two lyrics he composes and the dancing of Italian Mary, drunk with the memory of "the old cultures" (p. 57). She is a "reply to Greek and Latin" from the bare ground, but he must reimagine her as "the satyr— / (Priapus!)" and cast her as "the peon in the lost / Eisenstein film" (p. 58) in order to appreciate her passion. In the lyrics

he finds beauty only by fleeing the world of particulars for the abstract totality of a world spirit in "If there is subtlety" (pp. 74–75) and by imagining a "most voluptuous evening" that would grant love "the full octave of its run" and bring his *Sunday in the Park* to an unearned resolution (p. 86). The lyrics are counterpointed by letters from the distraught female poet, Cress. The first four passages from the letters in Book 2 recount the devastation Paterson's silence wreaks on her, both as a poet suffering "the complete damming up of all [her] creative capacities" (p. 45) and as a woman whose "economic and social maladjustments" (p. 64) must be "sufficiently trivial and unimportant and absurd as to merit [his] evasion" (p. 48). The fourth passage answers his "Hymn to the Deity" (pp. 74–75) with her lament that in forsaking her he has rendered her powerless. The exclamation of "despair!" (p. 75) that hovers between the lyric and the letter is the terminus of his meditation on temporality and the beginning of her unanswered plaint; it is the only bond between two otherwise isolated people whose divorce metaphorizes the social dysfunctionality of Paterson.

This disjunction would eventually point Williams to an alternative representational strategy for *Paterson*. The representational dilemma disclosed by Dr. Paterson's failure to embrace the world outside himself, which is replayed in his abortive encounters with the Beautiful Thing in Book 3 and Phyllis in the "Idyl" of Book 4, is poetic: the failure of the poem to achieve its goal. It is also political, given the poem's public function. Writing the poem of Paterson forced Williams to rethink the pragmatics of actual representation. The creation " 'in miniature [of] an exact portrait' of the people" might have been achievable in the more homogeneous America of Erskine's day, when the franchise was also more limited. By 1870, *Paterson*'s census figures showed "native born 20,711, which would of course include children of foreign parents; foreign 12,868" (p. 10), a city where the immigrant population hovered about three times the national average. Even so, property, citizenship, and gender restrictions kept the percentage of voters among the population at large to about 5 percent. In the city of the 1940s and 1950s, however, the portrait of the *electorate* had too many faces and spoke

with too many accents to be embodied by Dr. Paterson. In him political and poetic representations were to have merged, but to a greater extent than Pound and Olson, Williams conceded that this sort of authorial center (Dr. Paterson; Ego, scriptor; Maximus of Gloucester) could not hold.

Thus, in the course of *Paterson* a new method of representing his chosen city emerges. It gives the poem a new geography. By Book 4 the ideal of marriage explicitly has been displaced by the pragmatics of "dissonance" (p. 176) and "antagonistic / cooperation" (p. 177). This shift emphasizes the female poet Cress's role in the representation of urban society. We must take her seriously, as Mike Weaver notes, because she and others who battle against the conditions that beset them "are represented in *Paterson* not because they are neurotic, but because their veracity as thwarted human beings—their unimpaired though distorted vigour—finds expression in action."[38] The reunification of word and action was, we have seen, a prime cultural interest for Williams. Cress's self-representation through concrete details like the difficulties of a working-class, single mother finding work commensurate with her intellectual abilities makes one less inclined to accept Dr. Paterson's interpretation of the world he would represent or the extreme form of Williams's own faith in individual freedom. Her letters provide the poem's strongest internal evidence of the Doctor's distance from the lives of his townspeople, as they collapse the distance between Williams and his persona.

The original letters, written to Williams by an acquaintance, Marcia Nardi, in effect accuse him of slumming. She argues that "The very circumstances of [his] birth and social background" have saved him from real knowledge of the disenfranchised, allowing him the leisure to reconstruct the working class to suit his "literary sympathies" (p. 91). Her life in particular and "woman's wretched position in society" in general *are* aesthetic material in *Paterson* (p. 86), as they were in Williams's introduction to a group of Nardi's poems. The terms of his praise, which finds in her fight against limits imposed on women the source of her poetry, rhetorically transform economic constraint into artistic freedom. First, by

hailing her "pioneer *living*," he transforms his "discovery" into another hero *In the American Grain*, a bohemian Hester Prynne who turns her back on social convention. Then, her material conditions become poetic material as pioneer living is idealized as *aesthetic pioneering*. The man who swore he "would not 'die for art,' but live for it, grimly! and work, work, work," thereby reinvented Nardi's difficult life as a series of aesthetic choices, imagining for her a more complete form of internal dissent than he allowed himself as an experimental poet.[39]

Cress/Nardi's letters give her a strong claim to the title of poet of urban experience. She has a voice as a representative of what Williams described to Horace Gregory as the world "below 14th St."—a working-class and bohemian section of Manhattan to which Williams was only an occasional visitor. (Williams confessed to Marianne Moore that Paterson is "primitive" and "provincial"; his lifelong hometown, Rutherford, was a commuter suburb.) Still, Williams wavered on the status of the "Cress" letters in the poem. If he informed Gregory that the longest letter "does not belong in the poem itself," not long before he had advised Parker Tyler apropos of the letters that "prose and verse are both *writing*" and should not be separated.[40] His apprehensiveness registers the risk the letters pose to the argument of the poem, not merely to its structure: If "Cress" has the last word, "Dr. Paterson's" representational project fails; yet, if the poem rejects the transplanted letters, it reveals the limits of its inclusiveness, and if this strongest dissent is accommodated to Dr. Paterson's perspective, then *Paterson* exists under the limits of a constraining consensus.

As Cress opens a new perspective, a letter from "A[llen] G[insberg]" continues the expansion of the poem's range beyond the world Williams personally knew. It describes a slice of the "below 14th St." life that exists within Paterson in words that become an allegory of the problematic of representation in the poem. "A.G." excitedly announces to his mentor, "I have seen so many things—negroes, gypsies, an incoherent bartender in a taproom overhanging the river, filled with gas, ready to explode, the window facing the river painted over so that the people can't see it" (p. 194).

He declares that these scenes populated by denizens of the margin are "really at the heart of what is to be known," but he doubts that the older poet is aware of them. Figuring "the heart of what is to be known" as existing only behind windows that no longer allow even mediated access to other worlds, the letter provides a nice figure for the decentered, open totality that had become the structural principle of *Paterson* after Williams scuttled the four-book plan. Williams thereby rejected his earlier visions of a recovered organic community. He came to see *Paterson*, like Abbott's *New York* and Evans's *America*, as traversed by social, economic, and cultural lines of force that bound people together, but also by rifts that ran deep. He came to appreciate the inevitability of conflict in the present moment, but he did not abandon his hope that it was leading somewhere.

The presence of these letters in *Paterson* implies that Williams had come at least to sense that he was not, as the tenets of possessive individualism led him to believe, a person like any other. His access to the world around himself was mediated by his class, race, and social standing, even if he never appreciated the extent to which it was the case. Coming to know others, he began to realize, is a form of compassionate labor that is not achieved without mediation. The language of *Paterson*'s original ending may promise, but it certainly defers, redemption. In a scene with obvious echoes of *The Odyssey* (it conflates Odysseus's arrivals on Scheria and Ithaka), the poet emerges from the sea where his faithful bitch awaits (p. 203) and turns inland to begin again. Odysseus's homecoming was but the beginning of his work; he had to clear his house, restore the fertility of his lands, and renew his bonds with his wife, son, father, and faithful servants. And so Williams insisted that what was (to have been) *Paterson*'s end ended nothing, as the "beginnings" of Paterson were never anything but moments of a history that had always already begun. Odysseus will again become a man like a city, but a strong patriarch is no figure for *Paterson*; instead, the poem enacts a further filiation—with Walt Whitman, to whose Camden the swimmer turns (p. viii). The first

great American urban poet, Whitman was a mystic democrat for whom the human body was the measure of the city. "Surviving," as Crane wrote, "in a world of stocks," he, like Williams, believed in, and sought to represent his city as, that contradictory figure of liberal utopia: a corporate body of free individuals.

Book 5 picks up the concern with art's past, present, and future announced at the end of Book 4. Turning from the city's grim particulars to the tradition he had spent a lifetime battling, Williams made a provisional peace with it. The change in focus has been read as reflecting the aging poet's need to contemplate what has endured as he approached his death, and as necessitated by his decreased mobility after several strokes.[41] Yet, Book 5 is an effective coda to the poem's speculations on representation and community. It extends the work of *Paterson* Books 1 through 4 by turning to the place of art in and as a community, a

> WORLD OF ART
> THAT THROUGH THE YEARS HAS
>
> *SURVIVED!*
> (p. 209)

However long works survive, and whatever pressures they exert on his writing, they are never timeless; they are resolutely of their times and places: *The Last Nights of Paris*, Mexican border towns of the 1950s, medieval France, a sixteenth-century imagining of Christ's nativity. They survive because the particulars of those individual works, no less than the particulars of Williams's own life and works, present paths toward the ideal union of actual particulars—*"by multiplication a reduction to one"* (p. 2)—he sought. Art becomes part of the open-ended, constitutive conversation of past and present without which we would not know, or add to, what (we think) we know, not the storehouse of treasures he rebelled against.

Thus Williams imagined a new role for art, not as an expression of an imminent "total culture" but as an ideal of unity that does not negate differences among its constituents. Such is the burden of a passage quoted from Mezz Mezzrow's *Really the Blues*, in

which Bessie Smith's voice brings together black and white, man and woman, mind and body ("every note that woman wailed vibrated on the tight strings of my nervous system" [p. 221]). Mezzrow married a black woman and lived in Harlem, but he does not thereby offer himself as the poet of the race. As a middle-class Jewish kid he chose his life of "studying hard" the blues' roots in a heritage of slavery and Jim Crow, and its currency in jails, the racism of daily life, and the struggles of black musicians against white swing and Tin Pan Alley.

Williams never got that far. His own relationship to jazz is awash in stereotypes: he celebrated the cool of black jazz artists in poems like "Shoot It Jimmy!" and "Ol' Bunk's Band," but he also told Walter Sutton that he found jazz "primitive" and too much a matter of "sexual arousal." These somewhat contradictory sentiments reflect his sense of African-American culture generally. Like women, blacks in Williams's writing too often exist not in and for themselves, but as the material Other capable of showing Anglo-ethnic males the way back to their whole selves. The narrator of "The Colored Girls of Passenack—Old and New," confesses his fantasy of a "Negress" whose body is "a racial confessional of beauty lost" among white women.[42] *Paterson* asserts this difference in the contrast of a "white girl, her head / upon an arm, a butt between her fingers" (p. 51), with

> 3 colored girls, of age! . . .
> —their color flagrant,
> their voices vagrant
> their laughter wild, flagellant,
> (p. 51)

who soon may be among the unmarried pregnant girls listed by "D J B" in her letter (p. 124).

Still, despite and even through its failings, *Paterson* effectively critiques the limits of representation and attempts to theorize urban culture. Much of it comes down to language, which is not a means of escape, but a collective medium in *Paterson*. The con-

tested ground of ideology, identity, and differentiation, language is in this poem the site in which to raise a question crucial to the survival of a democratic, urban culture: Is it possible to imagine, amidst antagonisms, conflicting interests, uneven development—indeed, amidst animosity, resentment, exploitation, even downright hatred—some common ground of culture? If we renounce, as Williams did, the hope for a "total culture," then *Paterson's* aesthetic of incompletion creates a space in which unity may continue as a possibility perpetually before us in a culture that is always changing. In its "final" form—open, decentered, language at odds with itself—*Paterson* is a poem-including-history, but it is also a prospective poem that in attempting to record

> the vague accuracies of events dancing two
> and two with language which they
> forever surpass (p. 23)

expresses more than it knows.

The poem is thus an antidote and counterpoint to the authority claimed by Ferriss and the modern planners of Chapter 3, and the theorists of homogeneity who would, by the 1950s, have developed a theory of the United States as an organism all of whose constituent members must support its reproduction. Their tenets led to the silencing of dissent, the exclusion of immigrants from certain parts of the globe. It even led to the denunciation of Williams as anti-American and the revocation of his appointment as Poetry Consultant to the Library of Congress in 1952. In contrast with Williams's forward-tending attempt in *Paterson* to reopen the documentary record and discover a new means of representing the social energy circulating through Paterson's history, we will see in the next chapter, on the 1948 detective film *The Naked City*, an attempt, as the Cold War was beginning, to recontain those same energies (so prominent in *The American Scene* and *Sister Carrie* as well) by rooting out ambiguity and subjecting a documentary record to the conventions of narrative closure.

Containing the Multitudes

Policing Desire in 'The Naked City'

> Certainly one of the attractions of the city is that somewhere every type of individual—the criminal and the beggar, as well as the man of genius—may find congenial company and the vice or talent which was suppressed in the more intimate circle of the family or in the narrow limits of a small community discovers here a moral climate in which it may flourish.
> —Robert Park, "The City as Social Laboratory" (1929)

I

If we read Williams's project in *Paterson* against the observation by Robert Park that is the present chapter's epigraph, we see that Williams's move forward to a postmodern form was also a return to already existing insights about the decentered city. As a pioneer urban sociologist, Park wanted his readers to take seriously the attraction the city as a sphere of liberation offered, whatever its undoubted accompanying dangers, which he did not shy away from analyzing or Williams from including in his poem. Park's rigor and his withholding of judgment attest to the seriousness of his undertaking to understand the industrial city's social and cultural order on its own terms before intervening in it. Free of the nostalgia for an organic community that is a recurrent topos in American culture, Park and his Chicago colleagues collected data that suggests what Richard Sennett calls "a brilliant, counter-intuitive insight":

that the loosening of social bonds and the latitude allowed indi-
vidual behaviors produces in urban cultures a field of meaningful
differences that can offer city dwellers richer engagement with
their surroundings as they "pass from place to place, activity to
activity, taking on the coloring of each scene."[1] The alienation
feared by the critics of cities is to be overcome by the city dweller
who simultaneously produces a self and its society.

Film noir is likely the genre that has most consistently explored
the world Park's observation describes, so it is nearly unthinkable
to undertake *Urban Verbs* without watching the detectives so
popular in books, films, and on television. I begin with film-noir
New York for its illumination of some of the attractions to which
Park alluded and for its representation of the complexity and am-
biguity of urban lives. However, my ultimate focus lies elsewhere.
From the risky city, I turn to a different sort of police thriller, *The
Naked City* (1948), as an index of the distrust of the city in postwar
America.

The Naked City depicts New York as a volatile mix of unassim-
ilated immigrants and wanton desires, where a well-respected doc-
tor's lust for a beautiful woman drives him to become the pawn of
a jewelry-theft ring, and the woman's own desire for a life beyond
her means leads to her death when the operation's legmen turn on
her. Yet, this film does not represent desire in the noir style. It cen-
sors all the objects of attraction. Indeed, we never see Mary Batory,
the deceased woman who is the focal point of the story. A film
about the policing of desire, *The Naked City* is a tribute to the ap-
paratus of detection and social control under the management of
technocrats like young Officer Jimmy Halloran, who is learning
the ways of the city and the whys of corpses. Repressing the social
forces that contribute to urban crime, and representing the Naked
City as a pathologically abnormal city, a topography of secret
places and unspeakable lusts, *The Naked City* contrasts urban life
with an idyll of family life in the suburbs.

If the antiurbanism of *The Naked City* sounds familiar—and it
is—it is brought up to date by its deployment of the perspective
and discursive framework of social science. The film supports the

shift in advanced opinion during the period away from the values of pluralism and the mythos of self-making that accompanied the increasing bureaucratization of public life and another eruption of xenophobia that led to more restrictive immigration legislation, one intention of which was to protect the nation from foreign subversion. The accepted sociology of the 1940s and 1950s played an important role in the revaluation of these values; it abandoned evolutionary and progressive models of social development in favor of a "structural-functional" paradigm that approaches societies as steady states. In the writings of Talcott Parsons (who declared the death of evolutionary sociology but retained an organic metaphorics), it is axiomatic that all of a healthy society's functions contribute to the efficient reproduction of its structure. New elements therefore threaten the integrity of the social structure. Desire is no longer the spur of development that it was for Herbert Spencer. Potentially destabilizing, it is therefore dysfunctional, as it always is in *The Naked City*.

The new sociology thus gave a new importance to psychiatry as a set of technologies for intervening in the lives and on the bodies of individuals; in a social organism that is assumed to be balanced and healthy, we are the source and locus of dysfunctionality. The medical model of psychology became hegemonic in this period, and Parsons himself encouraged the viewing of social control mechanisms within this paradigm. He made frequent comparisons between social relations, "the control functions . . . attributed to the most ordinary patterns of interaction between persons," and "the very striking achievements of modern medicine in such fields as the control of infectious disease through application to them of the findings of bacteriology and immunology."[2] He also encouraged the expansion of doctors' and other medical professionals' disciplinary authority over patients' mental health as a form of proactive treatment. *The Naked City* advances this medicalized sociology. Its depiction of police work portrays surveillance and interdiction as natural, organic functions, a form of social self-immunization that is therapeutic for individuals as well as the group. It is in this respect very much a film of the Cold War, a pe-

riod when the fear of foreign influences turned the social body on itself. But to throw into greater relief *The Naked City*'s departure from the moral ambiguity of the city in Hollywood film noir, I turn first to a film closer in spirit to Park's description of urban society, Otto Preminger's *Where the Sidewalk Ends*.

Film-noir stories of criminals, private eyes, and rogue cops comprise some of the best representations of American double-mindedness about urban experience. From Sam Spade and Philip Marlowe to *Blade Runner*'s Rick Deckard, the film-noir detective typically works in an ethnically diverse inner city where characters communicate in a street argot that is supposed to mark their distance from the world of the audience. In *Blade Runner* the linguistic melting pot has created a new language, "city speech," out of the foreign phrases and the heavily accented English of the streets. The detective in these films is a man who has seen everything but is powerless to change much of anything. A loner with a dark past, he plays by his own rules and has no illusions that he serves the public good because he doubts the integrity of its putative defenders. His marks of individuality are all "dysfunctional": alienation, cynicism, refusal to follow orders; but the fact that he retains his individuality in a time of mass conformity qualifies him as a hero.

Gangster films often make a folk hero of the "magnate by other means," casting him as a populist response to the industrial monopolists who portrayed themselves as self-made men, but who often made themselves by staying just ahead of the curve of reform. For, if the gangster's motives are indisputably criminal, the magnates who vie with the gangsters for control of the city are understood to be no less corrupt in their exercise of power over governments, markets, and the aspirations of the working class; they own whatever politicians are not "crooked." As F. Scott Fitzgerald famously suggested in Nick Carraway's uneasy combination of moral platitudes and introspective dishonesty, Tom Buchanan's boorish will to dominate, and Jimmy Gatz's innocent-seeming faith in American mythology, the lines between truth and lies,

business and crimes, is faint indeed in the big city. Thus, on one level, the city is depicted as the den of evil the Jeffersonian agrarians feared it would be and a succession of American novelists, essayists, and other intellectuals have depicted it as being.[3]

At the same time, the nocturnal city has its undoubted, if dangerous, allure, which is crucial to the portrayal of its moral ambiguity in the noir genre. Gangster speech and style have long been imitated by many among the young (and not so young) who use it to proclaim their defiance of social conventions. Some of New York's most popular newspaper columnists—including Mark Hellinger, who would produce *The Naked City*—have owed much of their popularity to their positions as scribes of night life and the underworld, where the focus is not on the gritty world of small-time criminals, but the high life enjoyed in common by respectable and not so respectable businessmen. To this laissez-faire morality is added the dangerous sexuality of the nocturnal city, an eroticizing of violence as well as a violent sexuality that heightens the voyeuristic thrill the genre offers. The sexual attraction usually proves fatal (or nearly so) to at least one of the main characters. While the drama of detection and pursuit is most often a battle among men, illicit sexual desires are frequent motives for action by the protagonist and his prey.

This world is brilliantly rendered in *Where the Sidewalk Ends* (1948). The film reunites the director and stars of *Laura* (1944) to tell the story of New York Police Detective Mark Dixon. Mark is the son of small-time mobster Sandy Dixon, who died trying to shoot his way out of prison. Driven to succeed in his chosen field by the desire to settle his score with the city and prove that he is not what he appears by inheritance to be, Dixon has dedicated his career to taking off the street a hood named Scalesi. In a city full of criminals, Scalesi is the focus of Dixon's animus because he was given his start by Sandy.

The plot pits Dixon against Scalesi, but also against his new superior, Lieutenant Thomas. A competent administrator and a by-the-book detective, Thomas has just taken "a big step up in the Department," in the words of Inspector Foley, who reserves harsher

words for Dixon. Dixon started with Thomas, but he has been compiling a record of abuse including "twelve more legitimate citizen complaints this month for assault and battery" that have just resulted in his demotion. Chided by Foley for not being a team player, Dixon finds little use for standard operating procedures in the world he polices. *Where the Sidewalk Ends* sides with Dixon to the extent that it shows the failure of Thomas's method, which assumes that the logic of events is easily discerned. Dixon is a better detective because he recognizes the contingency of events and the complex motivations of the city's people, but his position in that world—not above it like Thomas—undermines the moral authority of his police work and renders his success ambiguous.

The film's action begins with the murder of a gambler from Texas named Morrison, who had been beating the house for "about nineteen grand" at one of Scalesi's floating craps games. We see an argument erupt when the gambler's escort, the beautiful model Morgan Taylor, decides to leave and Morrison moves to accompany her. Another man at the game, Ken Paine, insists that Morgan keep Morrison at the table long enough for Scalesi to recoup his losses. When she refuses, Paine hits her. (It is later revealed that Paine is Morgan's estranged husband. He used her to lure Morrison to the game; so he acts from jealousy as well as responsibility for Scalesi's loss.) Morrison defends his "date" from Paine's rough handling, and the two men briefly struggle. Paine knocks out Morrison with a blackjack and leaves.

Morrison dies, but from stab wounds, not the blackjack blow. At the scene, Scalesi alibis to Dixon and Thomas that Morrison was "down a grand or so" to the house when he made a play for "the girl" and a jealous Paine killed him. Whether from his desire to get Scalesi or the knowledge of the world bequeathed him by his father, Dixon is able correctly to size up the situation: Morrison was ahead and Scalesi or his lieutenants killed him when he tried to leave. Dixon's surmise is overruled by Thomas, who is willing to entertain Scalesi's story and orders Dixon to bring Paine to the station for questioning. By the time Dixon tracks him to his Lower East Side flat, Paine is drunk and angry because he thinks Morrison

has skipped out without sharing the night's winnings. Apprised of his situation, Paine refuses to go to the precinct and give a statement. When Dixon does not leave, Paine assaults him. In a scene that echoes the fight with Morrison, Paine suffers a blow to the head from Dixon and dies.

Thus the film's first fifteen minutes. What we have learned is that if Scalesi is an acquitted murderer on his way to beating another rap, the police are incompetent to recognize the facts of a crime unless they were raised on the wrong side of the law, in which case they become killers themselves in the course of preserving order. Indeed, Dixon is already infamous for his tactics; he is accused by Inspector Foley of not being satisfied with "detect[ing]" criminals or even hating them, but "get[ting] fun out of beating them up." Thus, he sees no point in explaining the events of his latest transgression, especially since Paine was in the public eye as a war hero; only privately was he an alcoholic, a gambler, and a wife-beater.[4] (Paine, it happens, had a metal plate in his head as a result of a war wound, but in a city of secrets, how was Dixon to know?) To cover his tracks, Dixon dresses as Paine, takes a cab to Grand Central Station, and buys a train ticket to Pittsburgh. He then returns to the apartment, drives the body to the docks, knocks out the watchman, and dumps it into the East River. When the body is found, he hypothesizes that Scalesi had Paine killed to keep him from implicating Scalesi in Morrison's death.

The body of the film concerns Dixon's attempt to cover up his homicide by framing Scalesi for Paine's death, a plan complicated almost immediately when Morgan lets it slip that her father, Jigs, vowed to go after Paine if he ever beat her again. Jigs at once becomes the prime suspect. While the plot is principally a battle among men—Dixon, Thomas, and Scalesi—behind it all stands Morgan. Passive throughout the film, she contributes to two deaths simply by being an object of desire, and she derails Dixon's plan when he falls for her. Seeing that his alibi entails sacrificing Jigs and hurting her, behavior that proves he "couldn't shake" his criminal inheritance, and sensing one last opportunity to bring down Scalesi, Dixon arranges a middle-of-the-night meeting at

which he hopes to provoke his own murder. While Morgan sleeps on his sofa, Dixon indites a letter to Inspector Foley that explains the events leading to Paine's death and fingers Scalesi for his own soon-to-be-accomplished fate. By a sort of rough justice that is the best the dark city can offer, if Paine, already dead, still takes the fall for Morrison but without any consequences except to a reputation that was too bright, Dixon gets revenge on Scalesi, who will go to the chair for killing a police officer, even if he goes down as a bad cop, too much "Sandy Dixon's son." As things play out, however, one of Scalesi's men implicates Scalesi in Morrison's death when questioned by Thomas, who at Foley's suggestion uses Dixon's hard-hitting approach. This information makes Dixon's theory about Paine's death plausible as well. Meanwhile, at the meeting, Scalesi hangs fire, realizing that Dixon is "crazy" and wants to be killed, but he is trapped as he tries to leave. Back at the precinct house, Dixon is praised by Inspector Foley for his successful, if unorthodox, method of solving the case, and his letter is returned unopened. Commended by the police bureaucracy and reinstated to his old rank, Dixon can savor his triumph over Scalesi and leave with his new love.

Instead, Dixon insists that his confession be read. Inspector Foley does so and then arrests Dixon, whose decision disturbs more than it settles. Dixon's insistence seems to concede the authority of the institutions of detection he had found inadequate for dispensing justice throughout his career. His decision is necessary, perhaps, for achieving closure (assuring that no evil goes untried) and as final proof to himself that he has not inherited his father's character: he takes responsibility for his actions. Laboring under a guilt that is not his own, Dixon has always operated on the fringes of the law, hoping to escape punishment by administering it and producing justice from his knowledge of the criminal mind. Now, he seems willingly to subject himself to the discipline he had resisted.

His act of contrition is no clear act of salvation. Morgan insists that "they have to see it was all an accident," but Dixon knows that "innocent people get into some terrible jams, too," and he

trusts the courts no more than he has trusted the police handbook. Dixon's decision may even be one more defiance of the system, given the desires and denials that motivated his pursuit of Scalesi. Neither cop nor criminal, Dixon is at the film's end offered the conventional rewards for faithful service: a respectable woman and accolades from his superiors. Logically, he has no reason to refuse them and to reveal his secret, because the department is satisfied with the results and he clearly prefers his investigatory methods to their own. Dixon's gesture of sullying his name in order, he hopes, publicly to clear it is, then, a last assertion of his troubled individuality against the determinism of inheritance and the difference-effacing protocols of the bureaucracy. If he were to disown his actions he could become the hero of a tabloid tale in which cops are honest and only mobsters kill war heroes. Rather than go along, he publishes his secret and lets his story play against the ideology of professional competence, justice, and honor. The film unsettles the grounds for judging Dixon, though at the risk of condoning his disregard for the rights of suspects, as it had earlier attempted to complicate our judgment of Paine; Morgan's ex-husband was "definitely a joik," as a friend of hers says, but he was also a jobless former hero down on his luck. Even though the film's focus on individuals keeps it from exploring structural relations of class and gender in any detail, its method of locating individual histories within them argues that lives and motives are more complex than the fictions of legal formalism posit. *The Naked City* undertakes to free viewers from these complexities by celebrating the efforts of a force that is professional, dispassionate, and not in the least roguish.

II

Directed by Jules Dassin from a screenplay by Malvin Wald and Albert Maltz, *The Naked City* is also a film noir in the eyes of some critics and the blurb writer for the Ivy Classics video. Yet it is difficult to imagine a police film that is more the polar opposite of *Where the Sidewalk Ends*. A film titled *The Naked City* and de-

scribed by its principal writer as "semi-documentary" would seem to promise some such exposé of life in the gutters—which is where the sidewalk ends—as the noir world of detective fiction offers.[5] That expectation is reinforced in the film's opening sequence as a series of aerial views of Manhattan progresses northward from the Battery accompanied by a drum roll, and Hellinger, who is the film's narrator as well as its producer, introduces a "story . . . of the city itself" by warning viewers that "frankly, it is a bit different from most films you have ever seen." *The Naked City* was unique in its mode of production; it was the first Hollywood film shot on location in New York. As Dreiser at the beginning of the century had observed a scrupulous accuracy of names and places in Carrie Madenda's Chicago and New York and produced a book that extended the boundary of the literary treatment of city life, Wald proposed an equivalent filmic document. Hellinger explains in the voice-over that "the actors played out their roles on the streets, in the apartment houses, the skyscrapers of New York itself, and along with them, a great many thousand other New Yorkers played out their roles also" in 107 shooting locations distributed throughout New York City, the vast majority of them within the Borough of Manhattan.

The opening sequences of *The Naked City* are panoramic and Whitmanic. The narrator promises us "the city as it is: the hot summer pavements, the children at play, . . . the people without make-up"; the sort of neutral recording Whitman employed. After those aerial views, the camera descends to show the city as it looks at one in the morning: the deserted spaces of Wall Street, a theater, a factory, the docks, and the deck of a cargo ship. Yet New York has "a pulse" that "never stops beating," the narrator tells us as we see elevated trains on their runs, office buildings still partially lit, a gallery of people who "earn their bread at night"—a woman who mops the floors of Grand Central Station, a linotype operator who composes an article for a newspaper, a disc jockey who wonders aloud if anyone is listening—and people "rounding off an evening of relaxation" at private parties and nightclubs. Soon, we view another montage of scenes depicting the city waking up: street clean-

ers flush the gutters, freight trains arrive in the yards, mail trucks begin their runs.

Inserted among these scenes is an activity that gets more screen time, presaging its centrality: two men chloroform a young woman and drown her in her bathtub. Though this scene has its basis in the facts of an actual murder—Wald was granted access to the files of unsolved murders kept by the New York Police Department—we see little of the event. The chloroforming of the victim in the wee hours is filtered through blinds, and we never see the body in the bathtub. In fact, we never see the victim's face at all. Still, the murder of Jean Dexter, born Mary Batory, begins the storyline of *The Naked City*, as it transforms the camera from a neutral and democratic viewfinder into the locus of a mobile and amorphous apparatus of detection. It becomes the unseen, omniscient eye of the security state's domestic surveillance apparatus.

In opting for documentary techniques, Wald called on a tradition that had been put to many uses and gained great authority in the preceding decades. Documentary photography had been a weapon in the fight for Progressive reforms since the 1890s, when Danish immigrant Jacob Riis took his camera as well as his reporter's notepad to the slums of Manhattan in order to expose *How the Other Half Lives* to people who were content to ignore the problems of urban poverty. In the first decade of this century, Lewis Hine embarked on a similar career. As a staff photographer for *The Survey*, a Progressive journal, and after 1908 as a photographer for the National Child Labor Committee, Hine sought to expose, in order to prevent, the exploitation of children (and, implicitly, all laborers, female and male) by mill and factory owners who had few limits on the demands they could make of their employees. In the 1930s, independent investigative reporters like Hine and John Spivack, who exposed the murderous abuses of power on Southern prison farms, were joined by government-sponsored documentarists. The federal Resettlement Administration, later renamed the Farm Security Administration, employed photographers to build a documentary record of the nation; their work included gathering evidence to support the need for New Deal social policies. Walker

Evans traveled the country and focused attention on sharecroppers, as Erskine Caldwell and Margaret Bourke-White had on their own. Dorothea Lange collaborated with Paul Taylor to document the conditions of California's migrant laborers. She and Ansel Adams later independently recorded the forced evacuation of Japanese Americans to internment camps in 1942.

Film became an important documentary medium in the United States in the 1930s. The Resettlement Administration recruited Pare Lorentz and Joris Ivens, two of the nation's best-known documentarists; Lorentz's *The Plow that Broke the Plains* and *The River* made the government's case for agricultural reform and its flood-control projects. Independent filmmakers associated with Nykino and the Workers' Film and Photo League produced films that argued for more radical change. In the early years of television, Edward R. Murrow demonstrated its documentary power with his *See It Now* series, an exposé of Senator Joseph McCarthy in 1954, and *C.B.S. Reports* that included "Harvest of Shame" (1960), which detailed the continuing mistreatment of migrant workers in America. If some of these reporters and photographers exploited their subjects by speaking for them and measuring their lives by a canon foreign to them, they nonetheless accomplished some laudable reforms.

The Naked City, on the other hand, is not intended to awaken the desire for progressive change—or desire of any sort. It participates in a second wave of documentary that began in earnest with the nation's entrance into World War II. In those years, prominent Hollywood directors began making war films. Frank Capra produced the *Why We Fight* series and *Know Your Enemy—Japan*; John Ford made *December 7th* and *The Battle of Midway*; John Huston filmed *The Battle of San Pietro*; William Wyler focused on the Air Corps in *Memphis Belle* and *Thunderbolt*. Otto von Sternberg, meanwhile, made a film about the domestic front, *The Town,* which told the story of the war from the perspective of citizens in Madison, Indiana. Parsons addressed these uses of documentary in an essay on "Propaganda and Social Control" that predicted the government's further ventures in the documentary field. Published

in 1942, the essay endorsed the dissemination through film and other media of a practice of "'social psychotherapy'" that would reinforce the goal of "continuity with the great traditions and institutional patterns of Western society which [are] at stake." The federal government's postwar uses for documentary film included announcing scientific and medical advances, enhancing education and professional training, and, particularly, selling the American way of life at home and around the globe. The Office of War Information was rechristened the International Motion Picture Division of the Department of State. By 1951 it was producing 400 two-reel films a year; in 1952, it operated on a budget of more than thirteen million dollars. *This Is America*, a series of short subjects for theatrical viewing, was in production from 1942 to 1951. Begun as a series of twenty-minute reports about life in the armed services and at home during the war, *This Is America* went on to consider many facets of life in the United States, including the detection, conviction, and reform of criminals in such documentaries as *New Prisons—New Men* (1944), *Crime Lab* and *Who's Delinquent?* (1948), *State Trooper* (1949), *Pinkerton Man* (1950), and *Prison with a Future* (1951).[6]

It is within this milieu that *The Naked City* is best approached. As a film of the Cold War, *The Naked City* accustoms us to—by naturalizing—the complex internal security network that was then in the process of being deployed to track the movements of suspicious-seeming individuals. A brief list of domestic security legislation enacted in the decade after the war includes Truman's Loyalty Order (Executive Order 9835) and the National Security Act in 1947, the Selective Service Act of 1948 that authorized the peacetime draft, the McCarran Internal Security Act of 1950, and in 1954 the Communist Control Act and Eisenhower's Executive Order 10450, which superseded Truman's Loyalty Order and changed the criterion for dismissal from a government job from evidence of disloyalty to a finding that "employment . . . is [not] clearly consistent with the interests of the national security." The new directive conflated politics and morality, politicizing the personal in ways that suggested that being American was an entire way of life. The new grounds for dismissal included "infamous, dis-

honest, immoral, or notoriously disgraceful behavior," as well as support for a range of political causes. While the Taft-Hartley Act (1947) was labor legislation, it, too, supported security goals by limiting the power of labor and withholding certification from unions whose leaders had not filed affidavits swearing their loyalty to the nation and its form of government. The anti-Communist hysteria achieved one of its most ludicrous moments in the 1953 attempt to subpoena Truman to defend himself before the House Committee on Un-American Activities against charges that he had been blind to Communist infiltration of his administration.[7]

One of *The Naked City*'s premises is that these surveillance capacities, the real hero of the film, are not an intrusion into private life but a means to ensure private freedoms. Widely accepted in the 1950s, this hypothesis continues as the basis of some of the nation's most popular television shows of the 1990s, the "real-life" crime dramas that are direct descendants of this filmic experiment. The large following of these shows reflects a suburbanized audience's fears of the unpredictability of cities that are concentrated nodes of differences. The same fear underwrote *The City*, that film of the 1939 World's Fair I discussed in Chapter 3, and it has been continued by a succession of law-and-order national administrations.

The emphasis in *The Naked City* falls on bureaucratic procedures, not individual crusaders like Mark Dixon. Certainly, the fact that Dixon prowls at night while police work is for Officer Jimmy Halloran a daylight job that he leaves each evening for his family in the suburbs reflects their characters: Dixon has things to hide; his moral world is full of shadows. But the regular hours kept by plainclothes Officer Halloran indicate as well that policing has become another form of social management whose operatives are white-collar technocrats overseeing a process. Parsons defined a society as "a system of interdependent structures and processes such that it tends to maintain a relative stability and distinctiveness of pattern and behavior *as an entity*." Further defining *structures* as the interpersonal relations that define subject positions, Parsons located them at the foundation of social order as the causes of action. He further assumed that all the structures that articulate a

complex society and the distinctions they produce are necessarily functional; that is, the relations among the different members promote the stability of the society as a whole. Franklin H. Giddings had observed about Spencer that "the basal theories" of his sociology rest on "the persistence of force, the direction and rhythm of motion, the integration of matter and the differentiation of form," which make it "a physical philosophy of society notwithstanding its liberal use of biological and psychological data."[8] For all of Parsons's disavowals of Spencer's evolutionary model, the same may be said of his social models.

The structure of the social system is metaphorized in the film by the webs that police work defines and administers. As an island, Manhattan is particularly well-suited for the strategies of containment and exposure the film deploys, which put it on the way to becoming the prison it will be in John Carpenter's 1981 dystopian film, *Escape from New York*. It is constructed of overlaid grids that seek to name and fix all points on the island: the gridiron plan of streets that reduces topography to a Cartesian regularity, the subway system, the underground lines of the telephone system. The grids are reproduced on the map of the city's streets in the squad room: they mark the boundaries of the precincts that are subdivisions of the urban panopticon, and they track the motion of the police cruisers, each of which is signified by a coded disc. These maps can also be used to mark the distribution of classes and ethnicities along the grid of streets and avenues. The telephone switchboard at Homicide is a different sort of grid; it is not a representation, but marked on its coordinates are the various agencies and offices that must themselves be coordinated in a murder investigation.

Peter Conrad observes of these grids, the abstract calculus of detection, that "the arithmetic of *The Naked City*" is the means by which the police subdue "a too prolific city":

In the script, the police radio room dispatches cars 206 and 159—symbolized by metal discs on a map of Manhattan—to 198 West 69th Street, Apartment 4-D. The film changes the location of the crime to 52 West 83rd Street and instigates the investigation by showing a switchboard making a

sequence of connections, first to Roosevelt Hospital, then to the Medical Examiner, then to the Technical Research Laboratory, next to Homicide (extension 72). The entrapment of Garza [the murderer of Jean Dexter] is also a mathematical exercise. Signal 32 sends squad cars 702, 509, and 110 to Rivington Street . . . , officers from the Fifth and Seventh precincts hunt Garza, who's wanted by police in the Tenth Precinct for a murder committed in the Twentieth.[9]

Resolving all activity to the clarity of a formula and the predictability of an arithmetic progression, *The Naked City*'s police are able to dispose with the questions of motivation that unsettle so many judgments in *Where the Sidewalk Ends*.

A representative of the systems of detection and control, Halloran builds a case by making connections among such disparate events as a pawnshop burglary in Long Island City, jewelry thefts from the homes of the rich, and the murder of a young woman, cases that are, as Conrad notes, "'miles apart' . . . geographically as well as figuratively."[10] Since detection is a matter of fixing identities as well, of positioning individuals within the web of events, Lieutenant Muldoon does not tolerate the presence of unknown parties in a case; in the course of his investigations, he uses the wily "McGillicuddy" ("Joseph P.") to designate any unidentified suspect. In the country at large, an assumed name indicated an immoral intent at best—at worst, subversive activity. After all, 1948 was the second year of the House Un-American Affairs Committee's investigation, when the imperative for all who were subpoenaed was to confess themselves and "name names." Taking another name is therefore a mark of depravity: Dr. Stoneman, the film's fallen medical professional who is led to crime by love, becomes Mr. Henderson of Baltimore on his all-night trysts with Jean Dexter, who changed her own name from Mary Batory to conceal her class and ethnic position and to insinuate herself among the wealthy of New York. Even the different surnames of Ruth Morrison and her remarried mother, Mrs. Hylton, are treated suspiciously by the film's Irish Catholic detectives.

The dead, too, can be interrogated and their secrets exposed. Answering questions posed by the trained eyes of the medical examiner and Lieutenant Muldoon, the corpse narrates its last few

minutes: "Bruises on . . . neck, shoulders, and arms" proclaim a struggle that precludes the case being an accidental death or a suicide; barely noticeable burn marks around the nose and lips speak to the use of chloroform on the decedent; "white foam around [the] mouth" testifies that Jean Dexter was alive when she was placed in the bathtub. Muldoon draws from the bruises further testimony that two suspects were involved in the murder: the number and position of contusions on the decedent's arms are consistent with one man holding her while another man placed some chloroform-soaked material over her nose and mouth. While the body is being deposed by the coroner, an agent from the Technical Laboratory investigates the household furniture.

The gridding of urban social and spatial systems in the film extends as well to its stratification of ethnicity. The film's upper class is all WASP-surnamed: Stoneman, Morrison, Hylton, Niles; Mary Batory becomes a Dexter hoping to shed her working-class origins. The police are principally Irish Americans, Muldoon and Halloran, although they are assisted by Italian Americans Perelli and Constantino. The policeman specified in the script as black is played by a white actor; Mrs. Hylton's servant is the film's only African American. The origins of the working class are, like their characters, more obscure. We learn that Batory is Polish. The heritage of Willie Garzah (as his name is spelled in the film) and his accomplice Pete Backalis remains uncertain, although a likely pronunciation of the second name—Back-alleys—may say enough about his type. This pattern fuels the fears of the film's time, when the perceived threat of foreign subversion was coupled with a flagging faith in the power of assimilation to produce concerns about the unity of American culture and society and the nation's ability to respond to "the Communist threat."

Some of the groundwork for the linkage of immigration and subversion had been laid with the Smith Act of 1940. Targeted at preventing subversive activity by foreign nationals after the outbreak of the European war, it required all resident aliens to be finger-printed and registered with the government. The Act's provisions are "notable as the first [instance] in which Congress followed the doctrine of guilt by association" in determining who might pose a

security risk. The obsession with security and the distrust of "foreign elements" only increased after the war. The claims of justice as well as the strategic advantage to be had by permitting a mass exodus from Eastern Europe to the United States led Truman to push through Congress emergency resettlement acts that allowed 410,000 citizens who might have names like Garzah, Backalis, or Batory to immigrate. The majority view was expressed in the McCarran-Walter Immigration Act (1952), which perpetuated the use of population figures from the 1920 census as the basis for national-origins quotas, expanded the government's powers of surveillance over aliens, and reinforced provisions of security acts that ordered the deportation of aliens suspected of any past activities prejudicial to the public interest. It passed over a veto by Truman, who objected to the system of ethnic preferences that "keeps out the very people we want to bring in" and denounced its security provisions as "worse than the infamous Alien act of 1798."[11]

As a result of these overlaid structures of class, ethnic, and professional positions, individuality is reduced to an effect of social reproduction, as Parsons theorized. His writings shifted the balance between the individual and society decidedly in favor of the priority of society's claims on the individual through his focus on "institutional patterns[, which] are . . . agencies of the 'control' of the behavior of [a society's] members, in that they keep it in line with the established structure and functional requirements of the social system."[12] Self-making like Carrie's, Jay Gatsby's, or J. Ward Moorehouse's in *The 42nd Parallel* gives way to the ideal of an individual who fulfills her or his function among the patterned elements and role expectations of the society. No one rises meteorically in *The Naked City*, a film that has no compelling characters, either in the Jimmy Cagney mold or detectives who struggle with their own complexes. In their place are common criminals, slaves to desire who change their names to hide their shame, and a web of scientific investigatory procedures under the command of a lieutenant who makes clear the department's wishes: "We want no . . . heroes," nobody like Dixon, who "like[s] to read about [him]self in the newspapers."

As Parsons explained it, individuality is constructed not by de-

sire, but by the various institutions of social reproduction—the "defined status relationships" of "strategic structural significance"—in which one is situated. Park's crucial 1925 insight that "delinquency is not primarily a problem of the individual, but of the group," and should be addressed by supplying an environment in which one "can have not only free expression of his energies and native impulses, but a place where he can . . . be free to formulate a plan [for] . . . a reasonably happy existence," is thereby replaced by an etiology of delinquency as individual maladjustment to a healthy society. Social control is no longer a process of mutual adaptation of self and society, as it was for many turn-of-the-century voluntarists. Rather, Parsons asserted, "the well-integrated personality feels an obligation to live up to expectations in his variously defined roles, to be a 'good boy[,]' to be a 'good student,' an 'efficient worker,' and so on," while the neurotic individual resists the claims of legitimate authority on him.[13] Bringing its ideology of social relations in line with this viewpoint, the final cut of *The Naked City* suppresses the complaints made by the workers in the montage scenes. More importantly, it silences Lieutenant Muldoon's speculations on crime. In the screenplay, Muldoon seems to absolve the dead woman of blame for her seemingly immoral and certainly illegal actions because "people get so pounded and pounded" in a city of "eight million people struggling for life, for food, for air, for a bit of happiness" when "there ain't enough of everything to go around." Mary Batory did not want too much, he seems to suggest, only better than she had. Contemporary audiences would have been predisposed to trust Muldoon's judgment because he was played by Barry Fitzgerald, who had for years been the screen's most popular Irish priest. The shooting script still took the side of law enforcement, but it scattered throughout the dialogue such critiques of existing economic and social relations as this musing and the Captain's confession that while he cannot make sense of what "this boy Del Vecchio" did in an unspecified, unrelated case, he does "see eighteen years of feeling lonely and beaten. So he—exploded." In the final cut, all such hints of the social causes of antisocial behavior are erased.

The medical psychiatry of the period, which Parsons embraced, agreed with the final cut, not Muldoon's perspective. It sought the causes of maladaptive behavior inside the individual rather than in the society to which she or he must adapt. The 1959 *Encyclopaedia Britannica* defined the practice of psychiatry for its popular audience as the treatment of disorders "from the standpoints of biology, pathology, and general medicine, as it is recognized that the psychoses must be the outcome of a malfunctioning organism." The factors that contribute to a patient's disorders are enumerated as "the nature of his life situations, the state of his organism, and the whole of his past history, both personal and ancestral," but not his or her position in a dysfunctional social organism.[14] In the medical model of disorder and its cures that intervene on the individual body—lobotomy, shock therapy, psychopharmacology—as with Parsons's sociology, *dysfunctionality* is interpreted as a characteristic of individuals who do not contribute to the reproduction of the social organism in its present state.

Because in this social order marked individuality is a danger, this film requires a different sort of hero than the complex, alienated Dixon. The closest thing to a hero in *The Naked City* is Halloran; he is the hero as ordinary man in a time when anonymity was a laudable state of nondeviance. Halloran fought the war as a foot soldier and served without any special valor, and he follows the same behavior pattern on the New York force. Indeed, his sole attempt at heroism backfires when Garzah gets away because Halloran went in without waiting for back-ups. To identify with Halloran is to accept one's social position and its prescribed functions, whose limits are not of one's own making, and to want only the happiness it makes available (the morality Michaels ascribes to Howellsian fiction). That happiness is portrayed in this film in the conventional form of the nuclear family. Representing the suburban ideal, Jimmy and Janey Halloran live in a Queens neighborhood inhabited by couples like themselves who seem to have no need for policing. Paired with the more rural house of Mary Batory's parents, the Hallorans' block of semidetached brick structures brackets the Depression and the war's years of upheaval, as they

spatially bracket Manhattan. An ethic like the Batorys' weathered the Depression, restored prosperity, and produced the sons who keep the world safe for democracy. Jimmy and Janey represent the generation that came of age during the war and are now by their own hard work and their parents' sacrifices able to live the promise of suburban life in economically, racially, and visually homogenous, family-centered communities where children can leave their rocking horses on the street without fear of having them stolen by the similarly outfitted neighbor children. Men like Halloran, who "walked half-way across Europe with a rifle in his hand" and returned to his loving wife and "spunky" son, Billy, are proposed by the film as the true Americans—not the urban riffraff, Mary Batory, Frank Niles, who lies about his service and spent the war running up an unpaid liquor bill, or even their friend Ruth Morrison, who went to Vassar and came back "one of those career girls [who] has her own apartment" instead of a husband and family.

The extension of the suburban demographics the film praises was actively supported by the federal government. The Federal Housing Administration had been created during the Depression to make available affordable home loans. Like the postwar Veterans Administration home loan program, it was targeted toward the purchase of new houses, which in turn stimulated the homebuilding industry. Leading this housing recovery during the war years 1942–44 was a $23 million investment in factories that doubled the nation's industrial capacity. The majority of this industrial plant construction was sited on the outskirts of existing cities, and it in turn produced a demand for housing for the new labor force and the workers in the service sector that supported the new population. While there were only 114,000 housing starts in 1944, two years later nearly a million homes were built; in 1950 that figure reached 1,692,000 starts, over 60 percent of them in the suburbs.[15] In metropolitan New York, the majority of that suburban construction was in Queens neighborhoods like the Hallorans'.

What *The Naked City* suppresses in its depiction of suburban values and urban depravity is the complicity of the government, private industry, and the financial sector in creating a city aban-

doned by the middle class through these policies, which were intended to give the middle class a direct stake in the nation's future. The city of this film is mystified as immoral by nature and in need of subjection to the normalizing powers of a cadre of white male professionals. This was a time of deep suspicion, as well as the golden age of the expert capable of surveilling the city, constraining the wanton body, and delving into the criminal mind, the era of the technician who could prescribe against the causes of social deviance. Having described their techniques and ideology, I turn now to the film's depiction of that regime in action.

III

While *The Naked City* purports to offer life in the raw, like the police shows that follow its lead, the film censors more than it exposes. The murder occurs off-camera; even the screenplay's mildly off-color jokes, like a straphanger's comment that he "wouldn't mind being the washrag" in Jean's bathtub, are suppressed. For all the telltale signs in the body of evidence, the "beautiful" but "immoral" body of Jean Dexter is never exposed to the camera. It is simultaneously present and hidden: studied, discussed, described, but never visible. The city presents a similar aspect as Halloran gazes down on it from the window of Dr. Stoneman's office—just as "naked," nonetheless just as secretive. The film implies that New York is a city like a woman, not only as a space of desire but in its very topography. It conceals secret interiors, what Henry James called *penetralia*, that are beyond the knowledge of the detectives, their probing, and "the bright, hot light" of investigation.

Desire is, I have said, the "epidemic" threat to the health of the urban social organism in *The Naked City*. This fact measures how far its world is from the urban world Dreiser depicted in *Sister Carrie*. In that novel, as in Spencer's sociology, desire is a natural force; part of the biophysics of social growth, it is, he wrote, "the incentive to action where motives are readily analyzable, . . . probably the universal incentive; . . . the conduct we call moral is determined by it."[16] Clearly, wanting too much does not harm Carrie

Meeber; it keeps her alive. But one of the key revisions of socio-logical theory made by Parsons was the preference for stable equilibrium over dynamic equilibrium that makes desire a force of errancy. In *The Naked City*, too, desire is no longer healthy. It is "unnatural," according to Dr. Stoneman, and he has the professional authority to make such judgments.

Adapting the medical model to its subject, *The Naked City* represents desire as an addiction to which the weak-willed are susceptible. It leads to deceit, theft, even murder. Desire shames mature men, leads young girls to daydream idly in front of store windows when they should be working, leads to the spectacle of twice-married women making passes at married young detectives and alienated grocery delivery boys dressed in black fantasizing the murder of women beyond their reach. Surviving long enough to make his life a warning to viewers, the ironically named Dr. Stoneman confesses himself ("Me! Stoneman!") a sex-addict. Once he saw Jean Dexter in the dress shop where she modeled, he was "drunk with her, lost." The script of his confession to the police overflows with metaphors from the pathology of drug addiction, not all of which made it into the final cut of the film. Stoneman, a married man, portrays himself as having lusted for Jean Dexter in the same "way a sick man loves alcohol or a narcotic. There was nothing right about it, only a sick hunger." His surrender to desire having caused him to forsake his will, he "wallow[ed] in [his] own filth" as he slowly went "mad." The wedding of what Stoneman calls their "unnatural hungers," his "for a woman like her" and hers "for money," led him to provide Jean with lists of the guests his wife invited to dinner parties. Jean and her partner, Niles, passed the lists to Garzah and Backalis, who burglarized the temporarily empty apartments and houses.

The entrapment of Stoneman by Mary Batory, who "poses" as Jean Dexter, has another meaning specific to the Cold War. The connection between the subversion of Stoneman's moral sense and treasonous actions would have been drawn by the audience because the man led to subversion by carnal desire rather than political convictions was a commonplace of the period. Indeed, the web

is spun still wider. If Jean is the lure to transgression, consciously advertising herself as well as the outfits she wears in the dress shop, she is a pawn of Niles, the degenerate scion of an upper-class family who is driven by the needs of his lifestyle to almost any sort of crime.

As a response to the dangers of desire and the problems of sexual frustration, a new "sexual liberalism" made sexual fulfillment an acceptable topic of discussion in the 1950s, as Elaine Tyler May has shown. This discourse on sexuality was not primarily deployed as a means of liberating desire. The assumption remained that sexual activity was acceptable only in marriage, where pleasing one's husband was looked upon as part of the proper wife's role, as we see in Jimmy's return from his hard day on the street. Attired in plaid summerweight shorts and an abbreviated top, trim and pretty in a girl-next-door way that contrasts with the expensive beauty of Jean Dexter, Janey greets and cuddles Jimmy to the extent the decency codes allow while little Billy stays upstairs. Part of the production of normalcy, the discussion of healthy sexuality created a normative model of heterosexuality and a catalogue of treatable sexual dysfunctions that would comprehend Jean Dexter's lust for money, Dr. Stoneman's lust for Jean, and the self-centered deferral of marriage and family responsibilities by the film's other fashionably dressed, promiscuous single folk.

These somewhat contradictory impulses toward sexual liberalism and the repression of desire in the name of family values was, May further shows, all part of an undertaking to discipline women and reinstate the gender-specificity of certain fields of activity. The mobilization for World War II had called women, most of them married, out of the home to take the place of men serving overseas. After the war, women were debarred from traditionally male forms of labor; they pursued careers in lower-paying fields associated with nurturing, decorating, and healing, or became housewives if it was economically feasible. During the war the nation celebrated *Rosie the Riveter*, and *This is America* produced a 1942 documentary, *Women at War*. With the end of hostilities, women of this series were models in *Beauty for Sale* (1946; Morgan Taylor and

Jean Dexter both model in dress shops) and nurses in *Women in White* (1948). If it was the case that more women were now going to college, many of them were also calling for courses that would train them to be better homemakers, and most of those college women married and sacrificed their careers to raise families. Parsons advocated the maintenance of limits on women's activity as in the interests of society at large. He counseled that women should strive to become "good companions" rather than economic competitors with their husbands because two-income families would severely strain the family structure, which, like other structures, was maintained by the performance of specialized functions by all of its members.[17] Psychologists were also active in reinforcing the limits of gender in the period. Some of the strain women's absence from the home would cause was implied by the focus on mother-child relations as the most crucial determinant of character development in children. Women were thereby assigned primary responsibility for social reproduction and primary blame for deviant behaviors in American youth.

Given the intersection of the campaign to recontain women with the antiurban model of containment, Jean Dexter's fate may profitably be read as a moralized rewriting of the career of Carrie Madenda. Dreaming of escape from the poverty of life in Lakewood, New Jersey, with her compliant working-class family (her father is grateful to be a banker's gardener), Mary Batory is attracted by the city's range of opportunities for self-making. Of Jean's plans for success her former employer tells Halloran, "somewhere in the back of her pretty head there was a fixed notion that she couldn't be happy without being rich. I don't think Jean ever would have married unless the man had money—real money." The final words on her life's meaning are offered by her mother, who laments that her daughter was led astray by "wanting too much. . . . Bright lights and thee-aters and furs and nightclubs. . . . Why couldn't she have been born ugly?" Her view is seconded by Mary's father, who wants to return to Lakewood as soon as possible because "we don't like this place, this fine city."

In fact, *Sister Carrie* was filmed in 1950. The fate of the novel on screen is a good barometer of the period. William Wyler's version begins with Carrie's loving family giving her a tearful send-off from Columbia City. In Chicago she is always concerned for her reputation, as are the other characters. Fitzgerald, no longer an absentee owner, counsels Hurstwood to look after his own reputation because "a man in the liquor business can't be too careful"; the dubious morality of alcohol consumption is a recurrent theme. He even attempts to save Hurstwood from giving in to his family-destroying desire for Carrie by paying the manager's salary directly to Mrs. Hurstwood. In New York, there are no trolley strikes or unemployment crises, no gay young men to run around with, no fancy restaurants, no fashion parades on Broadway, no female friends to teach Carrie the ways of wealth. There is thus no need for Ames, who is dropped. Carrie and Hurstwood continue to care for each other as their fortunes wane, even after her miscarriage, so much so that Carrie leaves him not out of anger or greed but because she feels she has ruined Hurstwood's relation with George, Jr. The film ends with Carrie pleading for a chance to restore Hurstwood, blaming herself for his fall and wishing she had not been so innocent and he so considerate that he never confessed his crime to her. Like the tearful send-off and the miscarriage, this relationship and Carrie's remorse do not exist in the novel; they are added to stress the importance of the family and the impossibility of starting life over and being happy again. Even with these emendations that make the movie more respectable, Paramount was slow to release the film; it reached theaters only in 1952.

Of course, the disciplining of feminine desire had its complement in a reconstruction of masculinity. While Stoneman's fall may at first seem the most obvious candidate for this cautionary function, its similarity with Hurstwood's demise, in the novel as well as the film of *Sister Carrie*, makes it less interesting because already typical. Jean Dexter's partner in crime, Niles, whose business is merely a front for his trafficking in hot jewelry, is more important to the reconstruction of gender and the attack on urban im-

morality. Niles is of interest not only in himself but because, just as Jean Dexter reads as a heavily moralized response to the career of Carrie Madenda, who changed her name, forgot her past, but never regretted it, Niles reads convincingly as a deromanticized recreation of the most famous self-made New Yorker in American fiction, Jay Gatsby. Like Gatsby, Niles claims to have been an officer during a world war. But while Gatsby produces for Nick his World War I medal from "little Montenegro," Niles's tale is debunked, and we have no reason to believe his story that a "trick knee from college football" kept him out of the service. He is not a self-made son of the midwest inventing his life along the contours of an American dream he read of as a wide-eyed child, but the dissipated son of "parents [who] have money and position." Over his head in a jewelry-theft ring, he admits he must appear to be "a circus character altogether." His words echo Tom Buchanan's assessment of Gatsby's car as a "circus wagon," his actions, Tom's claim that Gatsby is "a common swindler who'd have to steal the ring he put on [Daisy's] finger."[18] In fact, Niles is engaged to Ruth (from whom he conceals his partnership with her friend Jean), and the ring he gave her was stolen.

Quickly revealed as calculating and cynical, Niles is stripped of all traces of Gatsby's allure, which is attributable to the lingering ambiguities at the heart of James Gatz's character and his never-renounced romanticism. Unlike Gatsby, Niles does not through the fabulations of his desire give an aura of respectability to a world whose viciousness is exposed in Nick Carraway's evasions of his past and Tom Buchanan's domineering brutishness. Niles has no vision of a glorious, unattainable past he is living to recapture, and objects have for him none of the magic they hold for Gatsby, for whom fine shirts or the green light at the end of a dock are invested with longing for the person and the past he cannot reclaim. The jewelry Niles sells may have sentimental value for others, but for him it is just another form of capital. Still trapped in adolescent fantasies of male success and power, he is without feeling for anyone. While Gatsby's character is, Nick cannot help confessing, perhaps the purest expression of American society and culture in the

period, Niles's flaws are the result of an individual pathology. His corruption is straightforward and complete.

IV

Yet Niles is not the murderer. Tracking that man, Garzah, is made difficult because he lives on the Lower East Side, in an immigrant world and interior city whose *penetralia* frustrate the technologies of detection. In contrast to the city north of Houston Street, where streets and avenues run at right angles and progress with a mathematical certainty, the land here retains the names and topography of what we might call a "prehistorical" (or, at least, prerationalist) New York. Streets start and stop randomly, run at odd angles, and blocks are interrupted by alleys not shown on most maps. Even worse for the forces of order, the people who live there map space on different coordinates. When Halloran asks for Garzah's address, his brother tells him that, last he knew, Willie "had a room somewhere around the Williamsburg Bridge." Asking in the neighborhood he is told that Garzah lives "down the street someplace," "across the street—corner house, I think—or the next one," as if the buildings lack numbers. Worse still, names are not attached firmly to streets. When Halloran gets a lead, he reports that he has tracked Garzah to "Norfolk Street, between Rivington and Houston," but when Muldoon calls for back-up and orders a perimeter set up to catch Garzah, it is constructed around Rivington between Essex and Norfolk, not Norfolk between Rivington and Houston.

When Halloran flushes Garzah, he retreats to the unseen city. Exiting the tenement by the back door, Garzah enters the block's *penetralia*—an area both interior and exterior that functions symbolically like the sewers in some other noir films. A network of walled yards canalized by alleyways, it compresses into a viewable space the randomness, the swarming confusion of the surrounding neighborhood. It is an "insider's" terrain. Garzah is a master of its passages. Halloran, used to—and representative of—the regularity of police grids, the phone lines, and the systematic regularity of

investigations, is unable to trail him. Only the camera can keep pace with him; by now it is no longer a neutral apparatus, but an aggressive instrument of detection—it taunts him by making him duck behind headstones in a stone-cutter's shop to avoid being seen.

Having thrown the police on the streets because of his intimate knowledge of the unseen city, Garzah is able to resurface in what only he thinks of as "a great big, beautiful city," a judgment based on the promise of anonymity it offers him as "a big man" when there are "half a million big men in New York." Seeking freedom, he heads for the bridge.

All of the figures of containment, of surveillance maps and grids, converge on the Williamsburg Bridge, where Garzah is eventually cornered and killed. This bridge is the most richly symbolic grid-work and spatial and social limit in the film. No mere unremarked ligature, the continuation and conjoining of two roads on separate landmasses, the bridge erupts in *The Naked City* into a contradictory presence, turning the city's connective tissue into a place in itself. An artery for traffic circulation and by customary usage a continuation of the ethnic quarter, the bridge comes alive on its pedestrian deck: mothers stroll with babies in carriages, girls jump rope, boys and girls rollerskate, and older folks sun themselves. Its webwork of intersecting beams recalls the fire escapes that, according to Henry James's chronicle of streets nearby, at first suggest the aspect of "a spaciously organized cage."[19] The appearance of an iron cage provides one clear justification for preferring this bridge to the more famous but less aggressively modern Brooklyn Bridge: it produces yet another correlative of the city as an abstract, mathematical structure, a structure of containment, this time out of a structure designed to support circulation. Indeed, another important reason for preferring the Williamsburg Bridge is that it carries subway traffic to the outer boroughs as well as automobiles and pedestrians, all of which we see in the course of the climactic pursuit of Garzah. While for the law-abiding citizens who live in Queens and Brooklyn and work in the City the bridge joins the worlds of home and work, for Garzah the bridge is part of the not-

to-be-bridged chasm that protects the suburban family from the crowded corruption of Manhattan.

Pursued by police who close in on him from both Manhattan and Brooklyn, Garzah traps himself by scaling one of the towers. Recognizing that "there's no place [Garzah] can go to now," Lieutenant Muldoon suspends the hot pursuit and has his men holster their handguns. Atop the tower Garzah does not stand triumphant, not even for a moment, like Cody Jarrett (James Cagney), who "made it, Ma! Top of the world!" in Raoul Walsh's gangster classic, *White Heat* (1949). Instead, he is dwarfed by the metal arch in a camera shot that restores him to scale after the manhunt had briefly made him into a man of importance. His ultimate insignificance to the city at large is captured by a camera looking over his shoulder as he dangles from the tower; below, oblivious of the commotion, we see a quartet of white-clad men and women going about their tennis on outdoor courts along the East River.

Like so many other perspectives in the film, the angle from which we see Garzah and the tennis players cannot be associated with any of the characters. The camera hovers in midair, rather like a police helicopter (recall that *The Naked City* opens with aerial views and the hum of airplane engines) as it becomes associated with the security apparatus of the city itself as an omnipresent eye. At key points in the pursuit of the criminals, the screenplay had called for camera angles that give us the scene from Halloran's perspective, making *The Naked City* more explicitly his movie. Dassin rightly chose to keep the camera detached and omniscient, monitoring all activity from what Hugh Ferriss, so aptly for the world of this film, called "the Argus-eyed viewpoint of the city itself."[20] Throughout the film, the camera serves as the audience's guarantee that the case will be solved because of its superior, unobstructed point of view. Whatever difficulty the detectives on the street encounter in their attempts to control a city that resists the discipline of arithmetic order and the bright lights of a surveillance that would lay bare the welter of occult desires that pose dangers to the regime of the nuclear family, the camera remains unperturbed. It finds without effort its desired object.

The decision not to have Garzah electrocuted by the third-rail of the subway as he falls is one departure from the screenplay I regret. That fate is an ideal representation of the film's ideological opposition to mobility. More importantly, it allows the city's infrastructure to participate in the dispensation of justice more actively than it already does. The possibility of such an organic response of the social system is at the heart of this film, as it is at the heart of Parsons's theory of social statics. To explain the dynamic of detection and protection in *The Naked City*, Wald himself approvingly cited Parker Tyler's 1949 analysis of the film. Tyler had recourse to the conflation of pathology and criminology authorized by the increased bearing of medical models on psychology and criminology in the attempt to "cure" deviance and contain the discontent that breeds subversiveness. Calling *The Naked City* a "journalism of science," Tyler explained that in it "the social body is . . . laid bare ('naked') as a neutral fact . . . which, like the human organism itself, might catch a disease—the criminal—and this disease may elude its detectors."[21] Wald concurs with Tyler that the analogy is central to the film's representation of the structure of social action.

Tyler's reading is good as far as it goes. However, the ensuing discussion of the role played by the blind man on the bridge in the capture of Garzah reveals blindnesses of its own. It is true that when Garzah "in full flight bumps up against a blind man and his seeing eye dog . . . , he fires his revolver at the annoying dog, and his pursuers are led to him by the report." (Note that in Tyler's scenario, the gun is another journalist or policeman—it transmits a *report*.) At issue is whether or not this event occurs "in the same way the sick body reacts blindly to the hidden disease in it and then draws the vigilant 'police of the blood' to help fight the disease." It is an analogy that Parsons would approve. In his immunological model of the social system, "the reaction of spontaneous moral indignation" on the part of "the majority of the members of the society" contains and constrains the behavior of the isolated member. This reaction and the attempt to "insulate" society from the deviant are, he suggests, two "'secondary' defenses" that all healthy systems possess.[22] While the dog does not by itself restrain Garzah,

its protective response (defending its master) does initiate the process.

Certainly, an intention of restoring the civic body to healthy equilibrium exists in the film, and it is a convention of film noir to conflate the human and the natural by having the weather reflect the moral and physical climate of the city, but Tyler's use of the metaphor goes further than Parsons's did to naturalize police surveillance by eliding the role of medical practitioners in combating disease, while speaking instead of antibodies as the blood's own police force. His medicalized account of police work contains the events of the Dexter case within what Foucault has suggestively called "the metaphysic of evil," that is, the notion that illness is produced by the introduction of a destabilizing force into a body or mind whose natural state is one of equilibrium.[23] This explanation remains most people's unreflective understanding of both disease and crime, and it is also consonant with Parsons's theory of social organisms. In this model, illness is something a body happens "to catch" in two senses: the body is infected from without, but the infecting agent is also caught and neutralized by the body's immune system. Yet, as we know, many forms of disease are not introduced from without but arise from defects of the body's genetic and organic structure. Bodies themselves are not stable.

The ideological benefit of this model is nevertheless great, as the audience is saved from having to consider that the social body, analogously with the human body, is "the space of the origin and distribution of disease."[24] Crime is not figured in this film as a state of the social body attacking itself, as it would be if the film presented the structural and cultural "contradictions of capitalism," as critics of the period (who were themselves quarantined) were calling them, or as it would be if all of the sociologizing about Jean Dexter and the Del Vecchio boy had not been removed from the film. Instead, the film and Tyler's reading of it insist on the ultimate clarity of explanations derived from discourses of physical, social, and moral health that deliver up to the trained eye the secrets of the body, human or social, as a set of predictable, controllable patterns. Moreover, the very social work that sustains a

"structure of equilibrium" that is from another perspective the source of social pathologies is itself naturalized by Tyler's metaphorizing of the police and private citizens as a corps of vigilant antibodies, while the criminal activities that Muldoon's excised observations make seemingly inevitable are rendered isolated disturbances, not symptoms of structural dysfunctions internal to the organism.

The Naked City thus takes theories of the efficient city to their dystopian extreme, exposing to a critical viewing the dangers posed by faith in technological reason not tempered by a respect for democracy and pluralism. The perils of assuming the benignity of the security apparatus are absent from the film. The narrator cautions that in any investigation, "a lot of people, innocent or not, have to walk out of the shadows" and face the bright lights, but the film suggests that only the guilty suffer. The falsity of that assumption went on display in 1947, when the Committee on Un-American Activities investigated Hollywood; those investigations would turn uglier in the coming years with McCarthy's vicious attacks. The director and one of the writers of *The Naked City* themselves became victims of the logic and the technologies the film describes so well: Albert Maltz, as one of the "Hollywood Ten," was jailed for contempt of Congress when he refused to answer questions posed by the Committee on Un-American Activities, while Jules Dassin was forced to pursue his career in Europe.[25]

The screenplay had sought to balance the impressive depiction of technologies of constraint with "violence . . . of another sort," the sharp slap that starts the breath of a baby born uptown "at two o'clock in the morning on a hot summer night at the time of a shooting star." The film substitutes for this too-obvious calculus of compensation for the Batorys' fallen daughter a more complex disburdening that is pitched toward the individual viewer, not the nuclear family (even though two of the final shots are of the Hallorans and the Batorys). In the final cut, Hellinger intones the film's signature line, "There are eight million stories in the Naked City. This has been one of them." Rather than disturbing through its

suggestion of a welter of illicit tales, this tag allays the fear. By its declaration of closure, the all-seeing voice isolates the case and implies that it left no lasting ill-effects beyond the Batorys' grief. By contrast, where *Where the Sidewalk Ends* ends is but the beginning of the exposure of a sordid tale of ambiguous character. Hellinger's line also assures the audience that they, the anonymous, have their stories; to be "normal" is not to be utterly transparent.

By the end of *The Naked City*, the small crime wave looks more like a heat wave or a mild infection than a sign of conflicts festering within the structure of American society. It requires professionals to perform a defined set of countermeasures, but it passes in time and the body, on whatever scale, is restored to a healthy equilibrium. So the hope was that the activity of the moral police coupled with the immunological power of a reinvigorated civic religion would speed the nation's return to normalcy and protect the private pleasures of the hardworking family. The collective denial of the nation's structural problems would not last until Halloran's retirement, however. The baby born at the end of the screenplay might well have grown up like many of its brothers and sisters, who burned their draft cards and drove the ROTC and the CIA recruiters off their college campuses. He or she might well have become active in movements for civil rights, women's rights, the protection of a fragile environment. He or she might even have taken his or her desires for reality.

Denying the benevolence of the authorities they were raised not to question, activists of the 1960s exposed the oppression and repression on which the illusory cultural unity of the period was constructed. Its built forms were above all "the plastic sterility of the 'international style' " and the massive, spare housing blocks that rose "where tribal villages had stood." John Higham, whose description I am quoting, makes another crucial observation: "television, bureaucracy, and suburbia seemed more destructive of . . . differences."[26] These social developments, so central to the world of *The Naked City*, have also been destructive of the noneconomic values of public space. In the final chapter of *Urban Verbs*, I turn to the reaction against this regime of space construction. Specifi-

cally, I turn to a set of essays by Robert Venturi and his wife, Denise Scott Brown, that criticize the failures of modern progressivism and architectural formalism, and projects of theirs that attempt to develop the built landscapes of cities as complex expressions of a pluralistic culture.

Popping the Modernist Bubble

Venturi, Scott Brown, and the Cultivation
of the Complex Cityscape

The complexity of life in the city engenders in the inhabitants an equivalent complexity of thought and a tone of mind that can make a joke of paradox and contradiction.

—Lewis H. Lapham, "City Lights"

I

The trajectory of *Urban Verbs* has been from the rise of the American industrial city to what is often remarked as its obsolescence, from James's contrast of turn-of-the-century New York with his memories of a more homogenous, more pastoral city to Paterson, New Jersey, which Williams's archaeology shows forcefully was designed for failure, and *The Naked City*, which portrays New York as socially diseased, a danger to the more homogenous, pastoral suburbs of Queens and New Jersey. The present chapter extends the pluralist ethos to the 1960s as it examines the renewal of interest in urban diversity that changed the way architects and planners approach built space. My subject is Robert Venturi and his wife, architect-planner Denise Scott Brown, whose interest in the "difficult order" of architectural forms and urban life I find very much in the tradition of Williams's attention to the diversity and

vitality to be found locally by the engaged observer. My focus is on their critique in the 1960s and early 1970s of the failure of the modernist-progressivist approach to urban redevelopment as it is represented in their writings and several of their projects that treat urban space as something that exists in time as well as space and is, in effect, always under (re)construction. Specifically, I am interested in how their commitment to approaching cities as "set[s] of intertwined activities that form a pattern on the land" informs their design of spaces that facilitate these patterns rather than rationalize them, with the result that these patterns of life are in some sense written into the structure of the architecture. It is not my intention to offer another genealogy of architectural postmodernism; there are several, and the Venturis' position in them is vexed.[1] The chapter will move from a reading of specific Venturi and Scott Brown projects to a consideration of their place in the larger rethinking of the direction of art and architecture at the end of the modernist moment.

Venturi and Scott Brown are perhaps not the obvious choice here. Their best known work of the period, *Learning from Las Vegas*, was criticized as suburban-centered, catering to the tastes of the "silent majority," and supporting geographic, demographic, and economic changes that were rending the nation's cities. At times their approach is antiurban, if by *urban* one means the high-density communities of the nation's largest cities. The book's focus on strip development and the process of communication through signs and symbols in a high-speed environment has little immediate applicability to the pedestrian scale of these cities. In *Learning from Las Vegas* the authors also accept the highway as our contemporary milieu and contend that the auto-scaled environment shapes our sensibilities (pp. 98/139, 104/153); such assumptions motivate their study of those particular environments. However, as Scott Brown explains their purpose in the preface to that text, it was not to suburbanize the nation, but "to reassess the role of symbolism in architecture, and, in the process, to learn a new receptivity to the tastes and values of other people and a new . . . perception of our role as architects in society" (p. –/xvii). Examining

whether what they learned could be applicable to the creation of a pluralist architecture is my interest.

Whatever my personal distress over the Venturis' turn to suburbia, it must nevertheless be said that the growth of dormitory suburbs since the 1930s and particularly in the postwar decades has profoundly reshaped the urban environment. Federal policy supported the movement of the middle class out of the cities by a tax structure that favors homeowners and home-loan programs that favor new housing as a means to support the construction industry. In the intra- and interregional job wars throughout the period, businesses were lured beyond the cities by low-tax environments and the availability of a disciplined workforce in the growing suburbs. A 1965 federal study of social and economic differences between central city and suburban populations masked these disparities because it used the Bureau of the Census definition of the "Standard Metropolitan Statistical Area" as its baseline for urban areas. Instead of concentrating on larger industrial cities and the newer residential suburbs, it studied all cities of more than 50,000 inhabitants, and it included as "suburban" the rural areas of counties that have suburban populations; in the Southwest, this definition included Indians on reservation land. Yet, as the report repeatedly notes, social and economic differences are considerably more pronounced in the older industrial cities of the Northeast and Midwest, and in cities with populations over 500,000. More importantly, the report confirmed the perception of increasing stratification found by others who studied suburbanization in the period: while the nonwhite population of cities had risen at ten times the rate of population increase for whites in the 1950s, the rate of increase for whites in suburbia was 36 times the population increase for nonwhites during the same period.[2] White flight to "safe" neighborhoods intensified in the 1960s in response to the end of de jure segregation and the increasing local political power of racial minorities; it continued through the urban economic crises of the 1970s that the exodus helped to produce.

True, by the 1970s members of the working class and minority groups were also abandoning the cities (a trend that has continued

and even increased), but the suburbs they moved to were often seg-
regated by race and class. The city they left behind was increas-
ingly polarized by extremes of wealth (in gentrified areas and
luxury apartment complexes) and entrenched poverty. The "selec-
tive abandonment of the inner urban core" of the nation's largest
cities has left it with older, less competitive industries, the govern-
ment and finance sectors, and an "irregular workforce composed
primarily of minorities and the poorest segments of the metropoli-
tan population." This regional redistribution of jobs and revenues
has blurred city boundaries in all but their strictly legal sense—the
only definition that matters in such crucial matters as revenue col-
lection and social service distribution. Increasingly unable to raise
sufficient revenue themselves, cities were further disabled by a
59 percent cut in federal funding throughout the Reagan 1980s.[3]

Recent attempts at revitalization have done little to reverse the
problem, as they have relied on selective renewal of blighted areas
of the urban core that provide jobs only at the high and low ex-
tremes of wages and skills. Studies of Los Angeles as a new urban
space by Mike Davis and Edward Soja have shown how regional
redistribution has produced a downtown where sleek towers of Pa-
cific Rim finance, mostly built with foreign capital, overshadow
side-street sweatshops crammed full of undocumented immigrants
from Asia and Latin America. The trends Davis and Soja report are
of interest not for their uniqueness—the city they present is rec-
ognizable as well in the Northeast and Midwest—but because of
what it tells us of the premature death of the once-touted "post-
modern" alternative to the modern city.

A key feature of southern Californian space is the freeways
whose effects on American culture Venturi and Scott Brown re-
peatedly remark. Built through another federally funded program,
they have supported the dispersal of urban populations to suburbs
that are racially, economically, and occupationally homogeneous
by increasing the land-area within what potential homeowners
consider a reasonable commuting distance. No longer imaginable
as a whole, the postmodern city is that inscrutable, shimmering
circuitboard Oedipa Maas sees from Mulholland Drive in Thomas

Pynchon's novel *The Crying of Lot 49*. The "fortunate" citizen, plugged into a computer terminal or cocooned in the space of a private car on the interminable freeway, is reduced to the positionality of an electron. It is not only die-hard urbanists who have decried this new social space. Writing an "appreciative essay" on Los Angeles's freeways, David Brodsly concedes that if "in an area of sprawling suburbanization and hundreds of randomly attached communities, the freeway serves to . . . delineate and integrate urban space," integration is highly selective because traveling the raised or sunken freeway is a means of avoiding contact with people unlike oneself. Freeway driving is, he observes, a practice that "discourages the individual's involvement with much of the city. . . . Commuting is not touring," but point-to-point transportation. Maps of the Los Angeles Basin drawn in 1971 by members of different socioeconomic groups reinforce his argument and reflect the inequality of access to the new city; the predominantly black residents of the urban core rendered a pedestrian-scaled downtown (within the ring of freeways), while commuters from suburban Northridge noted like communities and sites of recreation throughout the county.[4] Brodsly's information implies what the Chicago sociologists assumed, what James's Central Park experience and the poetry of *Paterson* make clear: urbanity depends upon pedestrian scale and spaces for face-to-face encounters.

It is perhaps an indication of the fragmentation of urban space as much as a renewed interest in complexity that the scope of Venturi and Scott Brown's plans is usually not beyond the neighborhood. Only in their proposal for a civic center in Thousand Oaks, California, is the city as a whole addressed—metonymically. Far from endorsing these trends as the expression of a new way of life, they have frequently criticized the failure of American urban planners and architects to achieve the "monumentality that expressed cohesion of the community through big-scale, unified, symbolic architectural elements" (p. 46/50) that had been realized in earlier eras of civic development. The absence of considerations of the public from midcentury American architecture has made the present need for public spaces only more pressing. In this respect, Fer-

riss's Metropolis, no less than Le Corbusier's *Ville contemporaine* and slab-and-plaza stretches like New York's Avenue of the Americas, is symptomatic of the failure of corporate-sponsored urban development and of modernist architecture's aesthetic program— and Rockefeller Center remains a noteworthy exception. Because American architects have tended to seek the ideal form of the building surrounded by space at least since Sullivan proposed the form of the skyscraper, *solus*, we have been left with "space for crowds of anonymous individuals without explicit connection with each other" (p. 46/50).

Why this is so is suggested in the words of a friend who admires the work of Ludwig Mies van der Rohe: "A building should not mean, but be." We saw in chapters on James's and Ferriss's New York that the Baroque palazzi and Modern French chateaux along New York's Fifth Avenue and the Gothic cathedrals of commerce that dominated the downtown skyline were full of meaning. The City Beautiful movement sought to increase the legibility of designated public areas of cities by the use of a neoclassic vocabulary that symbolized both republican civicism and imperialism. Most modernist architects disavowed an architecture of meaningful decoration. The International Style's autotelic chastity—its refusal to communicate about anything but technological processes of construction—signified in its first years a rejection of the cultural politics of monumentality, a desire to create a new architecture for an industrial society, and a faith in progressivist technological solutions to modern economic and social crises. As part of a comprehensive urbanism, modernist planning had its roots in a social critique of laissez-faire urban development, which was an arm of capitalism engaged in producing poverty and squalor as well as material advancement, and in an aesthetic critique of market-driven development patterns that produced built landscapes lacking formal unity. At its most extreme the new architecture was, as we have seen, an aesthetic of total planning. In the 1930s, with the West in the depths of an economic depression, total planning had an obvious political and economic appeal. The dynamic equilibrium of controlled, steady economic and urban growth was

promoted as an achievable postpolitical, postideological utopia. Economists and planners promised "a 'rational' dominion of the future, . . . the elimination of the *risk* it brings with it." Le Corbusier grandiosely offered the capitalists and political leaders whose patronage he courted the choice between architecture and revolution.[5]

This familiar sketch of modern architecture oversimplifies to make its point. Modernist vocabularies also included streamlining, stripped classicism, art deco, the idiosyncratic style of Frank Lloyd Wright, and other idioms not covered by Henry-Russell Hitchcock and Philip Johnson's 1932 proclamation that "there is, first, a new conception of architecture as volume rather than as mass. Secondly, regularity rather than axial symmetry serves as the chief means of ordering design. These two principles, with a third proscribing arbitrary applied decoration mark the productions of the international style." My reservation need not be limited to practice in the United States. There were in Europe as well "numerous 'outsiders' of considerable talent who were to a greater or lesser extent suppressed because their work did not fit the required pattern" and are only recently being rediscovered.[6] Important as their vocabularies are to our appreciation of the diversity of architecture from the 1930s through the 1960s, they nonetheless remain exceptions to the rule of modernist urban development in the United States.

More important for the fate of American cities, the social critique of existing urban development was lost in the transatlantic movement of modernist architecture. Despite the social vision of many of its innovators, International Style architecture became an appropriate style for the culture detailed in the previous chapter, where individuals were less producers than products who realize themselves in private acts of consumption, not by participation in—much less transformation of—the res publica. International Style became the preferred style of American capitalism as it gained aesthetic credibility through its visibility in venues like the Museum of Modern Art, where Hitchcock and Johnson curated the groundbreaking International Exhibition of Modern Architecture, and Harvard's Schools of Planning and Architecture, where Walter

Gropius and José Luis Sert were on faculty. In addition to their cultural authority (were they any less European imports than buildings in the Gothic, Modern French, or Neoclassical styles they replaced?), buildings in the International Style were attractive because of their relative inexpensiveness and the ease with which they were reproduced anywhere, features expressive of the triumph of technocracy. Signaling technology's triumph over architecture, those glass jars took dominion everywhere the mechanized hand of industrial capitalism extended.

It would be a mistake to read the visual vacuity solely as a reflection of the weakness of political and collective life in the United States in these years. As Colin Rowe and Fred Koetter observe in their survey of the crisis in modernist urbanism, "by 1930, the disintegration of the street and of all highly organized public space seemed to have become inevitable; and for two major reasons: the new and rationalized form of housing and the new dictates of vehicular activity." The influence of the automobile was registered by many architects and planners on both sides of the Atlantic; as well, the advent of television and air-conditioning moved Americans indoors and closed their windows and doors. The issue of rationalizing housing is more complex. Rowe and Koetter are correct that in Le Corbusier's machines-for-living-in and similar model housing units, the buildings' overall structures "now evolved from the inside out, from the logical needs of the individual residential unit," and the land surrounding the units was often treated as residual space.[7] Even so, we saw in Chapter 1 that turn-of-the-century plans to upgrade the housing stock in the worst tenement districts were linked in intention by at least some reformers to "Americanization" campaigns that attempted to reorient the lives of immigrant populations from the streets to the domain of family-centered privacy. So, the turn from considering public space in the United States stems from motives that are ideological as well as technological.

By the late 1960s, however, architecture had been plunged into what has since been identified as the "postmodern condition." Modern architecture's self-legitimation rested on the propositions

that it "is the instrument of philanthropy, liberalism, 'the larger hope' and 'the greater good,' " and that its unbiased adherence to scientific method allowed "empirical facts to dictate the [technological] solution" to particular problems. However, not only was the promised triumph of reason and freedom never realized, "there no longer appears to be any convincing reason to suppose that matters will ever be otherwise," Rowe and Koetter conceded in the 1970s.[8] Scientific method had given way to the goal of efficient production and management while, as we saw in Chapter 3, the "Man" who was to be freed is a fiction. The recognition struggles of the 1960s by blacks, Chicanos, women, the poor, and many other groups all asserted the interests of actual communities of men and women who were no longer willing to surrender their autonomy to expert authority. The vocational crisis did not mean an end of practices motivated by perceived obligations to science or the desire architecturally to advance the cause of human freedom. The United States carried out a slum clearance program, but without committing the necessary resources to make it work. Larger-scale projects disrupted communities' patterns of life while new low-rent housing was not made available in sufficient quantities. Much of what was available was in large, alienating housing projects that worked better as presentation models than as human environments.

If the day-to-day practice of urban redesign sought cost-effective rationalist solutions, the endgames of the modernist ideology often produced the afflatus of the faith. Technologism continued on course, evolving plans and texts for postindustrial utopias that were informed by a futurist poetic. The British group Archigram designed a "Plug-in City" (1964), Arata Isozaki space cities, and the Italian Superstudio took the overcoming of nature to the extreme, imagining (in 1970) a world without buildings, streets, or other artifacts of the known built environment. Superstudio's brave new cityscape was a Cartesian grid dotted with portable environmental-control pods. This landscape without figures was heralded by its designers as a realm of freedom achieved through the rationalization of design and the "elimination of the formal structures of

power"—and with it the variety that makes the built landscape in-
teresting.[9] The equation of architecture with formal structures of
power was naive, but the project's underlying pathos derives more
from its repression of necessity; it offers us the illusion of freedom
from the inevitability of waste, decay, and death—no future as well
as no past—in a world without foodstuffs, power plants, recycling
centers, or cemeteries.

The opposite pole of the extreme reaction against the profes-
sionally designed future was carried out in the name of giving the
people what they want. This sentiment, when sincere and not
cynical, was motivated by a desire to protect common folk from
the will of planners. Yet, as Rowe and Koetter comment, too often
"the people" is but a bloodless abstraction (the populist's equiva-
lent of the progressivist's "Man"), and one forgets "how much in
need of protection from each other its components happen to
stand" in a society whose members have unequal access to power
over the form the built landscape takes. Rowe and Koetter place
Venturi and Scott Brown among the populists on the strength
(weakness?) of Venturi's argument in "Mickey Mouse Teaches the
Architects" that the Disney Company knows and supplies the
townscape Americans want: the illusion of a stable past, not a fu-
ture.[10] The Venturis also followed sociologist Herbert Gans to the
middle-class suburb of Levittown to see what in its built environ-
ment was considered desirable by its denizens.

The negative assessment of Rowe and Koetter was reiterated
more recently by Andreas Huyssen, who acknowledges "the power
[the Venturis] mustered to explode the reified dogmas of modern-
ism and to reopen a set of questions" considered heretical by most
of their peers, but still dismisses their work with the offhand re-
mark that "it would be gratuitous to ridicule such odd notions of
cultural populism today." I disagree with Huyssen. I find more
critical potential in the Venturis' use of irony as "the tool with
which to confront and combine divergent values in architecture"
(p. 108/161), a lesson learned from contemporary developments in
other arts. Pop Art's at least quasi-democratic celebration of "the

miraculousness of the commonplace" supplanted the hermetic celebration of "the paintiness of paint" by the Abstract Expressionists; so the Venturis' interest in communication through familiar and readable architectural forms led them beyond the rejection of explicit symbolism and the emphasis on spatial and structural expression pursued by the "'Abstract Expressionists' of modern architecture" (p. 73/104). Indeed, the Venturis were affected by the Pop artists' contemporary "eroticization of the everyday," and I will argue later for the critical dimension of that gesture.[11] As architects, they were seeking to cultivate the too frequently ignored potential of the everyday built landscape, not to reproduce it. They were exploring ways of making meaningful the empty spaces created by the urban formalists by redeploying "denotative ornament and the rich tradition of iconography in historical architecture" (p. 72/101) that was readable by a wide audience.

Also very much in the Pop spirit, they proposed that architects reimagine their vocation along the lines of the jester (p. 108/161). Taking their own advice, they produced one of the seminal texts in the development of American architecture after modernism, *Learning from Las Vegas*. That text is the record of Venturi, Scott Brown, a third coauthor, Steven Izenour, and a design studio from Yale University's School of Architecture setting out to recover what the subtitle of the second edition calls "the forgotten symbolism of architectural form." Among other things, the book suggests that architects should consider whether techniques of commercial persuasion are open to appropriation—ironic or otherwise—in ways that make architecture more responsive to the world in which it is built.

A good deal of recent architecture has developed from these affinities with the work of Pop visual artists. Consider the now virtually canonical postmodernism of Charles Moore's Piazza d'Italia in New Orleans or Michael Graves's Portland Public Service Building alongside Mies and Philip Johnson's High Modern Seagram Building in New York. Unlike the Seagram's glass curtain and bare, unoriented plaza, Moore's Piazza and Graves's Portland Building

ask us to connect their forms with their civic and cultural purposes. Moore's use of the five classical orders of columns in a contemporary treatment that includes neon detailing and a fountain that rises like a relief map of Italy invite casual passersby to wander into the Piazza and read the various styles, even if they sense only general references to Romanness. The Portland Building's huge pilasters, Roman lettering ("PVBLIC"), and Raymond Kaskey sculpture of "Goddess Portlandia" all proclaim, while deflating conventional representations of, civic grandeur. As was the case at the turn of the century, people who know architecture may read specific allusions to architecture's past "quoted" by the new structures, but a more general level of signification communicates to most of the rest of us.

At the time, however, many critics were incensed by the Venturis' openness to their subject. Literary critic Laurence Holland dismissed *Learning from Las Vegas* as "conservative rebell[ion]" and called down the shades of Emerson and Whitman, and the authority of Henry James's *The American Scene*, to bolster his claims of the degraded and provisional state of America's monuments. Lance Wright accused the authors of abandoning "God's plan for architecture," while Michael Sorkin accused them of being elitists practicing "a kind of grotesque cultural slumming of the lowest order." It is worth remarking against these criticisms that the jester is no mere entertainer. As Shakespeare's Achilles instructs us, the jester is "a privileged man." Supposed to have some insight into the master's (or society's) foolishness, the jester is granted the privilege of artfully revealing it. More useful as an approach to the book is Robert Maxwell's suggestion that the Las Vegas study be read as the effort of visually literate architects to come to terms with America.[12] What his review accounts for and the others miss is the authors' intention to understand how Americans lacking formal training relate to the built environment without denying their professional positions. The authors were, as they explained, undertaking a *formal* analysis of the historical sources and visual logic of space and signage in the commercial vernacular and auto-scaled environments.

II

The negative characterization of Venturi and Scott Brown's work is reductive, although like most reductive claims it is not entirely false, especially as applied to some of their writings. When Venturi and Scott Brown use the length of lines for different pavilions at Expo '67 as an index of what "the people" want (p. 102/151), or when they respond to the allegation that they are "silent-white-majority architects" with a claim that most of the middle class, "black as well as white, liberal as well as conservative," share a taste for suburbia and that to ignore this truth is to "reject the very heterogeneity of our society" (pp. 106/155, 154), they undermine their own claims to be sensitive to urban heterogeneity and their recognition that commercial builders, no less than architectural expressionists, limit the range of consumer choice. What of that taste do they share? Do blacks and whites move to suburbia seeking the same amenities? How would their ideal landscapes differ? So, also, Scott Brown sounds like one of Disney's "Imagineers" when she argues that "nouveau riche environments" can "suggest what economically constrained groups' tastes might be if they were less constrained," and that owners' ornamental embellishments of their tract houses represent authentic aspirations.[13] To some extent they might, but she overlooks regional and ethnic variations and stops short of considering the way those preferences are shaped by a status system in architecture. The problem is not that the masses are wholly manipulated by a mercenary Culture Industry within which they are trapped (there *is* a utopian dimension to acts of consumption), but neither are people's choices infinite or their decisions the unmediated product of native genius. The greater problem with the Venturis' analysis at such times is that their commitment to the value of the complex and contradictory landscape is not supported by an appreciation of the fragmented urban self whose relation to that urban landscape is analyzed by the best urban sociologists from Park through Sennett. In homogeneous communities like 1960s Levittown, as in 1930s Radburn, differences are not deep enough to be challenging.

If the demands of pluralism make the period their work describes—a period we are still in—no time for the heroic and unifying vision of modernism, neither is its place to be taken by an architecture of exhaustion whose slogan might be, "Whatever is, is OK." The latter choice is not an option Venturi and Scott Brown advocate, but it is one that constantly threatens to absorb them as they question the progressivist and aestheticist sources of architects' authority. The real problem with these lapses of criticism is that the rhetoric of inclusivity negates the recognition of diversity contained in Scott Brown's fine suggestion that cityscapes "be seen as the built artifacts of a set of subcultures" (though today we may flinch at the prefix *sub-*). Given the skewed distribution of resources among the groups who comprise a city, her description of, and desire for, a plural urban landscape argues for the necessity of a careful and critical reading that attends to what is omitted or repressed as well as to who and what is manifest. Perhaps the best way to state the problem with the Venturis' analysis of the American scene is to say that at points they imply there is only one popular landscape. The possibility of reading the cityscape as plurivocal, a skill the design studios in Las Vegas and Levittown sought to sharpen, provides a sounder reason for taking the Pop landscape seriously than does the naively empiricist rationale that "it is our context."[14] In fact, the first project of Scott Brown's that I discuss shows this awareness of the possible disjunction between life and landscape, and the popular resistance to some of its elements suggests as well the problems with ascribing certain tastes to all clients.

Scott Brown's redevelopment work in Philadelphia's Crosstown Corridor (1968) is the first of a set of Venturi and Scott Brown projects ranging from housing to uses of Pop elements as magnets for public spaces and as satirical devices that I will read as responses to local requirements. It is an appropriate beginning because the forces that produced the crisis in that neighborhood were all part of the pattern of suburbanization: decreasing job and revenue bases, selective redevelopment in the interest of suburban commuters, and freeway development. All converged on a community

whose interests were not represented in the plans for the area, and whose aspirations were not to be understood from the condition of the building stock. The Crosstown neighborhood, a center of the city's African-American community, had been in decline since the 1950s, when it was first slated for demolition to make room for the last segment of an expressway that would ring the central business district and provide easy downtown access from the suburbs. As a result of its limbo, the Crosstown had seen no influx of new money for a decade. By the late 1960s, nearly three-quarters of its 6,000 residents were going to require public housing if relocated, but there remained a lack of affordable decent housing for the poorest inner-city residents because "renewal" was in practice a diffuse concept that sanctioned the construction of downtown shopping areas, more profitable middle-class housing, and new municipal projects as well as public housing.

Had public housing been available, the process of relocation, likely to a large, low-rent "project," would still have dispersed the members of the Crosstown Community. Scott Brown's intervention began as consultations with the local Citizens' Committee to help them formulate their desires for renewing the community and their relation to the city; such advocacy planning had begun in the University of Pennsylvania's urban planning department while she was a graduate student and faculty member.[15] The plan the residents and the professionals generated (pp. 126–32/–) was one of several proposals for the neighborhood. All of them pitted two sets of interested "readers" against each other: the people who lived on South Street and wanted their living conditions improved, not changed, and the civic and business sectors whose representatives wanted the area to become a sign of a thriving urban economy regardless of who, if anybody, lived there.

The battle over the future of South Street thus provides a case study of how urban space is socially produced and its uneven development exploited. One of the freeway plans that purported to solve the problem clearly demonstrated the economic imperatives and the at least latent racism behind the logic of destroying neighborhoods in order to save them.[16] It proposed running the express-

way underneath South Street and erecting smokestacks to scrub the exhaust of the estimated 90,000 cars that would use the underpass each day. Having thereby made the land worthless to developers who might otherwise expand the downtown business district, and undesirable to housing speculators who would otherwise want to replace the neighborhood with upscale housing, the Crosstown neighborhood would be "free" to remain in the hands of Philadelphia's black community, while the business community got the easy downtown access that would make commuting from the suburbs attractive.

The Citizens' Committee's paramount concerns were: stopping the freeway, renovating low-cost housing, creating employment opportunities, and increasing local business and home ownership. Scott Brown coordinated plans for renovating South Street as a commercial and neighborhood center using the existing structures as much as possible in order to maintain continuity with the life of the neighborhood. The design team also proposed a museum on a historical and cultural promenade that would showcase the black community's long history in the city. South Street was to be black in its ownership and its culture; its history would be represented not only in the museum but by the shops and services that meet local needs, and by cultivation of the "not-too-apparent order" of the built landscape that had evolved over time and through use.

The planning process nevertheless provided some instructive failures. The Citizens' Committee rejected the design team's proposals for increased mobile community-service delivery in favor of more permanent relationships to city agencies, articulating their concern that "anything that can drive up here can drive away again." It also deleted plans for murals by noting that "if we had people with the time and ability to organize wall painting, we'd be using them to organize something more important." The fate of those two proposals offers ironic confirmation of Scott Brown and Venturi's contention that architects do not understand their clients: the architects' tastes and priorities were in these cases clearly of a different class and culture, one more willing to trust in the goodness of government initiatives and more responsive to a sepa-

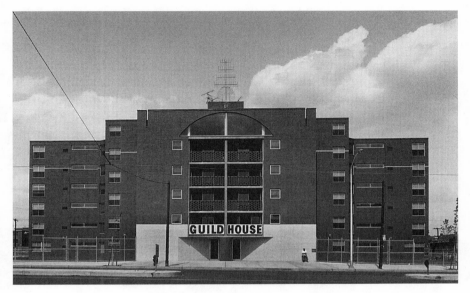

Figure 12. Guild House, Philadelphia (1961). Photograph by William
Watkins. Courtesy of Venturi, Scott Brown and Associates.

rate aesthetic dimension of everyday life. In fairness, the plans
were not as shallowly "Pop" as they may at first seem. While vans
are no substitute for permanent delivery sites as signs of the long-
term commitment the Crosstown Community demanded, mobile
services continue to bring health care, libraries, arts and entertain-
ment, even swimming pools to inner cities, and murals have long
been an expressive medium for defining and disseminating the
voice of oppressed communities and advancing activist agendas.
The murals Scott Brown proposed were characterized as decora-
tive; perhaps anxious about a redirection of the program toward the
message-oriented art of black and Latino activism, the City at one
stage rejected the funding proposal for the Crosstown renovation
by claiming that it was "too political," not too superficial.[17]

Venturi's Guild House for the elderly (Philadelphia, 1961; see
Figure 12) and his project for a public housing complex in New
York's Brighton Beach (1967) remain two of his best examples of

how to reassemble the elements of an existing urban landscape in objects that are both attractive and functional. Guild House is deliberately ordinary; it was designed to look "like what it is not only because of what it is but also because of what it reminds you of" (p. 69/93). It is also the subtly mannerist work of an architect who considered carefully the function and form of the project. A six-story residential structure, it was built with bricks of a darker hue than typical in order to blend better with the facades of its smog-tinted neighbors. The central section of the building, which fronts the property line, is a facade whose decorative function is emphasized by vertical cuts at the top, which reveal the sky behind it. At street level it is of white brick that extends to the height of the first balcony's railing, on which "GUILD HOUSE" is printed in letters easily seen from the street. The white brick breaks the monotony and helps distinguish the entrance, as does a squat column that appears to support the balconies. Topping three more balconies, the lunettes of the communal space round the central section into a six-story arch that again announces an entry function. If architects may read references to a palazzo in the loggias and the elaboration around the entrance, the rest of us recognize in the facade's scale, the cornerstone, and at one time, the large *sculpture* of an antenna, a transfer to the residents of the architectural rhetoric of institutional power, rhetoric contradicted by the modesty of the rest of the plan.

The wings of Guild House recede from the streetline in steps, taking maximum advantage of the building's southern exposure by creating more space for windows and breaking up what would otherwise have been a long wall along the sidewalk. (The play of fire escapes and stoops in older buildings similarly effaced the clear demarcation between the street and private property.) The effect of this organization on the interior is positive; most doorways are grouped around a central space, not strung along narrow corridors. The fenestration is traditional double-hung windows scaled larger than normal to increase the light and suit the building's scale; these windows also play optical tricks on viewers by frustrating our expected sense of perspective: windows farther back from the street are larger than those closer to the street. As housing, Guild House

succeeds in ways that should be central to any public-housing plan: it is relatively inexpensive, so it can be built well, and it is not out of scale with, or radically different in design from, surrounding structures.

While these values are now generally accepted, the problems created by a departure from the expressionist, megastructural orientation of the then-dominant approach to public housing were in evidence in the reception accorded a pair of apartment buildings Venturi designed for a site near the water in Brighton Beach. His proposal sought both to take maximum advantage of the site by providing ocean views from all apartments and to minimize the extent to which the new structures would create a visual and physical obstruction for residents of existing buildings behind the new construction. Venturi's entry was praised by a minority of the design jury for being in keeping with the neighborhood's appearance, being affordable, therefore able "to be built well, not meanly," and "offering real benefits for the people who occupy it rather than polemic satisfaction" for architects and politicians. However, the jury's majority, led by Philip Johnson, found the design merely "ordinary" and selected a more dramatic project designed in what he called the accepted "grammar of our time." The winning entry was a self-contained island of high towers launched from an elevated ground floor that provided views for the residents but a massive obstacle for neighbors. As it turned out, that project was unbuildable within the project's budget (pp. 134–37/–).

The vocabulary of these projects is rather understated because although they are publicly funded their function is private. To observe Venturi and Scott Brown's most interesting uses of signage and Pop elements I must turn to their public space projects, which are informed by their belief that spaces such as squares are a realm of intensified communication. Their success in this area is somewhat ironic, because Kenneth Frampton spoke for many architects and planners in attacking as "reactionary" Venturi's claim that "the piazza, in fact, is 'un-American.' Americans . . . should be working at the office or home with the family looking at television." Frampton, no fan of Pop, misses Venturi's rather Warholian irony, with its implicit provocation for architects to rethink the

relation between architecture and social practice if they are producing significantly underused "public" space, as well as his refusal to glorify a television that is only "looked at." More importantly, he ignores Venturi and Scott Brown's complaint in *Learning from Las Vegas* that our public spaces have failed because they are anonymous, and Venturi's extension of that analysis to his 1978 conclusion that

> We are now suffering from that enthusiasm [of modernist architects with the piazza]—witness the subsequent urban renewal piazzas that disrupt the social fabric and dry up the commercial and visual vitality of the centers of American cities. This is because as architects of the fifties, we saw the piazza as pure space and we designed our piazzas as dry configurations of compositional elements . . . balanced to somehow promote urbanity in space,

when they ought to support a vital, diverse urban life.[18] Le Corbusier's cruciform highrises, Ferriss's buildings like mountains, the International Style tower set alone in the middle of a block, all of these plans defined buildings as isolated forms; around them was residual space, not focused, defined spaces. The explicit symbolism of statues, the obelisk's ability to focus space while commemorating an event, the complex patterns of surrounding buildings' facades were all deliberately eliminated from modernism's ascetic urban-redevelopment plans; it was in part to examine what had become of these elements that Venturi and Scott Brown traveled to Las Vegas.

Venturi's plan for Transportation Square in Washington, D.C. (1968), illustrates the extent to which focused public space had become a nonissue in the postwar era. An office structure designed specifically for a trapezoidal block fronting Maryland Avenue, S.W., it was accepted but then rejected by the District's Fine Arts Commission (pp. 138–40/–). Gordon Bunshaft, a disciple of Mies and head of the Commission, objected to the way the building met the Avenue, producing a defined space in its midst. Stating the Commission's desire, he informed Venturi, "What we're gonna have here is a building that stands in the center of space with space all around it," and sent the proposal back for revision.[19] Eventually, he got the office box he wanted.

Yet, public spaces remain excellent places to explore the inter-
face of architecture and ideology, because they are by custom sites
of social exchange and because institutions and their constituen-
cies require relatively stable self-representations, architectural and
otherwise, that anchor the signifiers whose free-floating is said to
define the postmodern condition. At the same time, they are diffi-
cult projects to do well because of those same pressures. My dis-
cussion of three projects, two built and one unbuilt, demonstrates
a range of success in these undertakings.

Western Plaza, also in Washington, D.C. (1977; see Figure 13), is
situated in the middle of Pennsylvania Avenue, perhaps the na-
tion's most hypersignificant street, between Thirteenth and Four-
teenth Streets. At the northwestern vertex of the Federal Triangle,
it is surrounded by a number of famous sights, including the White
House. Oriented on the minor order of north-south and east-west
streets, the plaza redirects the diagonal flow of Pennsylvania Ave-
nue around itself, as the White House does two blocks further west.
Recreating this residual rectangle as significant space was thus as
impossible as it was required by the terms of the brief. To empha-
size the major order, the original plan called for two 25- by 85-foot
pylons that were to function like the obelisks that punctuate Ba-
roque avenues, a reference in keeping with the idiom of L'Enfant's
city plan; the pylons would also have provided a frame that termi-
nates the western end of Pennsylvania Avenue better than the
oblique view of the Treasury Building's rear portico does. The ab-
sence of the pylons mitigates the effect of the project's intention-
ally disorienting combination of scales; their mass would have cre-
ated a tension with the miniaturized city that was to have included
scale models of the White House and the Capitol, and the existing
statue of General Pulaski at the east end of the plaza, which is in a
more realistic scale. In the absence of the pylons, one can only
speculate whether they would "disintegrate as elements of a frame
to accommodate to the local," as Venturi said they would.[20] My
own sense, having tried to imagine their presence, is that they
would have announced the plaza's presence more effectively to
drivers, but by looming over the small area they would have sacri-
ficed the intimacies of pedestrian scale, still significant in Wash-

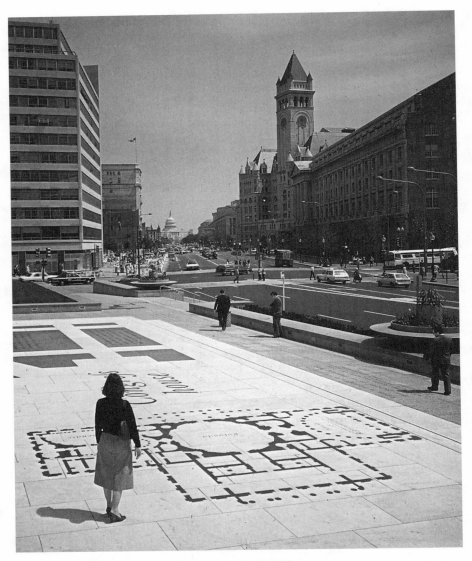

Figure 13. Western Plaza, Washington, D.C. (1977).
View southeast toward the Capitol. Photograph by Tom Bernard.
Courtesy of Venturi, Scott Brown and Associates.

ington, to boulevard views and the requirements of auto-scaled announcements.

As installed, Western Plaza is a flat surface on which is inscribed a map with floor plans of the Capitol and White House. Its boundary is created by 39 inscriptions that *Washington Post* architecture critic Benjamin Forgey characterized as "profound, pompous and even funny observations about the capital city."[21] What the plaza does right—what it "learns from Las Vegas"—is to create an environment filled with elements that are attractive to people who do find it and is sufficiently out of the line of traffic not to be unnerving or unhealthy.

What Western Plaza might have done better was to render more fully the complexity of the city's social order by selecting quotations that take better account of the contradiction between the promise of liberty the federal presence represents and the continued disenfranchisement of the city's African-American majority. While the pylons would have provided a spatial representation of that imbalance, the inscriptions proposed for them, the Constitution's first clause and the Declaration of Independence's pronouncement of "inalienable Rights" are too easily read through rather than contrasted with the everyday experience of the black majority of the city's residents and workforce. Some of this story of African-Americans' slow progress and continual frustration is carried by three quotations that by their placement at the plaza's west end become a graphic representation of marginalization: Abraham Lincoln's claim that he "never doubted the constitutional authority of Congress to abolish slavery in this District; and . . . ever desired to see the national capital freed from the institution in some satisfactory way" (1862); Paul Laurence Dunbar's observation that "Negro life in Washington is a promise rather than a fulfillment. But it is worthy of note for the really excellent things which are promised" (1900); and Martin Luther King, Jr.'s, observation about the March on Washington, that "every American could be proud that a dynamic experience of democracy in this nation's capital has been made visible to the world" (1963). Equally to the point, if impossible to get approved, would have been the comment of a Texan

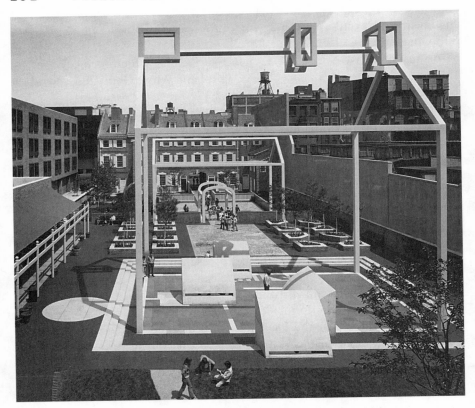

Figure 14. Franklin Court, Philadelphia (1972). Photograph by Mark Cohn. Courtesy of Venturi, Scott Brown and Associates.

member of the House D.C. Committee in the 1970s that requiring a percentage of contracts in the city to be awarded to black-owned businesses would be like requiring a percentage of contracts in his own district to be awarded to cowboys; passages from arguments for D.C. statehood, or other words that speak to the city's long history of underrepresentation.

A more successful space is Franklin Court in Philadelphia (1972; see Figure 14), where Venturi and Scott Brown "restored" Benjamin Franklin's residence and created a small museum of Frankliniana

as part of Philadelphia's American bicentenary commemoration. In this design, the architects faced the challenge of recreating a building razed in 1812, whose structure is unknown except for some remains on the site. The Venturi plan rejected the Park Service's suggestion that a simulacrum of the lost house be erected. The design instead focuses on our uneasy relation to the past through the device of a "ghost house," a frame of twelve-inch metal tubing erected over the building's original site, and covered troughs that expose and protect remains of the foundation that are now visible from street level. The ghost house, foundation remains, an exaggerated eighteenth-century formal garden, benches that reinterpret the period style, and a mulberry tree on the site of the one under which Franklin received guests, organize the street-level space. Selections from family journals that refer to the house are placed throughout the park and do the major work of "reconstructing" life in the house. The space becomes complex and contradictory because it is a recovery and a re-creation, a museum and an open park. (The exhibition space is located below ground.) A historical monument with an educational purpose, it reminds us how lightly we have regarded our architectural heritage, while creating an inviting public space. Most importantly, it is not a monofunctional space. If it were only a museum it would not be a gathering space, if it were only a park it would not have preserved the site's particular history.

My final—and favorite—example of Venturi and Scott Brown's work, a proposal for the Thousand Oaks, California, Civic Center (1969), was designed in response to a brief calling for a "permanent structure which will be likely to serve the community for upwards of half a century" (pp. 142–43/–). This proposal is perhaps their best example of how to work with the commercial vernacular and automotive scale in a critical-ironic mode, even if it did not ultimately fulfill "the image Thousand Oaks had of itself" (see Figures 15 and 16). The reason for the project's rejection could be summed up in one citizen's question, "Are they really serious?" They were. The proposal was a send-up of Californianity, as Scott Brown explains: "In a medieval town, a civic place is *defined* by

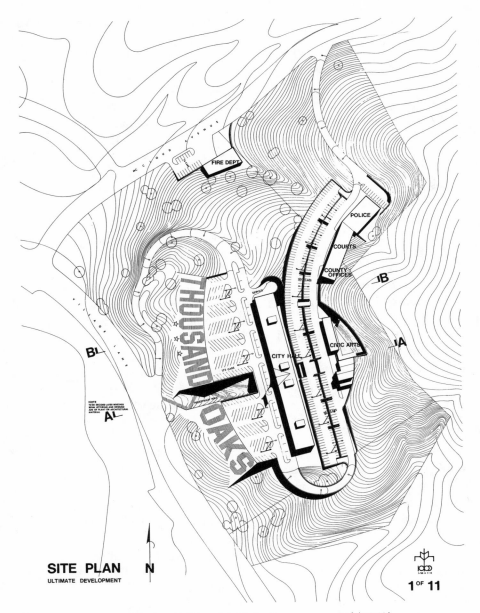

Figure 15. Thousand Oaks, California, Civic Center proposal (1969), site plan. Courtesy of Venturi, Scott Brown and Associates.

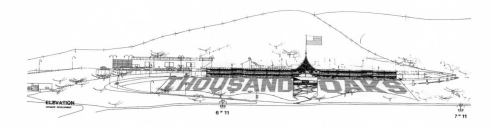

Figure 16. Thousand Oaks, California, Civic Center
proposal (1969), elevation from the Ventura Freeway.
Courtesy of Venturi, Scott Brown and Associates.

the important buildings that enclose it. In a California suburb, a
civic place is *located*, rather than defined, by symbolic images that
can be perceived at high speeds across the vast spaces of the high-
way," in this case the Ventura Freeway between Los Angeles and
Santa Barbara. The architects proposed "twisting [a] 'civic strip' up
the hill around a phony freeway ramp" into the main parking lot /
village square. "THOUSAND OAKS" would be etched on the hill-
side, suggesting "the flowered parterre of a Victorian courthouse"
or, perhaps, advertisements for new subdivisions or the Lion Coun-
try Safari just off the 405 Freeway in Orange County.

Building the Civic Center on the site the city selected would
have required bulldozing a stand of the eponymous coast live oaks.
The plan called for saving one and installing it over the main entry-
way to city hall as the building's central tower and flagpole. The
nation's "natural" destiny would then have been symbolized by the
flag tied to the last of the "Thousand Oaks," which at once emble-
matizes the "natural" and our eradication of nature. (California
cheese is "as natural as California," says the television ad.) By
night, the tree / flagpole would "stand out small but bright against
the dark hillside," because it would be "etched in neon," a light
source that metonymizes the force that drives American progress.

The proposal's rejection suggests the force of its irony, which
remains potent because even if our postmodern economy depends

on the production and reproduction of representations and styles, it also depends upon the vast majority of consumers not reflecting critically on their content or the world they construct. In this case, the project's centerpiece too baldly contradicted the image of republican civic virtue projected by the Roman lettering on the building's facade, and it effectively deconstructed the natural religion of American manifest destiny that is still subscribed to in the bedroom communities of Ventura County and elsewhere in southern California where *The Crying of Lot 49* still reads more like realism than satire. I can imagine in Thousand Oaks a photographic, or other artistic, exhibition on the theme of the environmental costs of suburban expansion, even a re-exhibition of the Civic Center plans, but I cannot foresee the acceptance of the neon oak as a town symbol before the City of Thousand Oaks has itself been naturalized by a longer existence. At that point, we might also imagine some future city council inscribing around the civic center quotations from John Muir about the beauty of oak forests, achieving an effect not unlike that of Franklin Court.

To pursue this possibility means forgetting that public architecture and the visual arts have different modes of exhibition and reception, which are worth dwelling on for a moment. No privilege of separate space protects architects, given their works' more public venue, the expenses of construction, and their clients' wishes for buildings they feel represent them. An artist like Hans Haacke, for instance, may display artworks that attack the ethics of individuals and corporations who underwrite "cultural events" and even work with precisely the exploitation involved in mounting such exhibitions. His works now travel the country with little protest (although he had a New York show canceled years ago), as the nation pays lip service to the belief that art maintains its separate sphere, while in reality recognizing its more limited audience. So, too, the disjunction between art and "the world" creates a space for "The Homeless Vehicle Project" of artist Krystof Wodiczko, a work with explicit political commitments. Rosalyn Deutsche notes that the project's exhibition at "a city-owned exhibition space in lower Manhattan" coincided with Mayor Ed Koch's midwinter "evic-

tion" of the homeless from public places. The project may have thereby "established its divergence from the official role of environmental disciplines" that "engineer redevelopment" and "suppress the evidence of rupture by assigning social functions and groups to designated zones within the spatial hierarchy," but Wodiczko's reinsertion of forgotten people into public consciousness was achieved by the superimposition of ghostly images of the never-built vehicles onto *photographs* of public spaces. I have doubts that the project really did increase "the visibility of the evicted," because Manhattanites intending to see the exhibition had to go out of their way, while they cannot help seeing some of the thousands of their homeless fellow citizens each day.[22] Nevertheless, Wodiczko's project is interesting and provocative, and it bears comparison with the Thousand Oaks project. Since I find it difficult to imagine that Scott Brown fully expected the project to be met with approval, I read it, too, in the spirit of critical art intended to provoke questions about the nature of representation in what are now sometimes referred to as "edge cities." Unbuildable, it was able to be displayed in an area where it was viewed by a large number of the people whose expectations it challenged.

III

Critical artists are by no means immune from the sort of pressures that impinge upon architects and planners, particularly when they are dealing with the National Endowment for the Arts. Yet, the art market makes such work acceptable to private and institutional collectors, while the favorable public relations resulting from sponsorship of cultural events is usually judged to outweigh the critical content of individual works. The widening of the audience for contemporary "anti-institution" art, compounded with a certain reading of the trajectory of Pop and postmodern art as cultural commentary, has caused Terry Eagleton and Fredric Jameson to conclude that the arts have lost their potency. Eagleton writes that, "in a sardonic commentary on the avant-garde" attempt to move art from the institution to the everyday world, Pop and post-

Pop artists have admitted "with all the *sang-froid* [they] can muster" that art is no more than another commodity. Jameson turns his sights directly on architecture and on Venturi and Scott Brown in particular. Commenting on the landscape of late capitalism, he excoriates an architecture "that has been emblematically 'learned from Las Vegas,' " although one glaring irony of his analysis of John Portman's Bonaventure Hotel (which he treats as representative of postmodern architecture) is that his critique is anticipated point by point in Venturi and Scott Brown's critique of an example of *late-modernist* expressionism in, of all places, *Learning from Las Vegas* (pp. 65–72/90–103).[23]

Jameson's essay ends with a call for "a pedagogical political culture which seeks to endow the subject with some new heightened sense of its place in the global system" of late capitalism. He subsequently took up his own challenge, reading Frank Gehry's redesign of his Santa Monica residence as an attempt "to think . . . the relationship between that abstract knowledge and conviction or belief about the superstate, and the . . . daily life of people in their traditional rooms and tract houses" in the radically collisional spatiality created by the additions and alterations Gehry effected. The argument is of interest for its attempt to formulate a notion of critical architecture, one that can with revisions move us from the Venturis' individual projects to the larger critical currents in which they are situated. For Jameson, the strength of the corrugated metal "wrapper" Gehry built around the 1920s pastel pink bungalow he purchased lies in its ability to evoke a world whose basic unit is "no longer family or neighborhood, city or state, nor even nation." The rest of the house intensifies this gesture. Its materials signify "the costs of housing and building, and, by extension, of the speculation in land values"—the social costs that include "the production of poverty and misery, people not only out of work, but without a place to live, bag people, waste and industrial pollution, squalor, garbage, and obsolescent machinery." Through openings in that wrapper, violently inserted between the public street and the private house, one sees single-family space "withering away"; the rooms are as if "preserved as in a museum."[24] The wrapper thus calls us back to the future of capitalist development.

Jameson offers a provocative reading, but I think the house maps a more familiar social terrain as well. It is, after all, still home to a nuclear family, its Latina maid, and some pets. This house, constructed from the detritus of American life and filled with cardboard furniture, is a class-specific fashion whose success depends upon its radical discontinuity with surrounding structures. Gehry's design is unlikely to succeed in the East Los Angeles barrio, nor is it likely to house middle- or upper-middle-class families for whom the "original" would evoke stronger personal associations. On the other hand, it would be acceptable in exclusive suburbs because it is the work of a recognized architect. (Within two weeks of Jameson's presentation of "Spatial Equivalents" at a conference in southern California, the *Los Angeles Times Magazine* ran a cover story on Gehry entitled, "L.A.'s Hottest Architect['s] . . . Bid for Immortality."[25]) In this grimmest reading, Gehry's wrapper, not the rooms, is a museum piece. However, by mediating the opposition between commodity and criticism informing Eagleton's and Jameson's arguments, one may continue to value the house's off-balance space and the wrapper that reminds us of the disparity between the dream of home ownership and its effect on most of the world, without holding Gehry to an essentially modernist standard of critical purity these critics learned to love only after its passing.

Instead of questioning the commitments of an architecture like Venturi and Scott Brown's, or Gehry's, we might better understand it if we were to read not through the lens of a cultural history that links realism with laissez-faire capitalism, modernism with industrial capitalism, and postmodernism with a multinational or postindustrial capitalism that has engulfed all cultural production. There are other accounts of the turn from modernism to postmodernism in the arts that will prove more useful for understanding the Venturis. I have already mentioned Rowe and Koetter's account of the failure of modernist utopianism, brought about by the recognition that while architecture can ameliorate the conditions it directly affects—it can provide healthier spaces in which to perform the activities of daily life—it can by itself effect no radical redistribution of social power. Indeed, in the United States it reinforced that distribution as the financial sector profited from the

sale of bonded indebtedness and conservatives attacked the pro-
grams for coddling lazy Americans who are always, by implication,
of African or Hispanic origin. I want now to consider a specifically
aesthetic dimension of this "crisis," not in order to wall it off from
social concerns, but to examine the connection between the arts of
a throw-away culture and a "responsible" architecture in order to
suggest that Venturi and Scott Brown's professional reticence, their
refusal to speak of a new utopian architecture, like Gehry's deci-
sion to build for the short run, is more than a sign of despair for the
future or a capitulation of architecture to insatiable consumerism.

Arthur C. Danto has illuminated a likely unarticulated anxiety
motivating Jameson's and Eagleton's dismissals of Pop and its off-
spring in his argument that Pop and Minimalism brought us into
the "Post-Historical Period of Art." The bare white or black canvas
terminated the series of erasures by which modern artists interro-
gated the minimum conditions for a work of art, while in the wake
of Andy Warhol's *Brillo Box*—which Canadian Customs officials,
backed by the Director of the National Gallery of Canada, would
not recognize as a work of art—one needed a theory of art in order
to distinguish art from "mere" objects. What this means, Danto
explains, is that "art was no longer possible in terms of a progres-
sive historical narrative. The *narrative* had come to an end."[26] His
thesis entails the end of arguments for the historical necessity of
any style at a particular time and presents the possibility that the
progression of art history ends not with the triumph of the work-
ers' state (vulgar Marxism, anyway) but the disarticulation of eco-
nomic and cultural production within the overall framework of so-
cial production. Thus, perhaps, the unforeseen denouement of the
discourse that positions art as a realm of freedom.

However, the idea that Pop Art lacks a critical relation to mass
culture is a misconception of some critics. It is nowhere more ap-
parent than in Huyssen's reproduction of comments made by War-
hol in a frame that reveals the superficiality of Huyssen's reading
of Pop more than the superficiality of Warhol's reading of America:

Warhol naively praises the reification of modern life as a virtue: "Someone
said that Brecht wanted everybody to think alike. I want everybody to

think alike. . . . It's happening here without being under a strict gov-
ernment. . . . Everybody looks alike and acts alike, and we're getting more
and more that way. I think everybody should be a machine. I think every-
body should like everybody. . . ." Warhol himself seems to be a victim of
the advertising slogans he himself helped design before he became an
artist.[27]

Huyssen thereby reduces Warhol to his art, forgetting that "Andy
Warhol" was both a creator and a creation—one that neither acted,
looked, nor thought like anybody we might have been tempted to
call the American everyman in 1963. He became a deadpan parody
of the values of the American middle class by caricaturing its
pathologies.

Warhol's humor was often difficult to gauge. An elusive critique
of capitalism, it is at the same time, as Danto remarks, "a celebra-
tion of a form of life in which he believed fervently." Warhol's
paintings and prints are seductive and do seem immediately acces-
sible, there to be consumed as simply as the Coca Cola whose
democratic consistency he marveled at. His Pop ethic proposes
that if anything can be Art, any one of us can be anything he or she
wants to be. But that promise also looms as a discomforting ques-
tion about the American mythology of who we are and how we
produce our individualism. Not only his alternative star system,
which parodied the Hollywood studio system, but also his silk-
screened icons are double-edged. If it is true, as Danto (rightly, I
think) suggests, that "warmth, nourishment, orderliness, and pre-
dictability are profound human values which the stacked cans of
Campbell's soups exemplify," and that "the Brillo Pad emblema-
tizes our struggle with dirt and the triumph of domestic order," is
there not a severe social dysfunction being remarked in the avail-
ability of canned families and steel-wool deities that remove the
stain from our (by this definition) superficial lives?[28] This deadpan
satire is, it should already be clear, the strategy of many of the Ven-
turi and Scott Brown projects I have discussed. It is especially the
case in the Thousand Oaks Civic Center, where the elevation of
the everyday to monumental proportions underwrites a question-
ing engagement of the culture's visual language.

The Venturis learned that Pop deadpan from Warhol and, par-

ticularly, from Ed Ruscha, whose artist books of the 1960s tackled such subjects as *Twentysix Gasoline Stations* (1962), *Some Los Angeles Apartments* (1965), *Every Building on the Sunset Strip* (1966), and *Thirty Four Parking Lots in Los Angeles* (1967). Ruscha's photographs present their subjects straight, in the same way Berenice Abbot's New York photographs did. In Ruscha's books, a response is provoked by the choice of subject and its repetition. The gas stations, apartment buildings, or parking lots are not all that different; these records thus lack the depth of *Changing New York*, but so, he implies, does the landscape. Insisting that we see the popular landscape, its sameness and subtle differences, apart from any explanatory or valuative narrative, these books are another form of what Abbott called the "civic use of the camera": they prompt viewers to reflexive acts of interpretation. Venturi and Scott Brown's adoption of the deadpan approach can make it "difficult," as Stanislaus von Moos observes, "to draw a line between those of the Venturis' statements (and forms) that are frankly funny (while being at the same time dead serious as art) and those that are tantamount to satire," although we can say with some certainty that the proposal for Thousand Oaks crossed the line.[29] Its celebration of the artistic merit of freeways and neon was also, inevitably, a provocation to question if they are the stuff of community.

What I have been discussing is a similarity in content between certain of the Venturis' work and Pop Art. There is as well a congruence in their formal method that goes beyond an interest in popular symbolism. The formal element is more important to all the projects I have considered and it clarifies further Venturi and Scott Brown's understanding of urban form. Warhol's production strategies (art *was* a business for him) often followed the logic of the disposable society promoted by advertising and industrial production: if one portrait makes its subject important, why not 30 on one canvas, particularly in a time when photographs and magazines have undermined the uniqueness of the portrait—and, better still, why not 30 silkscreens of the 30, a set of originals? Yet, like other Pop Artists whose work is otherwise quite different, Warhol had a

curious affinity for the "leftovers" that disrupt the temporality of preplanned obsolescence that is both a rhythm of production and a (suppressed) history of style. He explained that "if you can take [a leftover] and make it good or at least interesting, then you're not wasting as much as you would otherwise." The "Junk-aesthetic" Pop Artists—Jasper Johns, Robert Rauschenberg, and others—took this art of reclamation further, making art of the scraps and rejects they found around them. The scavenger-artists (Rauschenberg at times restricted his search for material within a few-block radius of his loft) not only disrupt the rhythm of production, they destabilize the economy of meaning by tapping into a surplus of potential meaning-values of objects that were created for specific functions and are now supposed to be useless. In doing so, they create a new art of the city, a sophisticated form of city play based on the perception that New York is "a maze of unorganized experience peopled by the unexpected."[30] The random juxtapositions of the urban landscape—the streets, the gutters, the front page, the list of names in an apartment-building directory—are treated as provocations for further couplings that yield an eroticized urban archaeology of chance meetings and fleeting memories. Calling them "Combines," Rauschenberg acknowledges a lack of unity and repose in his works, which makes them a uniquely urban art. In a more burlesque vein, Red Grooms's *Ruckus Manhattan* landscape celebrates the randomness and transience of city life with a rickety subway, soft buildings, some of which seem to be decaying (the Woolworth Building, on the other hand, is metamorphosing into a dragon), and an animated taxi ride through the City's streets. Difference and deviance are presented, even caricatured, but without malice. The dangers, the rough edges, of the city are dissolved into an infectious spirit of play as the Nashvillean's curious mode of civic boosterism creates a public art.

This Pop Art practice extends the techniques of collage beyond its modernist limits. An important medium for visual artists, collage was anathema to modernist urban planners intent on creating cities wholly of and for the twentieth century. Rowe and Koetter defend collage in language that echoes the Pop Artists when they

call it "a method of paying attention to the left-overs of the world, of preserving their integrity and equipping them with dignity. . . . As a convention and a breach of convention, [it] necessarily acts unexpectedly."[31] Its adoption by no means implies an end to attempts to further develop knowledge of urban form and function; indeed, it argues just the opposite. What it does signal is a dissatisfaction with the techno-evolutionary myth of progressive urban design as it insists on the historicity of the dream of the rational city. Resisting the notion that cities have a single primary function and therefore an ideal form, an urban collagist tacitly acknowledges the presence, now and over time, of groups or "subcultures" that organize and use urban space differently. Collage is thus an art of reclamation; it entails a preservation of historical reference and encourages new sets of associations and an agglomeration of potential new significances for the elements that it recycles. It accepts floating architectural signifiers as part of the history of architecture, not as a dilemma to be overcome by a new literalism. The choice between a single truth and meaninglessness is, as I argued in Chapter 3, a false one. If "architecture depends in its perception . . . on past experience and emotional association" (p. 64/87), that condition is no reason for doing the same thing over and over, but it is cause for architects and planners concerned with the diversity of everyday life to study what in the landscape has remained vital, if changed in significance. Even in a building as understated as Venturi's Guild House, one sees the cognitive tensions the strategy produces: it accepts the form and construction of the existing, nondescript buildings around it while bestowing an older architectural rhetoric of grandeur on the presently marginalized; the building is visually both quite ordinary and also "architectural" because of Venturi's subtle distortion of its proportions. At Franklin Court the layering of historical times and styles is more complex and more powerful.

In exploring the post-historical world of Pop Art, I am far from confusing Warhol's ideal artworld, in which "you ought to be able to be an Abstract Expressionist next week, or a Pop artist or a real-

ist, without feeling that you have given something up," with Marx's disalienated state in which it is "possible for me to do one thing today and another tomorrow, to hunt in the morning, fish in the afternoon, rear cattle in the evening, criticize after dinner . . . without ever becoming a hunter, fisherman, shepherd, or critic."[32] I do not believe that one entails the other any more than I think that a wholesale transformation of the urban landscape would transform economic and social relations, but I do find a profoundly utopian dimension to this apparent art-historical crisis. Comfortable with Danto's argument that the art of the age is necessarily plural because it responds to no internal dialectic that determines how it must look (if uncomfortable with what in my argument may sound like an echo of Ezra Pound's brag that "artists are the antennae of the race"), I can nonetheless discern in post-Pop aesthetic pluralism a figure for the new utopian city. In parts Popscape (like it or not) and criticist, it avails itself of the range of utopian visions by employing them with a collagist sensibility, that is, "while simultaneously disbelieving in them" as achievable sites of some final and complete emancipation. Returning utopia to its original domain as an ideal and a criticism of actual life but not a prescription, because down to its very name—nowhere / the place of happiness—utopia is a space whose play cannot be stabilized, one may arrive at the form of postmodern urbanism envisioned by Louis Marin as the attempt, not to streamline and rationalize, but "to build up a totality in which different codes are competing, are in conflict, are not coherent, in order to give people living in this totality, and consuming it, an opportunity . . . to use the town as a multicoded or overcoded totality . . . allowing for behaviors characterized by a factor of unpredictability."[33] Such a space takes the ideals of equality and freedom seriously, but not to the extremes of Superstudio, whose plan for achieving equality made freedom meaningless because it provided no range of choices in which it could be exercised, or to the extremes of the libertarians whose defenses of freedom are deeply antisocial. Leaving the two ideals in play is the unending road to utopia; in designing the realm of their

ideal relationship one attempts to place Herbert Spencer's ultimate man in Hugh Ferriss's Imaginary Metropolis.

To end where I began: In *The American Scene*, Henry James found himself wondering what the American "Accent of the Future" would be. He could not answer this question of the "very ultimate future" except to say it will not be English as he knew it.[34] What interests me is his assumption that there is an *ultimate* future. Witnessing a process of rapid and ongoing social and cultural development, James described and decried "ingurgitation" in the great American "bleaching vat"; even so, he was impelled to assert a telos he was powerless to imagine. If the urban melting pot was in fact a site of the complete Americanization of immigrants, the future should have been readable. James's travelogue is eloquent in its proof (despite itself at times) that the "American" changes along with the "immigrant." The impossibility of answering James's question inheres in the knowledge that the promise of urban culture lies neither in its distillation of a new yet homogeneous American out of the melting pot's home brew, nor in the particularism of the multicultural "salad" where different groups are tossed together but remain unchanged except for a superadded, rather tasteless, American dressing.

If the consensus politics of the 1950s made it seem that James's future would come to pass in a form that would have been rather familiar to him, the 1960s undid that prophecy. A generation of pluralist cultural values has shown, as well, how inclusive Venturi and Scott Brown's late-1960s and early-1970s program wasn't. Reflecting on these developments in 1982, Venturi described a "world . . . at once smaller and more diverse, more interdependent yet more nationalistic," in which "even small communities seriously maintain ethnic identities and carefully record local history" and urban communities are at once "more aware of differences among themselves and more tolerant of those differences."[35] The Venturis remain inclusive and nonprescriptive, even optimistic in ways a brief survey of domestic and world affairs makes painfully clear.

If the virtue of urban culture is its ability to shock us out of our-selves, our cities will never be risk-free, smooth-functioning organ-isms or machines. If cities are geographic pockets of concentrated difference, it is incumbent upon all citizens not to withdraw from life in common by practicing a limiting identity politics or becom-ing preoccupied with inner space, but to find common ground on which to rebuild cities as physical, political, and ethical spaces shared by different communities whose overlappings weave the so-cial fabric. Cities will also remain "dangerous" because tolerance is a quality more often demanded than supplied.

In the week the second trial of the policemen who beat Rodney King was given to the jury, Richard Rodriguez, surely one of our most optimistic observers of American urban culture, had to re-mind us of the overwhelming evidence that "assimilation is recip-rocal" because "people meet, they argue, they flirt, they fight, they compete, they have children, they divorce, they remarry, they be-wilder themselves." In the essays that comprise *Days of Obliga-tion*, Rodriguez records how these everyday activities bring about a complex, overcoded, shared space. He charts the displacements of communities in cities like San Francisco, Los Angeles, San Di-ego, and Tijuana, where the borders among cultures dissolve and reform; old ways shed by some are renewed by others. In 1970s San Francisco, gay urban pioneers gentrified working-class neighbor-hoods that were once upper-middle-class, refurbishing Victorian family houses for use by single men. At the same time that Anglo Californians become pantheists or study Zen, the native Indians and Asian immigrants convert to Protestantism; affluent Christian fundamentalists who believe homosexuality is a contagion furnish their homes in accord with new ideals of domesticity learned from "the gay house in illustrated life-style magazines." Autobiographi-cal passages construct the author as a model of the urbanity Park and Wirth predicted. Moving among groups all at some point marked as "we," he enacts his poetics of miscegenation as he cre-ates himself as the point where cultures converge. Rodriguez also registers the backlash: the murder of Harvey Milk, San Francisco's gay City Supervisor; "the Ku Klux Klan; nativists posing as envi-

ronmentalists, blaming illegal aliens for freeway congestion. And late at night, on the radio call-in shows, hysterical, reasonable American voices say[ing] that they have had enough."[36] Yet he remains optimistic that conflict is the first step toward recognition, as those early urbanists posited.

Self-isolation may be a right, even for some groups at some times expedient, but it is wrong in the long run because while traditions may be self-enclosed, cultures are dynamic compounds of beliefs and practices that change as people change—and our own identities are always being reconstructed in response to an array of political, economic, and social forces. The process *is* endless, because times change, immigrants arrive, and while people get along, just as inevitably, they don't think alike, they argue. The April 1992 outburst in Los Angeles and other cities was for the silent majority a wake-up call from its long ideological sleep. Its excesses are not to be applauded, but less so are the bitter rhetorical aftershocks that emanated from a suburbanized people who, like James in 1905, were shocked into the recognition that they are not alone. Future conflicts are inevitable as long as economic and political power are so inequitably distributed. Still, conflict is not just a demon fretting the naked city, because we can work together even as we pull apart. In this, if in anything, lies the vitality of American urban culture.

REFERENCE MATTER

INTRODUCTION

1. Sennett, "New York," pp. 1–23.

2. Park, "The City as Social Laboratory," in *Social Control*, p. 18. Sennett advances an assessment of the Chicago School's optimism; see his treatment of Park and Wirth in "New York," and again in *Conscience*, pp. 126–27. Wirth's 1938 essay "Urbanism as a Way of Life" has also been described as "one of the most devastating critiques [of urban society] in the bulky literature on the city" (Callow, "The City in Modern Times," in Callow, ed., p. 482), an assessment essentially that of Herbert Gans, "Urbanism and Suburbanism as Ways of Life" (in Callow, ed., pp. 504–18), who focuses on Wirth's anxiety over the rise of mass society and the replacement of intimate relationships with instrumental ones.

3. Wirth, "Urbanism as a Way of Life," in Callow, ed., p. 497.

4. Sennett, "New York," p. 11.

5. More than any other text in *Urban Verbs, Paterson* pairs with the texts on either side of it. Written from the 1940s until the poet's death, it is in fact contemporary with *The Naked City*, though the social and poetic climate of the 1920s and 1930s is, I argue in Chapter 4, of greater importance to Williams's conception of the poem.

6. Hofstadter, Introduction, in Hofstadter, ed., p. 3. I return to the relation of tenement reform and "Americanization" in Chapter 1.

7. Wiebe, p. 162.

8. Tafuri, *Architecture and Utopia*, p. 52.

9. Wittner, p. 126. Talcott Parsons, "Social Classes and Class Conflict in the Light of Recent Sociological Theory" [1949], and "A Revised Approach to the Theory of Social Stratification" [1953], in *Essays*, pp. 323–35, 387–439, especially 435–39. On the fate of ethnic pluralism in the 1950s, see Higham, *Send These*, pp. 220–28.

10. Higham, *Send These*, p. 245.

11. Venturi, Interview, pp. 15, 14.

12. Baudrillard, "Modernity," p. 67.

ONE

1. Rowe, *Henry Adams*, p. 158; Henry James, *American Scene*, p. 291 (further references to this book will be made in the text); Rowe, *Henry Adams*, p. 158.

James amplified the cultural politics of the margin in his American notebook (*Notebooks*, p. 316), where he associated the newfound character bestowed on Harvard by the fence with the medieval air of Oxford and Cambridge.

2. Henry James, *Washington Square*, pp. 4, 15.

3. Buitenhuis, p. 206. Posnock suggests ("Henry James," pp. 34–35) that the homogeneity of New England echoes in James's description of the Emersonian self, whose connection to "the 'great grey wash' of the American Scene of 1904" the essay explores.

A similar point to Posnock's is made by Stuart Johnson with regard to James's reaction to the "monotony" he detected in hotels: "the American ideal is not James's, and he does not envy the conditions of the hotel world, only the happiness it produces. The conditions could only be attractive for [one who has] . . . a strong self as a unity, exempt from difference as a mode of definition" (p. 94).

But James's critique of hotel-society's pecuniary "short-cut" (*American Scene*, p. 11) of collecting styles rests on debatable assumptions of a more authentic American self whose development is suppressed by an economic culture and an organic relationship of European art-objects to their cultures. In truth, styles have frequently crossed national or period boundaries; Americans followed Europeans in developing tastes for the exotic along with an imperialist foreign policy. The logic of the shortcut was already in the system, only the traces were fresher in the States.

4. Seltzer, pp. 106, 142, 131.

5. Posnock, pp. 32, 33, 53. Posnock returns to the workings of a decentered Jamesian consciousness in "William and Henry James."

6. Agnew, "The Consuming Vision of Henry James," in Fox and Lears, eds., p. 78. In the course of a provocative essay on how James's aesthetic practice shared *and transformed* the logic of the consumerist gaze, Agnew briefly discusses *The American Scene* and finds the restless analyst to be more thoroughly elitist than I do.

Reading Brook Thomas's excellent essay, "The Construction of Privacy," one sees how little James's feelings toward American publicity changed over two decades.

7. James returned to the United States at the height of immigration; more than one million immigrants entered the country during his stay. While their percentage of the total population remained fairly constant

from 1870 to 1900, the origin of that population shifted markedly to southern and eastern Europe.

As for my use of the term "Anglo-ethnic" for a social aristocracy that prominently included Astors, Vanderbilts, and van Rensselaers, the culture they evolved looked toward England more than anywhere else; so, too, the English past was most important for James. I thank Richard Dellamora for suggesting the term to me as a corrective to the idea that only everyone else is an ethnic.

8. Stern, Gilmartin, and Massengale, p. 169; *Real Estate Record and Guide* [1908], quoted in Stern, Gilmartin, and Massengale, p. 169; Schuyler, "The Skyscraper Problem" [1903], *American Architecture*, 2: 444. As guides to the architectural history of New York, Stern, Gilmartin, and Massengale, and its companion, Stern, Gilmartin, and Mellins, are without equal. As for the history of the skyscraper, a useful survey of previous arguments and another attempt at periodizing their development is Winston Weisman, "A New View of Skyscraper History," in Hitchcock, Fein, Weisman, and Scully, pp. 115–62.

9. Croly, "What is Civic Art?" [1904], quoted in Stern, Gilmartin, and Massengale, p. 31. I discuss the 1893 Fair in the next chapter as it pertains to *Sister Carrie*'s Chicago and Dreiser's vision of an urban future.

On the City Beautiful, see Mario Manieri-Elia, "Toward an 'Imperial City': Daniel H. Burnham and the City Beautiful Movement," in Ciucci et al., particularly pp. 76–89, 119. I find his carefully historicized evaluation of the movement's ideology, political uses, and benefits a useful counter both to ideology critiques that concentrate on certain contemporary justifications of the approach to the exclusion of reading the built results, and to a strain of American Studies criticism that takes a moralizing stand against such civic building projects when there is poverty in the cities. Manieri-Elia leaves the City Beautiful enmeshed in its contradictions, reading it as potentially a tool of reaction, certainly not a utopia, but as providing clear advantages over the status quo of the 1870s and 1880s.

10. Hamilton Wright Mabie, "The Genius of the Cosmopolitan City" [1904], quoted in Stern, Gilmartin, and Massengale, p. 19.

11. Stevens, "An Ordinary Evening in New Haven," *Collected*, p. 470.

12. Stern, Gilmartin, and Massengale, pp. 310, 18, 21; Montgomery Schuyler, "New New York Houses, East Side" [1911], quoted in Stern, Gilmartin, and Massengale, p. 22. The description of stages of metropolitanism is based on Stern, Gilmartin, and Massengale, pp. 12–24.

13. Croly, "Rich Men and their Houses" [1902], quoted in Stern, Gilmartin, and Massengale, p. 321.

14. Veblen, *Theory*, pp. 229–31. The American woman is a "convenience" in a line that includes "stoves, refrigerators, sewing-machines,

type-writers, [and] cash-registers" (*American Scene*, p. 347). James's irony is aimed at the ingenious Yankee male who abandoned the social and sexual fields, and reduced *himself* to a machine, but Posnock ("Henry James," p. 40) is surely correct that her unexampled triumph becomes a triumph for him, since "a cultural division of labor produces and packages the American woman's unfettered individualism as an advertisement for 'the American name,' an advertisement of only a 'slightly different order' than the 'ingenious mechanical appliances.'"

15. Emerson, "Woman" [1855], *Works*, 11: 340.

16. Henry James, "The Speech of American Women," *Speech and Manners*, pp. 28, 44; Emerson, "Woman," *Works*, 11: 353; Henry James, "The Question of Our Speech," *Question*, pp. 52, 45.

James's essays, which were a product of his American tour and were published as articles in 1906–7, expand his criticism of American social indistinctions and their relation to the absence of the complexity of forces that shaped European society.

Jane Austen's novels offer exemplary instances of the power of conversation. On the other hand, the oft-divorced Nancy Headway in "The Siege of London" (1883; *New York Edition*, 14: 143–271), whose New Mexico back-piazza manners leave her ill prepared for her quest to become accepted in Society, exemplifies two of James's preoccupations in those essays on the American woman's speech and manners: the lack of established hierarchies that allows her to occupy the social field without first exhibiting the discriminations he valued, and the prevalence of easy divorces that disrupt the home.

17. Wharton, pp. 131–32.

18. Erenberg notes (pp. 12–13) that since "social position was not fixed, 'activities which are known as social functions' came to dominate society. To be a member of society, one had to act as society decreed and attend events that defined society. . . . To select the elect, these functions had an elaborate set of rules to fix proper behavior and define the minor hierarchies in social life. Such questions as places at dinners and balls, the proper subjects of conversation, who led the cotillion, and the proper decorum for young ladies gave a form to one's actions and empowered the group to make choices over one's behavior."

19. The first country club was from its inception structured around the family. See Curtiss and Heard, pp. 6–7.

20. Curtiss and Heard, pp. 4, 139. The token resolution of the recent conflict over playing the P.G.A. Tournament at an all-white country club was, perhaps, less a victory over racism than an affirmation of the centrality of class in American society.

21. Van Rensselaer, "People in New York" [1895], quoted in Stern, Gil-

martin, and Massengale, p. 20; Stewart, "Hotels of New York" [1899], quoted in Stern, Gilmartin, and Massengale, pp. 257–61.

22. Foucault, "Space/Knowledge/Power," p. 16; Foucault, *Discipline,* pp. 203, 208; Lloyd Morris, pp. 238, 244. On Bunau-Varilla and Komura, see McCarthy, pp. 143–56.

23. Seltzer, p. 143 n. 51; McCarthy, pp. 59, 61. Posnock ("Henry James," p. 43 n. 31) criticizes Seltzer for failing to recognize that "the bourgeois norm is not discipline but rather antinomy." Seltzer's revised model of power suggests such a recognition, but it comes at the end of the chapter and does not undo what comes before it.

The twin incarnations of the "hotel-spirit," the Waldorf's first director, George C. Boldt, and its first *maître d'hôtel,* Oscar Tschirky, insisted, "We do not regulate the public taste. Public taste does and should regulate us" (quoted in McCarthy, p. 11). This self-depreciation omits what James justly called the management's trendsetting "genius," but it is more than a fiction of consumer power; many have tried and failed to produce and regulate the circuit of consumer desire.

24. Koolhaas, p. 124; Hungerford, p. 60; "The New Astoria Hotel" [1897], quoted in Stern, Gilmartin, and Massengale, p. 257; McCarthy, pp. 79–80; Moses King, *Moses King's New York* [1893], quoted in Erenberg, p. 35. Empire was the persistent theme not only in architecture, but also at costume parties among New York's elite, suggesting a shared ideological function.

25. Marin, pp. 54, 65. My analysis of the Waldorf-Astoria is influenced by his critique of amusement from the patron's perspective.

26. Jameson, *Political Unconscious,* p. 291.

27. Stern, Gilmartin, and Massengale, p. 88.

28. Buitenhuis, p. 189. Peter Conrad discusses (pp. 65–85) the cultural politics of literary impressionism and realism as they affect representations of urban poverty.

29. Posnock, "Henry James," pp. 35, 46, 45.

30. Gwendolyn Wright, *Building,* pp. 118–23; Henderson, *Proceedings of the Lake Placid Conference on Home Economics* (1902), and Neill, address at New York School of Philanthropy (1905), quoted in Gwendolyn Wright, pp. 126–27.

Riis's essays, which began with his work at the crime desk, were influential in drawing attention to the need for tenement reform, although they have since been criticized for stereotyping, sensationalizing, and dehumanizing their subjects. In 1910, the Immigration Commission found that, "in connection with the prevailing opinion about filth, which is supposed to be the natural element of the immigrant, it is an interesting fact that while perhaps five-sixths of the blocks studied justified this belief, so far as the

appearance of the street went, five-sixths of the interiors of the home were found to be fairly clean, and two out of every five were immaculate. When this is considered in connection with the frequent inadequate water supply, the dark halls and the large number of families living in close proximity, the responsibility for uncleanliness and unsanitary conditions is largely shifted from the immigrants to the landlords, and to the municipal authorities" (quoted in Barnes and Barnes, pp. 89–90).

31. Foucault, "Space/Knowledge/Power," pp. 18, 17–18.

32. Wardley, p. 654. Edel writes (p. 293) that James called Central Park "an actress destitute of talent." In fact, in *The American Scene* James likens it to "an actress in a company destitute, through an epidemic or some other stress, of all other feminine talent. . . . [Her] valour by itself wins the public and brings down the house—it being really a marvel that she should in no part fail of a hit" (p. 176).

On the evolution of parks, see Olmsted, "Park," in *Creating*, pp. 346–67.

33. Ross Miller, "The Landscaper's Utopia," pp. 179–93. Boyer, p. 37; Trachtenberg, *Incorporation*, pp. 112–21. Foucault, "The Subject," in Wallis, ed., pp. 427, 429, 427.

The disciplinary argument hinges on three items: Olmsted's marginalizing of competitive sports, references to the park's "tranquilizing" effect, and Bentham's theory of the benefits derived from "innocent amusement." Olmsted made reference to Bentham in "Public Parks and the Enlargement of Towns" [1870], in *Civilizing*, pp. 73–74. Had he refused to allot space for athletics in his Greensward Plan or advocated a system of local recreational fields, the argument for his desire to create a docile population would be stronger. The references to riots and unrest that Trachtenberg finds in the rhetoric of tranquilization are secondary to a medical and psychological discourse when Olmsted, in "The Structure of Cities" (in *Civilizing*, p. 40), referred to the utility of a tranquil field for those who participate in "the more intense intellectual activity which prevails equally in the library, the work shop, and the counting room."

Olmsted undertook steps he thought necessary to educate the park's users in the means of preserving a fragile environment as a place of recreation and a respite from crowded streets; the "Regulations for the Use of Central Park" that Olmsted wrote in 1860 will appear unremarkable to users of parks or wilderness areas today. On recreation, see *Creating*, pp. 127, 130–31, 214, 355, and "Public Parks," in *Civilizing*, pp. 95–96; on park rules, see "Regulations for the Use of Central Park," in *Creating*, p. 279, and "Instructions to the Keepers of the Central Park, 1873," in Olmsted, Jr., and Kimball 2: 454–65.

34. Olmsted, "Public Parks," in *Civilizing*, p. 78 (emphasis added); Trachtenberg, *Incorporation*, pp. 110–11. It is also true that many of the

behaviors Olmsted invoked, particularly the leering and wolf-whistles of young men toward female passers-by are not looked upon with approval by our "radical" reformers either.

For a reading of the park similar to mine but against a different set of critics, see Zetzel.

35. Trachtenberg, *Incorporation*, p. 109; Dal Co, "From Parks to the Region: Progressive Ideology and the Reform of the American City," in Ciucci et al., p. 164.

36. Henry James, *Letters*, pp. 352, 327; "The Jolly Corner" [1909], *Novels and Tales*, 17: 43–85.

37. Auchincloss, p. 149.

TWO

1. James, *American Scene*, p. 347; Dreiser, *Sister Carrie* (page references will be made in the text).

2. Michaels, "*Sister Carrie*'s Popular Economy," p. 382; a slightly revised version is reprinted in Michaels, *Gold Standard*.

3. "Thirty Years of Building," *Real Estate Record and Guide* [1898], quoted in Stern, Gilmartin, and Massengale, p. 145; statistics on the Chicago fire and rebuilding are taken from Condit, pp. 18–19.

4. My sources in this paragraph are: on land values, Condit, p. 26; on annexation and infrastructure construction, Melville Scott, pp. 31–32; on suburban building, Stilgoe, p. 141.

5. Michaels, "*Sister Carrie*'s Popular Economy," p. 382; Fisher, in Sundquist, ed., p. 263; Kaplan, *Social Construction*, p. 139. Kaplan critiques Michaels's "logic" in "Naturalism."

Cowperwood is a master at adapting to new situations, something he learned as a child by watching the behavior of a black grouper. Hurstwood, on the other hand, depends on his position for his power, his air of charm. When he buys into the Warren Street pub in New York, his image plummets accordingly. Finally, he is unable to change even his clothes, the novel's basic unit of identity; in New York, they are too shabby to make a good show and too thin to protect him during a winter on the street. Drouet is "an unthinking moth of the lamp" (p. 52) who lacks Ames's comprehension of society's larger forces. Yet when we find him in New York he is a manager for Bartlett, Caryoe, keeps "a couple of swell girls over here on Fortieth Street" (p. 394), and is thinking of opening his own dry goods company (pp. 378–79) because he has developed the potential in his position.

6. Moers, pp. 109, 103.

7. Michaels, "*Sister Carrie*'s Popular Economy," pp. 386, 388, 383, 382. See also Bersani's response, and Michaels, "Fictitious Dealing."

Michaels's argument also overlooks a combination of desire and moral

vision given its fullest statement in Simon Nelson Patten's *The New Basis of Civilization* [1907]. Robert Wiebe usefully summarizes Patten's argument as a claim that "society, after a long history under a scarcity or Pain Economy, had recently achieved a surplus or Pleasure Economy. As soon as race intelligence caught up with economic progress, society would pass to its climax of self-direction, cooperation, and altruism in the Creative Economy" (p. 141; see also Paul Boyer, pp. 228–30). Thus, moralism and abundance were not necessarily at odds in the period. However, I do want in my reading to maintain a distance between Ames's moral critique and Dreiser's critique of moralism.

8. Michaels, "*Sister Carrie*'s Popular Economy," pp. 380, 377, 390, 389, 381.

9. Sullivan, *Autobiography*, pp. 313, 249, 255; Sullivan, phrase written on drawing for plate 3 of *A System of Architectural Ornament* [1924], quoted in Weingarden, "Louis H. Sullivan's Ornament and the Poetics of Architecture," in Zukowsky, ed., *Chicago*, p. 233; Jordy, "The Tall Buildings," in Wit, ed., p. 147.

The critical propagation of Sullivan's myth and its symbols has a long history; it is prominent throughout Mumford's criticism. For a recent instance, see Trachtenberg, *Incorporation*, pp. 225–29.

10. Sullivan, *Autobiography*, p. 297, and see his Democratic chant, pp. 260–85.

11. Michaels, "*Sister Carrie*'s Popular Economy," pp. 376, 382.

12. Bowlby, p. 61.

13. Morton Horwitz, "Progressive," pp. 681, 682.

14. Foucault, "The Subject," in Wallis, ed., pp. 421–24.

15. Hofstadter, *Social Darwinism*, pp. 31–50; Haskell, p. 2; Hollinger, Comments in Symposium on Spencer, Scientism and American Constitutional Law, quoted in Aviam Soifer, "The Paradoxes of Paternalism and Laissez-Faire Constitutionalism: The U.S. Supreme Court, 1888–1921," in Samuels and Miller, eds., p. 162.

16. Holmes, dissent in *Lochner*, p. 75.

17. Pizer, p. 14; Spencer, *Social Statics*, pp. 11, 388.

18. James, *American Scene*, p. 136. Spencer, *First Principles*, pp. 458, 459; Sklar, p. 23; Sklar summarizes Say's Law on p. 54.

19. Sklar, p. 180; Harlan, dissent in *Standard Oil*, p. 96; Sherman Anti-Trust Act [July 2, 1890], in Commager, ed., 2: 136; Roosevelt, First Annual Message to Congress [1901], in Commager, ed., 2: 201–3. On the three phases of judicial construction of the Sherman Act, see Sklar, pp. 117–54.

20. Spencer, *Social Statics*, p. 60; Giddings, "Theory," p. 9; Spencer, *First Principles*, p. 218.

21. Brooks Adams, p. 61. On Conant, see Sklar, pp. 62–68.

22. Spencer, *Social Statics*, p. 388; Haskell, p. 203; Spencer, *Social Statics*, p. 11.

23. Haskell, pp. 28–29; Ward, 1:31–37; Giddings, "Theory," pp. 10, 74; George G. Wilson, p. 140; Giddings, "Theory," p. 35.

24. Layton, p. 54; Thurston, quoted in Layton, p. 55; Morison, quoted in Layton, p. 59. As the later chapters of Layton's study show, engineering associations in the 1920s and 1930s maintained a predominantly conservative, laissez-faire ideology.

A salient instance of the failure of Progressive reform involves the resistance to Rexford Tugwell's work with the Resettlement Administration that led to his resignation; see Schaffer, "Resettling."

25. Henderson, p. 396. He appealed to the authority of economics and physics in representing the social scientist as a "practical" man who seeks "an exact balance between the debits and credits, the causes and results of social action" (p. 396).

26. Dreiser, "Birth and Growth of a Popular Song," in *Magazine Articles*, 2:19; "Whence the Song," *Magazine Articles*, 2:51–52, 2:60–61. However, people mentioned by name are always successful through hard work.

27. Veblen, *Theory*, p. 37.

28. Henry Adams, pp. 340–41, 380. Dreiser's World's Fair articles are reprinted in *Newspaper Writings*, pp. 121–38.

29. Spencer, *Social Statics*, pp. 29–30.

30. Brooks Adams, p. 297.

31. Michaels, "Fictitious Dealing," p. 170; Bowlby, p. 52.

32. Eric Sundquist, "Introduction: The Country of the Blue," in Sundquist, ed., p. 20.

33. Spencer, *Social Statics*, p. 397. Spencer introduced "Altruism" in *Principles of Ethics*, 2:263–76, which he considered as superseding *Social Statics*.

34. Howard Horwitz, pp. 99, 113; Lester Ward, 1:68.

35. Irigaray, p. 181.

36. Veblen, *Theory*, p. 126. Saleswomen of the time were expected to dress stylishly, but not above their class; that is, they were not to be thought to be competing with their well-to-do customers. See Benson, pp. 230–40. In the novel, the daily fashion parades on Broadway are the most dramatic display of vicarious consumption.

37. Foucault, "The Subject," in Wallis, ed., p. 422.

38. Spencer, *Social Statics*, p. 60.

39. See Soifer, "The Paradoxes of Paternalism," in Samuels and Miller, eds., pp. 161–90; Morton J. Horwitz, "*Santa Clara* Revisited: The Development of Corporate Theory," in Samuels and Miller, eds., pp. 13–63.

40. Sullivan, *Autobiography*, pp. 319–26; Howells, *Letters*, pp. 22–25; Schuyler, "Last Words about the World's Fair" [1904], *American Architecture*, pp. 571, 557; Croly, "What is Civic Art?" [1904], quoted in Stern, Gilmartin, and Massengale, p. 31.

41. James Gilbert, p. 109; Bloom, *The Autobiography of Sol Bloom* [1948], quoted in Gilbert, p. 87; Gilbert, p. 15; Schuyler, quoted in Stephens, "For the Record," p. 37.

42. It is true that the narrator follows up his own description with moralizing judgments against the "greedy company" and the "aimless, wandering" activity around this "insect-infested rose of pleasure" (pp. 39–40), but Petrey is surely correct to read such rhetoric as deliberately overwrought and intended to satirize the morals of popular romance novels (on which, see Davidson and Davidson).

43. Tafuri, *Architecture and Utopia*, p. 52.

THREE

1. Ferriss, *Metropolis*, p. 142 (further references will be made in the text).

2. Le Corbusier, *City of Tomorrow*, pp. 5–12; Pound, "The City" [1928], in *Selected Prose*, p. 224.

3. Tafuri, "'*Machine et Mémoire*': The City in the Work of Le Corbusier," in Brooks, ed., pp. 207–8.

4. Tafuri, *Sphere*, p. 134; Kallaí, *Lissig* [1921], quoted in Tafuri, *Sphere*, p. 136; Ilya Ehrenburg, *And Yet It Moves* [1922], quoted in Tafuri, *Sphere*, p. 145.

5. Banham, p. 38; Sant' Elia, p. 21; Le Corbusier, *Towards*, pp. 277–93; the Mossoviet, in Tafuri, *Sphere*, pp. 152–53.

6. Lewis, "Review," p. 44; Lewis, *Caliph's*, p. 48; Pound, "Patria Mia" [1913], *Selected Prose*, p. 104; Pound, "The City," *Selected Prose*, p. 225.

7. Mumford, "The Regional Framework of Civilization" [1925], *Reader*, pp. 215–16.

8. Hitchcock and Johnson, p. 35.

9. Ferriss and Corbett also collaborated on the "Titan City" [1925], another project for a skyscraper metropolis; see Willis, "Titan City," and Stern, Gilmartin, and Mellins, pp. 332–35.

10. Ferriss, *Power*, pp. 10, 9; Montgomery Schuyler, "The Woolworth Building" [1913], *American Architecture*, p. 620. The Woolworth Building's nickname, the "Cathedral of Commerce," stems from the mosaic of the "Gods of Commerce" in the lobby as well as its gothic form.

11. Bunshaft, quoted in Vincent Scully, "Robert Venturi's Gentle Architecture," in Mead, ed., p. 31. On the 1916 Zoning Law, see Willis, "Zoning," and Stern, Gilmartin, and Mellins, pp. 31–39, 507–10.

12. Ferriss, "Truth," p. 101.

13. Bragdon, *The Frozen Fountain* [1932], quoted in Stern, Gilmartin, and Mellins, p. 30.

14. Hood, "A City under a Single Roof" [1929], quoted in Tafuri, *Sphere*, p. 192. Tafuri, "The Disenchanted Mountain: The Skyscraper and the City," in Ciucci et al., notes (p. 439) that by 1931 the percentage of unrented office space in Manhattan was "5 percent in the downtown area, 10.9 percent in the City Hall district, 11.8 percent in the Grand Central area, and 25.4 percent in the area of the [Grand Army] Plaza." Despite the vacancies, 3.5 million square feet of new office space were placed on the market in 1931.

15. Advertisement, reprinted in Koolhaas, pp. 113–14.

16. Starrett, "Mountains of Manhattan" [1928], quoted in Stern, Gilmartin, and Mellins, pp. 513–14.

17. Koolhaas, p. 118; Hood, comment in George W. Gray, "The Future of the Skyscraper" [1931], quoted in Stern, Gilmartin, and Mellins, p. 614. Stern, Gilmartin, and Mellins note (pp. 597–605) that the proposed Larkin Building began the height wars; my account is based on theirs.

18. Ferriss, *Power*, p. 10. Mumford, "City of Tomorrow," p. 332; Mumford, "The Sacred City," p. 271.

19. Pilcher, "Architecture" [1932], quoted in Stern, Gilmartin, and Mellins, p. 27.

20. Koolhaas, pp. 98, 95.

21. Pound, translator's postscript, p. 295; Williams, "The Great Sex Spiral, II," p. 111; Pound, translator's postscript, p. 297. Ferriss on the conflict of science and art, *Power*, p. 94; see also "Technology," "Impact," and "Time."

22. Veblen, *Theory*, p. 126, and see my discussion of Veblen in Chapter 2. Talcott Parsons later suggested that "many of the symbols of feminine attractiveness have been taken over directly from the practices of social types previously beyond the pale of respectable society. This would seem to be substantially true of . . . at least the modern version of the use of cosmetics. The same would seem to be true of many of the modern versions of women's dress." ("Age and Sex in the Social Structure of the United States" [1942], *Essays*, p. 96.)

23. Pound, "Affirmations" [1915], *Selected Prose*, p. 374; Pound, "National Culture: A Manifesto, 1938," *Selected Prose*, p. 162, Pound, "Remy de Gourmont: A Distinction" [1920], *Literary Essays*, p. 344.

24. Pound, Canto XLV [1937], *Cantos*, p. 229.

25. Ferriss, *Power*, pp. 4, 9. Ferriss was not fighting a straw man. As Philip Johnson assembled the 1932 International Exhibition of Modern Architecture for the Museum of Modern Art, he lamented that landscapes comprising "a Greek temple made into a bank, a Gothic church become an

office tower, or, worst of all, a 'modernistic' hodgepodge of half-hidden construction and fantastic detail" were still the rule (quoted in Stern, Gilmartin, and Mellins, p. 344).

26. Ferriss, *Power*, p. 9; Ferriss, "Technology," pp. 60–61.

27. Baudrillard, *For a Critique*, p. 188; Horkheimer and Adorno, p. 3. When I speak of the Imaginary Metropolis as imaging the dialectic of Enlightenment, I do not claim it as "Enlightenment architecture," which its first theorist, the Abbé Laugier, described in his *Observations sur l'Architecture* [1753], as an architecture of "regularity and fantasy, relationships and oppositions, and casual unexpected elements that vary the scene; great order in the details, confusion, uproar, and tumult in the whole" (quoted in Tafuri, *Architecture and Utopia*, p. 4).

28. Hitchcock and Johnson, pp. 35–40; see also pp. 69–77.

29. Baudrillard, *For a Critique*, p. 159, quoting Barthes; Baudrillard, *For a Critique*, pp. 75, 82.

30. Hitchcock and Johnson, p. 75. My criticism of the "functional-effect" applies equally to those "deconstructionist" architects whose undermining of the narrative of architecture and dwelling serves only to evolve another style.

31. Ferriss, "Civic," pp. 12, 13; Willis, Afterword, in Ferriss, *Metropolis*, p. 178, see also pp. 166–68.

32. Baudrillard, *For a Critique*, p. 196.

33. Ferriss, quoted in Oaks, p. 1; Stern, Gilmartin, and Mellins, p. 30.

34. Mumford, "The Sky Line: Mr. Rockefeller's Center," p. 29; Stern, Gilmartin, and Mellins, p. 31; Willensky and White, p. 273; Tafuri, "The Disenchanted Mountain: The Skyscraper and the City," in Ciucci et al., p. 481. On the Center's design history, see Stern, Gilmartin, and Mellins, pp. 617–71, and Tafuri, "The Disenchanted Mountain: The Skyscraper and the City," in Ciucci et al., pp. 461–83.

35. Hood, "A City under a Single Roof," quoted in Tafuri, *Sphere*, p. 193.

36. Willis, Afterword, in Ferriss, *Metropolis*, p. 174.

37. Simmel, "The Metropolis and Mental Life" [1909], in *Sociology*, p. 423.

38. Mumford, *The Golden Day* [1926], in *Reader*, pp. 264–65; Mumford, "Home Remedies for Urban Cancer" [1962], *Urban Prospect*, p. 197; Mumford discusses biological reproducibility in, for example, "The Ideal Form of the Modern City" [1952], *Urban Prospect*, p. 167.

39. Clarence Stein, p. 52, and see also pp. 71–72.

40. Schaffer, *Garden Cities*, p. 94. My statistics are from Schaffer, *Garden Cities*, pp. 160, 173–74; he cites 1980 census figures. On restrictive covenants, see Birch, p. 433.

41. Sennett, *Conscience*, p. 196; Mumford, "The Regional Framework of Civilization," *Reader*, p. 209.

42. Dargan and Zeitlin, *City Play*; Wald and Maltz, screenwriters, *The Naked City*.

43. *The City* [1939], quoted in Stern, Gilmartin, and Mellins, p. 86; film review in *Architectural Review* [1939], quoted in Stern, Gilmartin, and Mellins, p. 86; Ilya Ehrenburg, *And Yet It Moves*, quoted in Tafuri, *Sphere*, p. 145. On the Futurama, see Stern, Gilmartin, and Mellins, pp. 747–51; my description of Democracity is based on a pamphlet published by the New York World's Fair.

44. Croly, "What is Civic Art?" [1904], quoted in Stern, Gilmartin, and Massengale, p. 31; Venturi, "Interview," p. 13.

45. Marin, pp. 59–61.

F O U R

1. Huyssen, p. 186.

2. Dickie, *Modernist Long Poem*, pp. 4, 16.

3. Pound, Canto LXXIV [1948], *Cantos*, p. 444; Woodward, *At Last*, p. 17, see also pp. 92–94.

4. Dickie, *Modernist Long Poem*, p. 55; Crane, "The Bridge," *Complete*, pp. 48, 90, 89.

5. Conarroe, pp. 150, 133, 130; Rowe, "Modern Art," p. 169; William Carlos Williams, *Paterson* (1963 ed.), p. 10. (Further references to *Paterson* will be made in the text and are to this edition; my work on this chapter was substantially complete before the publication of Christopher MacGowan's revised and annotated edition of the poem.)

6. Williams, letter to Henry Wells [Apr. 12, 1950], *Selected Letters*, p. 286.

7. Wood, p. 174.

8. William James, *Pragmatism*, pp. 549, 548; Dewey, "Americanism and Localism" [1920], *Characters*, 2: 537–41. I have found Bercovitch's "Emerson" and *Office* valuable for understanding the history—and literary history—of Williams's brand of liberalism.

9. Williams, *I Wanted*, pp. 72–73; Burke, "Literature as Equipment for Living," *Philosophy*, pp. 300–1.

10. Abbott, "Proceedings of the Conference on Photography: Profession, Adjunct, Recreation" [1940], quoted in Sundell, p. 271; Trachtenberg, *Reading*, p. 225; Abbott, from a form letter sent to 200 contributors to the Museum of Modern Art and the Museum of the City of New York [1933], quoted in Sundell, p. 269.

11. Williams, "Sermon," pp. 282, 283.

12. Williams, "Marianne Moore" [1931], *Selected Essays*, p. 128.

13. Williams, *Autobiography*, p. 359.

14. Pound, Canto XXIV [1930], *Cantos*, p. 112, Canto CXVI [1969], *Cantos*, p. 811.

15. Description of Forest Garden, *Paterson Intelligencer*, June 30, 1830, quoted in Paul Johnson, p. 434; Paul Johnson, p. 433; Crane on "the hand of ART," *Paterson Intelligencer*, Dec. 12. [1827], quoted in Paul Johnson, p. 434.

16. Patch on his "art," *Paterson Intelligencer*, July 15, 1828, quoted in Paul Johnson, p. 440; mechanics and manufacturers, *Paterson Intelligencer*, July 9, 1828, quoted in Paul Johnson, p. 444; Patch's boast, *New York Post*, Oct. 1, 1827, quoted in Paul Johnson, p. 436.

17. Crane, letter to *Paterson Intelligencer*, May 11, 1831, quoted in Paul Johnson, p. 438.

18. Williams, "The Yachts," *Collected Poems*, 1: 388–89. In his first poem about the 1913 strike, "The Wanderer," Williams maintained a clear distinction between the "more sensitive" poet and the "fox-snouted, thick-lipped" workers (*Collected Poems*, 1: 112). As he matured, the dignity of the poor became a recurrent theme of his poems, although he still romanticized poverty. His proletarian portraits of the mid-1930s credit the poor with an individuality missing in the middle class. Conflating marginality and freedom, Williams hailed their extravagance: "It is the anarchy of poverty that delights me," he wrote in "The Poor" (*Collected Poems*, 1: 452), and he recorded his pleasure in poems like "Proletarian Portrait" (*Collected Poems*, 1: 384–85), "To a Poor Old Woman" (*Collected Poems*, 1: 383), and "Late for Summer Weather" (*Collected Poems*, 1: 384). What he squinted at was that only the expendability of the poor "freed" them to be "anarchic." Williams also effaced class from "An Early Martyr" (*Collected Poems*, 1: 377–78), his poem for John Coffey, who took up thieving in order that his trial might create a platform from which to oppose his version of justice to existing property laws; in his essay on Coffey, "A Man," Williams claimed only a "logical" interest in a struggle between an individual and an abstract system.

19. William Jennings Bryan, "Cross of Gold" Speech, in Commager, ed., 2: 175.

20. Pound, "A Visiting Card" [1942], *Selected Prose*, p. 308. Williams also argues for Social Credit in "Revolutions Revalued: The Attack on Credit Monopoly from a Cultural Viewpoint" [1936], in *Recognizable Image*, pp. 97–118; "Social Credit"; and his review of Pound's *Jefferson and/or Mussolini*.

21. Williams, response to questions from the editors of *Partisan Review* [1939], *Interviews*, p. 83; Douglas, p. 43.

22. Williams, "American Poet," p. 17; Williams, "Revolutions Revalued," in *Recognizable Image*, p. 100.

23. Nelson, pp. 24 (quoting General Montcalm), 38.

24. Williams's source was Barber and Howe, pp. 412–13.

25. Williams, letter to Horace Gregory [July 22, 1939], *Selected Letters*, p. 185. On the Jackson Whites, I have consulted Williams's source, Storms, as well as Crawford.

26. Williams, "To Elsie" (*Spring and All* XVIII), *Collected Poems*, 1: 217.

27. Williams, "The American Background" [1934], *Selected Essays*, p. 139; Aymar Embury II, "Farmhouses of New Netherlands," in Mullins, ed., p. 12. Williams's brother was an architect and his friend Herbert Fisher was well-informed about Jersey Dutch houses and local history.

28. Heusser, p. 97. On natural aristocracy, see Wood, pp. 471–518.

29. Williams, "Revolutions Revalued," in *Recognizable Image*, p. 101. On the early history of the s.u.m., see Joseph Stancliffe Davis, vol. 1.

30. Williams, "The Virtue of History," *American Grain*, p. 195; Hamilton, "Report on the Subject of Manufactures" [1791], *Papers*, 10: 260.

31. Hamilton, "Report," *Papers*, 10: 250, 10: 253, 10: 251.

32. Parrington, 1: 310, Williams, "Revolutions Revalued," in *Recognizable Image*, p. 99; Federal Writers' Project, p. 351.

33. Federal Writers' Project, p. 176; Hewitt, p. viii; Federal Writers' Project, p. 355. See also Cottrell's tourist pamphlet.

34. Wood, p. 562.

35. Williams, "Père Sebastian Rasles," *American Grain*, pp. 105–29; Williams, "The Discovery of Kentucky," *American Grain*, p. 137; Williams, "A Morning Imagination of Russia," *Collected Poems*, 1: 303–6.

36. Williams, "The Great Sex Spiral, II," p. 111.

37. Thirlwall, p. 277.

38. Weaver, p. 133.

39. Williams, Introduction, pp. 413–14 (emphasis added); Williams, *Autobiography*, p. 51. In the letter to Wells (*Selected Letters*, p. 284), Williams confessed himself "a most conventional person."

40. Williams, letter to Gregory [1958], *Selected Letters*, p. 265; Williams, letter to Moore [June 23, 1951], *Selected Letters*, p. 305; Williams, letter to Tyler [Mar. 10, 1951], *Selected Letters*, p. 263.

41. Breslin, pp. 204, 210; Thirlwall, pp. 290–99; Woodward, pp. 133–34, 153–54.

42. Williams, "Shoot It Jimmy!" (*Spring and All* XVII), *Collected Poems*, 1: 216; "Ol' Bunk's Band," *Collected Poems*, 2: 149–50; Williams, interview with Walter Sutton [1961], *Interviews*, p. 55; Williams, "The Colored Girls of Passenack—Old and New," *Farmer's Daughters*, p. 55. On

Williams's view of black music, see also Nielson, "Whose Blues?"; on his representation of blacks generally, see Nielson, *Reading Race*, pp. 72–84.

FIVE

1. Sennett, *Conscience*, pp. 126, 127.

2. Parsons, "Propaganda and Social Control" [1942], *Essays*, pp. 150, 152. He returns to the analogies among psychology, biology, and the social structure in "Psychoanalysis and the Social Structure" [1950], *Essays*, p. 337.

3. The classic, if somewhat overstated, survey of American intellectual antiurbanism is White and White.

4. Paine is not the only wife-beater mentioned in the film. Dixon seems to have met the smart-talking Martha, at whose restaurant he is a regular, when he arrested her husband for abuse. In return, she now looks out for him.

5. Wald, Afterword, *Naked City*, p. 107. I will refer primarily to the film, not the screenplay. On the question of calling the semidocumentary film of police work film noir, see, for example, Krutnik, pp. 202–8.

6. Parsons, "Propaganda and Social Control," *Essays*, pp. 174, 172. On film documentaries during World War II, see Richard Dyer McCann, "World War II: Armed Forces Documentary," in Barsam, ed., pp. 136–57; on the use and funding of documentary film as part of the Cold-War propaganda campaign, see Barsam, "'This Is America': Documentaries for Theaters, 1942–1951," in Barsam, ed., pp. 115–35, and Thomas M. Pryor, "Films in the 'Truth Campaign,'" in Lewis Jacobs, ed., pp. 292–95; on the Left tradition in American documentary cinema, see Alexander.

7. Eisenhower's Executive Order 10450 [Apr. 27, 1953], in Commager, ed., 2: 780–82; Truman Loyalty Order [Mar. 27, 1947], in Commager, ed., 2: 707–10; National Security Act [July 26, 1947], in Commager, ed., 2: 721–23; Selective Service Act [June 24, 1948], in Commager, ed., 2: 728–29; McCarran Internal Security Act [Sept. 23, 1950], in Commager, ed., 2: 741–44; Communist Control Act [Aug. 24, 1954], in Commager, ed., 2: 797–98; Taft-Hartley Act [June 23, 1947], in Commager, ed., 2: 716–19.

8. Parsons, "Propaganda and Social Control," *Essays*, p. 143 (emphasis added); Giddings, "Theory," p. 9.

9. Peter Conrad, p. 278.

10. Peter Conrad, p. 279.

11. Smith Act [June 28, 1940], in Commager, ed., 2: 613; Commager, headnote to the Smith Act, in Commager, ed., 2: 613; Harry S. Truman, Veto message on McCarran-Walter Immigration Act [1952], in Commager, ed., 2: 776.

On the immigration debate during the period, see Higham, *Send These*, pp. 58–62. As he shows in admirable detail in *Strangers*, nativism has a long history in the United States. The immigration policies of this period were established in the Immigration Laws of 1917, 1921, and 1924; see Commager, ed., 2: 315–17, 2: 372–74; and Higham, *Send These*, pp. 51–57.

12. Parsons, "Propaganda and Social Control," *Essays*, p. 144.

13. Parsons, *Social System*, p. 39; Park, "Community Organization and Juvenile Delinquency," in Park, Burgess, and McKenzie, p. 111; Parsons, "The Motivation of Economic Activities" [1940], *Essays*, p. 56.

Remarking the changed nature of social mobility in a corporate economy with no significant number of new immigrants making rapid strides, Parsons stressed instead the possibility of rising through education, the use of lateral mobility to make "an end run" around the structure internal to a corporation, and the possibility of rising along with everyone else in a rising economy; see "A Revised Approach to the Theory of Social Stratification" [1953], *Essays*, pp. 435–38.

14. Henry W. Brossin, "Psychosis," *Encyclopaedia Britannica*, 1959 ed., 18: 722. Parsons discusses the neurotic personality in "Propaganda and Social Control," *Essays*, pp. 150–53.

15. A classic study of suburbanization is Jackson, especially, for my purposes, pp. 190–218. I have also consulted Brian J. O'Connell, "The Federal Role in the Suburban Boom," in Kelly, ed., pp. 181–92; Arnold Silverman, "Defense and Deconcentration: Defense Industrialization during World War II and the Development of Contemporary American Suburbs," in Kelly, ed., pp. 157–73; and Robert A. Beauregard, "Postwar Spatial Transformations," in Beauregard, ed., pp. 1–44.

16. Spencer, *Social Statics*, pp. 29–30.

17. See Parsons, "Age and Sex in the Social Structure of the United States" [1942], *Essays*, pp. 94–99, and "An Analytical Approach to the Theory of Social Stratification" [1940], *Essays*, pp. 79–80.

18. Fitzgerald, pp. 66, 121, 134.

19. Henry James, *American Scene*, p. 134.

20. Ferriss, "Civic," p. 27. Ferriss had nothing so insidious in mind, but the metaphor is apt.

21. Wald, Afterword, *Naked City*, p. 148; Tyler, "Documentary Technique in Film Fiction" [1949], in Lewis Jacobs, ed., p. 265.

22. Tyler, "Documentary Technique in Film Fiction," in Lewis Jacobs, ed., p. 265; Parsons, "The Motivation of Economic Activities," *Essays*, pp. 56, 52.

23. Foucault, *Birth of the Clinic*, p. 196.

24. Foucault, *Birth of the Clinic*, p. 3.

25. Wald, Afterword, *Naked City*, p. 147; see also Salzman, especially, pp. 95–104.

26. Higham, *Send These*, p. 244.

S I X

1. Robert Venturi, Denise Scott Brown, and Steven Izenour, *Learning from Las Vegas* (1972); *Learning From Las Vegas: The Forgotten Symbolism of Architectural Form* (1977), p. –/76. These two editions have significant differences: the original hardcover edition includes a portfolio of projects absent from the paperback edition, which includes studio notes not in the original. Page references are to both editions, in chronological order; further references will appear in the text; dashes indicate material absent from one edition.

With regard to postmodernity, the Venturis are of course chronologically postmodern, but that is the least interesting sense of the term; in other respects they straddle the fence. Jencks finds their aesthetic program modernist because it asks us, "in the name of rationality to follow an exclusive, simplistic path"—of preferring one form of architecture to another; nevertheless, he names Venturi and Short's headquarters building for the North Penn Visiting Nurses' Association (1960) "the first anti-monument of Post-Modernism," because it taught a generation of architects the use of "odd angles and skewed space" (pp. 45, 62, 87). Portoghesi, *After Modern* (pp. 80–85), treats Venturi's design philosophy, his often witty "articulat[ion of] differences in themes and eras," and his ability to speak to specialized and general audiences at once; yet Venturi rates only a passing reference in his *Postmodern*. Scott Brown (Introduction, Venturi and Scott Brown, *View from the Campidoglio*, p. 10) and Venturi ("Diversity, Relevance and Representation in Historicism, or *Plus ça Change . . .* plus a Plea for Pattern all over Architecture with a Postscript on my Mother's House" [1982], *View from the Campidoglio*, p. 116) both reject the "postmodern" label, which they regard as the name of a particular style.

2. Advisory Commission, pp. 4, 141, 31, 142. See also the studies cited in Note 15 to the previous chapter.

3. Soja, p. 181; Lapham, p. 6.

With respect to Los Angeles, Brodsly notes (p. 33) that between 1953 and 1962 the area within a 30-minute drive from downtown Los Angeles increased from 261 square miles to 705 square miles. For more recent studies of the Los Angeles region's stratification by race and class, and its correlation to shifts in the composition of the job-base, see Soja's maps (pp. 202, 206, 211, 213, 214, 218). Correlating the geography of these distributions with freeway routes offers powerful testimony to their effects on urbanity.

4. Brodsly, pp. 23, 38, 27.

5. Tafuri, *Architecture and Utopia*, p. 52; Le Corbusier, *Towards*, p. 249. My historical markers in this paragraph are discussed at greater length in Chapters 1 and 3.

6. Hitchcock and Johnson, p. 20; Blundell Jones, p. 14. Richard Guy Wilson, "Architecture in the Machine Age," in Wilson, Pilgrim, and Tashjian (pp. 149–204), is a fine overview of American architecture of the period.

7. Rowe and Koetter, p. 56.

8. Rowe and Koetter, pp. 3, 2.

9. Rowe and Koetter, p. 97; on Superstudio, see, e.g., Rowe and Koetter, pp. 42–48.

10. Rowe and Koetter, pp. 97, 45.

11. Huyssen, p. 188; Danto, pp. 137, 138; Ross, p. 152. Venturi returns to the relationship between late-modern architecture and Abstract Expressionism in "A Definition of Architecture as Shelter with Decoration on It, and Another Plea for Symbolism of the Ordinary in Architecture" [1978], *View from the Campidoglio*, pp. 62–65.

12. Holland, "Rear-guard," p. 457; Lance Wright, pp. 263, 264; Sorkin, p. 35; Shakespeare, *Troilus*, II.iii.59; Maxwell, "The Venturi Effect," in Stern, ed., p. 27.

13. Scott Brown, "Learning from Pop" [1971], *View from the Campidoglio*, p. 27. The Venturis' problem in this regard is, I think, attributable to uncritical extrapolations from Herbert Gans's studies of suburbanite ideals; see, for example, his "Urbanism and Suburbanism as Ways of Life," in Callow, ed., pp. 504–18.

14. Scott Brown, "Learning from Pop," *View from the Campidoglio*, pp. 26, 28.

15. On the advent of advocacy planning at Penn, see von Moos, *Venturi*, p. 18.

16. See the account by Verman. Also see Osborn; Scott Brown, "Alternative Proposal."

17. Scott Brown, "Pop Off: A Reply to Ken Frampton" [1971], *View from the Campidoglio*, p. 36 (her response to Frampton, "America").

18. Frampton, "Towards a Critical Regionalism: Six Points for an Architecture of Resistance," in Foster, ed., p. 25; Venturi, *Complexity*, p. 131; Venturi, "A Definition" [1978], *View from the Campidoglio*, p. 62.

19. Bunshaft is quoted in Vincent Scully, "Robert Venturi's Gentle Architecture," in Mead, ed., p. 31.

20. Venturi, "Learning the Right Lessons from the Beaux Arts" [1979], *View from the Campidoglio*, p. 94.

21. Forgey, p. C4.

22. Deutsche, "Uneven Development: Public Art in New York City," in Ghirardo, ed., pp. 202, 204, 206. We might ask if we want to see "Homeless Vehicles" as more than a symbol—doesn't the production of homeless vehicles signify the acceptance of homelessness?

23. Eagleton, p. 68; Jameson, "Postmodernism," pp. 81–83. I suspect that Portman's stature as a major commercial developer is more of a motivating factor for Jameson than any qualities of the hotel itself.
As for Jencks's term "late-modernism," I find it at least intuitively useful even though Herman Rapaport is correct that "unlike the modern and the postmodern, the so-called late modern is not governed by a distinct set of ideas that mark it off epistemically from either the modern or the postmodern. . . . At best the late modern is a residual movement in which the furthest elaborations of modernism continue even as the postmodern has already come into its own" (p. 353).

24. Jameson, "Postmodernism," p. 92; Jameson, "Spatial Equivalents," in *States*, pp. 146–47, 133, 130, 146, 131, 135. Revised versions of both "Postmodernism" and "Spatial Equivalents" are included in *Postmodernism*, Jameson's book-length survey of the culture of late capitalism.

25. Venant; Jameson, "Spatial Equivalents," States of "Theory" Conference (revised for the published proceedings).

26. Danto, p. 9.

27. Huyssen, p. 148.

28. Danto, pp. 136, 41.

29. Abbott, "Proceedings of the Conference on Photography: Profession, Adjunct, Recreation" [1940], quoted in Sundell, p. 271; von Moos, p. 65.

30. Warhol, *The Philosophy of Andy Warhol* (1975), quoted in Ross, pp. 169–70; Rauschenberg, *Mostly About Rauschenberg* (unreleased film of 1974–75), quoted in Alloway, "Robert Rauschenberg," in National Collection of Fine Arts, *Rauschenberg*, p. 11.

31. Rowe and Koetter, p. 142.

32. I borrow the juxtaposition of Warhol and *The German Ideology* from Danto (who does not confuse them), pp. 222, 221–22.

33. Ezra Pound, "The Teacher's Mission" [1934], *Literary Essays*, p. 58; Rowe and Koetter, p. 149; Marin, pp. 59–61.

34. Henry James, *American Scene*, p. 139.

35. Venturi, "Diversity," *View from the Campidoglio*, p.109.

36. Rodriguez, "Slouching," p. M1; Rodriguez, *Days*, pp. 37, 84.

Abbott, Berenice. *New York in the Thirties*. Text by Elizabeth Mc-Causland. New York: Dover, 1973. [Reprint of *Changing New York* (1939).]

Adams, Brooks. *The Law of Civilization and Decay: An Essay on History*. New York: Knopf, 1943 [1896].

Adams, Henry. *The Education*. Ed. Ernest Samuels. Boston: Houghton, 1973 [1918].

Adorno, Theodor. *Aesthetic Theory*. Ed. Gretel Adorno and Rolf Tiedemann. Tr. C. Lenhardt. London: Routledge, 1984.

———. "Culture Industry Reconsidered." *New German Critique* 6 (1975): 12–20.

———. *Prisms*. Tr. Samuel and Sherry Weber. London: Neville Spearman, 1967.

Advisory Commission on Intergovernmental Relations. *Metropolitan Social and Economic Disparities: Implications for Intergovernmental Relations in Central Cities and Suburbs*. Washington, D.C.: Government Printing Office, 1965.

Alexander, William. *Film on the Left: American Documentary Film from 1931 to 1942*. Princeton, N.J.: Princeton University Press, 1981.

Althusser, Louis. *Lenin and Philosophy and Other Essays*. Tr. Ben Brewster. London: New Left Books, 1971.

Annual Urban Design and Planning Citation [Denise Scott Brown, Washington Avenue, Miami Beach, Redevelopment Plan]. *Progressive Architecture*, Jan. 1983: 122–23.

Auchincloss, Louis. *Reading Henry James*. Minneapolis: University of Minnesota Press, 1975.

Badger, Reid. *The Great American Fair: The World's Columbian Exposition and American Culture*. Chicago: N. Hall, 1979.

Bakhtin, Mikhail Mikhailovich. *The Dialogic Imagination: Four Essays*. Ed. Michael Holquist. Tr. Caryl Emerson and Michael Holquist. Austin: University of Texas Press, 1981.

Banham, Reyner. "Antonio Sant' Elia." *Architectural Design*, Jan.–Feb. 1981: 35–38.

Barber, John W., and Henry Howe. *Historical Collections of the State of New Jersey*. New York: priv. printed, 1844.

Barnes, Mary Clark, and Lemuel Call Barnes. *The New America: A Study in Immigration*. New York: Fleming H. Revell, 1913.

Barry, Nancy K. "Epic History and the Lyrical Impulse in the *Paterson* Manuscripts." *William Carlos Williams Review* 12.2 (1986): 1–12.

Barsam, Richard Meran, ed. *Nonfiction Film: Theory and Criticism*. New York: Dutton, 1976.

Barthes, Roland. *S/Z: An Essay*. Tr. Richard Miller. New York: Hill and Wang, 1974.

Baudrillard, Jean. *For a Critique of the Political Economy of the Sign*. Tr. Charles Levin. St. Louis: Telos, 1981.

———. "*La fin de la modernité ou l'ère de la Simulation*." In *Bienniale de Paris 1982, Section d'Architecture: La modernité, ou, l'ésprit du temps*. Paris: L'Equerre, 1982. Pp. 32–33.

———. "Modernity." Tr. David James Miller. *Canadian Journal of Social and Political Thought / Revue canadienne de théorie politique et sociale* 11 (1987): 63–72.

Baylin, Bernard. *The Ideological Origins of the American Revolution*. Cambridge, Mass.: Harvard University Press, 1967.

Beardsley, Monroe C. Review of *Learning from Las Vegas*. *Journal of Aesthetics and Art Criticism* 33 (1974): 245–46.

Beauregard, Robert A., ed. *Atop the Urban Hierarchy*. Totowa, N.J.: Rowman and Littlefield, 1989.

Beck, Haig. "Elitist." *Architectural Design*, Nov. 1976: 662–66.

Benert, Annette Larson. "Monsters, Bagmen and Little Old Ladies: Henry James and the Unmaking of America." *Arizona Quarterly* 42 (1986): 331–43.

Benjamin, Andrew. "Derrida, Architecture, Philosophy." *Architectural Design*, Mar.–Apr. 1988: 8–11.

Bennington, Geoff. "Complexity without Contradiction in Architecture." *AA Files* 15 (1987): 15–18.

Benson, Susan Porter. *Counter Cultures: Saleswomen, Managers, and Customers in American Department Stores, 1890–1940*. Urbana: University of Illinois Press, 1986.

Bercovitch, Sacvan. "Emerson, Individualism, and the Ambiguities of Dissent." *South Atlantic Quarterly* 89 (1990): 623–62.

———. *The Office of "The Scarlet Letter."* Baltimore: Johns Hopkins University Press, 1991.

Bercovitch, Sacvan, and Myra Jehlen, eds. *Ideology and Classic American Literature*. New York: Cambridge University Press, 1986.

Berger, Harry. "The Renaissance Imagination: Second World and Green World." *Centennial Review* 9 (1965): 36–78.

Bernstein, Michael André. *The Tale of the Tribe: Ezra Pound and the Modern Verse Epic.* Princeton, N.J.: Princeton University Press, 1980.

Bersani, Leo. "Rejoinder to Walter Benn Michaels." *Critical Inquiry* 8 (1981): 158–64.

Birch, Eugenie Ladner. "Radburn and the American Planning Movement: The Persistence of an Idea." *Journal of the American Planning Association,* Oct. 1980: 424–39.

Blanton, John. Review of *Learning from Las Vegas. American Institute of Architects Journal,* Feb. 1973: 56–57.

Blundell Jones, Peter. "Where Do We Stand? A Lecture about Modernism, Post-Modernism and the Neglected Possibility of a Responsive Architecture." *A+U* 198 (1987): 14–30.

Boelhower, William Q. *Through a Glass Darkly: Ethnic Semiosis in American Literature.* New York: Oxford University Press, 1987.

Bollard, Margaret. "The Newspaper Landscape of Williams' *Paterson.*" *Contemporary Literature* 16 (1975): 317–27.

Bové, Paul. "The World and Earth of William Carlos Williams: *Paterson* as a 'Long Poem.'" *Genre* 11 (1978): 575–96.

Bowlby, Rachel. *Just Looking: Consumer Culture in Dreiser, Gissing and Zola.* London: Methuen, 1985.

Boyer, M. Christine. *Dreaming the Rational City: The Myth of American City Planning.* Cambridge, Mass.: MIT Press, 1983.

Boyer, Paul. *Urban Masses and Moral Order in America, 1820–1920.* Cambridge, Mass.: Harvard University Press, 1978.

Bremen, Brian A. "'The Radiant Gist': The Poetry Hidden in the Prose of Williams' *Paterson.*" *Twentieth-Century Literature* 32 (1986): 221–41.

Breslin, James E. B. *William Carlos Williams: An American Artist.* Chicago: University of Chicago Press, 1985.

Breugmann, Robert. "Two Post-Modern Versions of Urban Design: Venturi and Scott Brown and Rob Krier." *Landscape* 26.2 (1982): 31–37.

Brodsly, David. *L.A. Freeway: An Appreciative Essay.* Berkeley: University of California Press, 1981.

Brooks, H. Allen, ed. *Le Corbusier.* Princeton, N.J.: Princeton Architectural Press, 1987.

Brooks, Van Wyck. *Van Wyck Brooks: The Early Years; A Selection from His Works, 1908–1921.* Ed. Claire Sprague. New York: Harper, 1968.

Brossin, Henry W. "Psychosis." *Encyclopaedia Britannica,* 1959 ed., 18: 722.

Bryson, Norman. *Vision and Painting: The Logic of the Gaze.* London: Macmillan, 1983.

Buitenhuis, Peter. *The Grasping Imagination: The American Writings of Henry James*. Toronto: University of Toronto Press, 1970.

Burg, David F. *Chicago's White City of 1893*. Lexington: University of Kentucky Press, 1976.

Bürger, Peter. *Theory of the Avant-Garde*. Tr. Michael Shaw. Theory and History of Literature 4. Minneapolis: University of Minnesota Press, 1984.

Burke, Kenneth. *The Philosophy of Literary Form*. 3rd ed. Berkeley: University of California Press, 1973 [1941].

Cady, Edwin H. *William Dean Howells as Critic*. London: Routledge, 1973.

Caldwell, Erskine, and Margaret Bourke-White. *You Have Seen Their Faces*. New York: Modern Age Books, 1937.

Callow, Alexander B., Jr., ed. *American Urban History: An Interpretive Reader with Commentaries*. New York: Oxford University Press, 1969.

Carney, Francis. "The Summa Popologica of Robert ('Call Me Vegas') Venturi." *Royal Institute of British Architects Journal*, May 1973: 242–44.

Christman, Henry M. *The Mind and Spirit of John Peter Altgeld*. Urbana: University of Illinois Press, 1960.

Ciucci, Giorgio, Francesco Dal Co, Mario Manieri-Elia, and Manfredo Tafuri. *The American City: From the Civil War to the New Deal*. Tr. Barbara Luigia La Penta. London: Granada, 1980.

Cohen, Stuart E. "Contextualism: From Urbanism to a Theory of Appropriate Form." *Inland Architecture* 31.3 (1987): 68–69.

Coles, Robert. *That Red Wheelbarrow: Selected Literary Essays*. Iowa City: University of Iowa Press, 1988.

———. "William Carlos Williams." *Raritan* 6.3 (1987): 113–21.

———. *William Carlos Williams: The Knack of Survival in America*. New Brunswick, N.J.: Rutgers University Press, 1975.

Commager, Henry Steele, ed. *Documents of American History*. 6th ed. New York: Appleton, 1958.

Conarroe, Joel. *William Carlos Williams' "Paterson": Language and Landscape*. Philadelphia: University of Pennsylvania Press, 1970.

Condit, Carl W. *The Chicago School of Architecture: A History of Commercial and Public Building in the Chicago Area, 1875–1925*. Chicago: University of Chicago Press, 1964.

Conn, Peter. *The Divided Mind: Ideology and Imagination in America, 1898–1917*. New York: Cambridge University Press, 1983.

Connor, Steven. *Postmodernist Culture: An Introduction to the Theories of Contemporary Culture*. London: Basil Blackwell, 1989.

Conrad, Bryce. *Refiguring America: A Study of William Carlos Williams's "In the American Grain."* Urbana: University of Illinois Press, 1990.

Conrad, Peter. *The Art of the City: Views and Versions of New York*. New York: Oxford University Press, 1984.

Corkin, Stanley. "*Sister Carrie* and Industrial Life: Objects and the New American Self." *Modern Fiction Studies* 33 (1987): 605–19.

Corrigan, Peter. "Reflections on a New North American Architecture: The Venturis." *Architecture in Australia*, Feb. 1972: 55–66.

Cottrell, Alden T. *The Story of Ringwood Manor*. Trenton: New Jersey Department of Conservation and Development [1944].

Crane, Hart. *Complete Poems and Selected Prose*. Ed. Brom Weber. New York: Anchor-Doubleday, 1966.

Crawford, Constance. "The Jackson Whites." M.A. thesis. New York University, 1940.

Cronon, William. *Nature's Metropolis: Chicago and the Great West*. New York: Norton, 1991.

Culver, Stuart. "How Photographs Mean: Literature and the Camera in American Studies." *American Literary History* 1 (1989): 190–205.

Curtiss, Frederic H., and John Heard. *The Country Club, 1882–1932*. Brookline, Mass.: priv. printed, 1932.

Dal Co, Francesco. "Addressing the American City." *Crit* 17 (1986): 8.

———. "On History and Architecture: An Interview with Francesco Dal Co." *Perspecta* 23 (1987): 6–23.

Daley, Janet. "Hugh Ferriss: Metropolis." *AA Files* 16 (1987): 64–68.

Danto, Arthur C. *Beyond the Brillo Box: The Visual Arts in Post-Historical Perspective*. New York: Farrar, 1992.

Dargan, Amanda, and Steven Zeitlin. *City Play*. New Brunswick, N.J.: Rutgers University Press, 1990.

Davenport, Guy. "The Nuclear Venus: Dr. Williams' Attack upon Usura." *Perspective* 6 (1953): 183–90.

Davidson, Cathy N., and Arnold E. Davidson. "Carrie's Sisters: The Popular Prototypes for Dreiser's Heroines." *Modern Fiction Studies* 23 (1977): 395–407.

Davis, Joseph Stancliffe. *Essays in the Earlier History of American Corporations*. 2 vols. Harvard Economic Studies 16. New York: Russell and Russell, 1965 [1917].

Davis, Mike. "*Chinatown, Part Two*: The Internationalization of Downtown Los Angeles," *New Left Review* 164 (1987): 65–87.

———. *City of Quartz: Excavating the Future in Los Angeles*. London and New York: Verso, 1990.

———. "Urban Renaissance and the Spirit of Postmodernism," *New Left Review* 151 (1985): 106–13.

de Certeau, Michel. *The Practice of Everyday Life*. Tr. Steven F. Rendall. Berkeley: University of California Press, 1984.

Derrida, Jacques. "*Architetture ove il desiderio può abitare*." [Interview with Eva Meyer.] No tr. *Domus*, Apr. 1986: 17–24.

————. *Margins of Philosophy.* Tr. Alan Bass. Chicago: University of Chicago Press, 1982.

————. *Of Grammatology.* Tr. Gayatri Spivak. Baltimore: Johns Hopkins University Press, 1976.

————. "*Point de Folie—Maintenant l'architecture.*" Tr. Kate Linker. *AA Files* 12 (Summer 1986): 65–75.

————. *The Truth in Painting.* Tr. Geoff Bennington and Ian McLeod. Chicago: University of Chicago Press, 1987.

Dewey, John. *Characters and Events: Popular Essays in Social and Political Philosophy.* Ed. Joseph Ratner. 2 vols. New York: Henry Holt, 1929.

————. *Liberalism and Social Change.* New York: Putnam, 1935.

Dickie, Margaret. *On the Modernist Long Poem.* Iowa City: University of Iowa Press, 1986.

————. "Williams Reading *Paterson.*" *ELH* 53 (1986): 653–71.

Dijkstra, Bram. *The Hieroglyphics of a New Speech: Cubism, Stieglitz, and the Early Poetry of William Carlos Williams.* Princeton, N.J.: Princeton University Press, 1969.

D[ixon], J[ohn] M[orris]. "Some Decorated Sheds, or, Towards an Old Architecture." *Progressive Architecture,* May 1973: 86–89.

Dos Passos, John. *The 42nd Parallel.* New York: Harper, 1930.

Douglas, C[lifford] H[ugh]. *Economic Democracy.* 4th ed. London: Stanley Nott, 1934.

Dreiser, Theodore. *An Amateur Laborer.* Ed. Richard W. Dowell. Philadelphia: University of Pennsylvania Press, 1983.

————. *American Diaries, 1902–1926.* Ed. Thomas P. Riggio. Philadelphia: University of Pennsylvania Press, 1982.

————. *The Financier.* New York: New American Library, 1967 [1912].

————. *Newspaper Writings, 1892–1895.* Vol. 1 of *Journalism.* Ed. T. D. Nostwich. Philadelphia: University of Pennsylvania Press, 1988.

————. *Notes on Life.* Ed. Margeurite Tjadert and John J. McAleer. University: University of Alabama Press, 1974.

————. *Selected Magazine Articles of Theodore Dreiser: Life and Art in the American 1890s.* 2 vols. Ed. Yoshinobu Hakutani. Rutherford, N.J.: Fairleigh Dickinson University Press, 1985.

————. *Sister Carrie.* New York: Bantam, 1982 [1900].

Duffey, Bernard M. *A Poetry of Presence: The Writing of William Carlos Williams.* Madison: University of Wisconsin Press, 1986.

Eagleton, Terry. "Capitalism, Modernism and Postmodernism." *New Left Review* 152 (1985): 60–73.

Edel, Leon. *Henry James: The Master, 1901–1916.* Philadelphia: Lippincott, 1972.

Eliot, T[homas] S[tearns]. *The Waste Land: A Facsimile and Transcript.* Ed. Valerie Eliot. London: Faber, 1971.

Ellmann, Maud. "Ezra Pound: The Erasure of History." In *Post-Structuralism and the Question of History*. Ed. Derek Attridge, Geoff Bennington, and Robert Young. Cambridge, Eng.: Cambridge University Press, 1987. Pp. 244–59.

Emerson, Ralph Waldo. *The Works of Ralph Waldo Emerson*. 14 vols. Boston: Riverside, 1883–98.

Erenberg, Lewis. *Steppin' Out: New York Nightlife and the Transformation of American Culture, 1890–1930*. Chicago: University of Chicago Press, 1981.

Evans, Walker. *American Photographs*. New York: Museum of Modern Art [1938].

Federal Writers' Project. *New Jersey: A Guide to Its Past and Present*. American Guide Series. New York: Viking, 1939.

Ferriss, Hugh. "Architecture of This Age." *The Little Review* 12.1 Supp. ["Machine Age Exhibition"] (1927): 5–6.

———. "Civic Architecture of the Immediate Future." *Arts and Decoration*, Nov. 1922: 12–13.

———. "Cubes and Pyramids." *Christian Science Monitor*, Oct. 8, 1923, p. 4.

———. "The Impact of Science and Materialism on Art Today." *American Institute of Architects Journal*, July 1954: 3–6.

———. *The Metropolis of Tomorrow*. Princeton N.J.: Princeton Architectural Press, 1986 [1929].

———. "The New Architecture." *New York Times*, Mar. 19, 1922: sec. 3, p. 8.

———. *Power in Buildings: An Artist's View of Contemporary Architecture*. New York: Columbia University Press, 1953.

———. "Rendering, Architectural." [1929.] *Encyclopaedia Britannica*, 1959 ed., 19: 146–49.

———. "Technology and Vision." *American Institute of Architects Journal*, Feb. 1952: 60–64.

———. "Time for an Artistic Revival in Architectural Design." *American Institute of Architects Journal*, Feb. 1955: 51–57.

———. "Truth in Architectural Rendering." *American Institute of Architects Journal*, Mar. 1925: 99–101.

Filler, Martin. "Planning for a Better World: The Lasting Legacy of Clarence Stein." *Architectural Record*, Aug. 1982: 122–27.

Fitzgerald, F[rancis] Scott. *The Great Gatsby*. New York: Scribner's, 1980 [1925].

Fliegelman, Jay. *Prodigals and Pilgrims: The American Revolution Against Patriarchal Authority, 1750–1800*. New York: Cambridge University Press, 1982.

Forgey, Benjamin. "Tarnished Brilliance: Western Plaza: No Wonder It's 'Not Quite Right.'" *Washington Post*, June 18, 1983, p. C1.

Foster, Hal, ed. *The Anti-Aesthetic: Essays on Postmodern Culture.* Port Townsend, Wash.: Bay Press, 1983.

Foucault, Michel. *The Birth of the Clinic: An Archaeology of Medical Perception.* Tr. A. M. Sheridan Smith. New York: Pantheon, 1973.

———. *Discipline and Punish: The Birth of the Prison.* Tr. Alan Sheridan. New York: Vintage, 1979.

———. *The History of Sexuality,* Vol. 1: *An Introduction.* Tr. Robert Hurley. New York: Vintage, 1980.

———. "Space/Knowledge/Power." Tr. Christian Hubert. *Skyline,* Mar. 1982: 16–21.

Fowler, Sigrid H. Review of *Learning from Las Vegas. Journal of Popular Culture* 7 (1973): 425–33.

Fox, Richard Wrightman, and T. J. Jackson Lears, eds. *The Culture of Consumption: Critical Essays in American History, 1880–1980.* New York: Pantheon, 1983.

Frail, David. *The Early Politics and Poetics of William Carlos Williams.* Studies in Modern Literature 73. Ann Arbor, Mich.: UMI Research Press, 1987.

Frampton, Kenneth. "America 1960–1970: Notes on Urban Images and Theory." *Casabella* 359/360 (1971): 34–38.

Frank, Waldo, Lewis Mumford, Dorothy Norman, Paul Rosenfeld, and Harold Rugg, eds. *America and Alfred Stieglitz.* New York: Literary Guild, 1934.

"Franklin Court, Philadelphia, Venturi and Rauch." *American Institute of Architects Journal,* May 1977: 35.

Furth, David L. *Visionary Betrayed: Aesthetic Discontinuity in Henry James's "The American Scene."* Cambridge, Mass.: Harvard University Press, 1979.

Garnier, Tony. *Une cité industrielle.* Tr. Andrew Ellis. New York: Rizzoli, 1990 [French ed., 1918].

Gelpi, Albert. "Stevens and Williams: The Epistemology of Metaphor." In *Wallace Stevens: The Poetics of Modernism.* New York: Cambridge University Press, 1985. Pp. 3–23.

Ghirardo, Diane, ed. *Out of Site: A Social Criticism of Architecture.* Seattle: Bay Press, 1991.

Giddings, Franklin H. "The Relation of Sociology to Other Scientific Studies." *Journal of Social Science* 32 (Nov. 1894): 144–50.

———. "The Theory of Sociology." *Annals of the American Society of Political and Social Science* 5 supp. July 1894.

Gilbert, James Burkhardt. *Perfect Cities: Chicago's Utopias of 1893.* Chicago: University of Chicago Press, 1991.

Gilbert, Sandra M. "Purloined Letters: William Carlos Williams and 'Cress.'" *William Carlos Williams Review* 11.2 (1985): 5–15.

Gilbert-Rolfe, Jeremy. "Capital Follies." *Artforum*, Sept. 1978: 66–67.

Gillette, Howard F., Jr. "White City, Capitol City." *Chicago History* 18 (1989/90): 26–45.

Goldberger, Paul. "Disney Teaches the Architects." *New York Times Magazine*, Oct. 22, 1972, p. 40.

Gorky, Maxim. *The City of the Yellow Devil.* No tr. Moscow: Progress Publishers, 1972 [1906].

Gottdiener, Mark. "Closing the Semiotic Circle: Postmodern Architecture and the City." *Postmodernism and Beyond: Architecture as the Critical Art of Contemporary Culture.* Conference Supplement. Irvine, Cal.: Arnold and Mabel Beckman Center of the National Academy of Sciences and Engineering, Oct. 26–28, 1989. Pp. 25–27.

———. *The Social Production of Urban Space.* Austin, Tex.: University of Texas Press, 1985.

Gottdiener, Mark, and Alexandros Ph. Lagopolous, eds. *The City and the Sign: An Introduction to Urban Semiotics.* New York: Columbia University Press, 1986.

Gowans, Alan. *Architecture in New Jersey: A Record of American Civilization.* New Jersey Historical Series 6. Princeton, N.J.: Van Nostrand, 1964.

Graham, Don. "Not Post-Modernism: History as Against Historicism, European Archetypal Vernacular in Relation to American Commercial Vernacular, and the City as Opposed to the Individual Building." *Artforum*, Dec. 1981: 50–58.

Great Falls Development Corporation. *The Great Falls / S.U.M. Historic District, Paterson, New Jersey.* Paterson, N.J., 1977.

Green, Martin. *New York 1913: The Armory Show and the Paterson Strike Pageant.* New York: Scribner's, 1988.

Guimond, James. *The Art of William Carlos Williams: A Discovery and Possession of America.* Urbana: University of Illinois Press, 1968.

Hall, Peter Geoffrey. *Cities of Tomorrow: An Intellectual History of Urban Planning.* Oxford: Blackwell, 1988.

Hall, William F. "The Continuing Relevance of Henry James' *The American Scene.*" *Criticism* 13 (1971): 151–65.

Hamilton, Alexander. *The Papers of Alexander Hamilton.* 27 vols. Ed. Harold C. Syrett and Jacob E. Cooke. New York: Columbia University Press, 1961–87.

Harrison, Helen A., ed. *Dawn of a New Day: The New York World's Fair, 1939/40.* New York: Queens Museum–New York University Press, 1980.

Hartman, Geoffrey. *Criticism in the Wilderness: The Study of Literature Today*. New Haven: Yale University Press, 1980.

Haskell, Thomas L. *The Emergence of Professional Social Science: The American Social Science Association and the Nineteenth-Century Crisis of Authority*. Urbana: University of Illinois Press, 1977.

Henderson, Charles R. "Business Men and Social Theorists." *American Journal of Sociology* 1 (Jan. 1896): 385–97.

Heusser, Albert H. *George Washington's Mapmaker: A Biography of Robert Erskine*. Ed. Hubert G. Schmidt. New Brunswick, N.J.: Rutgers University Press, 1966 [reprint of *The Forgotten General* (1938)].

Hewitt, Edward Ringwood. *Ringwood Manor: The Home of the Hewitts*. Trenton, N.J.: Trenton Printing Company, 1946.

Higham, John. *Send These to Me: Immigrants in Urban America*. Rev. ed. Baltimore: Johns Hopkins University Press, 1984.

———. *Strangers in the Land: Patterns of American Nativism, 1860–1925*. New York: Athenaeum, 1963 [1955].

Hitchcock, Alfred, dir. *Rear Window*. Paramount, 1954.

Hitchcock, Henry-Russell, Albert Fein, Winston Weisman, and Vincent Scully. *The Rise of an American Architecture*. New York: Praeger–Metropolitan Museum of Art, 1970.

Hitchcock, Henry-Russell, and Philip Johnson. *The International Style*. Rev. ed. New York: Norton, 1966 [1932].

Hoffman, Daniel, ed. *Ezra Pound and William Carlos Williams: The University of Pennsylvania Conference Papers*. Philadelphia: University of Pennsylvania Press, 1983.

Hofstadter, Richard. *The Age of Reform: From Bryan to F.D.R.* New York: Knopf, 1955.

———. *Social Darwinism in American Thought*. Boston: Beacon, 1955 [1944].

———, ed. *The Progressive Movement, 1900–1915*. Englewood Cliffs, N.J.: Prentice, 1963.

Holder, Alan. "*In the American Grain*: William Carlos Williams and the American Past." *American Quarterly* 19 (1967): 499–515.

Holland, Laurence. *The Expense of Vision: Essays on the Craft of Henry James*. 2nd ed. Baltimore: Johns Hopkins University Press, 1982.

———. "Rear-guard Rebellion." *Yale Review* 62 (1973): 456–61.

Hont, Istvan, and Michael Ignatieff, eds. *Wealth and Virtue: The Shaping of Political Economy in the Scottish Enlightenment*. Cambridge, Eng.: Cambridge University Press, 1983.

Horkheimer, Max, and Theodor Adorno. *The Dialectic of Enlightenment*. Tr. John Cumming. New York: Continuum, 1987.

Horwitz, Howard. "The Standard Oil Trust as Emersonian Hero." *Raritan* 6.4 (1987): 97–119.

Horwitz, Morton J. "History and Theory." *Yale Law Journal* 96 (1987): 125–35.

———. "Progressive Legal Historiography." *Oregon Law Review* 63 (1984): 679–87.

Howard, Ebenezer. *Garden Cities of To-morrow.* Ed. F. J. Osborn. Cambridge, Mass.: MIT Press, 1965 [1902].

Howells, William Dean. *Criticism and Fiction.* Ed. Clara Marburg Kirk and Rudolf Kirk. New York: New York University Press, 1959.

———. *Letters of an Altrurian Traveller.* Gainesville, Fla.: Scholars' Facsimiles and Reprints, 1961 [1893–94].

———. *The Rise of Silas Lapham.* New York: Harper, 1958 [1886].

Hungerford, Edward. *The Story of the Waldorf-Astoria.* New York: Knickerbocker Press–Putnam, 1925.

Hutcheon, Linda. *A Poetics of Postmodernism: History, Theory, Fiction.* New York and London: Routledge, 1988.

Huyssen, Andreas. *After the Great Divide: Modernism, Mass Culture, Postmodernism.* Bloomington: Indiana University Press, 1986.

In re Jacobs, 98 N.Y. 98 (1885).

Irigaray, Luce. *This Sex Which Is Not One.* Tr. Catherine Porter with Carolyn Burke. Ithaca, N.Y.: Cornell University Press, 1985.

Jackson, Kenneth T. *Crabgrass Frontier: The Suburbanization of the United States.* New York: Oxford University Press, 1985.

Jacobs, Jane. *The Death and Life of Great American Cities.* New York: Vintage, 1961.

Jacobs, Lewis, ed. *The Documentary Tradition: From Nanook to Woodstock.* New York: Hopkinson and Blake, 1971.

James, Henry. *The American Scene.* Bloomington: Indiana University Press, 1968 [1907].

———. *The Art of Fiction and Other Essays.* New York: Oxford University Press, 1948.

———. *Autobiography.* Ed. Frederick W. Dupee. New York: Criterion, 1956.

———. *The Bostonians.* [1886.] In *Novels, 1881–1886.* Pp. 801–1219.

———. *Hawthorne.* New York: Harper, 1879.

———. *Letters, 1895–1916.* Vol. 4 of 4 vols. Ed. Leon Edel. Cambridge, Mass.: Belknap–Harvard University Press, 1984.

———. *The New York Edition of the Novels and Tales of Henry James.* 24 vols. New York: Scribner's, 1907–09.

———. *The Notebooks.* Ed. F. O. Matthiessen and Kenneth B. Murdock. New York: Oxford University Press, 1947.

———. *Notes of a Son and Brother.* [1914.] In *Autobiography.* Pp. 239–544.

———. *Novels, 1881–1886.* Ed. William T. Stafford. New York: Library of America, 1985.

———. *The Question of Our Speech; The Lesson of Balzac; Two Lectures.* Boston: Houghton, 1905.

———. *A Small Boy and Others.* [1913.] In *Autobiography.* Pp. 3–236.

———. *The Speech and Manners of American Women.* Ed. E. S. Riggs. Lancaster, Penn.: Lancaster House Press, 1973 [1906–7].

———. *Washington Square.* [1881.] In *Novels, 1881–1886.* Pp. 1–189.

James, William. *Writings, 1902–1910.* Ed. Bruce Kuklik. New York: Library of America, 1987.

Jameson, Fredric. *The Ideologies of Theory: Essays 1971–1986.* Vol. 1: *Situations of Theory.* Theory and the History of Literature 48. Minneapolis: University of Minnesota Press, 1988.

———. *The Ideologies of Theory: Essays 1971–1986:* Vol. 2: *The Syntax of History.* Theory and the History of Literature 49. Minneapolis: University of Minnesota Press, 1988.

———. *The Political Unconscious: Narrative as a Socially Symbolic Act.* Ithaca, N.Y.: Cornell University Press, 1981.

———, "Postmodernism, or, The Cultural Logic of Late Capitalism." *New Left Review* 146 (1984): 53–92.

———. *Postmodernism, or, The Cultural Logic of Late Capitalism.* Durham, N.C.: Duke University Press, 1991.

———. "Reification and Utopia in Mass Culture." *Social Text* 1 (1979): 130–48.

———. "Spatial Equivalents." The States of "Theory" Conference. Focused Research Project in Critical Theory: University of California, Irvine, Apr. 24, 1987.

———. "Spatial Equivalents: Postmodern Architecture and the World System." *The States of "Theory": History, Art, and Critical Discourse.* Ed. David Carroll. Irvine Studies in the Humanities 4. New York: Columbia University Press, 1990. Pp. 125–48.

Janowitz, Anne. "*Paterson:* An American Contraption." In *William Carlos Williams: Man and Poet.* Ed. Carroll F. Terrell. Orono, Maine: National Poetry Foundation–University of Maine Press, 1983. Pp. 301–22.

Jay, Paul. L. "American Modernism and the Uses of History: The Case of William Carlos Williams." *New Orleans Review* 9 (1982): 16–25.

Jencks, Charles. *The Language of Post-Modern Architecture.* 3rd ed. London: Academy Editions, 1981.

Jencks, Charles, and George Baird, eds. *Meaning in Architecture.* New York: Braziller, 1969.

Jodido, Philip, and Michael Ragon. "Architecture after Modernism: 2. Eulogy of the Ugly and Ordinary." *Connaissance des Arts* 322 (Oct. 1979): 86–93.

Johnson, Paul. "'Art' and the Language of Progress in Early-Industrial Paterson: Sam Patch at Clinton Bridge." *American Quarterly* 40 (1988): 433–49.

Johnson, Stuart. "American Marginalia: James's *The American Scene.*" *Texas Studies in Language and Literature* 24 (1982): 83–101.

Kaplan, Amy. "Naturalism with a Difference." *American Quarterly* 40 (1988): 582–89.

———. *The Social Construction of American Realism.* Chicago: University of Chicago Press, 1988.

Kasson, John F. *Amusing the Million: Coney Island at the Turn of the Century.* New York: Hill and Wang, 1978.

Kazin, Alfred, and Charles Shapiro, eds. *The Stature of Theodore Dreiser: A Critical Survey of the Man and His Work.* Bloomington: Indiana University Press, 1955.

Kelly, Barbara M., ed. *Suburbia Re-examined.* Contributions in Sociology 78. Westport, Conn.: Greenwood Press, 1989.

Kenner, Hugh. *The Pound Era.* Berkeley: University of California Press, 1971.

Klink, William R. "Paterson Forty Years after *Paterson.*" *Sagetreib* 6 (1987): 94–108.

———. "William Carlos Williams's *Paterson*: Literature and Urban History." *Urban Affairs Quarterly* 23 (1987): 171–85.

Klotz, Heinrich. *Postmodern Visions: Drawings, Paintings, and Models by Contemporary Architects.* Tr. Yehuda Shapiro. New York: Abbeville Press, 1985.

Knapp, James F. *Literary Modernism and the Transformation of Work.* Evanston, Ill.: Northwestern University Press, 1988.

Koetter, Fred. "On Robert Venturi, Denise Scott Brown, and Steven Izenour's *Learning from Las Vegas.*" *Oppositions* 3 (May 1974): 98–104.

Kolich, Augustus M. "William Carlos Williams' *Paterson* and the Poetry of Uncertainty." *Sagetreib* 6 (1987): 53–72.

Koolhaas, Rem. *Delirious New York: A Retroactive Manifesto for Manhattan.* New York: Oxford University Press, 1978.

Kraft, James. "On Reading *The American Scene.*" *Prose* 6 (1973): 115–36.

Krieger, Alex. "Civic Lessons of an Ephemeral Monument." *Harvard Architecture Review* 4 (1984): 148–66.

Kroll, Lucien. *An Architecture of Complexity.* Tr. Peter Blundell Jones. Cambridge, Mass.: MIT Press, 1987.

Kronick, Joseph G. *American Poetics of History: From Emerson to the Moderns.* Baton Rouge: Louisiana State University Press, 1984.

Krutnik, Frank. *A Lonely Street: Film Noir, Genre, Masculinity.* London: Routledge, 1991.

Kuhn, Thomas. *The Structure of Scientific Revolutions*. Chicago: University of Chicago Press, 1962.

Kurtz, Stephen A. "Toward an Urban Vernacular." *Progressive Architecture*, July 1970: 100–105.

Kutzinski, Vera M. *Against the American Grain: Myth and History in William Carlos Williams, Jay Wright, and Nicolás Guillén*. Baltimore: Johns Hopkins University Press, 1987.

Lange, Dorothea, and Paul Taylor. *An American Exodus: A Record of Human Erosion*. New York: Reynal and Hitchcock, 1939.

Lapham, Lewis H. "City Lights." *Harper's*, July 1992: 4–6.

Layton, Edwin T., Jr. *The Revolt of the Engineers: Social Responsibility and the American Engineering Profession*. Cleveland: Case Western Reserve University Press, 1971.

Le Corbusier (Charles Edouard Jeanneret-Gris). *The City of To-morrow and Its Planning*. Tr. Frederick Etchells. New York: Dover, 1987 [1929; French ed., 1924].

———. *The Radiant City*. Tr. Pamela Knight, Eleanor Levieux, and Derek Coltman. New York: Orion, 1967 [French ed., 1935].

———. *Towards a New Architecture*. Tr. Frederick Etchells. New York: Praeger, 1946 [1927; French ed., 1924].

———. *When the Cathedrals Were White: A Journey to the Country of Timid People*. Tr. Francis E. Hyslop, Jr. New York: Reynal and Hitchcock, 1947.

Leich, Jean Ferriss. *Architectural Visions: The Drawings of Hugh Ferriss*. New York: Whitney Library of Design–Watson Guptill, 1980.

Lentricchia, Frank. *Ariel and the Police: Michel Foucault, William James, Wallace Stevens*. Madison: University of Wisconsin Press, 1988.

Levy, H[yman]. *A Philosophy for a Modern Man*. New York: Knopf, 1938.

Lewis, Wyndham. *The Caliph's Design: Architects! Where Is Your Vortex!* Ed. Paul Edwards. Santa Barbara, Calif.: Black Sparrow Press, 1986 [1919].

———. "A Review of Contemporary Art." *Blast* 2 (1915): 38–47.

Lloyd, Margaret Glynne. *William Carlos Williams's "Paterson": A Critical Reappraisal*. Rutherford, N.J.: Fairleigh Dickinson University Press, 1980.

Lochner v. New York, 198 U.S. 45 (1905).

Longwell, Charles P. *Historic Totowa Falls and Vicinity: In Art, Literature, Events*. [Paterson, N.J.]: The Call Printing and Publishing Co., 1942.

Lubove, Roy. *Community Planning in the 1920s*. Pittsburgh: University of Pittsburgh Press, 1964.

Lynch, Kevin. *The Image of the City*. Cambridge, Mass.: MIT Press, 1960.

Lyotard, Jean François. *The Différend: Phrases in Dispute*. Tr. Georges Van

Den Abbeele. Theory and the History of Literature 46. Minneapolis: University of Minnesota Press, 1988.

———. *The Postmodern Condition: A Report on Knowledge.* Tr. Geoff Bennington and Brian Massumi. Theory and the History of Literature 10. Minneapolis: University of Minnesota Press, 1984.

Lyotard, Jean François, and Jean-Loup Thébaud. *Just Gaming.* Tr. Wlad Godzich. Theory and the History of Literature 20. Minneapolis: University of Minnesota Press, 1985.

Machor, James. *Pastoral Cities: Urban Ideals and the Symbolic Landscape of America.* Madison: University of Wisconsin Press, 1987.

Macpherson, C[rawford] B[rough]. *Democracy in Alberta: The Theory and Practice of a Quasi-Party System.* University of Toronto Press, 1953.

———. *The Political Theory of Possessive Individualism: Hobbes to Locke.* Oxford, Eng.: Oxford University Press, 1961.

Marchand, Roland. *Advertising the American Dream: Making Way for Modernity, 1920–1940.* Berkeley: University of California Press, 1985.

Mariani, Paul. *A Useable Past: Essays on Modern and Contemporary Poetry.* Amherst: University of Massachusetts Press, 1984.

———. *William Carlos Williams: A New World Naked.* New York: McGraw-Hill, 1981.

Marin, Louis. "Disneyland: a Degenerate Utopia." *Glyph* 1 (1977): 50–66.

Marsden, Dora. "The Art of the Future." *The New Freewoman,* Nov. 1, 1913: 181–83.

———. "Concerning the Beautiful." *The New Freewoman,* Sept. 1, 1913: 102–104.

———. "The Heart of the Question." *The New Freewoman,* Aug. 1, 1913: 61–64.

———. "Thinking and Thought." *The New Freewoman,* Aug. 15, 1913: 81–83.

Marx, Leo. *The Machine in the Garden: Technology and the Pastoral Ideal in America.* New York: Oxford University Press, 1968.

Maslan, Mark. "Foucault and Pragmatism." *Raritan* 8.3 (1988): 94–114.

Matthews, Kathleen. "Competitive Giants: Satiric Bedrock in Book One of William Carlos Williams' *Paterson.*" *Journal of Modern Literature* 12 (1985): 237–60.

Matthiessen, F. O. *Henry James: The Major Phase.* New York: Oxford University Press, 1944.

———. *Theodore Dreiser.* New York: Sloane, 1951.

May, Elaine Tyler. *Homeward Bound: American Families in the Cold War Era.* New York: Basic Books, 1988.

Mazzaro, Jerome. *William Carlos Williams: The Later Poetry.* Ithaca, N.Y.: Cornell University Press, 1973.

McCarthy, James Remington, with John Rutherford. *Peacock Alley: The Romance of the Waldorf-Astoria.* New York: Harper, 1931.

McQuade, Walter. "Giving Them What They Want: The Venturi Influence." *Life,* Apr. 14, 1972: 17.

Mead, Christopher, ed. *The Architecture of Robert Venturi.* Albuquerque: University of New Mexico Press, 1989.

Mezzrow, Milton ("Mezz"), and Bernard Wolfe. *Really the Blues.* New York: Random House, 1946.

Michaels, Walter Benn. "Fictitious Dealing: A Reply to Leo Bersani." *Critical Inquiry* 8 (1981): 165–71.

———. *The Gold Standard and the Logic of Naturalism: American Literature at the Turn of the Century.* Berkeley: University of California Press, 1987.

———. "*Sister Carrie*'s Popular Economy." *Critical Inquiry* 7 (1980): 373–90.

Miller, J. Hillis. *The Linguistic Moment: From Wordsworth to Stevens.* Princeton, N.J.: Princeton University Press, 1985.

———. "On Edge: The Crossways of Contemporary Criticism." *AAAS Bulletin* 32.1 (1979): 13–32.

———. *Poets of Reality: Six Twentieth-Century Writers.* Cambridge, Mass.: Belknap–Harvard University Press, 1965.

———. "Presidential Address 1986. The Triumph of Theory, the Resistance to Reading, and the Question of the Material Base." *PMLA* 102 (1987): 281–91.

———. "Williams' *Spring and All* and the Progress of Poetry." *Daedalus* 99 (1970): 405–34.

Miller, Michael B. *The Bon Marché: Bourgeois Culture and the Department Store, 1869–1920.* Princeton, N.J.: Princeton University Press, 1981.

Miller, R. Leonard. "Evaluation: Admiring Glance at a Celebrity [Robert Venturi's Guild House]." *American Institute of Architects Journal,* Feb. 1980: 38–41.

Miller, Ross L. "The Landscaper's Utopia Versus the City: A Mismatch." *New England Quarterly* 49 (1976): 179–93.

Moers, Ellen. *Two Dreisers.* New York: Viking, 1969.

Morris, Lloyd. *Incredible New York: High Life and Low Life of the Last One Hundred Years.* New York: Random House, 1951.

Morris, Wright. *The Territory Ahead.* New York: Harcourt, 1958.

Mujica, Francisco. *History of the Skyscraper.* New York: Da Capo, 1977 [1929].

Mullins, Lisa C., ed. *Colonial Architecture of the Mid-Atlantic.* Architectural Treasures of Early America 4. Pittstown, N.J.: National Historic Society–Main Street Press, 1987.

Mumford, Lewis. "The City of Tomorrow." *New Republic*, Feb. 12, 1930: 332–33.

———. *The Lewis Mumford Reader.* Ed. Donald L. Miller. New York: Pantheon, 1986.

———. "The Plan of New York, I." *New Republic*, June 15, 1932: 121–28.

———. "The Plan of New York, II." *New Republic*, June 22, 1932: 146–54.

———. "The Sacred City." *New Republic*, Jan. 27, 1926: 270–71.

———. "The Sky Line: Mr. Rockefeller's Center." *New Yorker*, Dec. 23, 1933: 29–30.

———. "Skyscrapers and the City of the Future." *New Republic*, Apr. 23, 1930: 275.

———. *Sticks and Stones: A Study of American Architecture and Civilization.* New York: Boni and Liveright, 1924.

———. *The Urban Prospect.* New York: Harcourt, 1968.

Museum of Modern Art. *Machine Art.* New York: Arno, 1964 [1934].

Nash, Ralph. "The Uses of Prose in *Paterson*." *Perspective* 6 (1953): 191–200.

National Collection of Fine Arts. *Robert Rauschenberg.* Washington: Smithsonian Institution, 1977.

Nay, Joan. "William Carlos Williams and the Singular Woman." *William Carlos Williams Review* 11.2 (1985): 45–54.

Nelson, William. *History of the City of Paterson and the County of Passaic, New Jersey.* Paterson, N.J.: The Press, 1901.

Nelson, William, and Charles A. Shriner. *History of Paterson and Its Environs: The Silk City.* 3 vols. New York: Lewis Historical Publishing Co., 1920.

New Jersey General Assembly. *An ACT to Incorporate the Contributors to the Society for Establishing Useful Manufactures. New Jersey Session Laws.* First Sitting, Nov. 22, 1791.

New York World's Fair Commission [Gilbert Seldes]. *Your World of Tomorrow.* New York: Exposition Publications, 1939.

Nielsen, Aldon Lynn. *Reading Race: White American Poets and the Racial Discourse in the Twentieth Century.* Athens: University of Georgia Press, 1988.

———. "Whose Blues?" *William Carlos Williams Review* 15.2 (1989): 1–8.

Nietzsche, Friedrich. *The Use and Abuse of History.* Tr. Adrian Collins. 2nd ed. New York: Macmillan, 1957.

Norwood, Christopher. *About Paterson: The Making and Unmaking of an American City.* New York: Saturday Review Press–Dutton, 1974.

Oaks, Gladys. "City Planner, Poet, Differ on Beauty of Skyscraper." *The World* [New York], June 1, 1930: sec. 5, p. 1.

Olmsted, Frederick Law. *Civilizing American Cities: A Selection of Fred-*

erick Law Olmsted's Writings on City Landscape. Ed. S. B. Sutton. Cambridge, Mass.: MIT Press, 1971.

———. *Creating Central Park, 1857–1861.* Ed. Charles E. Beveredge and David Schuyler. Vol. 3 of *The Papers of Frederick Law Olmsted.* Ed. Charles Capen McLaughlin. Baltimore: Johns Hopkins University Press, 1983.

———. *Landscape into Cityscape: Frederick Law Olmsted's Plans for a Greater New York.* Ed. Albert Fein. Ithaca, N.Y.: Cornell University Press, 1967.

Olmsted, Frederick Law, Jr., and Theodora Kimball. *Frederick Law Olmsted, Landscape Architect, 1822–1903.* 2 vols. New York: Benjamin Blom, 1979 [1922].

Olson, Charles. *The Maximus Poems.* Ed. George F. Butterick. Berkeley: University of California Press, 1983 [1953–75].

———. *Selected Writings.* Ed. Robert Creeley. New York: New Directions, 1966.

Orvell, Miles. *The Real Thing: Imitation and Authenticity in American Culture, 1880–1940.* Chapel Hill: University of North Carolina Press, 1989.

Osborn, Michelle. "The Crosstown Is Dead. Long Live the Crosstown." *Architectural Forum,* Oct. 1971: 38–41.

Park, Robert E. *Human Communities: The City and Human Ecology.* Glencoe, Ill.: Free Press, 1952.

———. *On Social Control and Collective Behavior.* Ed. Ralph H. Turner. The Heritage of Sociology. Chicago: University of Chicago Press, 1967.

Park, Robert E., Ernest W. Burgess, and Roderick McKenzie. *The City.* Chicago: University of Chicago Press, 1967 [1925].

Parrington, Vernon Louis. *Main Currents in American Thought: An Interpretation of American Literature from the Beginnings to 1920.* 3 vols. New York: Harcourt, 1958 [1927–30].

Parsons, Kermit C. "British and American Community Planning: Clarence Stein's Manhattan Transfer." *Planning Perspectives* 7 (1992): 181–210.

Parsons, Talcott. *Essays in Sociological Theory.* Rev. ed. Glencoe, Ill.: Free Press, 1954.

———. *The Social System.* New York: Basic Books, 1964 [1951].

Pateman, Carole. *The Sexual Contract.* Stanford, Calif.: Stanford University Press, 1988.

Paterson (City of), New Jersey. *Paterson: Facing a Horizon Bright with Promise.* Paterson, N.J., 1991.

Patten, Simon Nelson. *The New Basis of Civilization.* Ed. Daniel M. Fox. Harvard University Press, 1968 [1907].

Pawley, Martin. "Leading from the Rear." *Architectural Design,* Jan. 1970: 45.

————. "Miraculous Expanding Tits Versus Lacquered Nipples." *Architectural Design*, Feb. 1973: 80.

Peiss, Kathy. *Cheap Amusements: Working Women and Leisure in Turn-of-the-Century New York*. Philadelphia: Temple University Press, 1986.

Perloff, Marjorie. *The Dance of the Intellect: Studies in the Poetry of the Pound Tradition*. New York: Cambridge University Press, 1985.

————. *The Poetics of Indeterminacy: Rimbaud to Cage*. Princeton, N.J.: Princeton University Press, 1971.

Petrey, Sandy. "The Language of Realism, the Language of False Consciousness: A Reading of *Sister Carrie*." *Novel* 10 (1977): 101–13.

Phillips, Patricia C. "Hugh Ferriss." Review of [exhibition] "Hugh Ferriss: Metropolis" at The Whitney Museum at Equitable Center [New York]. *Artforum*, Nov. 1986: 139.

Pinnell, Patrick. "On Venturi I: Drawing as Polemic." *Skyline*, Dec. 1978: 5.

————. "On Venturi II: Allegory and Kitsch." *Skyline*, Jan. 1979: 5.

Pizer, Donald. *The Novels of Theodore Dreiser: A Critical Study*. Minneapolis: University of Minnesota Press, 1976.

Pocock, J. G. A. *The Machiavellian Moment: Florentine Republican Thought and the Atlantic Republican Tradition*. Princeton, N.J.: Princeton University Press, 1975.

————. *Virtue, Commerce, and History: Essays on Political Thought and History, Chiefly in the Eighteenth Century*. Cambridge, Eng.: Cambridge University Press, 1985.

Portoghesi, Paolo. *After Modern Architecture*. Tr. Meg Shore. New York: Rizzoli, 1982.

————. *Postmodern: The Architecture of Post-Industrial Society*. Tr. Ellen Shapiro. New York: Rizzoli, 1983.

Posnock, Ross. "Genteel Androgyny: Santayana, Henry James, Howard Sturgis." *Raritan* 10.3 (1991): 58–84.

————. "Henry James, Thorstein Veblen and Adorno: The Crisis of the Modern Self." *Journal of American Studies* 21 (1987): 31–54.

————. "William and Henry James." *Raritan* 8.3 (1989): 1–26.

Pound, Ezra. *The Cantos*. New York: New Directions, 1970.

————. *Literary Essays*. Ed. T. S. Eliot. New York: New Directions, 1968.

————. *Selected Prose, 1909–1965*. Ed. William Cookson. London: Faber and Faber, 1973.

————. *Social Credit: An Impact*. Pamphlets by Pound 5. London: Peter Russell, 1951 [1935].

————. Translator's Postscript. *The Natural Philosophy of Love*. By Remy de Gourmont. New York: Liveright, 1932 [1922]. Pp. 295–311.

Preminger, Otto, dir. *Where the Sidewalk Ends*. With Gene Tierney and Dana Andrews. Twentieth Century–Fox, 1950.

Pynchon, Thomas. *The Crying of Lot 49*. New York: Harper, 1986 [1966].

Raeburn, John. "'Cultural Morphology' and Cultural History in Berenice Abbott's *Changing New York*." *Prospects* 9 (1984): 255–91.

Raggi, Franco. Interview with Robert Venturi. *Modo* 5 no. 44 (1981): 14.

Rapaport, Herman. "The Zeitgeist Complex." *American Literary History* 5 (1993): 347–69.

"*Réaménagement d'Hennepin Avenue, Minneapolis*." *Architecture d'Aujourd'hui* 217 (Oct. 1981): 44–48.

Regional Plan Association. *Regional Plan of New York and Its Environs*. 2 vols. 1929–31.

Riddel, Joseph N. "The Anomalies of Literary (Post) Modernism." *Arizona Quarterly* 44.3 (Autumn, 1988): 80–119.

———. *The Inverted Bell: Modernism and the Counterpoetics of William Carlos Williams*. Baton Rouge: Louisiana State University Press, 1974.

———. "'Keep Your Pecker Up': *Paterson Five* and the Question of Metapoetry." *Glyph* 8 (1981): 203–31.

Riis, Jacob. *How the Other Half Lives: Studies Among the Tenements of New York*. New York: Hill and Wang, 1957 [1890].

Rodriguez, Richard. *Days of Obligation: An Argument with My Mexican Father*. New York: Viking-Penguin, 1992.

———. "Slouching Toward Los Angeles." *Los Angeles Times*, Apr. 11, 1993: pp. M1, 6.

Rodwin, Lloyd, and Robert M. Hollister, eds. *Cities of the Mind: Images and Themes of the City in the Social Sciences*. New York: Plenum Press, 1984.

Ross, Andrew. *No Respect: Intellectuals and Popular Culture*. New York: Routledge, 1989.

Rowe, Colin, and Fred Koetter. *Collage City*. Cambridge, Mass.: MIT Press, 1978.

Rowe, John Carlos. *Henry James and Henry Adams: The Emergence of a Modern Consciousness*. Ithaca, N.Y.: Cornell University Press, 1976.

———. "Modern Art and the Invention of Postmodern Capital." *American Quarterly* 39 (1987): 155–73.

Ruscha, Edward. *Every Building on the Sunset Strip*. [Los Angeles], 1966.

———. *Some Los Angeles Apartments*. [Los Angeles]: E. Ruscha, 1965.

———. *Thirty Four Parking Lots in Los Angeles*. N. p., 1967.

———. *Twentysix Gasoline Stations*. Alhambra, Calif.: Cunningham Press, 1962.

Rydell, Robert W. *All the World's a Fair: Visions of Empire at American International Expositions, 1876–1916*. Chicago: University of Chicago Press, 1984.

Salzman, Jack. *Albert Maltz*. TUSAS 311. Boston: Twayne, 1978.

Samuels, Warren J., and Arthur S. Miller, eds. *Corporations and Society:*

Power and Responsibility. Contributions in American Studies 88. Westport, Conn.: Greenwood Press, 1987.

Sankey, Benjamin. *A Companion to William Carlos Williams's "Paterson."* Berkeley: University of California Press, 1971.

Sanmartin, A. *Venturi, Rauch and Scott Brown.* London: Academy Editions, 1986.

Sant' Elia, Antonio, "Manifesto." [1914.] *Architectural Design*, Jan.–Feb. 1981: 20–21.

Sarib, Jean-Louis. *"Complexité et contradiction d'un architecture pluraliste." Architecture d'Aujourd'hui* 197 (1978): 2–7.

———. *"Venturi et Scott Brown, urbanistes." Architecture d'Aujourd'hui* 197 (1978): 76–79.

Sayre, Henry M., "Ready-Mades." *Journal of Modern Literature* 8 (1979): 3–22.

Schaffer, Daniel. *Garden Cities for America: The Radburn Experience.* Philadelphia: Temple University Press, 1982.

———. "Resettling Industrial America: The Controversy over FDR's Greenbelt Town Program." *Urbanism Past and Present* 15 (1983): 18–32.

Schmidt, Peter. *William Carlos Williams, the Arts, and Literary Tradition.* Baton Rouge: Louisiana State University Press, 1988.

Schricker, Gale C. "The Case of Cress: Implications of Allusions in *Paterson." William Carlos Williams Review* 11.2 (1985): 16–29.

Schulze, Franz. "Chaos as Architecture." *Art in America*, July–Aug. 1970: 88–96.

Schuyler, David. *The New Urban Landscape: The Redefinition of City Form in Nineteenth-Century America.* Baltimore: Johns Hopkins University Press, 1986.

Schuyler, Montgomery. *American Architecture and Other Writings.* Ed. William H. Jordy and Ralph Coe. 2 vols. Cambridge, Mass.: Belknap–Harvard University Press, 1961.

Schwartz, Frederic. "Design for the City: Recent Urban Plans of Venturi, Rauch and Scott Brown." *Crit* 8 (Fall 1980): 12–13.

Scott, Melville. *American City Planning Since 1890: A History Commemorating the Fiftieth Anniversary of the American Institute of Planning.* Berkeley: University of California Press, 1969.

Scott, Ridley, dir. *Blade Runner.* Warner-Ladd, 1982.

Scott Brown, Denise. "Addressing the American City." *Crit* 17 (1986): 6–8.

———. "An Alternative Proposal that Builds on the Character and Population of South Street," *Architectural Forum*, Oct. 1971: 42–43.

———. "Architectural Taste in a Pluralistic Society." *Harvard Architectural Review* 1 (1980): 41–51.

———. "On Architectural Formalism and Social Concern: A Discourse for

Social Planners and Radical Chic Architects." *Oppositions* 5 (1976): 99–112.

———. "Revitalizing Miami: A Plan for Miami Beach's Washington Avenue." *Urban Design International* 1.2 (1980): 20–25.

Scott Brown, Denise, and Robert Venturi. "Co-op City: Learning to Like It." *Progressive Architecture*, Feb. 1970: 64–73.

Scranton, Philip B., ed. *Silk City: Studies on the Paterson Silk Industry, 1860–1940*. Collections of the New Jersey Historical Society 19. Newark: New Jersey Historical Society, 1985.

Scully, Vincent. *American Architecture and Urbanism*. Rev. ed. New York: Holt, 1988.

See, Fred G. "The Text as Mirror: *Sister Carrie* and the Lost Language of the Heart." *Criticism* 20 (1978): 144–66.

Segrest, Roger. "The Perimeter Projects: Architecture of the Excluded Middle." *Perspecta* 23 (1987): 54–65.

Seltzer, Mark. *Henry James and the Art of Power*. Ithaca, N.Y.: Cornell University Press, 1984.

Sennett, Richard. *The Conscience of the Eye: The Design and Social Life of Cities*. New York: Knopf, 1990.

———. "New York Reflections." *Raritan* 10.1 (1990): 1–23.

———. "Plate Glass." *Raritan* 6.4 (1987): 1–15.

———, ed. *Classic Essays in the Culture of Cities*. New York: Appleton, 1969.

Shakespeare, William. *The Tempest*. Ed. Robert Langbaum. New York: New American Library, 1964.

———. *Troilus and Cressida*. Ed. Daniel Seltzer. New York: New American Library, 1963.

Sharp, William. "That Complex Atom." *Poesis* 6 (1985): 65–93.

Sharpe, William Chapman. *Unreal Cities: Urban Figuration in Wordsworth, Baudelaire, Whitman, Eliot, and Williams*. Baltimore: Johns Hopkins University Press, 1990.

Sharpe, William Chapman, and Leonard Wallock, eds. *Visions of the Modern City: Essays in History, Art, and Literature*. Rev. ed. Baltimore: Johns Hopkins University Press, 1987.

Sibley, Gay. "Documents of Presumption: The Satiric Use of the Ginsberg Letters in William Carlos Williams' *Paterson*." *American Literature* 55 (1983): 1–23.

Simmel, Georg. *The Sociology of Georg Simmel*. Ed. and tr. Kurt H. Wolff. New York: Free Press, 1950.

Sklar, Martin J. *The Corporate Reconstruction of American Capitalism, 1890–1916: The Market, the Law, and Politics*. New York: Cambridge University Press, 1988.

Slotkin, Richard. *Regeneration through Violence: The Mythology of the American Frontier, 1600–1860*. Middletown, Conn.: Wesleyan University Press, 1973.

Small, Albion. "The Era of Sociology." *American Journal of Sociology* 1 (July 1895): 1–16.

Smith, C. Ray. "Electric Demolition, A Milestone in Church Art: St. Francis De Sales, Philadelphia." *Progressive Architecture*, Sept. 1970: 92–95.

Soja, Edward W. *Postmodern Geographies: The Reassertion of Space in Critical Social Theory*. London: Verso, 1989.

Sollors, Werner. *Beyond Ethnicity: Consent and Descent in American Culture*. New York: Oxford University Press, 1986.

Sorkin, Michael. "Robert Venturi and the Function of Architecture at the Present Time." *Architectural Association Quarterly* 6.2 (1974): 31–35.

Spencer, Herbert. *First Principles*. 6th ed. Westport, Conn: Greenwood Press, 1976 [1900].

———. *Principles of Ethics*. 2 vols. New York: Appleton, 1898.

———. *Social Statics; or, The Conditions Essential to Human Happiness Specified, and the First of Them Developed*. New York: Schalkenbach Foundation, 1954 [1850].

Standard Oil Co. of N.J. et al. v. United States, 221 U.S. 1 (1911).

Steffens, Lincoln. *The Shame of the Cities*. New York: Hill and Wang, 1957 [1904].

Stein, Clarence S. *Toward New Towns for America*. Cambridge, Mass.: MIT Press, 1966 [1949].

Stein, Gertrude. *Selected Writings*. Ed. Carl Van Vechten. New York: Vintage, 1972.

Steinman, Lisa M. *Made in America: Science, Technology, and Modern American Poets*. New Haven: Yale University Press, 1987.

Stephens, Suzanne. "For the Record: Schuyler at the 1893 World's Fair." *Architectural Record*, June 1993: 36–38.

———. "Franklin Court." *Progressive Architecture*, Apr. 1976: 69–70.

———. "Monumental Main Street." *Progressive Architecture*, May 1979: 110–13.

Stern, Robert A. M. *Venturi and Rauch: The Public Buildings*. Architectural Monographs 1. London: Academy Editions, 1978.

Stern, Robert A. M., Gregory Gilmartin, and John Montague Massengale. *New York 1900: Metropolitan Architecture and Urbanism, 1890–1915*. New York: Rizzoli, 1983.

Stern, Robert A. M., Gregory Gilmartin, and Thomas Mellins. *New York 1930: Architecture and Urbanism Between the Two World Wars*. New York: Rizzoli, 1987.

Stern, Robert A. M., and John Montague Massengale. *The Anglo American Suburb*. London: Architectural Design, 1981.

Stevens, Wallace. *Collected Poems*. New York: Vintage–Random House, 1982.

Stilgoe, John R. *Borderland: Origins of the American Suburb, 1820–1939*. New Haven: Yale University Press, 1988.

Storms, John C. *Origin of the Jackson-Whites of the Ramapo Mountains*. 2nd ed. Park Ridge, N.J.: priv. printed, 1945.

Stott, William. *Documentary Expression and Thirties America*. New York: Oxford University Press, 1973.

Sullivan, Louis. *The Autobiography of an Idea*. New York: Dover, 1956 [1922].

———. *Kindergarten Chats and Other Writings*. Rev. ed. New York: Wittenborn, Schultz, 1947 [1918].

Sundell, Michael G. "Berenice Abbott's Work in the 1930s." *Prospects* 5 (1980): 269–92.

Sundquist, Eric, ed. *American Realism: New Essays*. Baltimore: Johns Hopkins University Press, 1982.

Susman, Warren I. *Culture as History: The Transformation of American Society in the Twentieth Century*. New York: Pantheon, 1984.

Tafuri, Manfredo. *Architecture and Utopia*. 2nd ed. Tr. Barbara Luigia La Penta. Cambridge, Mass.: MIT Press, 1980.

———. *The Sphere and the Labyrinth: Avant-Gardes and Architecture from Piranesi to the 1970s*. Tr. Pellegrino d'Acierno and Robert Connolly. Cambridge, Mass.: MIT Press, 1987.

Talbot, D. Amaury. *Woman's Mysteries of a Primitive People: The Ibibios of Southern Nigeria*. London: Frank Cass, 1968 [1915].

Tapscott, Stephen J. *American Beauty: William Carlos Williams and the Modernist Whitman*. New York: Columbia University Press, 1984.

Tashjian, Dikran. "History and Culture in 'The American Background.'" *William Carlos Williams Review* 11.1 (1985): 13–19.

———. *William Carlos Williams and the American Scene, 1920–1940*. Berkeley: University of California Press, 1978.

Taylor, Gordon O. "Chapters of Experience: *The American Scene*." *Genre* 12 (1979): 93–116.

Thirlwall, John C. "William Carlos Williams' *Paterson*: The Search for the Redeeming Language—A Personal Epic in Five Parts." *New Directions* 17 (1961): 252–310.

Thomas, Brook. "The Construction of Privacy in and Around *The Bostonians*." *American Literature* 64 (1992): 719–47.

———. "*Moby-Dick*, Parts Related to Wholes, and the Nature of Subaltern Opposition." Unpublished paper, 1993.

Tichi, Cecelia. *Shifting Gears: Technology, Literature, Culture in Modernist America.* Chapel Hill: University of North Carolina Press, 1987.

Trachtenberg, Alan. "*The American Scene*: Versions of the City." *Massachusetts Review* (1967): 281–95.

———. *Brooklyn Bridge: Fact and Symbol.* 2nd ed. Chicago: Phoenix Books–University of Chicago Press, 1979 [1965].

———. *The Incorporation of America: Culture and Society in the Gilded Age.* New York: Hill and Wang, 1982.

———. *Reading American Photographs: Images as History.* New York: Hill and Wang, 1989.

United States v. Trans-Missouri Freight Association, 166 U.S. 290 (1897).

Veblen, Thorstein. *The Engineers and the Price System.* New York: Viking, 1921.

———. *Essays in Our Changing Order.* Ed. Leon Ardzrooni. New York: Viking, 1934.

———. *The Theory of the Leisure Class: An Economic Study of Institutions.* New York: Mentor–New American Library, 1953 [1899].

Venant, Elizabeth. "Grand Designs: Frank Gehry, Prophet of 'Cheapskate' Architecture, Makes a Bid for Permanence." *Los Angeles Times Magazine,* May 3, 1987, pp. 13–19, 40–42.

Venturi, Robert. *Complexity and Contradiction in Architecture.* 2nd ed. New York: Museum of Modern Art, 1977 [1966].

———. "Excavating the Past: Venturi, Rauch and Scott Brown's La Jolla Museum Addition." *Cartouche* 13 (1988): 10–11.

———. "From Invention to Convention in Architecture." *Royal Society of Architects Journal* 136 (Jan. 1988): 89–103.

———. Interview [with Peter Eisenman]. *Skyline,* July 1982: 12–15.

Venturi, Robert, and Denise Scott Brown. Interview. *Harvard Architecture Review* 1 (1980): 228–39.

———. *A View From the Campidoglio: Selected Essays, 1953–1984.* Ed. Peter Arnell, Ted Bickford, and Catherine Bergart. New York: Icon-Harper, 1984.

Venturi, Robert, Denise Scott Brown, and Steven Izenour. *Learning from Las Vegas.* Cambridge, Mass.: MIT Press, 1972.

———. *Learning From Las Vegas: The Forgotten Symbolism of Architectural Form.* Rev. ed. Cambridge, Mass: MIT Press, 1977.

Venturi, Rauch and Scott Brown. Tokyo: A+U Publishing, 1981.

Venturi Scott Brown and Associates. Architectural Monographs 21. London: Academy Editions, 1992.

Verman, Marvin. "A Proposal to Use Existing Federal Mechanisms to Make This Expressway as a Seam in the City's Fabric." *Architectural Forum,* Oct. 1971: 44–45.

von Eckardt, Wolf. "Bare and Square." *Washington Post,* Dec. 20, 1980, p. D1.

von Halleberg, Robert. "The Politics of Description: William Carlos Williams in the Thirties." *ELH* 45 (1978): 131–51.

von Moos, Stanislaus. *Le Corbusier: Elements of a Synthesis.* Cambridge, Mass.: MIT Press, 1979.

———. *Venturi, Rauch and Scott Brown: Buildings and Projects.* Tr. David Antal. New York: Rizzoli, 1988.

Wald, Malvin, and Albert Maltz. *The Naked City.* Ed. Matthew J. Bruccoli. Carbondale: Southern Illinois University Press, 1979 [1947].

———, screenwriters. *The Naked City.* Dir. Jules Dassin. Prod. Mark Hellinger. Universal-International, 1948.

Wallis, Brian, ed. *Art After Modernism: Rethinking Representation.* New York: New Museum of Contemporary Art–Godine, 1984.

Walsh, Raoul, dir. *White Heat.* With James Cagney. Warner, 1949.

Ward, David. *Cities and Immigrants: A Geography of Change in Nineteenth-Century America.* New York: Oxford University Press, 1971.

Ward, Lester F. *Dynamic Sociology, or, Applied Social Science.* 2nd ed. 2 vols. New York: Greenwood, 1968 [1911].

Wardley, Lynn. "Woman's Voice, Democracy's Body, and *The Bostonians.*" *ELH* 56 (1989): 639–66.

Wasserstrom, William. *The Ironies of Progress: Henry Adams and the American Dream.* Carbondale: Southern Illinois University Press, 1984.

Weaver, Mike. *William Carlos Williams: The American Background.* New York: Cambridge University Press, 1971.

Wharton, Edith. *The Age of Innocence.* New York: Appleton, 1920.

White, Morton, and Lucia White. *The Intellectual Versus the City: From Thomas Jefferson to Frank Lloyd Wright.* Cambridge, Mass.: Harvard University Press, 1962.

Whitman, Walt. "A Passage to India." [1871.] *Leaves of Grass.* New York: Modern Library, 1940. Pp. 321–29.

Wiebe, Robert H. *The Search for Order, 1877–1920.* New York: Hill and Wang, 1967.

Willensky, Elliot, and Norval White. *AIA Guide to New York City.* 3rd ed. San Diego: Harcourt, 1988.

William Carlos Williams Commemorative Issue. *Journal of the Medical Society of New Jersey,* Sept. 1983.

Williams, Raymond. *Culture.* [London]: Fontana, 1981.

———. *Culture and Society, 1780–1950.* New York: Columbia University Press, 1960.

Williams, William Carlos. "An American Poet [H. H. Lewis]." *New Masses*, Nov. 23, 1937: 17–18.

———. *The Autobiography.* New York: New Directions, 1951.

———. *The Collected Poems of William Carlos Williams.* Ed. A. Walton Litz and Christopher MacGowan. 2 vols. New York: New Directions, 1986–1988.

———. "Comment." *Contact* 1.1 (1932): 7–9.

———. "Comment." *Contact* 1.2 (1932): 109–10.

———. "Comment." *Contact* 1.3 (1932): 131–32.

———. *The Embodiment of Knowledge.* Ed. Ron Loewinsohn. New York: New Directions, 1974.

———. *The Farmer's Daughters: The Collected Stories of William Carlos Williams.* New York: New Directions, 1961.

———. "The Great Sex Spiral: A Criticism of Miss Marsden's 'Lingual Psychology,' I" *The Egoist*, Apr. 1917: 46.

———. "The Great Sex Spiral: A Criticism of Miss Marsden's 'Lingual Psychology,' II" *The Egoist*, Aug. 1917: 110–11.

———. *I Wanted to Write a Poem: The Autobiography of the Works of a Poet.* Ed. Edith Heal. Boston: Beacon Press, 1958.

———. *In the American Grain.* New York: New Directions, 1956 [1925].

———. *Interviews with William Carlos Williams: "Speaking Straight Ahead."* Ed. Linda W. Wagner. New York: New Directions, 1976.

———. Introduction to Marcia Nardi, "A Group of Poems," *New Directions* 7 (1942): 413–14.

———. "Letter to an Australian Editor." *Briarcliff Quarterly* 3 (1946): 205–208.

———. "A Man Versus the Law." *The Freeman*, June 23, 1920: 348–49.

———. "'Men . . . Have No Tenderness': Anais Nin's *Winter of Artifice.*" *New Directions* 7 (1942): 429–36.

———. *Paterson.* Rev. ed. New York: New Directions, 1963 [1946–63].

———. *Paterson.* Rev. ed. Ed. Christopher MacGowan. New York: New Directions, 1992.

———. "Penny Wise, Pound Foolish." *New Republic*, June 28, 1939: 229–30.

———. *A Recognizable Image: William Carlos Williams on Art and Artists.* Ed. Bram Dijkstra. New York: New Directions, 1978.

———. Review of *Jefferson and/or Mussolini.* By Ezra Pound. *New Democracy*, Oct. 15, 1935: 61–62.

———. *Selected Essays.* New York: New Directions, 1969.

———. *Selected Letters.* Ed. John C. Thirlwall. New York: McDowell-Obolensky, 1957.

———. "Sermon with a Camera." *New Republic*, October 12, 1938: pp. 282–83.

———. "Social Credit as Anti-Communism." *New Democracy*, Jan. 15, 1934: 1–2.

———. "A Social Diagnosis for Surgery: A Poet-Physician on the Money-Cancer." *New Democracy*, Apr. 1936: 26–29.

Willis, Carol. "The Titan City." *Skyline*, Oct. 1982: 26–27.

———. "Unparalleled Perspectives." *Daidalos* 25 (1987): 78–91.

———. "Zoning and *Zeitgeist*: The Skyscraper City in the 1920s." *Journal of the Society of Architectural Historians* 45 (1986): 47–59.

Wilson, George G. "The Place of Social Philosophy." *Journal of Social Science* 32 (Nov. 1894): 139–43.

Wilson, Richard Guy, Denise Pilgrim, and Dikran Tashjian. *The Machine Age in America, 1918–1941*. New York: Brooklyn Museum–Abrams, 1986.

Wilson, Rob. "Lexical Scapegoating: The Pure and Impure of American Poetry." *Poetics Today* 8 (1987): 45–64.

Wise, Gene. *American Historical Explanations: A Strategy for Grounded Inquiry*. Rev. ed. Minneapolis: University of Minnesota Press, 1980.

Wit, Wim de, ed. *The Function of Ornament: The Architecture of Louis Sullivan*. New York: Norton, 1986.

Wittner, Lawrence S. *Cold War America: From Hiroshima to Watergate*. Rev. ed. New York: Holt, 1978.

Wood, Gordon S. *The Creation of the American Republic, 1776–1787*. New York: Norton, 1972.

Woodward, Kathleen. *At Last, the Real Distinguished Thing: The Late Poems of Eliot, Pound, Stevens, and Williams*. Columbus: Ohio State University Press, 1980.

———, ed. *Myths of Information: Technology and Postindustrial Culture*. London: Routledge, 1980.

Wordsworth, William, and Samuel Taylor Coleridge. *Lyrical Ballads*. Ed. R. L. Brett and A. R. Jones. London: Methuen, 1963 [1800].

Wright, Gwendolyn. *Building the Dream: A Social History of Housing in America*. New York: Pantheon, 1981.

———. *Moralism and the Model Home: Domestic Architecture and Cultural Conflict in Chicago, 1873–1913*. Chicago: University of Chicago Press, 1980.

Wright, Lance. "Robert Venturi and Anti-Architecture." *Architectural Review*, Apr. 1973: 262–64.

Wyler, William, dir. *Carrie*. Paramount, 1952.

Zabriskie, George. "The Geography of *Paterson*." *Perspective* 6 (1953): 201–16.

Zetzel, Suzanna S. "The Garden in the Machine: The Construction of Nature in Central Park." *Prospects* 14 (1989): 291–340.

ZONE 1/2. Cambridge, Mass.: MIT Press, 1987.

Zukofsky, Louis. "Beginning Again with William Carlos Williams." *Hound and Horn* 4 (1931): 261–64.

Zukowsky, John W., ed. *Chicago Architecture, 1872–1922: Birth of A Metropolis.* Munich: Art Institute of Chicago–Prestel Verlag, 1987.

———. *Mies Reconsidered: His Career, Legacy, and Disciples.* New York: Art Institute of Chicago–Rizzoli, 1986.

In this index an "f" after a number indicates a separate reference on the next page, and an "ff" indicates separate references on the next two pages. A continuous discussion over two or more pages is indicated by a span of page numbers, e.g., "57–59." *Passim* is used for a cluster of references in close but not consecutive sequence.

This book was typeset by G&S Typesetters, Inc. in 9.5/13 Trump Mediaeval. Designed by Kathleen Szawiola.

Library of Congress Cataloging-in-Publication Data

McNamara, Kevin R.
 Urban verbs : Arts and discourses of American Cities /
Kevin R. McNamara.
 p. cm.
 Includes bibliographical references and index.
 ISBN 0-8047-2645-0 (cloth)
 1. Cities and towns in art. 2. Arts, American.
 3. Arts, Modern—20th century—United States.
 I. Title.
 NX650.C66M36 1996
 700—dc20 95-42932
 CIP

♾ This book is printed on acid-free, recycled paper.

Original printing 1996

Last figure below indicates year of this printing:

05 04 03 02 01 00 99 98 97 96